Gustav Klimt

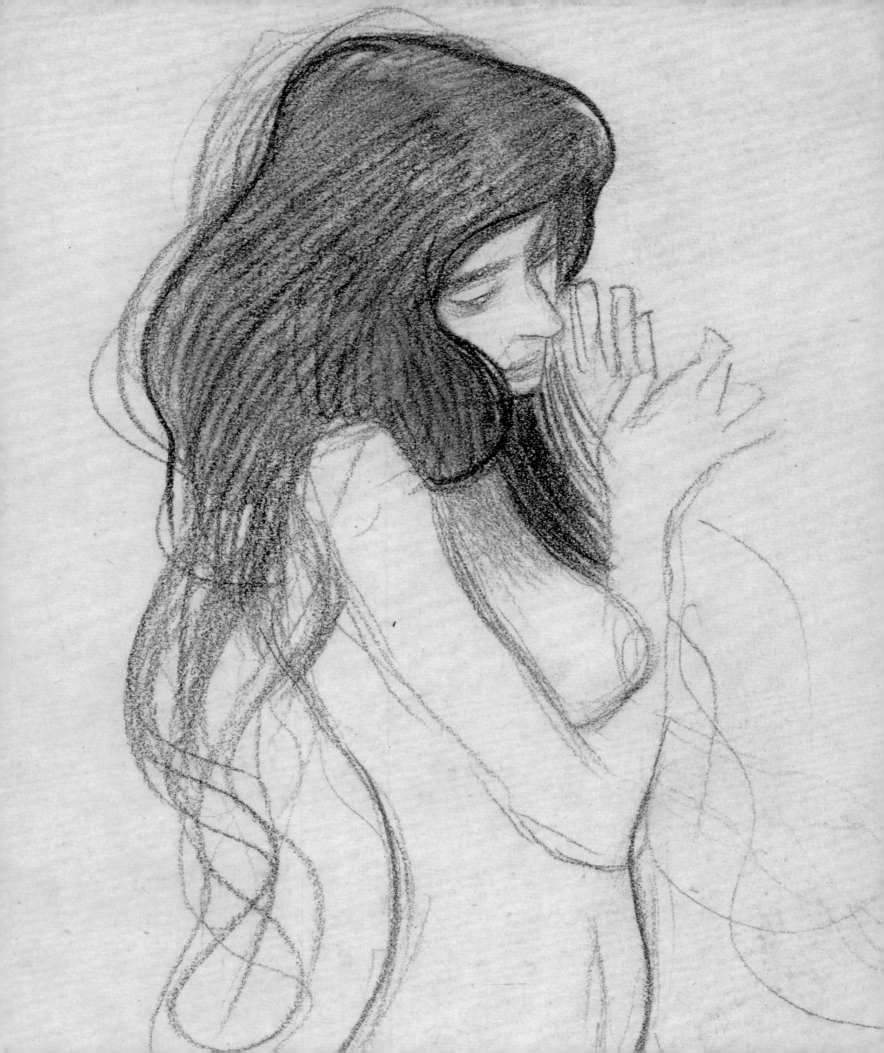

Marian Bisanz-Prakken

GUSTAV KLIMT

THE MAGIC OF LINE

Translated by Steven Lindberg

The J. Paul Getty Museum, Los Angeles, in association with the Albertina Museum, Vienna

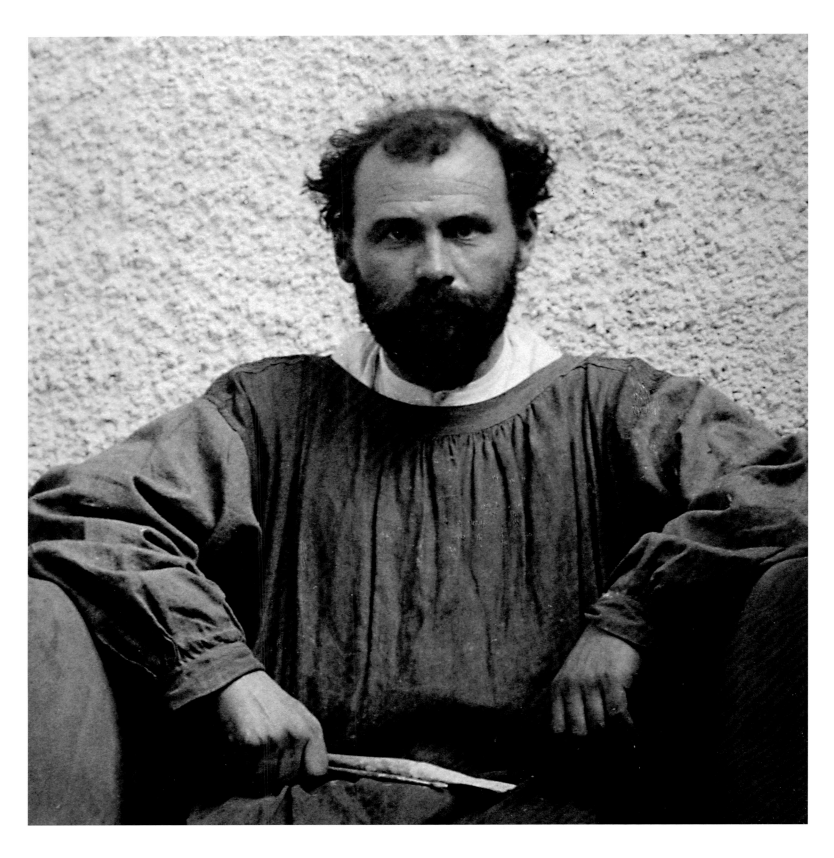

Gustav Klimt in the Beethoven exhibition,
Viennese Secession, 1902

Foreword

Gustav Klimt is closely connected to the Albertina, both for the scope and quality of this world-famous institution's holdings and for decades of research into his oeuvre of drawings. The Albertina's first acquisition was a gift from Otto Nirenstein (later Kallir) in 1920. Since then the Albertina's Klimt collection has grown to its present holdings of 170 sheets, which offer a unique overview of the various phases of the artist's development. In addition to outstanding individual works there are several series of studies for his painting projects, both the allegories and the portraits.

The Albertina's position as a center of research on Gustav Klimt's drawings was established by the exhibition and research activities of Alice Strobl, who was first Curator and then Vice Director at the Albertina. Between 1980 and 1989, the Albertina published the four-volume catalogue raisonné of Gustav Klimt's drawings that she wrote, with descriptions of nearly four thousand items. This body of work is still a milestone of Klimt scholarship.

Beginning in 1975 Marian Bisanz-Prakken provided her with crucial assistance establishing the chronology of these drawings, nearly all of which are undated. Since 1991 Marian Bisanz-Prakken has had sole responsibility for this cataloguing work. Thanks to this continuity in the area of Klimt scholarship, the Albertina has for decades been the international authority on the assessment of Gustav Klimt's drawings. The museum therefore naturally felt a responsibility to devote a comprehensive exhibition to his drawings on the 150th anniversary of his birth.

The present partnership between the Albertina Museum and the J. Paul Getty Museum brings the celebration of Gustav Klimt to the United States. The artist has long been familiar to East Coast audiences. Otto Kallir, former director of the Neue Galerie, Vienna, and Serge Sabarsky, a Viennese native—both involuntary emigrants to the USA in 1938—played key roles in engendering American appreciation of Austrian art of the turn of the century and Expressionism. Among the many shows dedicated to Klimt, Schiele, and to art circa 1900, outstanding ones include "Klimt and Schiele" (1965, Guggenheim Museum, New York), "Vienna 1900: Art, Architecture, and Design" (1986, Museum of Modern Art, New York), and since 2001 the ongoing exhibitions of the Neue Galerie, New York.

During World War II, Los Angeles was a haven for many great Austrian cultural figures who indelibly shaped the city and fostered in it an enduring audience for Austrian art, music, and literature. Although the city sadly lacks a painting by Klimt, there are several fine drawings by him in local collections including two major examples that entered the collection of the J. Paul Getty Museum in 2009. Soon after this exciting acquisition was made, Marian Bisanz-Prakken visited the Getty and informed Lee Hendrix, senior curator of drawings, that she was organizing a major retrospective of Klimt's drawings during the commemoration of the 150th anniversary of his birth. The Getty seemed like a natural partner for this great exhibition that will be the first ever on the West Coast solely devoted to the art of

Gustav Klimt. Another first is the exhibition's exclusive concentration on Klimt's drawings. Indeed, the rich and encyclopedic holdings of the Albertina, on which the Getty's show is largely based, give eloquent testimony to the centrality of drawing to Gustav Klimt's artistic enterprise. A few carefully selected works have also been borrowed from lenders in order to supplement the extraordinary collection from the Albertina. Both institutions would like to express their sincere gratitude to the lenders—both public and private—who have shared their precious drawings with us.

Our joint gratitude is due first and foremost to the curator of this exhibition, Marian Bisanz-Prakken, who contributed her knowledge from decades of research on Gustav Klimt to the project and the exhibition catalogue. Without her profound knowledge of the oeuvre of drawings by this giant of Viennese modernism, this exhibition could never have been realized as planned.

At the Getty, senior curator of drawings Lee Hendrix and Edouard Kopp, assistant curator of drawings, deserve special thanks in shaping an extraordinary exhibition for visitors to Los Angeles. David Bomford, former acting director of the Museum, together with Thomas Kren, acting associate director for collections, and Quincy Houghton, associate director for exhibitions and public programs, provided support for the project. Other staff critical to the exhibition's success at the Getty include Leanne Lee and Jessie Huh in the Department of Drawings; Sally Hibbard and Betsy Severance in the Registrar's office; Merritt Price, Nicole Trudeau, and Elie Glyn in Exhibition Design; Erik Bertoletti, Anne Martens, and Chris Keledjian in Collections Information and Access; Nancy Yocco and Lynne Kaneshiro in Paper Conservation; Toby Tannenbaum and Maite Alvarez in Education; John Giurini in Museum Communications and Public Affairs; Rob Flynn, Leslie Rollins, and Beatrice Hohenegger in Publications; Susan McGinty in Exhibitions; and Christian Huemer and Alexa Sekyra of the Getty Research Institute. We would also like to thank the Los Angeles Philharmonic for coordinating its programming with the exhibition and Karin Proidl, Austrian Consul General in Los Angeles, who lent support and helped get the word out to the considerable Austrian constituency of Los Angeles.

James Cuno
President and CEO, The J. Paul Getty Trust

Klaus Albrecht Schröder
Director, Albertina, Vienna

Detail from *Thalia and Melpomene*, 1898, cat. no. 24

Gustav Klimt the Draftsman

"If one surveys Klimt's lifework, he seems greatest as a draftsman." The renowned art historian Gustav Glück was by no means alone in that view, expressed in 1922.[1] Gustav Klimt's drawings were highly popular among connoisseurs and collectors, particularly in the years just prior to and after his death in 1918. In today's flood of exhibitions and publications on Vienna around 1900, Klimt's drawings are often presented only as decorative supplements to the paintings. In the public perception, the gold and splendid colors of the major works generally outshine the sparse effect of the drawings in the truest sense of the word. It is often overlooked that coming to terms with his drawings is an essential prerequisite to understanding Klimt's painting. The thought processes that preceded the often reworked paintings found expression in his extensive series of studies, as is clear from the catalogue raisonné of Gustav Klimt's drawings published by Alice Strobl.[2] By continuously working from living models, Klimt internalized his themes in thousands of sheets. The sensitive and immediate character of these works offer revealing insights into his ways of thinking and working, as he virtually never made written or oral statements about his artistic intentions. As a draftsman of human figures—primarily women—he often went far beyond depicting the themes of the paintings. In parallel with his creativity as a painter, his works on paper followed their own laws. For Klimt, drawing was a daily necessity, since his constant and diverse approach to the line formed the core of his activity as an artist. In addition to around 250 paintings, the more than four thousand drawings known to us today—the original number was doubtless much larger—represent their own universe.

Klimt's standing as a draftsman was unique, not just in Austria but internationally, and it was marked by the tension between progress and tradition. On the one hand, he revolutionized the depiction of the nude: his erotic studies, which led to accusations of pornography during his lifetime, blazed the trail for the uninhibited depiction of the human being by Egon Schiele, who was almost thirty years his junior. On the other hand, his expressive figure studies, allegories of grief and suffering, pointed the way for the younger generation, not just Schiele but also Oskar Kokoschka.

For all his modernity, the academic discipline of drawing series based on nude or clothed models remained definitive. He produced whole series of female and male models, as well as children, in the context of his allegories. Again and again, he got to the essence of a certain pose or gesture, always considering how it was tied to the picture plane and hence to its relationship to an imaginary spatial context. Consequently, each sheet is a self-contained, hermetically sealed world shaped by its own rules. It is symptomatic that Klimt always used the same format of paper as a matrix and reliable point of reference to balance the internal proportions. Two phases can be distinguished: from about 1897 to 1903 or 1904, he drew with black chalk on sheets of packing paper measuring about 45 × 31.5 cm,

then with graphite on paper from Japan cut down to sheets about 56 × 35 cm.[3]

The continuity of this practice points to the fact that, for all his stylistic revolutions, Klimt remained rooted in his origins as a painter of decorations in an overarching context. The creedlike "thus and not otherwise" of every single sheet is based on an apparently intuitively grasped balance between space and plane, fullness and emptiness, bright and dark, movement and stability, or transitoriness and permanence. His way of working was characterized by a constant tightrope walk between the relaxed line and formal discipline. "The incredible legerity of his stroke, the unerring confidence of his line, is the fruit of very serious work, which never ceased," said Hans Tietze in his obituary for the artist, who died in 1918.[4] The figures Klimt drew seem sensuous yet at the same time immaterial and of a hovering lightness. As if in a trance, they submit to an invisible order, whether in states of dream, meditation, melancholy, or of ecstasy. The Symbolists Fernand Khnopff and Jan Toorop, from Belgium and the Netherlands, respectively, were primarily responsible for this metaphysical aspect of Klimt's depictions of figures; with his "gift of receptivity," he confidently employed these complex impulses.[5] The figures he drew and painted do not move on their own initiative but appear to be ordered by remote control in their poses and gestures. They are ineluctably bound to the cycle of life, with the imagery of its stages occupying Klimt intensely from the time of his turn to Symbolism. From 1900 onward, his work was determined by the themes of Eros, love, birth, life, and death. Klimt's figures are not individuals but rather allegories of primeval situations of human life.[6] The sensuously energized and animated contours of the body are not about the inner life of the sitters but rather about supraindividual emotions or moods they represent.

The many studies for portraits of women from 1897 onward form a category of their own; analogously to the studies of models, they convey an impression of noble absence. These works furthered not only his search for the suitable pose and most appropriate clothing but also his exploration of the essence of the women to be depicted, even while he maintained an appropriate distance. The poses and gestures of the sitters seem very controlled and always conform to a higher order.

In all the phases of his spectacular development across epochs, the brilliant loner managed to reposition himself without abandoning his identity. As a draftsman he kept finding himself again and again, whether in the photographically realistic precision of the 1880s, the flowing linearity of the legendary period around 1900, the metallic and linear sharpness of the Golden Style, or the vehement and nervous handling of the line in his late years. The mainstays in his art of drawing were the primacy of the line and the commanding mastery of technical means, which he believed could be traced back to his extremely solid training at Vienna's Kunstgewerbeschule (School of Applied Arts). At the age of fifty, he still gratefully recalled his most important professor, Ferdinand Laufberger, who taught him his craft.[7]

About the Exhibition

This exhibition is by no means solely concerned with technical brilliance and the aesthetic of the line, although the selection of the drawings was guided by high standards of quality. In four chronological sections, the main phases of the artist's development are presented and analyzed, with the comparison with the paintings playing an important role. In the beginning Klimt worked primarily with black chalk, sometimes supplemented by blue, red, or white. Later he drew mainly with graphite and colored pencils, occasionally with ink. Watercolors and gold paints were used primarily in the early years, and late watercolors were rare. The spectrum of functions of his drawings was highly diverse, from the figure study to the monumental working drawing, from the illustration to the meticulously detailed allegory. In addition to a number of studies of female and—less frequently—male heads, the genre of highly finished half-length and head-and-shoulders portraits is represented here by outstanding examples. The series of studies, which are distributed throughout all his creative phases, are one absolutely special quality of the Albertina's Klimt holdings. These series, which are associated with specific projects for paintings, are presented here completely for the first time, thus offering deeper insight into Klimt's working methods. In general, concentrating on the drawings has the great advantage of looking at the artist from within, in a manner of speaking.

Historicism and Early Symbolism 1882–1892

This chapter of Klimt's career extends from the final phase of his education at the Kunstgewerbeschule by way of his successes as a painter in the Ringstrasse tradition to the crisis year of 1892, when he lost both his younger brother Ernst, with whom he had closely collaborated, and his father. It presents various aspects of his early drawing, from the figure study to the highly finished allegory. The first work exhibited here, which dates from 1882, documents Klimt's participation in the publication series *Allegorien und Embleme* (Allegories and Emblems). One highlight of his historicist phase is the group of realistic and yet empathetically drawn studies of heads and figures for the ceiling paintings of the grand staircase of the Burgtheater (1887–88). The spectacular *Allegory of Sculpture* (1889)—both the sketch and the main work are shown—and the 1892 designs for banknotes mark his transition to Symbolism.

The Turn to Modernism and the Secession 1895–1903

After several years of seclusion and inner reorientation, Klimt professed his faith in Symbolism publically for the first time with the painting *Love* (1895), which was reproduced in the series *Allegorien, Neue Folge* (Allegories, New Series). The studies for heads of a child and a man exhibited here were produced for this metaphysically oriented work. Soon thereafter Klimt became the leading figure of the modern movement in the arts and in 1897 he was appointed

Detail from *Portrait of a Woman*, study for *The Beethoven Frieze*, 1901, cat. no. 58

president of the newly founded Secession. He designed the poster for that association's first exhibition (March–May 1898) and was active as an illustrator for the first volume of its journal, *Ver Sacrum* (1898). One of the ink drawings created for that purpose and exhibited here is the spectacular *Fish Blood*, Klimt's earliest autonomous depiction of an erotically playful underwater motif. The genre of drawings of female ideal portraits, dominated by atmospheric moods characteristic of the *Seelenkunst* (art of the soul) of the early Secession period is represented here by two prominent examples.

One fundamental transformation occurred in the field of the figure studies. The drawings for the faculty paintings *Philosophy* and *Medicine*, most of which were produced between 1897 and 1901, include numerous depictions of nude men and women—young and old, beautiful and ugly—as well as of children. The groups of studies shown here testify to Klimt's tireless search for the basic pose that captures the relevant mood or state of human existence. Sensitive contours cause the self-absorbed figures to stand out against the blank areas of the sheet. The radical transition from *Stimmungskunst* (mood art) to the new ideals of monumentality occurs in *The Beethoven Frieze* (1901–2). The studies for this great work, which are represented here by a selection of outstanding drawings, are characterized by an emphasis on largely geometricized poses and gestures. Distinctive physical contours emphasize the programmatic differences between the individual personifications. The study for the head of one of the goddesses of fate in the third faculty painting, *Jurisprudence* (1903)—which was produced after *The Beethoven Frieze* and is characterized by the dominance of the line—resembles a woodcut.

A series of studies documents Klimt's activity as a draftsman in the context of his modern portraits of women, beginning with the painting *Sonja Knips* (1898). The larger groups include the wavy linear studies for the portrait *Serena Lederer* (1899) and the 1903 studies for the portrait *Adele Bloch-Bauer I* (1907), in which geometric ornaments mark the transition to the Golden Style.

The Golden Style
1903–1908

The Beethoven Frieze was followed by a series of monumental paintings in which gold plays an increasingly dominant role. After the Klimt Group left the Secession in 1905, Klimt and his friends planned the *Kunstschau* (Art Show), which opened in 1908, in which the major works of his Golden Style could be seen, including *The Kiss* (1908). By analogy to the paintings, which allegorize the entire spectrum of life themes, Klimt's creativity as a draftsman reached a culmination during this phase. Around 1903–4 he switched from black chalk on packing paper to graphite on Japanese paper. The metallic sharpness of his pencil lines, which recall the ornamental precision of the paintings in the Golden Style, is brought out particularly well in the 1904–5 studies for *Water Snakes I* and *Water Snakes II*. The taboo themes of lesbian love and autoeroticism that appear in a large number of these sheets,

several of which were used in Lucian's *Die Hetärengespräche* (Dialogues of the Courtesans) in 1907. In the studies for the allegories of *Hope I* (1903) and *Hope II* (1907) exhibited here, Klimt delved into the theme of pregnancy. In the drawings for *The Three Ages of Woman*—for which the life-size transfer sketch is shown here—he was preoccupied with physical and spiritual aspects of aging. In the 1907–8 studies of couples for *The Kiss* and "Fulfillment" in *The Stoclet Frieze*, the tension between relaxed sensuality and linear discipline reaches a climax. The studies for "Expectation," in turn, are dominated by ritual, angular gestures, which are also found in the studies inspired by dance for the painting *Judith II (Salome)*. The 1908–9 drawings for the 1910–11 painting *Death and Life* (revised 1916) are characterized by an atmosphere of melancholy and meditation

Of the drawings for the female portraits in the Golden Style exhibited here, the subtle, translucent studies of Margarethe Stonborough-Wittgenstein are of particular importance. The half-length portrait of an anonymous lady in a plumed hat of 1908 is unique in its combination of brush, graphite, and colored pencils.

The Late Years
1910–1918

During the final eight years of his life, Klimt largely withdrew from the public sphere. In 1912 his studio in the Josefstadt district of Vienna was demolished, and he set up his workshop on the rural periphery in the Hietzing district. Beginning around 1910, his work as a draftsman was increasingly occupied with erotic themes. In the context of his major works *The Virgin* (1913), here represented by an extensive group of studies, and *The Bride* (1917–18, unfinished), he developed a broad typological spectrum in his choice of models. In the period between these two painting projects, Klimt produced a large number of autonomous erotic studies. Toward the end of his life his use of line relaxed to the point of abstraction, and the models were sometimes depicted in extreme spatial configurations. Nevertheless, the primacy of the boundaries of the sheet and the connection to the plane remained Klimt's supreme guiding principle. His sole stylistic means remained the line, in seemingly endless variation, with which he effectively set the densely concentrated outlines of the body against the wildly sketched patterns of fabrics. Colored pencils in red and blue were usually combined with graphite and sometimes used alone. The studies for portraits of women, for which he received many commissions in his final years, occupy an important place. The diversity of his experiments with poses and various types of clothing is expressed in the studies exhibited here, especially in the series for the portraits *Paula Zuckerkandl* (1912), *Mäda Primavesi* (1913), and *Amalie Zuckerkandl* (1917–18, unfinished; studies, 1914). In addition to the drawings produced for the portrait paintings, he dedicated himself to half-length and head-and-shoulders portraits of anonymous women, concentrating on specific types, with highly effective results, as the examples shown here demonstrate.

Detail from *Portrait of a Lady Wearing a Fur,* study for *The Girlfriends,* 1916–17, cat. no. 168

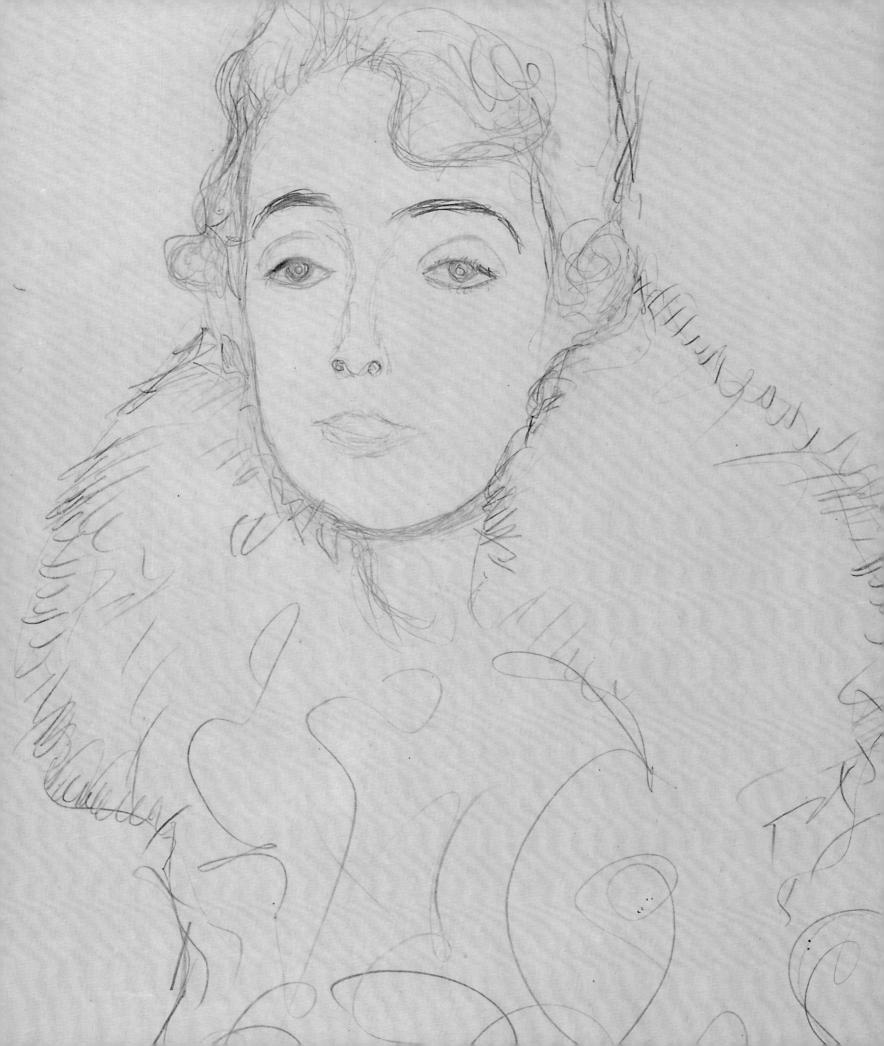

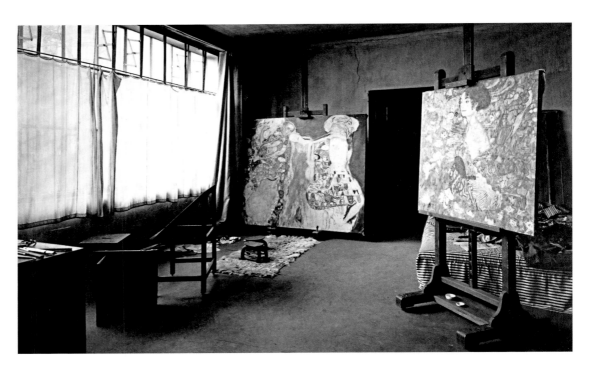

Gustav Klimt's studio, Feldmühlgasse 11,
Vienna, Ober-St. Veit, 1918

Reflections on the Practice of Drawing

None of the known contemporary observations of Klimt's practice as a draftsman are based on eyewitness testimony. Apart from sitters and models, no one witnessed this highly private creative activity.[8] This only emphasizes the value of the information contained in the famous photograph of Klimt's last studio made by Moritz Nähr after the artist's death. Next to the window is a piece of furniture that is clearly identifiable as a drawing desk, as well as a square painter's stool.[9] To judge from the height of the portrait *Lady with a Fan* standing on the easel (100 cm), the work surface measured about 70 × 70 cm. This format was just right to provide room for the standard size of drawing paper Klimt used—about 56 × 35 cm—no matter whether it was oriented vertically or horizontally. The work surface was approximately at a forty-five-degree angle to the floor. Because Klimt's drawings bear no traces of any kind of fasteners, it may be assumed that the sheets were placed freely on

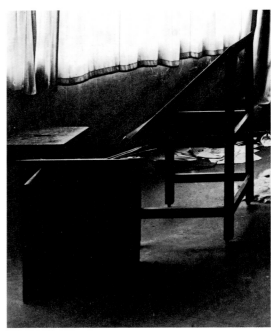

this support, which was presumably made of a nonslip material such as rubber. The height of the stool, whose seat was on a line with the lower support of the drawing table, was about 45 cm. The legs of the table were mounted on casters, which were either movable or based on a spring construction. This

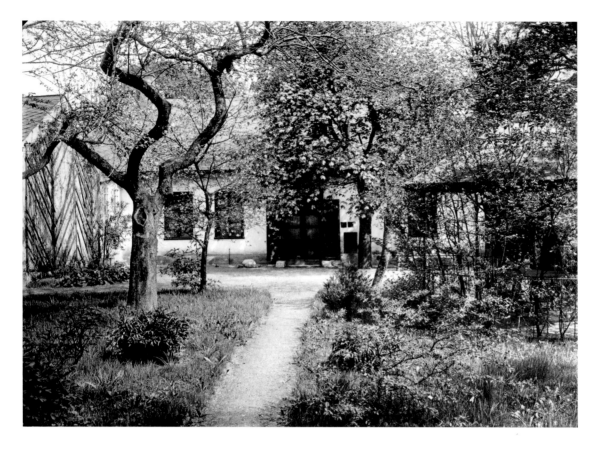

Gustav Klimt's garden and studio,
Feldmühlgasse 11, Vienna, Ober-St. Veit, 1918

mobile unit of stool and desk could easily be adjusted slightly as Klimt was drawing his models or sitters for portraits. It is conceivable that he also employed one of the two low African stools seen in the photograph in front of the painting *The Bride* when drawing models on the wide bed draped with sheets. In any case, he painted and drew intensely in this large workroom with northern light, though it can no longer be determined whether he worked in parallel sessions or strictly separated ones.

[1] Glück 1922, unpaginated.
[2] Strobl I–IV, 1980–89.
[3] Strobl IV, 1989, p. 211.
[4] Tietze 1919, p. 9.
[5] Max Eisler described the "gifts of taste, adaptation, and receptivity" that were "creative features" in Klimt's work as typically Viennese; see Eisler 1920, p. 5. On the influences of Khnopff and Toorop, see Bisanz-Prakken 1978–79, 1995, 2007; Exh. cat. The Hague 2006–7 (selection).
[6] On the primeval situations of life in Klimt's oeuvre, see Bisanz-Prakken 2001a, p. 150.
[7] Weixlgärtner 1912, p. 51.
[8] Contemporary portrayals of this activity should be appreciated with great caution.
[9] I am grateful to Dipl.-Ing. Oliver L. Schreiber of the Bundesdenkmalamt Österreich, Prof. Mag.-arch. Dipl.-Ing. Eduard Neversal, and Dipl. Ing. Michael Lisner for conversations, information, and assistance.

*Historicism
and Early Symbolism*

1882–1892

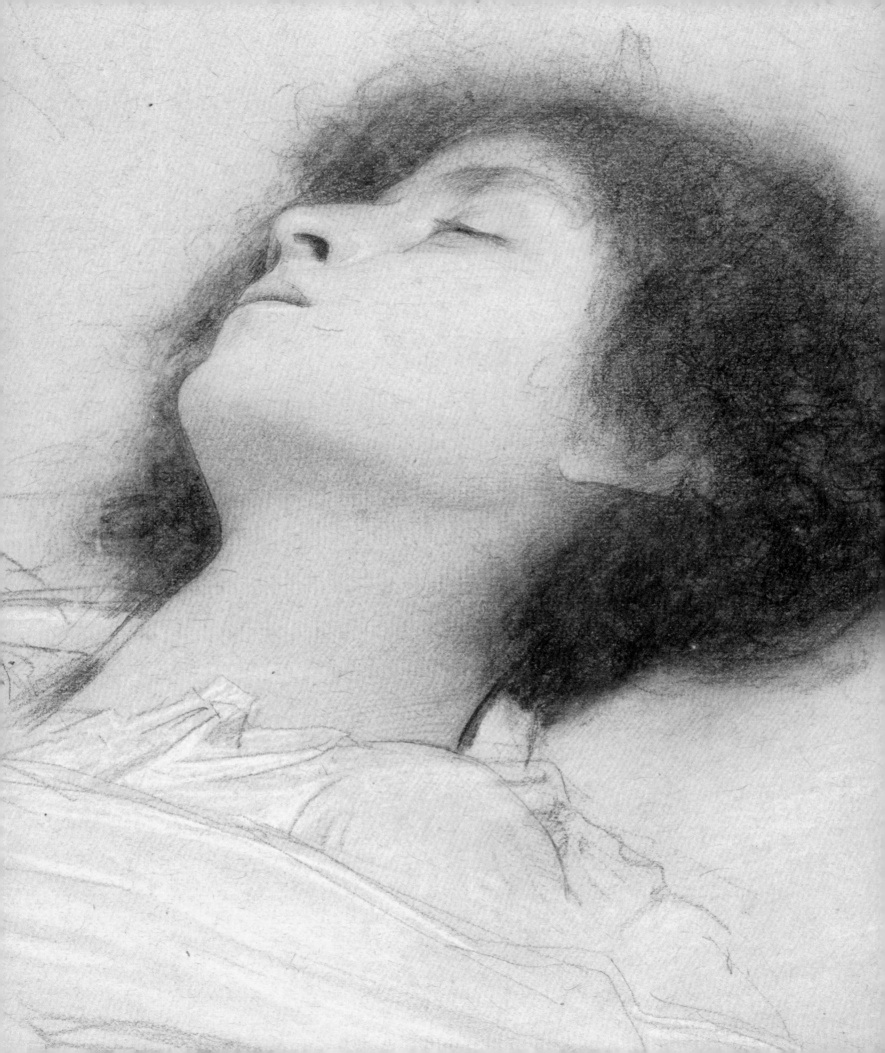

The Realms of Nature

The detailed allegories of the 1880s and 1890s occupy a prominent position in Gustav Klimt's oeuvre of drawings. The earliest group comprises five sheets the young artist produced—together with two works in oil—between 1881 and 1884 for the historicist series *Allegorien und Embleme*.[1] The editor, Martin Gerlach, invited a large number of both established and young, budding artists from Germany and Austria to participate in this ambitious project, and their submissions—for the most part drawings in a variety of techniques—were lavishly reproduced. The 151 contributions treated the "most important allegorical concepts that have occupied the arts for centuries," wrote the art historian Albert Ilg, then director of Vienna's Kunsthistorisches Museum, in his foreword to this publication. The thematic areas "from human life, from nature" include "Heaven and Earth, Time and Eternity, Vegetation, Animal Life, Days and Moons, Professions and Careers, Passions, Virtues and Vices."[2] The result was a kind of picture gallery on paper, which—in contrast to decorative paintings, many of which are not easily accessible—could be studied in both private and public. In a didactic overview, all the phenomena mentioned here were symbolized with an eye to the past but also with an optimistic view of the present and future.

In this project, drawing, which in historicism had largely played a subordinate role, was granted the status of a creative medium in its own right. Hence Gustav Klimt had an opportunity early on to showcase his extraordinary talents in this area. In 1882, at the age of twenty and still completing his education, he drew the allegory *The Realms of Nature* (fig. 1).[3] In the preliminary sketch for that work

seen here, the artist was feeling his way to the basic features of his portrayal in spontaneous, powerful lines and brushstrokes: three symmetrically arranged seated figures, a broad podium, and a simple line in the form of a tympanum (cat. no. 1). The pseudo-architectural context is further reinforced by viewing the figures slightly from below. With its painterly character, this sketch recalls the style of the famous Ringstrasse painter Hans Makart, who influenced Klimt for a time after his teacher Ferdinand Laufberger, who had oriented his work primarily around the Italian Renaissance, died in 1881.

Despite several changes in the poses, the figures depicted in this sketch function as they do in the work as executed. In keeping with Albert Ilg's explanations, the three seated figures depicted by Klimt correspond to the realms of animal, plant, and mineral kingdoms.[4] This concept was clearly based on the hierarchy of the natural realms established by the Swedish botanist Carl von Linné (Linnaeus) in his famous publication *Systema naturae* (1735). Albert Ilg essentially wrote that the man on the throne at the top, whose similarity to Michelangelo's *ignudi* in the Sistine Chapel was recognized early on, represents the highest intellectual level of the animal kingdom. The lion refers to his physical strength; the attributes of his intellectual superiority are the book and the eagle, which is only summarily sketched in the drawing. Subordinated to the man is the female element in the form of representatives of the plants and the stones, each with a genius at its side. In the sketch Klimt differentiated between the man's flesh tone in brownish watercolor and the bright areas of the women's skin; Klimt continued to apply

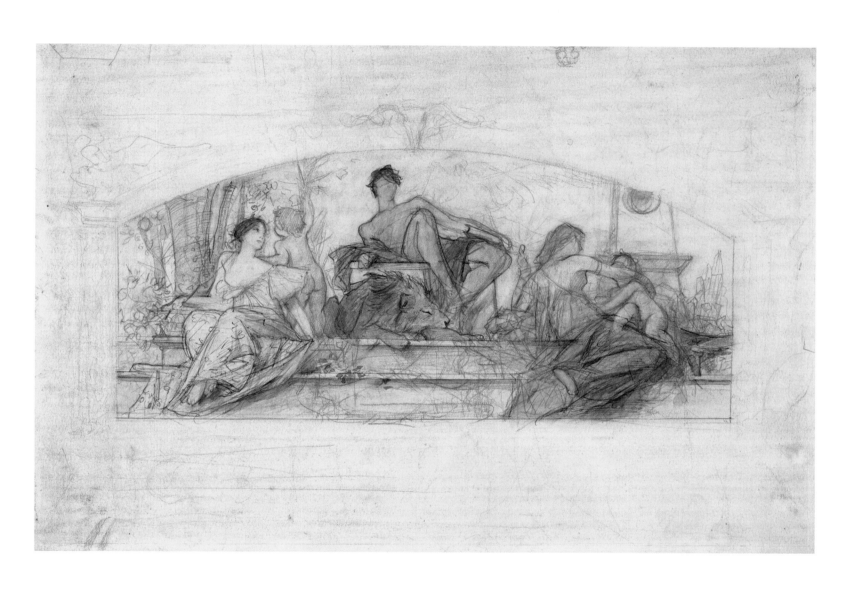

1

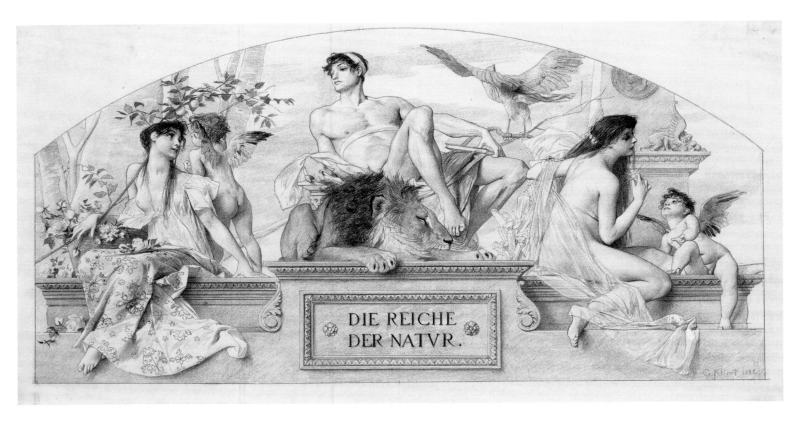

DIE REICHE
DER NATVR.

Fig. 1. *The Realms of Nature*, 1882,
graphite, white heightening, 27.5 x 53.1 cm,
Wien Museum

this contrasting effect even in his late depictions of male-female pairs. The almost frontal figure symbolizing flowers, whose skin shines brightly, is surrounded by pastoral vegetation. The introverted figure symbolizing minerals has her back turned halfway to the viewer and is holding a diamond up high in her hand; next to her lie uncut stones, and an obelisk looms as an inorganic, smooth counterpart to the tree trunks. In this sketch for the composition, Klimt was exploring above all the positions and gestures of the figures, which emphasize their meaning, and he dispensed with rendering their facial features except for the figure of flowers. Angularly accented pencil and ink lines mark the outlines of the three seated figures and their companions and lend a pulsating rhythm to the whole group. With this emphasis of angular and constructive elements, Klimt distinguished himself from Hans Makart.

A broad arc spans between the spontaneity of the sketch and the controlled precision of the executed work. Using purely graphic

means, Klimt achieved a wide spectrum of subtle contour lines and nuanced surface effects. He carefully adapted the poses, gestures, and expressions of his figures to one another—in terms of psychology as well. The comments of Albert Ilg, who wrote that the reader's attention "is drawn to the intentions of the creative artist, to his development, view, and tendency," sometimes seem to point to the future. For example, he writes of the figure of flowers: "The relationship of low vegetable life to higher animal life is cleverly expressed by the friendly, inquiring way the charming little woman looks up at the man."[5] "Low vegetable life" would later find its symbolically intensified continuation in Klimt's modern, vegetalized female figures, and even the hierarchy of man and woman in the sense of dominance and passive devotion would essentially determine Klimt's future themes. Ilg's statements about the female figures are noteworthy: "The artist appropriately decorates the garment of the goddess of flowers (Flora) with stylized

flower patterns, thereby indicating the importance of vegetal nature to the arts. The mineral kingdom is depicted in connection with its exquisite treasures—the precious stones, crystals, and useful stones that serve the fine arts of man."[6] From the time of his historicist period, Klimt repeatedly played the "realms"—organic and plant elements versus inanimate materials such as marble, gold, and precious stones—against each other.

In his early allegorical drawings, Klimt anticipated in many respects his developments in the area of painting. This is no doubt connected to the flexible artistic possibilities that come with the medium of drawing. For example, the "typical Klimt" is already presaged in the confident, subtly characterizing outlines of the allegory *Realms of Nature*. This compositional sketch instructively illustrates that this perfection was preceded by intense searching.

[1] Strobl I, 1980, pp. 27–41.
[2] Martin Gerlach, ed., *Allegorien und Embleme*, 2 vols. (Vienna, 1882), vol. 1, sec. I, p. 3.
[3] Graphite, white heightening, 27.5 × 53.1 cm, Wien Museum, inv. no. 25022; Strobl I, 1980, pp. 27–28, no. 47. Reproduced in *Allegorien und Embleme* (note 2), vol. 1, pl. 13. The original used for the print was later reworked, adding shading, modeling, and clouds; the reproduction looks more traditional than the original design, which had been conceived as a composition with bright planes.
[4] Albert Ilg, in *Allegorien und Embleme* (see note 2), vol. 1, p. 13.
[5] Ibid.
[6] Ibid.

**Half-Length Portrait of
a Woman with Her Forehead
Resting on Her Hand, 1884–85**
Study for *Antony and Cleopatra*

Black chalk, heightened with white chalk
45 × 31.7 cm
Kupferstichkabinett, Akademie der
bildenden Künste, Vienna | Bisanz-Prakken,
forthcoming

The Theater in Fiume

While still students at the Kunstgewerbe-schule, Gustav Klimt, his younger brother Ernst, and Frank Matsch founded the Künstlercompagnie (Artists' company), which from 1880 onward fulfilled commissions for decoration and was increasingly successful. Around 1882–83, the three artists began to work with the architectural firm Ferdinand Fellner und Hermann Helmer, which was primarily involved in designing theaters in various cities of the Austrian monarchy, in Germany, and in Switzerland. Klimt's work on the decorations for the theater in Fiume (Rijeka) and Karlsbad (Karlovy Vary) proved to be a breakthrough for his drawing.[1] In a growing number of figure and detail studies, the artist grappled intensely with the gestures and facial expressions of the people he depicted. Fabrics, skin, and jewelry are enlivened with white heightening.

This drawing of a woman gazing tragically with her forehead resting on her hand (cat. no. 2), which has come to light only recently,

could be identified as the only known study for one of three paintings Klimt produced for the ceiling of the auditorium of the theater in Fiume (fig. 1).[2] With long, sharply interrupted lines, Klimt defined the outlines of the woman's face, neck, hand, and folds of her garment. The face, modeled by means of white heightening, contrasts effectively with her deep-black, antique hairstyle and delicate Greek pendant earrings. Her pathos-filled gaze and drawn, sensuous mouth convey brooding sorrow; her supporting hand also casts a strong shadow on her right eye. Klimt innovatively employed the line as a constructive element that both articulated the plane and sensuously characterized the figure. As Alice Strobl emphasized, he was influenced during this period by the Austrian artist Hans Makart and international salon painters such as Alexandre Cabanel and Lawrence Alma-Tadema, but in the concise lines of his drawings he developed his unmistakable identity early on.[3]

The iconography of the ceiling painting known as *Dying Warrior* has not been questioned previously. But the emphatic presence of the tragic couple in the painting and the femme fatale permit the assumption that Klimt was depicting one of the most famous tragic couples in world literature and the fine arts: Antony and Cleopatra.[4] Whereas most artists—including Hans Makart—concentrate on the Egyptian queen's spectacular death by snake, Klimt focuses on the core psychological moment. The dying Antony in Roman dress and the exotic-looking Cleopatra have just kissed for the last time. Cleopatra has lost everything—the background alludes to the earlier battle for Alexandria—and looks death in the

Fig. 1. *Antony and Cleopatra*, ceiling painting in the auditorium of the theater in Fiume, 1884–85, oil on canvas

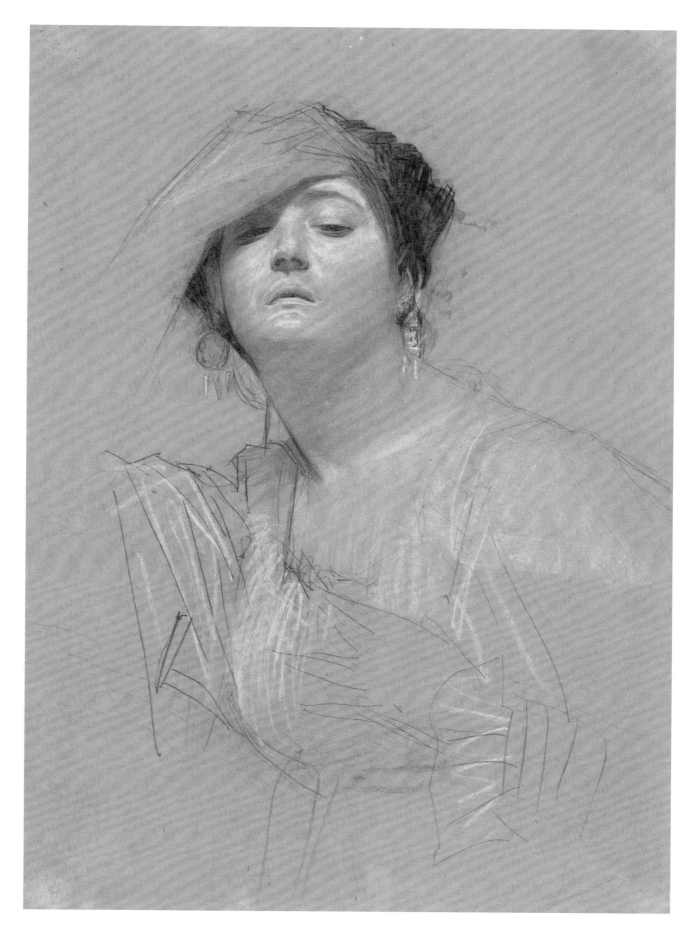

eye. Her emotional gaze is the center of attention in the painting and is the focus of the drawing as well. The drawing and painting differ in terms of Cleopatra's clothing: whereas the model in the study is wearing an antique-looking bright top, the upper body of the figure in the painting as executed has been laid bare—probably with an eye to her imminent suicide. The drawing in turn features more exotic sensuousness and a more ominous theatricality; the gesture of the hand grasping her breast seems to point ahead to her death by snake. Beyond its specific function, this impressive study has the character of an autonomous work—in part in view of its carefully considered positioning within the plane.

[1] Strobl I, 1980, p. 47.
[2] Novotny and Dobai 1975, no. 24; Weidinger 2007, no. 51.
[3] See note 1.
[4] A reading proposed by Dr. Ernst Czerny, Österreichische Akademie der Wissenschaften. Analogously another ceiling painting by Klimt in the theater in Fiume known as *Greek Music* or *Amor Giving a Laurel Wreath to a Singer* (Weidinger 2007, no. 49) should without a doubt be identified as the mythological lovers Orpheus and Eurydice. The connection of the ceiling painting *Woman Playing the Organ* (Weidinger 2007, no. 50) to depictions of Saint Cecilia have been noted earlier (see note 1).

The Burgtheater

Within the Albertina's holdings of Klimt, the eight studies for the decorations of the Burgtheater represent one focus, not only because of their unusual quality but also because of the historical significance of the project.[1] On October 20, 1886, Gustav Klimt, Ernst Klimt, and Franz Matsch were officially commissioned to paint the ceilings of the right-hand grand staircase of the nearly completed Burgtheater. The festive opening of its new building on the Ring followed on October 12, 1888.[2] For this work on their first large commission in Vienna, largely carried out in 1887, the members of the Künstlercompagnie were awarded the Goldener Verdienstkreuz (Gold Cross of Merit) by the emperor. This milestone in their careers was owed not least to the fact that they had been supported by two important figures: Karl von Hasenauer, the architect

of the Burgtheater, and Rudolf von Eitelberger, the director of the Österreichisches Museum für Kunst und Gewerbe.

The program for the design of the ceiling was the work of the artistic director of the Burgtheater, Adolf von Wilbrandt. Ten scenes—whose arrangement, form, and sequence were precisely stipulated—were to illustrate the history of theater from antiquity to the eighteenth century. In contrast to their previous decorations, in the Burgtheater the three artists were working with resin oil paint directly on the plaster surfaces. Some of the cartoons for the ceiling paintings, which were found in the Burgtheater in 1996, were by Gustav Klimt. They were restored sequentially, and today they are accessible to the public in a special room in the Burgtheater. These works form their own, very comprehensive chapter

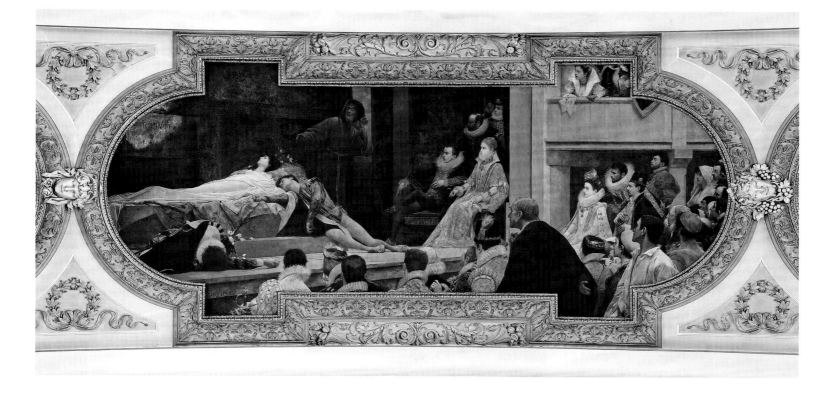

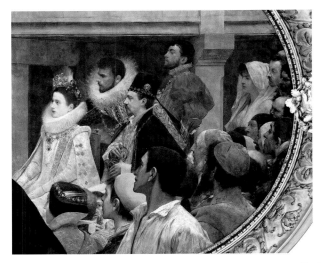

Fig. 2. *Shakespeare's Theater*, detail: group from audience

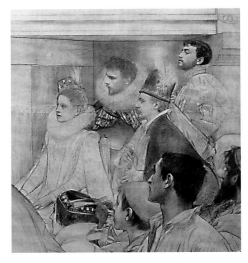

Fig. 3. Cartoon for *Shakespeare's Theater*, detail: group from audience, charcoal and graphite, 200 x 576 cm (total), Burgtheater, Vienna

and are here illustrated separately only to point out the various stages of the working process.[3]

Gustav Klimt painted *Shakespeare's Theater*, *Thespis's Cart*, *Theater in Taormina*, and *Altar of Dionysus*.[4] The most elaborate preparations were for *Shakespeare's Theater*, as the largest number of known studies concerned that work (fig. 1). The six sheets for *Shakespeare's Theater* also represent the majority of the Albertina's studies for the Burgtheater. The theme of the painting is a production of the tragedy *Romeo and Juliet* at the Globe Theater in London. As was the custom in the bard's time, all levels of society—the queen along with representatives of the higher nobility, the aristocracy, the bourgeoisie, and the common people—were gathered around the stage. Everyone was watching the dramatic scene with fascination: Juliet, in suspended animation, is laid out on the simple wooden stage; a lifeless Romeo is lying outstretched next to her. The corpse of Count Paris is seen at the front of the stage on the left; a horrified Friar Laurence is standing in the background on the right. While working on the cartoon, Klimt had professional photo-

graphs taken to use for the poses of several figures, for which Franz Matsch; his brothers, Georg and Ernst; and his sister Hermine modeled in historical dress.[5] Klimt depicted himself beneath the loge, as one of the representatives of the higher nobility—and his only known self-portrait—along with the other two members of the Künstlercompagnie.

In Klimt's figure painting, which is always marked by timeless, allegorical concepts, the coincidence of place, time, and action of *Shakespeare's Theater* is rare. For all the realism of detail, however, this scene has nothing at all anecdotal or sequentially narrative, as is the case in the work of Ernst Klimt and Franz Matsch. The figures appear ossified in their gestures and emotions. The dynamic of the scene can be traced back to immanent lines of motion, which mysteriously connect the viewers, who are separated from one another by their belonging to different social classes, and the actors, who move in other spiritual spheres.

The contrasts between the social classes are expressed spatially on the right side of the

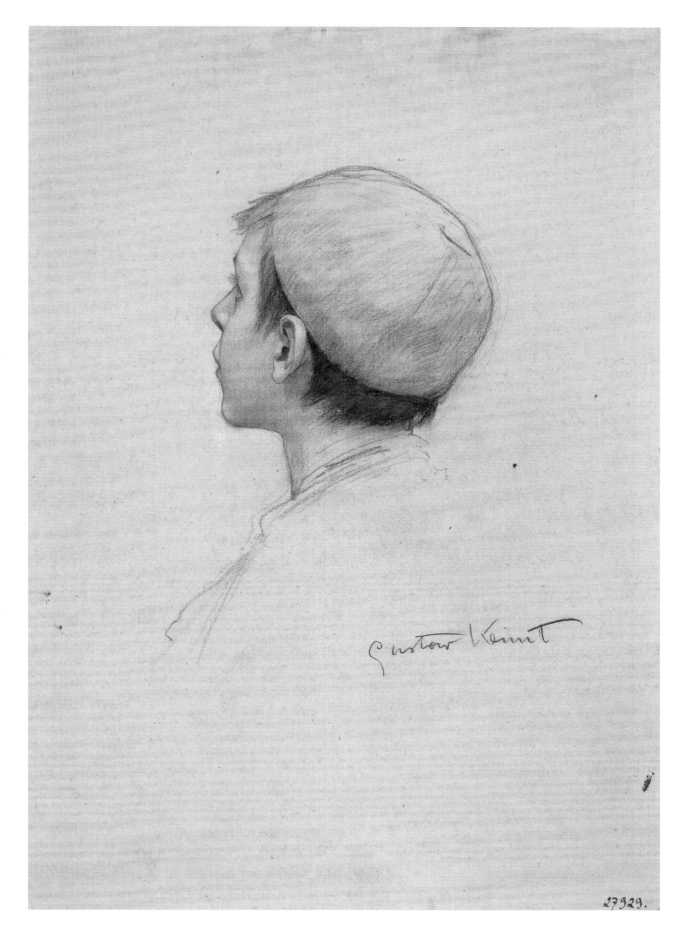

3

27929.

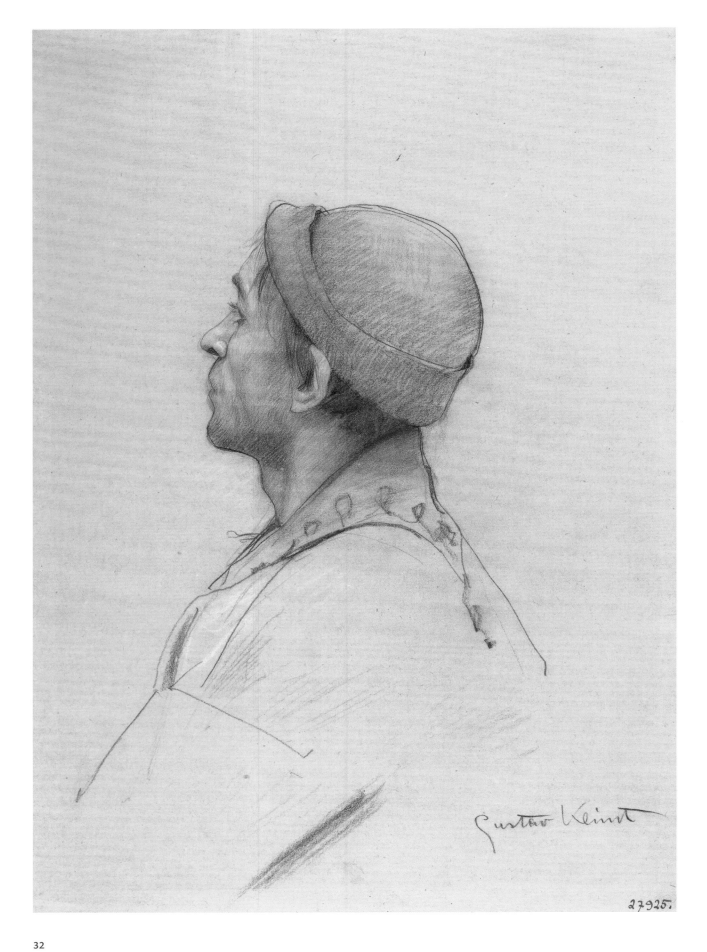

4

32

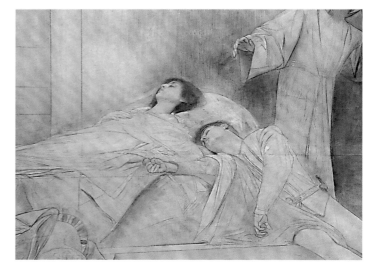

Fig. 4. *Shakespeare's Theater*, detail: Romeo and Juliet

Fig. 5. Cartoon for *Shakespeare's Theater*, detail: Romeo and Juliet, charcoal and graphite, 200 x 576 cm (total), Burgtheater, Vienna

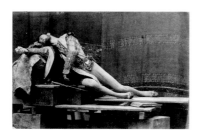

Fig. 6. Photo of Georg Klimt in costume as Romeo, 1886

painting. Against the backdrop of the ceremonially frozen figures of the queen and her retinue, the crowded representatives of the common people—the groundlings—stand out emphatically in the very front (fig. 2). In a wealth of contrasts, we see old and young, lush-haired and bald, light- and dark-skinned, bearded and shaven men and boys. Their historically inspired clothing and headgear are just as colorfully diverse. Most of the figures are depicted in *profil perdu* (lost profile) and are closest to the viewer not only spatially but also by virtue of their concentrated attention. This group seems alive above all thanks to the way the succinctly outlined figures overlap, seemingly by chance. But in essence each figure is self-engrossed and on his own—a decidedly ahistorical feature that already prefigures the later turn toward Symbolism in Klimt's oeuvre.

The important function of the contour lines shows how deeply rooted in the art of drawing Gustav Klimt was even as a painter. The studies made for this group, including the portrait

studies exhibited here (cat. nos. 3–6), signal a key moment in the evolution of his drawing. Klimt dedicated himself with a new intensity to the study of individual figures. He captured the various types and their costumes with great accuracy; the play of light and shadows is conveyed by powerful, repeatedly interrupted parallel hatching. It was very important to Klimt that these models express in a concentrated way a gazing into the distance, and this consolidates into particular succinctness in the empathetically registered contours of their profiles. The sometimes astonished, sometimes deeply moved expressions of the men and boys are evident from their slightly open mouths and raised eyebrows. The atmospheric three-quarter portrait of the seated man, whose face is a mere fragment in the work as executed, testifies to the artist's effort to internalize the themes of his painting by studying individual figures (cat. no. 6). The psychologizing role of the contour lines becomes increasingly significant. Each sheet becomes a world of its own, an autonomous

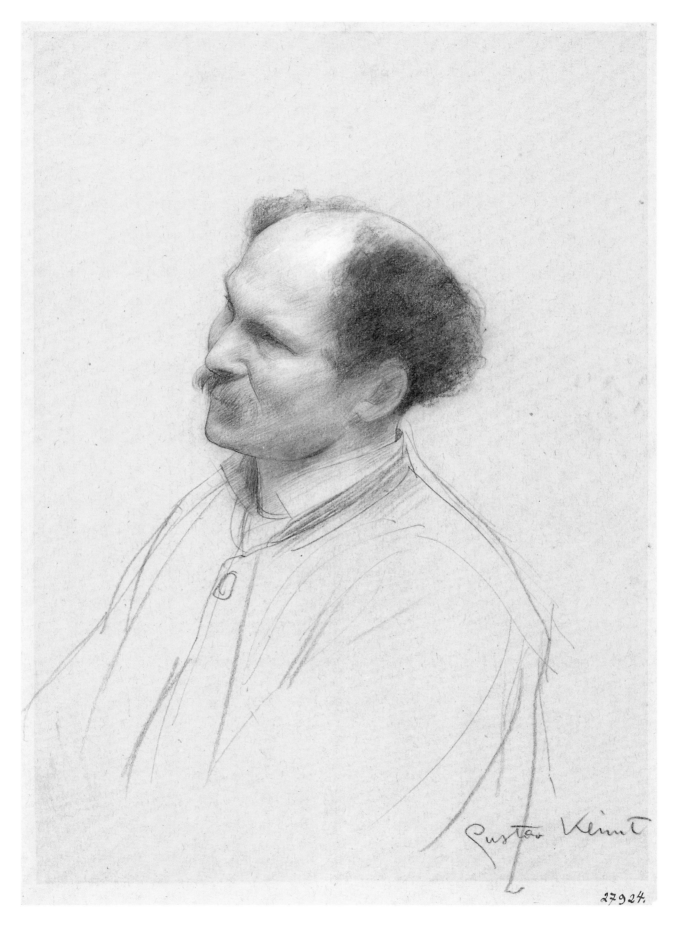

Gustav Klimt

27924.

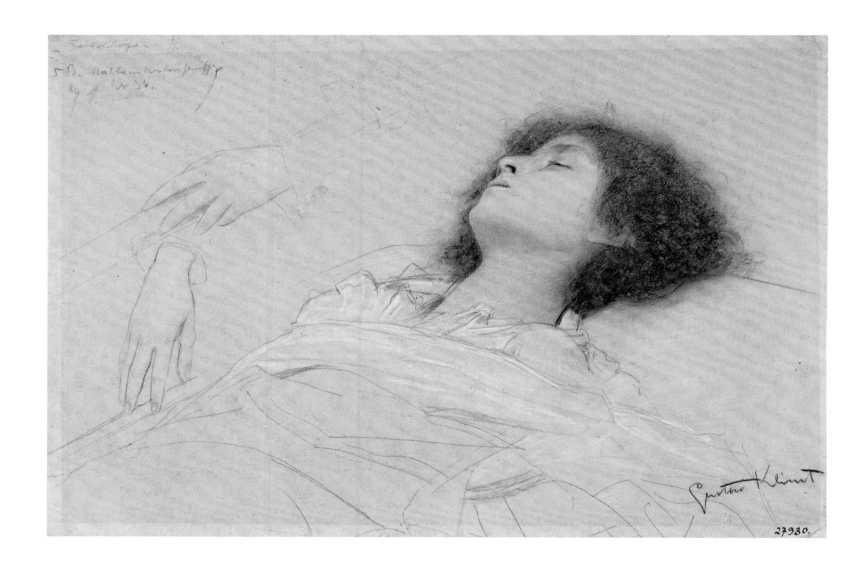

7

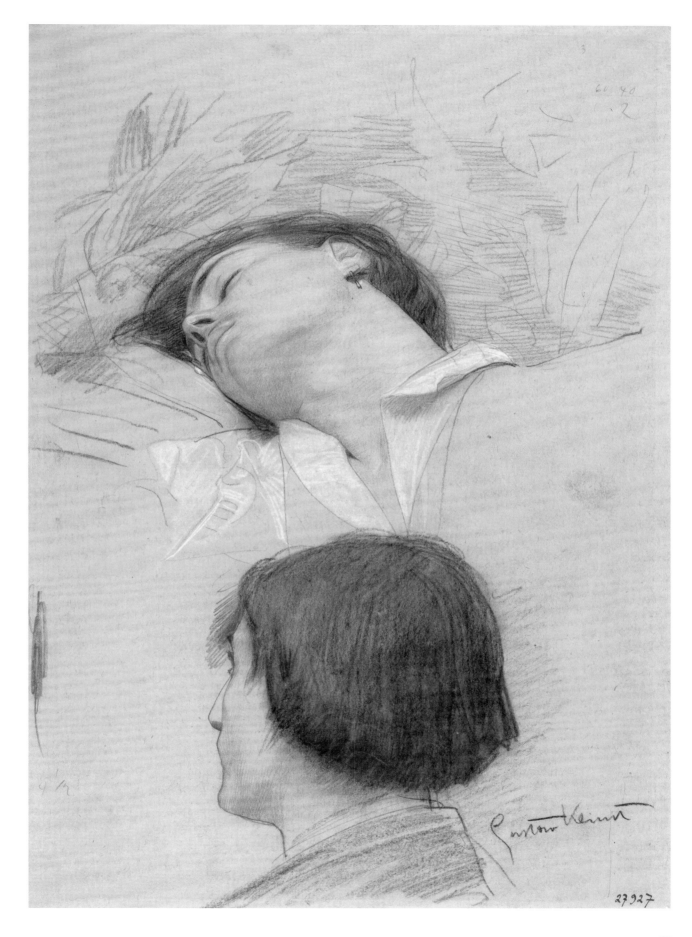

work of art. Comparison with the charcoal cartoon, in which Klimt very generously rendered the outlines and hatching, is particularly revealing (fig. 3).

There is a spiritualization of the contour lines in that part of the painting that is set off against the audience's world. On stage, the pale, transparent face of Juliet in suspended animation stands out in the darkness as the emotional climax of the scene (fig. 4). Just how important the face of his female protagonist was to Klimt is revealed by the highly subtle design of the preparatory study (cat. no. 7). His model was a young girl whose address he noted for safekeeping on the top left of the sheet. The study draws its life from the contrasting effect between the very dark, tou-

sled hair and the porcelain-like pallor of the face turned to the side, which is viewed slightly from below. The sharply emerging, sensitive line of the profile concentrates the emotional content of the portrait, whose expression is essentially characterized by the firmly closed mouth and the delicate strokes of the nearly closed eye. A tinge of metaphysics seizes the young creature, and her diagonal position further reinforces the impression of disappearing. Thanks to its psychological depth and perfection of design, this outstanding study can be regarded as the equal of the painted version. The great value drawing had as an essential part of the artist's process is likewise evident from the study of the face of the dead Romeo (cat. no. 8). Gustav's brother Georg posed with a beard for the study photograph of this figure's stance (fig. 6). The study sketch shows a different, beardless model who was also used for the painting, and on the lower half of the page with the study Klimt captured one of the aforementioned viewers. The handling of the lines in this drawing is more energetic than it is in the study for Juliet's face, but here too Klimt focused on the expression of the highly foreshortened face. Here too he placed great value on the contrasting effect between the pale skin and the dark hair. A particular accent is added by the white collar of his shirt being turned up. This section of the cartoon also reveals a fascinating side of Klimt's art of drawing that long went unrecognized (fig. 5).

Just how concerned Klimt was with choosing typologically appropriate models is also revealed by the study of the head of the figure of the reclining-but-propped-up man in the painting *Theater in Taormina* (cat. no. 9). Amid the artfully evoked ideal world of the south,

Fig. 7. *Theater in Taormina*, ceiling painting in northern stairwell of the Burgtheater, Vienna, 1886–88, resin oil paint on plaster, ca. 750 x 400 cm

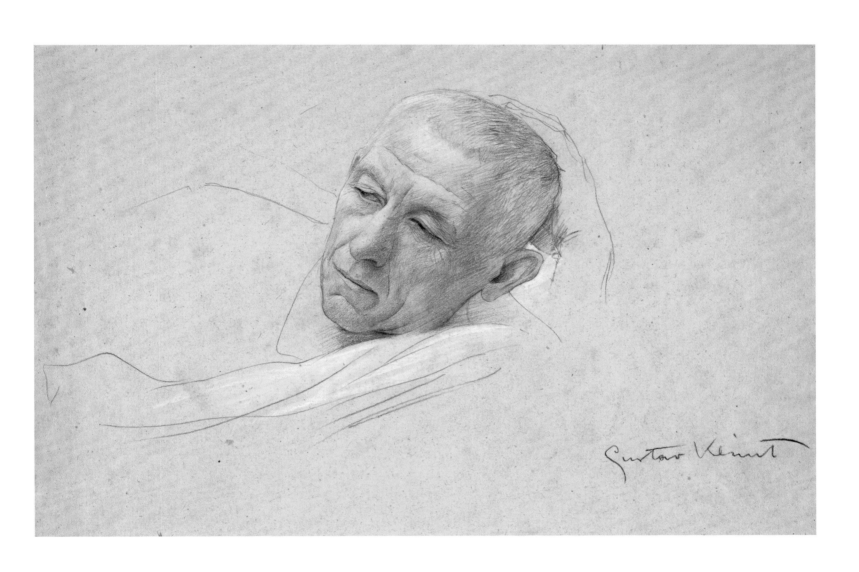

9

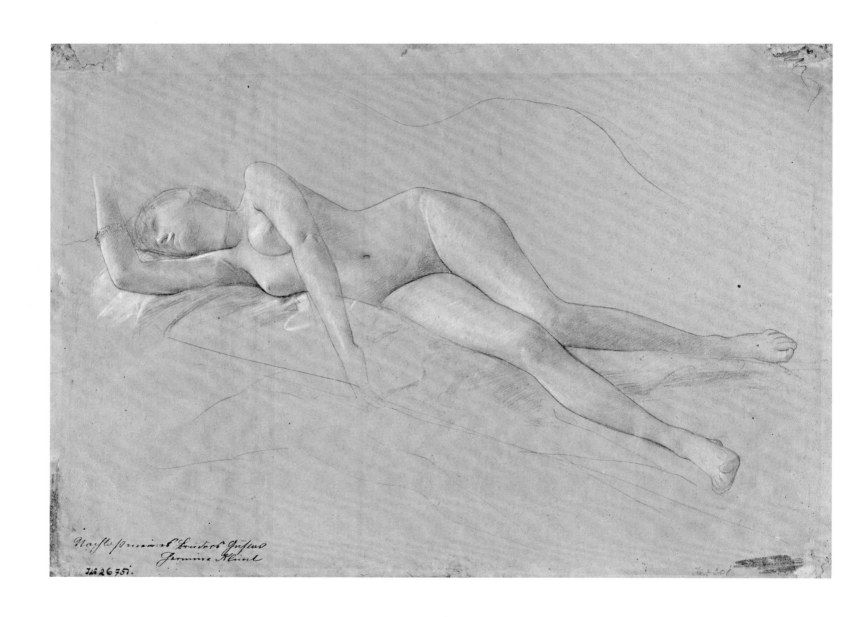

10

Fig. 8. *Altar of Dionysus*, lunette in southern stairwell of the Burgtheater, Vienna, 1886–88, resin oil paint on plaster, ca. 160 x 1200 cm

this elderly gentleman in Roman dress and with short hair is watching a performance of a woman dancing nude and two female musicians (fig. 7). Klimt's study drawing of the man posing in a white garment is even more nuanced than the painted version. With delicate hatching he recorded the wrinkles and irregularities of his skin bathed in gentle illumination and accentuated with white heightening the reflections of light. The lines of the body, the hand, and the garment, also heightened with white, appear only fleetingly, but the strikingly outlined head, effectively positioned in the plane, is all the more sharply emphasized as a result. In addition to these subtleties of execution, the man's essence is acutely characterized, with facial features that suggest the type of a spoiled, slightly cynical epicure.

In the painting *Altar to Dionysus*, which has a segmented frame and formed the counterpart to Franz Matsch's *Altar to Apollo*, Klimt was alluding to the origins of the Greek theater. He no doubt welcomed the associated themes of erotically obsessed maenads, but did not treat them in the traditional form with wild dances. His two maenads are rather pictures of self-possessed sensuality. The one on the left is sacrificing a small statue of Pallas Athena

to the god Dionysus; the one on the right is resting, exhausted by wild orgies, in a casually outstretched reclining position (fig. 8). The preparatory study was characterized by Alice Strobl as an early form of the femme fatale type in the artist's oeuvre (cat. no. 10).[6] The erotic expression of the passively dreamy model results both from the sensitive course of the contour lines and the sensuously modeled chiaroscuro. The way the contours of the body stretch across the entire breadth of the image and emphasize the contrast between the form and the blank sections of the sheet is astonishingly modern.

In summary, it can be said that the decorations of the Burgtheater represented a breakthrough for Klimt as a draftsman. The great spectrum of themes inspired him to grapple more profoundly and subtly with the human figure. The new thematic and artistic challenges led him to numerous formal and stylistic solutions. Despite the oft-cited inspiration of artists such as Hans Makart, Alexandre Cabanel, and Lawrence Alma-Tadema, Klimt proves to be thoroughly authentic in his drawings. More than any other artist, he grounded his themes in his study of the human figure. The psychologizing role of the line should be emphasized as one of his essential innovations.

[1] It has recently come to light that catalogue numbers 3–9 and 11 feature the signature or monogram that Gustav Klimt used on his curriculum vitae in 1893 (Strobl IV, 1989, fig. on p. 52). According to in-house research, all the sheets thus signed or monogrammed were previously owned by Franz Trau (see also cat. nos. 11, 12).

[2] On the Burgtheater project, see, for example, Nebehay 1969, pp. 84–98; Strobl I, 1980, pp. 54–65; Exh. cat. Vienna 2007, pp. 56–67; Rychlik 2007.

[3] For a detailed discussion of the cartoons, see Eyb-Green 1999.

[4] Novotny and Dobai 1975, nos. 39, 38, 41, 40; Weidinger 2007, nos. 64, 65, 66, 67.

[5] Eder 2000–2001, pp. 50–51.

[6] Strobl I, 1980, p. 56.

11
**Two Sketches of a Man
with Opera Glass, 1888–89**
Studies for *The Auditorium of
the Old Burgtheater*

Black chalk, heightened with white chalk,
on greenish paper, 45 × 31.7 cm
Albertina, Vienna, inv. 27928 | Strobl 1, 221

12
**Study for *The Auditorium of
the Old Burgtheater*, 1888–89**
(Portraits of Franz and
Mathilde Trau added in 1893)

Watercolor and gouache, 22.5 × 28 cm
The Panzenböck private collection
Bisanz-Prakken, forthcoming

The Auditorium
of the Old Burgtheater

After completing their work on the ceiling paintings in the new Burgtheater building, which was opened in 1888, Gustav Klimt and Franz Matsch devoted themselves to an extraordinary commission they had received from the City of Vienna in 1887. The old Burgtheater on Michaelerplatz was to be demolished, but the two artists were given the task of first recording the auditorium of this building, with its long and rich tradition, in two large-scale works to be executed in gouache. Klimt depicted the interior as seen from the stage (fig. 1), while Matsch depicted the same space but looking toward the stage.[1] They had been ordered not only to render the interior accurately but also to provide a detailed depiction of numerous prominent figures from public life. In Klimt's work, the viewers, who are shown taking their seats or already seated before a performance, include just under 150 famous men and women, including Karl Lueger, Karl von Hasenauer, Katharina Schratt, and Johannes Brahms.[2] For the portraits, Klimt worked mainly from photographs, but he studied the interior and life in the theater at the original location.[3] Klimt and Matsch were given season tickets for that purpose, enabling them to attend all the performances and observe the interior and the audience in detail. Several studies by Klimt of individuals or groups of figures and of details of the interior are known.[4]

This highly detailed "snapshot," which in 1890 was awarded the Kaiserpreis (Emperor's prize), is unique in Gustav Klimt's oeuvre of drawings and paintings. Nevertheless, the artist's intention to counter the conventional character of a commissioned work on several levels is evident. For example, he tried to over-come the monotony of the artificial-looking portraits by varying as much as possible the postures, chiaroscuro contrasts, and quasi-random overlapping of forms. Just how important these positions were to Klimt is evident from a sheet with studies of a man standing and observing the audience with his opera glass; both the profile and the rear view were used for two anonymous figures in the final version (cat. no. 11). Klimt recorded his model with striking contours and powerfully shaded parallel hatching. Using islandlike blank spaces and white heightening, he conveyed the reflections of light, and their effects are further increased by the greenish paper—which is rare in his oeuvre. In these spontaneously sketched studies, Klimt was attempting to discipline the fleeting impressions by means of lines and to fix the essential qualities of the poses and gestures, which was no doubt an important experience for him.

Another feature of the gouache is the asymmetric curve of the strikingly illuminated stripes of balcony, which on the right edge of the sheet condense into almost vertical bands as a result of the perspective. Moreover, the artist effectively played against each other the contrasts between the dense concentrations of people and the dark openings of the partially empty loges and the vacant rows of seats in front. Particularly characteristic of Klimt's style is the way the four brightly clad, translucent female figures enliven the foreground. As a metaphysical note, these anonymous figures in dreamlike meditation stand out from the crowd of human faces.

The almost ghostly character of these female figures, harbingers of the Symbolism of the 1890s, is brought out even more in the pre-

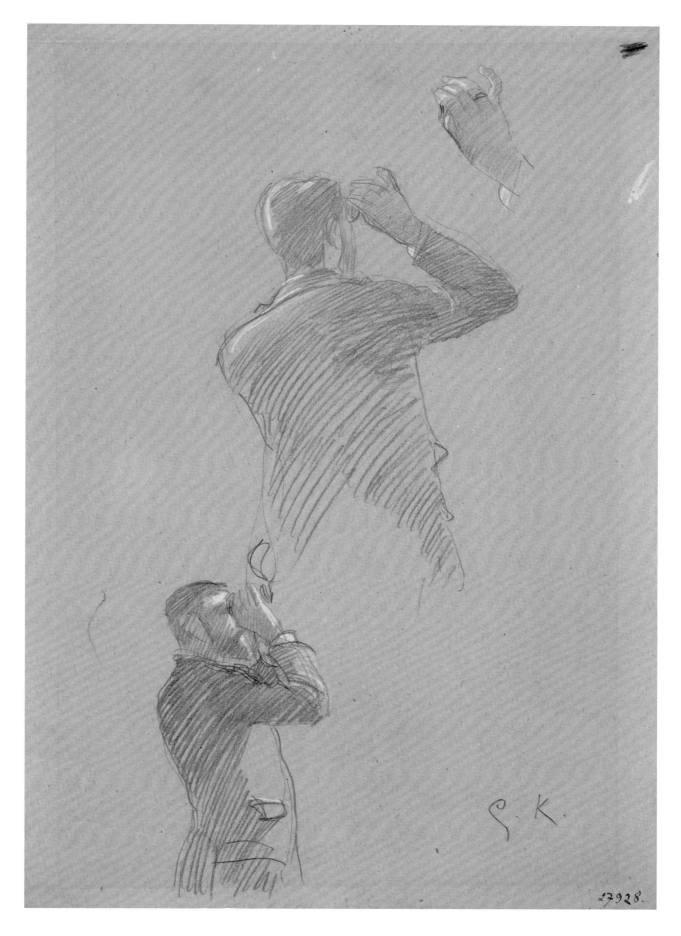

27928.

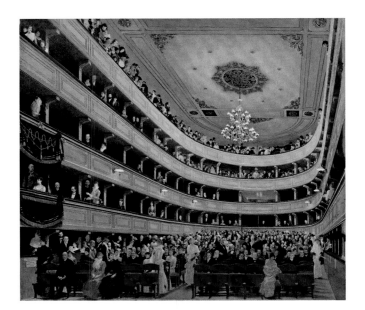

1 Strobl I, 1980, pp. 69–71, no. 191. The work by Klimt: watercolor, gouache, heightened with gold, on paper, 91.5 × 103 cm (sheet), 82 × 92 cm (image), Wien Museum, inv. no. 31813.
2 In a contemporaneous photogravure of this work, a schematic repetition of the image was added with the names of the most important figures depicted (Strobl I, 1980, pp. 70, 72, no. 191).
3 On his working from photographs, see Eder 2000–2001, p. 52 (with reference to Novotny and Dobai 1975, no. 44, and Nebehay 1969, p. 98).
4 Strobl I, 1980, nos. 192–223; Strobl IV, 1989, nos. 3287–88a.
5 Novotny and Dobai 1975, nos. 63, 64; Weidinger 2007, nos. 87, 88.

liminary work, which has only recently come to light (cat. no. 12). In this composition, which is considerably smaller though conceived as a complete image, the figures, which are not yet so numerous, are only fleetingly sketched. Many loges are still unlit, and in several details—such as the soft illumination on the loge at bottom left—this work deviates from the final version. Moreover, the artist was not yet on the stage but rather in the front of the parquet. Klimt thus captured a small segment of space, no longer looking up at the chandeliers. Compared to the final version, the palette as a whole is somewhat cooler and more muted, and the golden accents are conveyed not with gold paint, as in the finished work, but with delicate brushstrokes in bright pink or yellow and ocher. In this preliminary work, Klimt was primarily concerned with achieving a convincing depiction of the broadly opening interior, in which various light sources play around the figures and architectural details, which fuse into an atmospheric unity that was unusual for Klimt. The evening mood is brought out even more effectively here than in the work ultimately executed.

In the area in the center on the right in this scene, the later addition of the portraits of Franz Trau and his wife, Mathilde, stand out from the schematic look of the other theatergoers. It clearly amounts to a miniature edition of the portraits of the couple painted by Klimt in 1893, which are known today thanks only to black-and-white illustrations (fig. 2).[5] It is reasonable to assume that while working on the commissioned portraits the artist added the reduced portraits to the preliminary work painted in 1888–89, which apparently were in the possession of Franz Trau. The signature, in red capital letters and condensed into a block, appears to date from the same time. The connotation of a portrait commission with themes relating to the Burgtheater establishes broader circles: As demonstrated elsewhere in the present volume, in 1893 Franz Trau acquired eight of the finest studies for the ceiling paintings of the Burgtheater and had Klimt sign them (see cat. nos. 3–10); the aforementioned study, which has a monogram dating from 1893, was also acquired on that occasion. Whatever the connection between the portrait commission and the contemporaneous acquisitions by the Traus of works related to the Burgtheater may have been, it is clear that in the 1890s there had already been contacts between Klimt and this family of art lovers. Until now, the primary known connection was that Klimt purchased the Simile-Japan paper he had been using since 1904–5 from the Traus' tea store on the Graben in Vienna. The possibility that he might have made use of that source for the packing paper he used earlier cannot be ruled out in light of new information and should be further pursued.

Allegory of Sculpture

There are no known oil paintings by Gustav Klimt from the phase between the two large Ringstrasse projects—the Burgtheater decorations (1886–88) and the paintings in the staircase of the Kunsthistorisches Museum (1890–91). It is largely for this reason that the *Allegory of Sculpture* (1889, cat. no. 13), a work on paper that boasts a distinctly finished character, is so noteworthy. This major work is presented here in conjunction with the highly finished preparatory drawing, which was acquired by the Albertina in 2008 (cat. no. 14).[1]

This extremely refined work was made for a deluxe volume that in 1889 was provided with original works by a total of forty professors, teachers, students, and former students of the Kunstgewerbeschule. This *Gesamtkunstwerk*, or "total work of art," was dedicated to the school's patron, Archduke Rainer, on the

occasion of the institution's twenty-fifth anniversary.[2] The dense allegory of the silver-embossed cover, with its enameled portrait of the archduke, recalls examples of Prague imperial court art circa 1600 (fig. 1).[3] The chapters on painting, sculpture, and architecture were each accompanied by a full-page allegory, with the brothers Klimt and Franz Matsch—renowned former students of the institution—executing one each. All three artists made reference to Greek antiquity and employed a nearly monochromatic palette. The same conditions applied to each contribution—thereby revealing the great extent to which Gustav Klimt already stood out from his two colleagues.

In the *Allegory of Painting* by Ernst Klimt a female figure in Greek garb, equipped with brush and palette, poses before a tondo that she probably painted herself (fig. 2).[4] The motif was borrowed from an ancient Greek red-figure bowl and rendered naturalistically.[5] The main protagonist in Franz Matsch's *Allegory of Architecture*, likewise in Greek dress, is shown in a casually aristocratic pose (fig. 3).[6] A drawing board rests on her lap; one hand holds a work tool, the other a flower. A temple under construction can be seen in the background.

The *Allegory of Sculpture* is a far remove from the conventional historical clothing and realistic manner of representation seen in the other two allegories. A dark-haired, slender, stylized ideal figure appears, flawlessly naked, before a backdrop—a backdrop that poses a number of riddles. The orthogonal wall fragment arranged parallel to the picture plane is an emphatic presence, though how it might continue beyond the boundaries of the image remains unclear. Also uncertain is whether

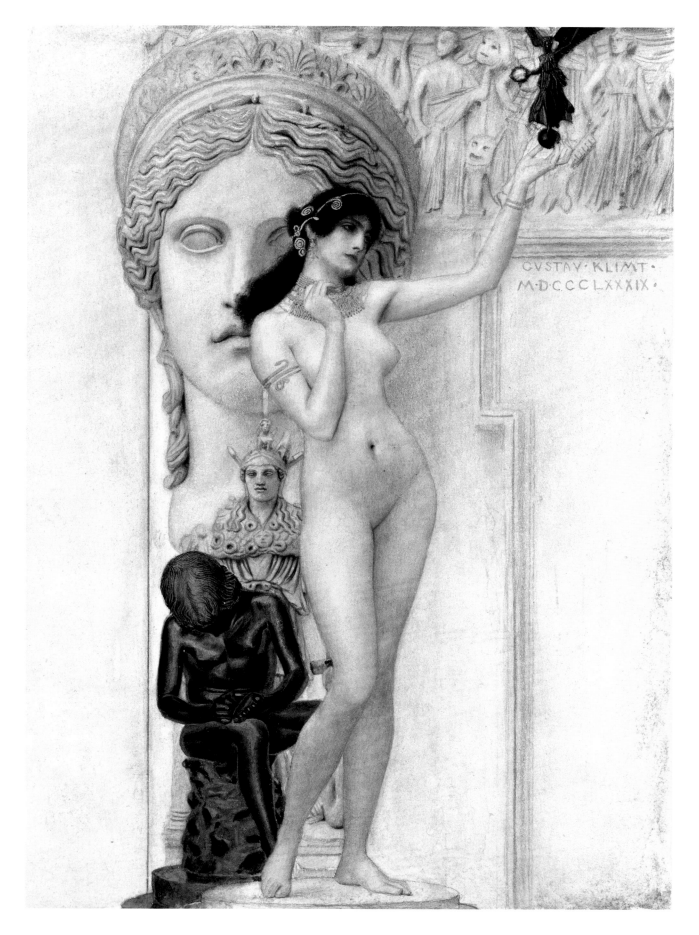

13

the vertical strip at the left is to be understood as an empty space or a bright wall. That Klimt may have allegorized various levels of reality in the staggered and overlapping sculptures is indicated in part by the way they are depicted: accordingly, the earthbound Spinario would be assigned to the realm of mortals and the world of the gods located further up—beginning with the partially concealed, scaled-down copy of the destroyed colossal statue of Athena Parthenos by Phidias. Towering above this figure is the monumental, strictly frontal head of the Juno Ludovisi, which also marks the point of intersection of the vertical and horizontal axes.

While the vertically staggered sculptures are relatively faithful reproductions of their historical prototypes, the horizontal figural frieze displays a much freer interpretation of its model—a relief from the Roman Sarcophagus of the Muses in the Kunsthistorisches Museum (fig. 4).[7] Klimt used the largely schematized forms of the Muses to allegorize the higher regions of the mind and imagination—

and it is toward these that the drawing's protagonist is seen extending her triumphant figure. Using the full length of her body contour and raised arm, the central nude spans the realms of everyday human life, of divine order, and of the arts.

One characteristic feature of the *Allegory of Sculpture* is the representation of the many, in places hidden, sides of the Pallas Athena. The Athena Parthenos, drawn from the Phidias replica, for instance, seems unusually tame. Her off-putting serpent shield is concealed for the most part behind the legs of the main figure; the stump clearly visible above the head of the Spinario references the missing head of the Nike. It is as if Klimt took Pallas Athena's function as patroness of the arts and transferred it from the disempowered statue of the past to the vibrant main figure of the present. It is she who raises the triumphant figure to the arts—doing so precisely in front of the section of the frieze of Muses featuring the Pallas Athena, this time fully accoutered. Moreover, the triumphant arm gesture of the nude

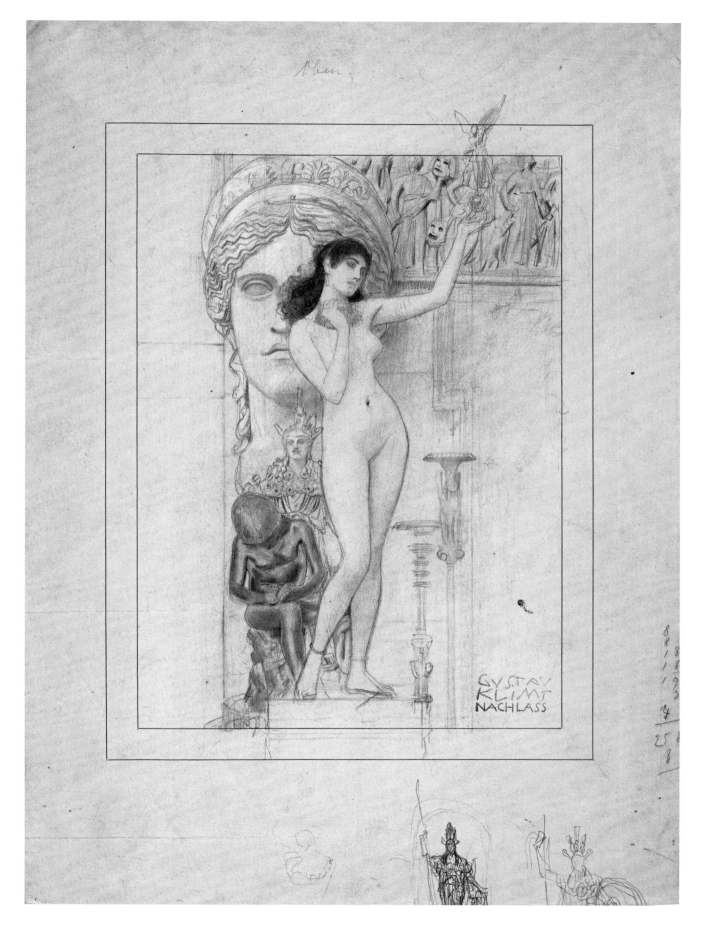

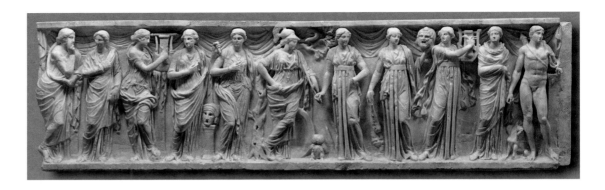

Fig. 4. Roman Sarcophagus of the Muses, AD 180–200, Kunsthistorisches Museum, Vienna

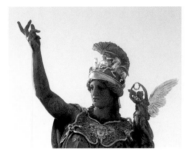

Fig. 5. Johannes Benk, Statue of *Pallas Athena* on the dome of the Kunsthistorisches Museum, ca. 1877–78, Kunsthistorisches Museum, Vienna

Fig. 6. *Greek Antiquity (Athena)*, painting in the spandrel of the stairwell of the Kunsthistorisches Museums, 1890–91, oil on canvas, ca. 230 x 230 cm, Kunsthistorisches Museum, Vienna

corresponds to the arm position seen on the Pallas Athena statue by Johannes Benk (ca. 1877–78) that crowns the dome of the Kunsthistorisches Museum (fig. 5). That Klimt gave considerable thought to the Pallas Athena's belligerent function is also indicated by the two sketches in the margin of the preliminary drawing where the goddess is seen holding up her lance. Klimt would concern himself with the programmatic function of the Pallas Athena time and again well into the early days of the Secession, beginning with the figure of *Greek Antiquity* in the Kunsthistorisches Museum (1890–91, fig. 6)[8] and his design for the fifty-guilder note (1892, cat. no. 16). The poster for the first Secession exhibition (1898) shows the armed tutelary goddess of the artists' union as she watches over the battle between Theseus and the Minotaur (fig. 7). In the programmatic painting *Pallas Athena* (late 1898) the demonized goddess is depicted holding a small, red-haired nude in her hand instead of a Nike figure (fig. 8).[9]

One of the fundamental differences seen when comparing the preliminary drawing to the main work is the position of the female nude: initially, she was placed too high. In the final version, Klimt shifted the main figure downward and provided her with a round base. This also intensified the frontal gaze of Juno (Hera), whose left eye is no longer completely concealed by the main figure's hair as it is in the preparatory work. Another differ-

ence is the treatment of the left vertical field of the picture plane. In the preliminary drawing Klimt used horizontal lines to suggest a wall; in the main work, however, he abandoned this structure and deliberately employed the bright, blank surface as a compositional element.

The preliminary drawing provides direct insight into the sensitive approach Klimt took toward the nature of his allegory. For example, he makes a subtle distinction between the cool, smooth marble, the "blind" gaze, and the hard, chiseled strands of hair of the Juno, on the one hand, and the living skin, the disheveled black hair, and the introverted facial expression of the main figure, on the other. The way in which these substances and structures, which are so different in nature, are played off against each other reveals the artist's aim: the sensory and symbolic confrontation of the dead past with the living, inspired present. The essence of the thematic message lies in the gentle curve of the shoulder and neck line, a line that was retraced with great subtlety in the black area comprising the hair. This line describes the outline; it divides the two substances—fair skin and dark hair—from one another and moreover expresses a spiritual-intellectual value that is already a far cry from historicism's optimistic faith in the future. The art of the present that points to the future is a figure that looks inside itself with melancholy and triumphs with contemplation—

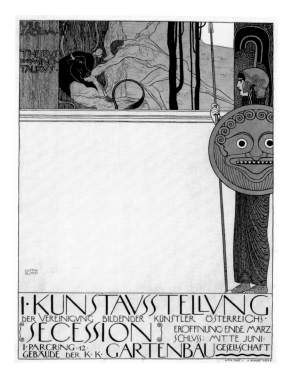

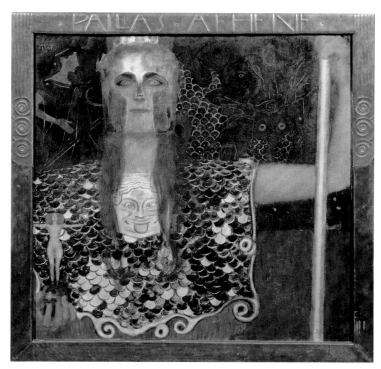

probably also as a metaphor of the inner condition of the artist. The main work is characterized above all by the brilliant rendering of the materials—not least of the gold—and a masterful handling of line. This is another instance of a highly finished drawing having provided fertile ground for technical and artistic experimentation. That Klimt took this important step toward Symbolism in the context

of a project that was deeply rooted in historicism is characteristic of his situation. The *Allegory of Sculpture*—a new version of which Klimt would draw in 1896 as part of *Allegorien, Neue Folge*—points almost prophetically to the Symbolism of Fernand Khnopff.[10] Klimt's 1889 work remained hidden from the public for decades; when it was first published (1978–79), it caused a sensation.[11]

Fig. 7. Poster for the first exhibition of the Viennese Secession, 1898, color lithograph, 97 x 70 cm, Albertina, Vienna

Fig. 8. *Pallas Athena*, 1898, oil on canvas, 75 x 75 cm, Wien Museum

[1] On the occasion of the acquisition, Marian Bisanz-Prakken gave a lecture titled "Die bildhafte Zeichnung im Rahmen der frühen Allegorien" at the Albertina, Vienna, on April 23, 2008.
[2] Mrazek 1978–79, pp. 37–40.
[3] Ibid., p. 38.
[4] Österreichisches Museum für angewandte Kunst, see Mrazek 1978–79, p. 44.
[5] Onesimos, *Theseus and Amphitrite, with Pallas Athena*, red-figured bowl, 500–490 BC, Musée du Louvre, Paris. The comparison was first made in the lecture cited in note 1.
[6] See note 4.
[7] The model was first identified in Strobl I, 1980, p. 79.
[8] Novotny and Dobai 1975, no. 48; Weidinger 2007, no. 76.
[9] Wien Museum, inv. no. 100.680. Novotny and Dobai 1975, no. 93.
[10] Gustav Klimt, "Skulptur," Strobl I, 1980, no. 276.
[11] Mrazek 1978–79.

Design for a Ten-Guilder Banknote, 1892

Black chalk, pencil, brush with watercolor, white heightening, pen with black ink
30 × 21 cm (sheet), 16 × 20 cm (image)
Österreichische Nationalbank, Geldmuseum | Bisanz-Prakken, forthcoming

Design for a Fifty-Guilder Banknote, 1892

Black chalk, pencil, brush with watercolor, white heightening, pen with black ink
30 × 21 cm (sheet), 10 × 14.9 cm (image)
Österreichische Nationalbank, Geldmuseum | Bisanz-Prakken, forthcoming

Designs for Banknotes

With the decorations for the Burgtheater he executed in 1887–88 and the allegories in the stairwell of the Kunsthistorisches Museum in 1890–91, Klimt had reached the climax of his early career. In 1892 the thirty-year-old artist then lost his younger brother Ernst and his father. The fact that he was scarcely productive at all that year points to a personal and creative crisis. This makes the designs for banknotes he produced in 1892, in the Geldmuseum of the Österreichische Nationalbank, all the more valuable. These two sheets are among the few reliably datable works from this phase of fundamental reorientation.[1] They were produced for a commission granted to Gustav Klimt and Franz Matsch in summer 1892 by the Österreichisch-Ungarische Bank: the two artists should each present two designs for banknotes as soon as possible. Matsch produced two designs for a five-guilder note; Klimt drew two designs, one for a ten-guilder note and the other for a fifty-guilder note. The drawings were not used. It was said they were "too one-sided" and had "so little appealing about their whole conception that one could not recommend accepting even one or encouraging the gentlemen to produce other sketches."[2] The commission was then given to Rudolf Rössler, who is now utterly forgotten, and his designs were accepted enthusiastically.[3]

In our context in particular, it is highly interesting that the first official rejection Klimt experienced in his career—at a time he was still working with Matsch—concerned the area of drawing. For the first time, the artist, who was accustomed to success, had to confront the fact that his modernity was not understood. The artistic level of his works—in which, no doubt unintentionally, he broke the bounds of commercial graphic art—was clearly too much for his clients. Yet their rejection of Matsch's far more conventional designs is more difficult to understand (figs. 1, 2). The injured pride of the two artists is documented, as is their demand to be compensated with 600 guilders for the work they had done in vain. This request was received with indignity by their distinguished partner in the negotiation, who said that in thirty years of working with numerous artists he had "never before encountered such a case of overestimating one's own value." The 600 guilders were transferred anyway.[4] What happened here on a small scale, out of the eye of the public, would reach a dramatic climax after 1900 with the official rejection of the faculty paintings (see pp. 75–105 and 126–29).

The figures of the design for the ten-guilder note (cat. no. 15) combine the modern expression of melancholic enrapture with important formal inventions. The innovative features of the representatives of trade and science, who sit solemnly on thrones and can be recognized by their attributes (staff of Mercury and scroll), include their strictly frontal orientation and their sparse, angular gestures. Klimt's geometric design principle here anticipates solutions that will later find their most uncompromising implementation in the orthogonal positions of the figures of his *Beethoven Frieze* (1901–2). Also far from the rhetoric of his allegorical figures on the Ringstrasse is the mysterious facial expression of the two seated figures. The woman on the left has a melancholy gaze; that of the one on the right is cerebral and introverted. The subtle nuances of the chalk on their faces and hair are contrasted sharply by the severe, schematic pen lines of their arms,

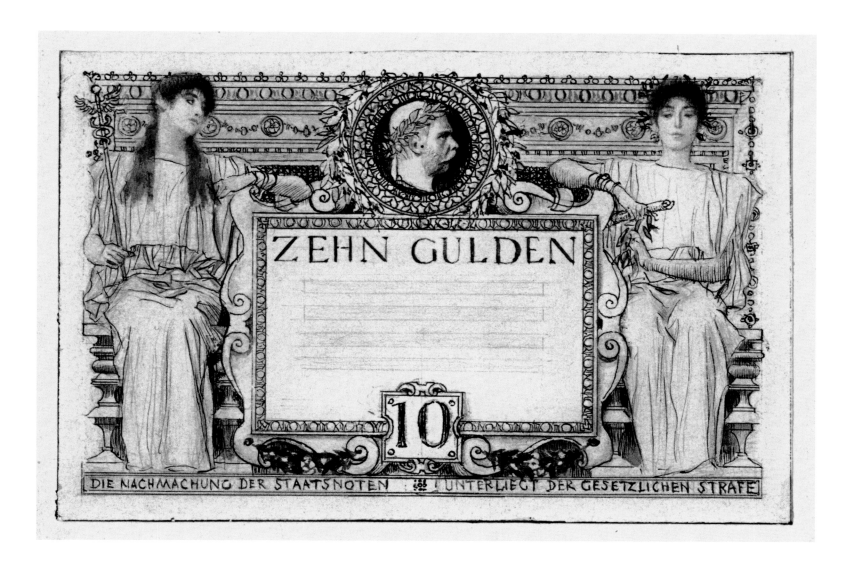

15

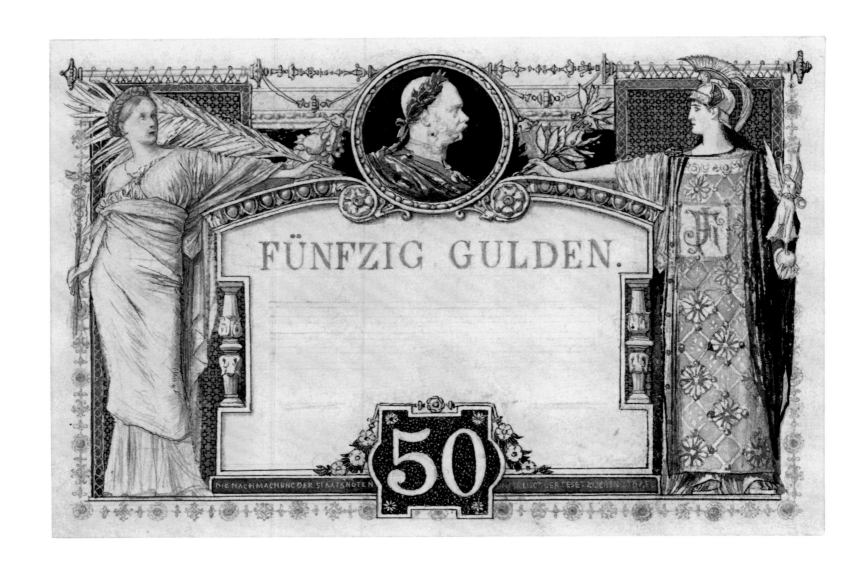

FÜNFZIG GULDEN.

50

DIE NACHMACHUNG DER STAATSNOTEN UNTERLIEGT DER GESETZLICHEN STRAFE

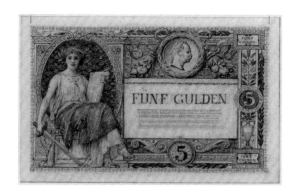
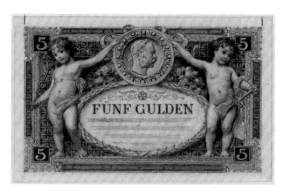

Figs. 1, 2. Franz Matsch, Two designs for a five-guilder bank note, 1892, Österreichische Nationalbank, Geldmuseum

hands, and draping garments, which largely undercuts the illusion of space and plasticity. In the centrally placed portrait medallion of the emperor, in turn, the pen, black chalk, and white paint condense into a brilliant intensity. Klimt succeeds here in achieving a spiritual refinement that is clearly distinct from the objective, neutral style of his colleague Franz Matsch.

On the fifty-guilder note (cat. no. 16) two monumental female figures pay homage to the portrait medallion of the emperor, who appears even more radiant and imposing here. The figure on the left looks like a synthesis of the goddess of agriculture, Ceres, and a personification of trade; the blonde woman with the long, bright garment and her hair pulled up in braids is carrying a staff of Mercury, whereas Pallas Athena, the belligerent goddess of wisdom, the sciences, and the arts, is holding up a small figure of Nike. Pallas Athena played an important role in Klimt's work from early on (see cat. no. 13), and in this design for a banknote too her towering significance is evident from the monogram of the emperor on the front of her garment. With outstretched arms the women are offering the emperor their symbols of triumph: a victor's palm and a laurel branch. As so often in his allegories, Klimt was working with a contrasting pair here. The figure on the left conveys an impression of gentleness, of smooth and bright plasticity in

comparison to the rigid, two-dimensional appearance of Pallas Athena. This is an astonishingly early use by Klimt of the "Egyptian" formula of a frontal orientation of the body with the face turned to the side. This column-like figure also anticipates the horizontal and vertical main lines of modern monumental art. The regular pattern and subtle shimmer of the goddess's garment betray—much as in examples of Byzantine or medieval Italian art—little of the forms of the body underneath. The decorative frame is composed of spatial layers of different structure. Using a monochrome palette and an astonishing variety of nuances, Klimt distinguishes the various substances—plants, types of stones, parts of textiles. In his banknote designs the artist employed many elements of his paintings for the Kunsthistorisches Museum, but once again he achieves surprising modern effects with the means of drawing, despite the strict requirement. In both works, elements of Greek and Roman antiquity and of Italian art of the Middle Ages and the High Renaissance merge with inspiration from examples of the English Pre-Raphaelites and the Belgian Symbolist Fernand Khnopff to create a highly independent synthesis. With his designs for banknotes, which remained an isolated case in Klimt's oeuvre, the genre of meticulously drawn allegories has been enriched by a remarkable facet from the artist's early period.

1 Marian Bisanz-Prakken, "Die Banknotenentwürfe von Gustav Klimt und Franz Matsch (1892)," in Exh. cat. Vienna 2010–11, pp. 5–7.
2 Director Wilhelm Meyer to management, Vienna, June 13, 1893, historical archive of the Österreichische Nationalbank, file no. 1210/1893, published in Exh. cat. Vienna 2010–11, pp. 38–39.
3 Ibid., pp. 54–55.
4 Ibid., p. 39.

The Turn to
Modernism and the Secession
1895–1903

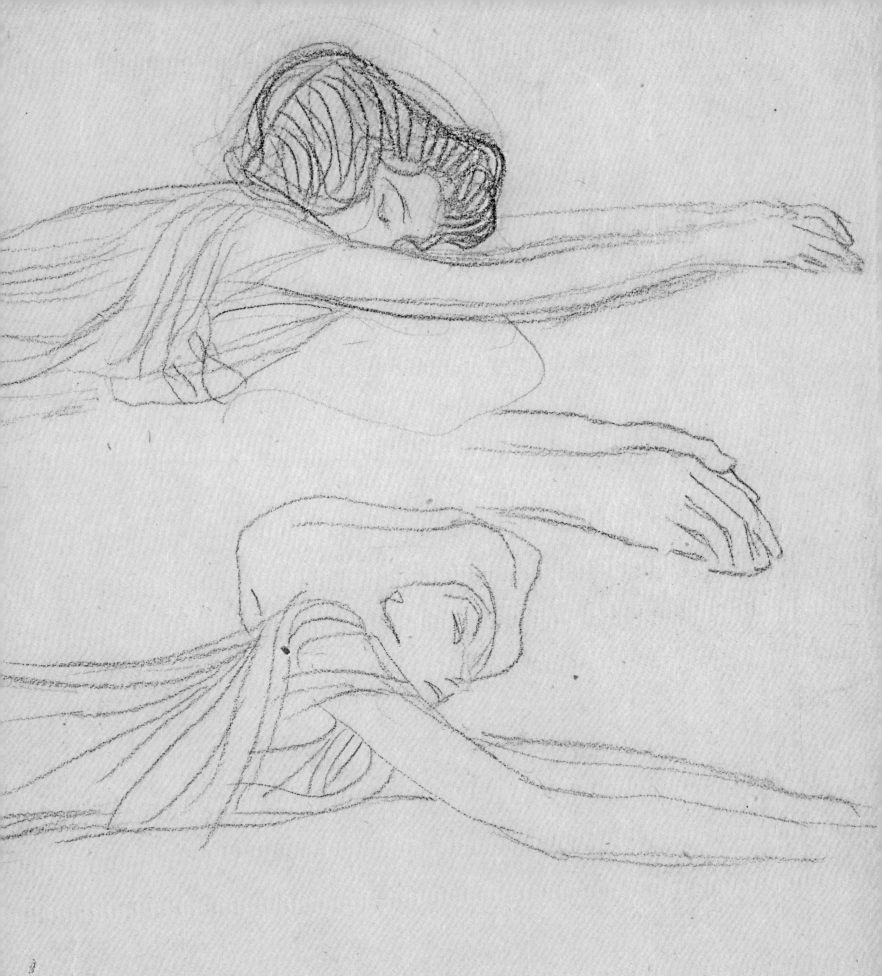

Love

In 1895 the signs of a change that in 1897 would lead to the founding of the Secession were gaining momentum on all levels of Vienna's cultural life. For example, the growing autonomy of the media of drawing and prints was manifested in the series *Allegorien, Neue Folge*, which was published beginning in 1895. It was the modern continuation of the series *Allegorien und Embleme*, to which Klimt had contributed as a young artist (see cat. no. 1). The new era was still to be captured in allegories, but this time the focus was on themes close to life, such as "Wine, Love, Song, Music, and Dance," as its editor, Martin Gerlach, emphasized in his introduction.[1]

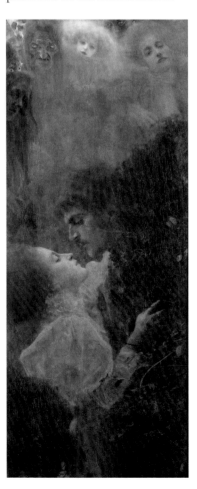

Fig. 1. *Love*, 1895, oil on canvas, 60 × 44 cm, Wien Museum

Gustav Klimt's contributions to *Allegorien, Neue Folge* were the painting *Love* (1895) and the highly finished drawings *Junius* (1896), *Sculpture* (1896), and *Tragedy* (1897).[2] With these works—incunabula of Viennese Symbolism—Klimt professed openly for the first time, after several years of seclusion and inner searching, a completely new direction. These works consolidated his position as a protagonist of Viennese modernism and in 1897 led to his being appointed president of the Vereinigung bildender Künstler Österreichs—Secession (Association of Austria's Fine Artists—Secession).

The studies shown here were produced for the painting *Love*, Klimt's first modern allegory of life (1895, fig. 1). In a dreamlike vision, the artist evokes the fateful bond between love, life, and death. A young woman's face in profile shines out of diffuse, dimly lit surroundings, yearning toward the kiss of her lover as if in a trance. Enigmatically illuminated heads appear at the very top, symbolizing the stages of human life up to death. The face of the small child is especially luminous; with her astonished, wide-open eyes, she seems to escape the pessimistic mood that generally dominates.

In the study for this child's face, Klimt was particularly concerned to capture the expression of dreamy seriousness (cat. no. 17). He employed the pencil in a variety ways. The sharp contour lines of her cheeks cause the girl's round, gently modeled face to shine out. He effectively contrasted the broad chaplet of the child's delicately braided hair with the dark background constructed of vertical parallel hatching. At the same time, he used the vertical structure as a new means to fix the

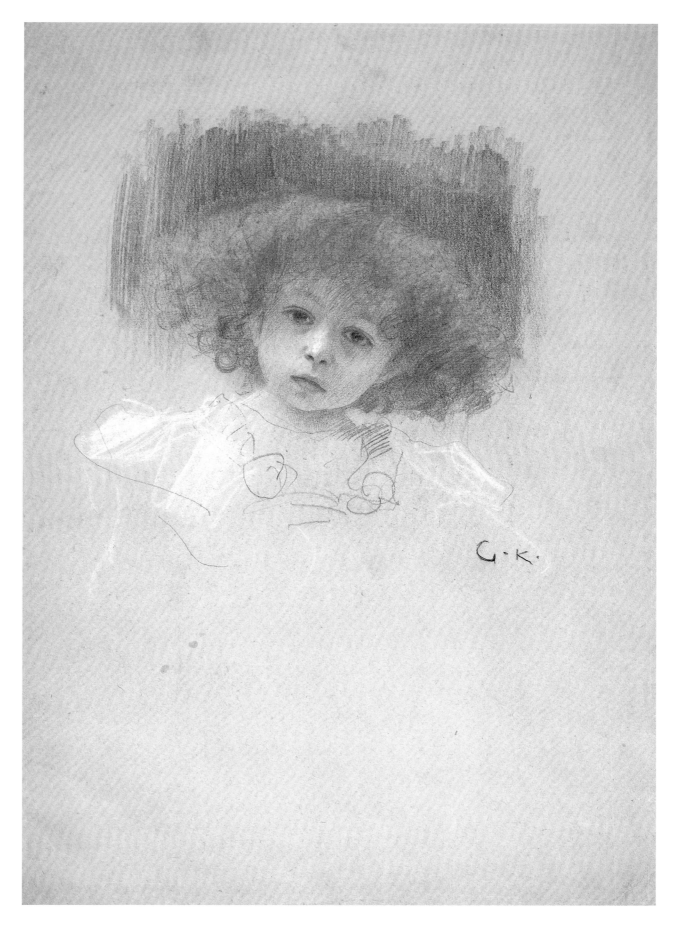

strictly frontal portrait within the plane. The white accents on the face and the quickly sketched clothing heighten the visionary content of the study, which points beyond its immediate purpose to the character of a cohesive, autonomous work of art.

The study of the bald old man was produced for the stages of life in the upper area of the painting, in which his physiognomy studied from reality heightens into an especially repellant effect (cat. no. 18). The model's address was noted directly on the sheet, as was also done in several other cases (cf. cat. no. 7). As with the study of the child, Klimt was interested in a specific type; here too he took into account the visionary lighting in the painting by means of subtle white heightening. The drawings of the child and of the old man should be included with the earliest studies in Klimt's work that belong in the realm of modern allegories of life. The fundamental influence of the Belgian Symbolist Fernand Khnopff is evident in both cases in the subtle pencil technique and in the strictly frontal positioning of the head and the gaze fixed on the viewer.[3]

[1] Martin Gerlach, in Gerlach, ed., *Allegorien, Neue Folge* (Vienna, 1895 ff.), n.p.
[2] *Love*: Novotny and Dobai 1975, no. 68; Weidinger 2007, no. 93; *Junius, Sculpture, Tragedy*: Strobl I, 1980, nos. 272, 276, 340.
[3] Marian Bisanz-Prakken, in Exh. cat. The Hague 2006–7, p. 72.

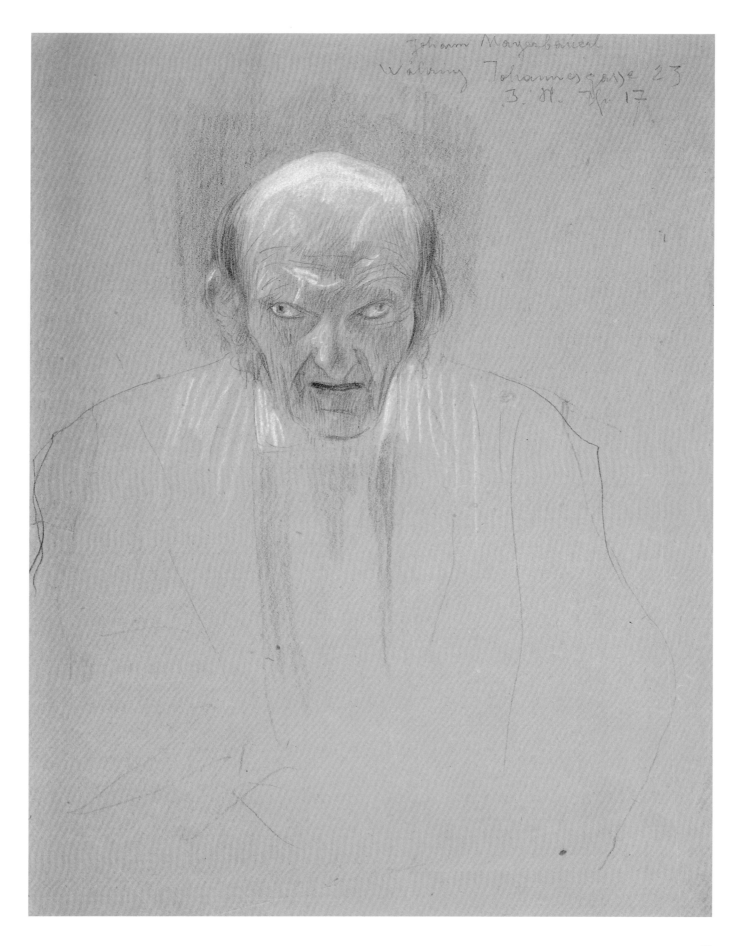

Illustrations for *Ver Sacrum*

Klimt's activity in the area of illustration and book decoration was concentrated primarily during his term as president of the Secession, which was founded in 1897. He produced a series of ink drawings for the issue of the journal *Ver Sacrum* (March 1898) dedicated to him: vignettes, initials, vertical-format illustrations, and the drawing *Fish Blood* (cat. no. 19), which was reproduced on a full page. This sheet occupies a special place in several respects. Already during this early phase, Klimt took his cue for the linear borders from the revolutionary square format of the journal. Moreover, this drawing was the beginning in his oeuvre of a pictorial genre characterized by a Symbolist combination of playful female eroticism and mysterious underwater scenes— for example, in paintings such as *Moving Water* (1898), *Goldfish* (1901–2), and *Water Snakes* (*I* and *II*, both 1904–7). *Fish Blood* is distinguished by pronounced black-and-white effects and a refined interplay of sensual body outlines, long strands of hair, and wavy

lines; the enormous fish head has an uncanny effect. This work, unmistakably influenced by Aubrey Beardsley's illustration style, represents without a doubt a high point in the art of early Secessionist drawing. For all the linear stylization, Klimt still characterized feminine curves with his subtle contours; the foreshortened figure of the nude looms into the pictorial field, conveying the impression of a certain spatiality. *Fish Blood* was followed a few months later by the painting *Moving Water*, which was presented in the Secession in November 1898 (fig. 1).[1] Here the streamlined, stylized, naked water nymphs move completely parallel to the picture plane, borne by broad, wavy lines. In their bodies the modern ideal of slenderness is already evident. At the same time, Klimt's innovative use of formations of lines flowing in parallel to express endless movement and a metaphysical state of floating is brought to bear fully for the first time. A crucial role in this process is played by the linear art of the Dutch Symbolist Jan Toorop, who in the years that followed would influence Klimt increasingly.[2]

Whereas *Fish Blood* evokes a timeless, mythological fairy-tale world, the ink drawing of the flying tripod presented here clearly refers to Greek antiquity (cat. no. 21). The motif borrowed from a hydra is associated with the omniscient oracle at Delphi, which is dedicated to Apollo.[3] Previously in the painting *Josef Lewinsky* (1894), Klimt had employed the motif of a tripod with smoke rising from it as a symbol for artistic inspiration.[4] The fact that this drawing was granted a special position as the cover motif of the Klimt issue of *Ver Sacrum* sheds particular light on the programmatic function of Apollo, the fa-

Fig. 1. *Moving Water*, 1898, oil on canvas, 53 × 66 cm, private collection, courtesy Galerie St. Etienne, New York

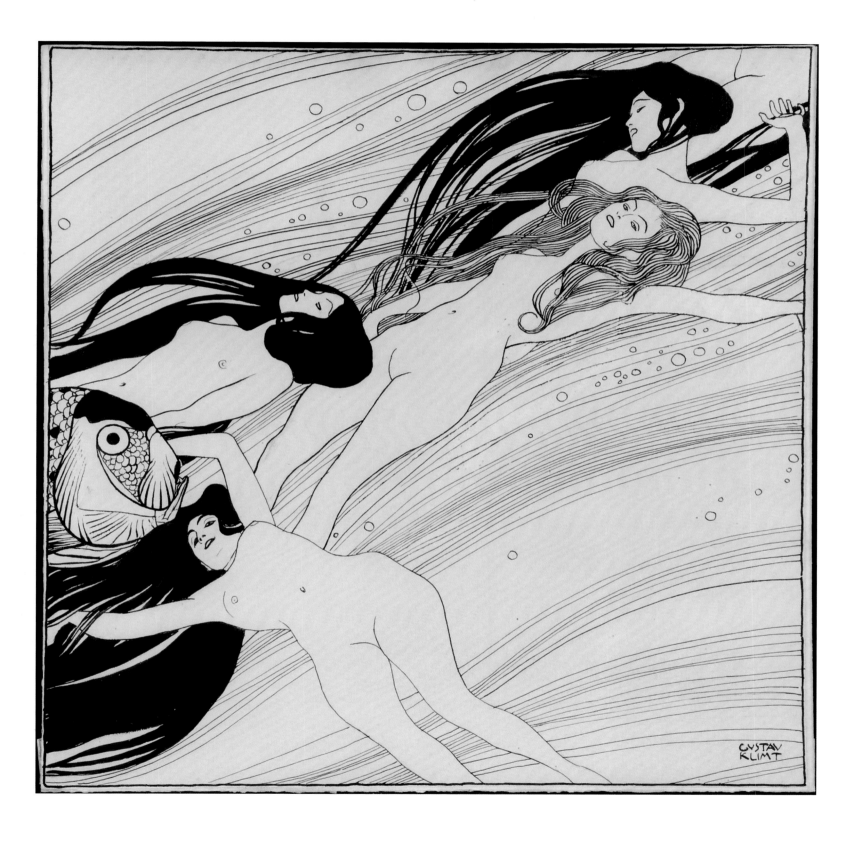

19

20

ther of the Muses, in the early Secession. Particularly noteworthy is his symbolic presence here in the form of the gold laurel cupola of the Secession building, which opened in 1898.

In the predominantly Japanese-inspired narrow vertical format, which was very popular in general in the graphic arts of *Ver Sacrum*, Klimt's qualities as a draftsman are shown to particular advantage. The balanced tension between bright areas and silhouette-like dark ones is combined with a subtle play of delicate, black lines, or lines of the blank paper by omission. The broad landscape in the lower part stands out as summarily but effectively rendered. The influence of ancient vase painting has been noted as well as that of

Aubrey Beardsley, but the final result bears the unmistakable handwriting of Gustav Klimt.[5]

Another variation on the theme of Apollo is found in this likewise slender, vertical-format initial D, into which Klimt placed the god's head in profile, with black curls and a laurel crown, in front of a detail of a laurel tree (cat. no. 20). The luxuriant, expansive crown of leaves forms the backdrop for the letter D and for the emblem of the Secession and alludes to a myth associated with Apollo: pursued by Apollo, the nymph Daphne, fearing the loss of her chastity, had herself turned into a laurel tree, which thereafter remained inseparably associated with the god. Klimt would address the theme again in the painting *Daphne* (1903).[6]

[1] Novotny and Dobai 1975, no. 94; Weidinger 2007, no. 128.

[2] Marian Bisanz-Prakken, in Exh. cat. The Hague 2006–7, pp. 121–24.

[3] The motif is derived from a hydra by the so-called Berlin Painter in the Vatican; see Strobl I, 1980, p. 113; according to Comini 1975, p. 11, fig. 8.

[4] Strobl I, 1980, p. 91.

[5] On the influences mentioned, see Strobl I, 1980, p. 113.

[6] Marian Bisanz-Prakken, "Der Klimt, den keiner kannte," *Die Presse*, November 10, 2007, "Spectrum," p. iv. The painting previously known as *Girl with Blue Veil* (Novotny and Dobai 1975, no. 130) was first identified here as the painting *Daphne*, previously thought lost.

GUSTAV·KLIMT·

21

Portraits of Women, 1897–98

From the time of his fundamental turn toward Symbolism, works on paper became increasingly significant for Klimt. The drawing, which during his historicist period had served primarily a subordinate function, developed during the 1890s into a medium employed in a variety of ways to convey intimate moods. Around 1896 this trend was manifested in a series of drawings of half-length portraits. These works, mainly based on anonymous female models, were produced independently of painted portraits and have a finished, autonomous character. The earliest examples of this genre, to which Klimt would later dedicate himself repeatedly in drawings, were produced between 1896 and 1898.[1] This group, which is marked by atmospheric effects, is exemplarily represented by the two portraits shown here.

Klimt himself regarded *Portrait of a Lady with Cape and Hat* (cat. no. 22), which he drew in 1897–98, as very significant: he exhibited the sheet in March 1898 in the first Secession exhibition and illustrated it on a full page in the issue of *Ver Sacrum* dedicated to him (March 1898).

The melancholically gazing face of a woman depicted using backlighting and the subtlest nuances shines out of dimly lit surroundings. With the overlapping, diffuse forms, a rich variety of graphic structures stands out: the angularly broken, radial hatching of her fur wrap, the delicately woven hair slightly accented with red, and the transparent hat decoration, which stands out sharply against the bright crack of light. The forms are enveloped by the slightly curved, allover vertical hatching of the backdrop. The emphasis of this outstanding drawing is not on portrait likeness but rather—characteristically of the Symbolism of the early Secession—on conveying a mysterious atmosphere. In this phase of his development as a draftsman, Klimt was very fundamentally inspired by artists whose drawings and prints are characterized by soft forms and richly nuanced black-and-white effects, including Franz von Stuck, Albert Besnard, Eugène Carrière, Anders Zorn, and Max Klinger. In that context, an exhibition of contemporary etching at the Künstlerhaus in 1895 was a formative influence on Klimt and his colleagues.[2]

In *Portrait of a Reclining Young Woman* of 1897–98, another autonomous work, Klimt emphasized above all the constructional element, but this drawing too is characterized by a subtle use of black chalk (cat. no 23). The model leans back and turns her face toward the viewer, and the diagonal line of her head and shoulders fills the entire width of the format. The focus is on the melancholy gaze of the eyes and the curving eyebrows; the slightly smiling mouth exposes teeth only delicately suggested. The fleeting, wavy lines of her clothing and of the back of the chair contrast subtly with the soft shading of the face and hair. A striking note is added by the high-neck collar (or necklace), which is defined by sharp horizontal lines. Within this delicately balanced constellation of planes, even the dark shadow between her neck and the back of the chair takes on its own decorative weight. The back of the chair establishes a barrier between the woman's face and the viewer. In the resulting void—another essential element of the composition—Klimt places a well-considered decorative accent in the form of his signature in block letters.

As has been shown with similar examples, the motif of an armchair employed as a barrier can be traced back to James Abbott McNeill Whistler.[3] The subtle chalk technique and the type of regularly proportioned round face depicted in close-up also reveal the influence of the Belgian Symbolist Fernand Khnopff. Khnopff and Whistler were also influences in Klimt's portrait of Sonja Knips (1898), to which the drawing shown here has certain similarities in terms of clothing, hairstyle, and the face (cf. cat. no. 67).

[1] Strobl I, 1980, nos. 376–408.
[2] Strobl I, 1980, p. 123; Bisanz-Prakken 1999, pp. 13, 79.
[3] Von Miller 2007, pp. 58–59. The work by Whistler discussed as a model is *Arrangement in Gray and Black No. 1: Portrait of the Artist's Mother*, Paris, Musée d'Orsay.

23

Thalia and Melpomene

The theme of the muses had already occupied Klimt in his historicist phase, for example, in the free interpretation of the Roman frieze of the Muses in the upper part of *Allegory of Sculpture* (cat. nos. 13, 14). The present drawing also has a friezelike format, but in other respects it differs completely from the historicist one.

This work, which can be dated to late 1898, may have been produced as a contribution to the series *Allegorien, Neue Folge*, judging from its highly finished character and the careful positioning of the title and signature, but it was not published. Klimt was concentrating here on the Muses of tragedy and comedy, whose heads he placed very close to the edge of the image and rendered in a symbolically contrasting combination of profile and frontal views. On the far right, frozen like a mask, is the face in profile of Melpomene, the allegory of tragedy, whose brooding gaze and down-turned corners of her mouth signal disaster. Her dark hair falls straight down, seeming to continue the vertical hatching of the backdrop, nuanced in shades of gray. This stylistic means—the so-called graphic rain of the late 1890s—accounts for the mysterious overall atmosphere of the depiction. At the same time,

this emphatically vertical linear structure determines the monumental character of the composition, in which the spatial layers overlap in parallel with the picture plane. Right behind Melpomene is the full, smiling face of Thalia, the allegory of comedy. Her sweeping, curly hair forms a symbolic and simultaneously decorative contrast to the dominance of the vertical flows of the lines. In the background, lined up along the upper edge, are three different masks. The mask partially covered by Thalia is visible only in outline, and it stands out above all for its magically luminous gaze.

An important source of inspiration for *Thalia and Melpomene* was no doubt the lithograph *The Sower* (1893) by the Dutch artist Jan Toorop, whose Symbolism played an influential role in Klimt's turn toward modernism (fig. 1). For all their individual differences, the works of the two artists reveal essential commonalities: the horizontal format; the allover, grayly shimmering fundamental tone; and the asymmetric arrangement of women's heads depicted in close-up; and in both cases their frontal-profile position has a basis in Symbolism. According to Toorop's own explanations, the frontal, inward-looking face stands for knowledge, while the profile is associated with longing. This contrast plays a profound role in Klimt's Symbolism.[1] Last but not least, the two depictions share the motif of long hair flowing in parallel. Klimt brilliantly employs the image that inspired him to serve his own intentions.

[1] Jan Toorop published this explanation of the illustration of the preparatory drawing for this lithograph in *Bouw- en Sierkunst* 1 (March 1898), 3, p. 28. On this, see Marian Bisanz-Prakken, in Exh. cat. The Hague 2006–7, p. 92.

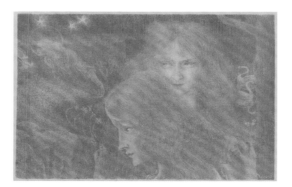

Fig. 1. Jan Toorop, *The Sower*, 1893, lithograph, 49 x 68 cm, Albertina, Vienna

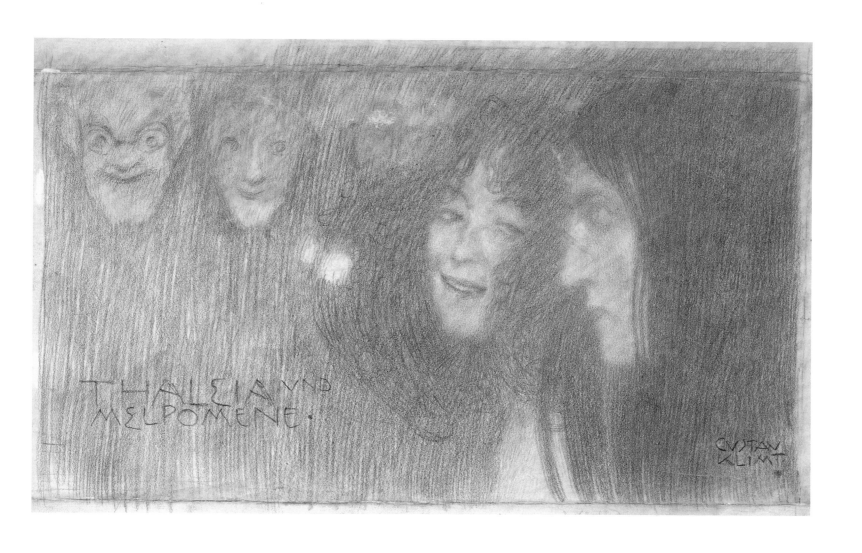

**Girl with Long Hair in Profile,
with a Sketch of *Nuda Veritas*,
1898–99**

Black and colored chalk, 55.5 × 37.5 cm
Private collection, courtesy Richard Nagy
Ltd., London | Bisanz-Prakken, forthcoming

Girl, with *Nuda Veritas*

This carefully executed, highly finished drawing, whose purpose remains unknown, can be regarded as a rarity in several respects. It is one of the few examples in the artist's oeuvre of drawings in which he used chalk in several colors. Moreover, Klimt was drawing on a type of paper that was unusual for him; its ribbed structure is clearly evident. The way Klimt

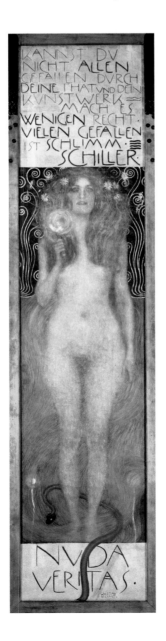

Fig. 1. *Nuda Veritas*, 1899, oil on canvas,
252 x 56 cm, Kunsthistorisches Museum
(Theatermuseum), Vienna

brought together two different motifs from his repertoire into an autonomous composition is also unique.

The pale profile of a young woman is at the center; her bare shoulder looms diagonally into the pictorial field. Her striking profile, with a pronounced chin, firmly closed mouth, downcast eyelid, and densely cascading hair correspond to an ideal type advocated by Jan Toorop, which in the late 1890s inspired Klimt to produce a series of autonomous portrait drawings. These introverted half-length portraits, which he executed in black, red, or blue chalk, are characterized by a subtle play of lines and the soft shimmer of hair falling in delicate parallel lines.[1] One important starting point for this special group was Toorop's lithograph *The Sower* (1893, fig. 1 on p. 70), one of the most important models for Klimt's allegorical drawing *Thalia and Melpomene* (cat. no. 24). Klimt's lyrical profile portraits are completely in keeping with the *Stimmungskunst* (mood art) that influenced the Secession in the initial years after its founding. The works of this phase are characterized by gentle transitions of forms and colors, combined with meditative moods.[2]

In the portrait shown here, the hair is rendered in a combination of black and violet chalk as well as light, dark, and cobalt-blue chalk. Both in color and in linear structure, the delicate shadings of the dark, mysteriously shimmering hair recall the waves in the painting *Moving Water* (fig. 1 on p. 62) from the same period.

At top left, behind the face in profile, a large, frontal face emerges as if in a vision; its sharply outlined red mouth, the light reflections on the bridge of the nose, and the magically glowing eyes establish individual

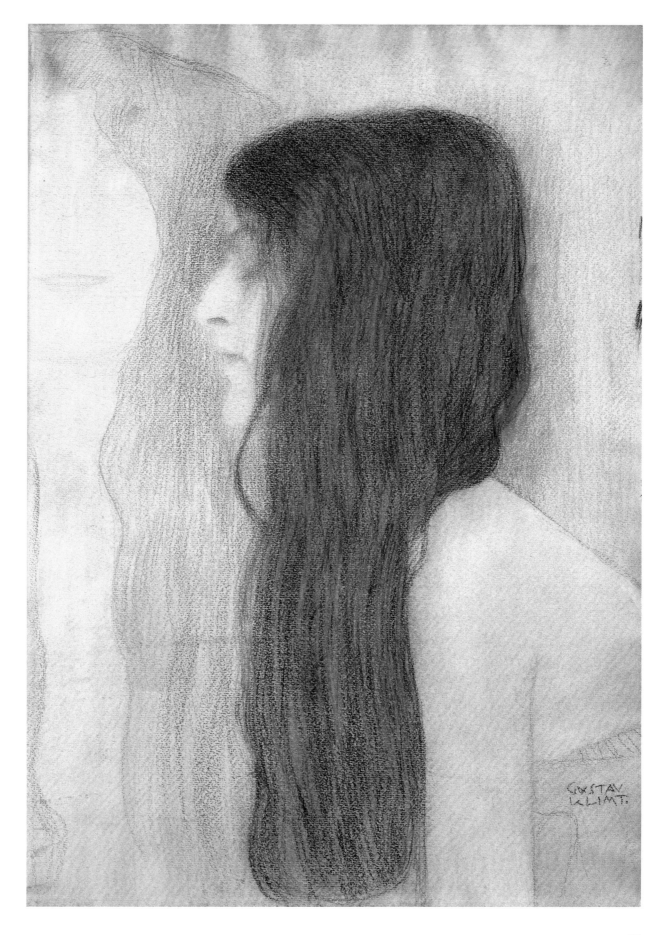

Fig. 2. *Girl with Long Hair in Profile* (cat. no. 25) in the eighteenth exhibition of the Viennese Secession, 1903–4

1. The group is discussed in Strobl I, 1980, p. 137.
2. On the *Stimmungskunst* of the Secession, see Bisanz-Prakken 1999, pp. 11–22, and specifically in relationship to the medium of drawing, ibid., pp. 120–23.
3. Österreichisches Theatermuseum, Vienna. Novotny and Dobai 1975, no. 102; Weidinger 2007, no. 135.
4. The gold paint in the eyes of the main figure in *Nuda Veritas* was first pointed out by Marian Bisanz-Prakken in Exh. cat. The Hague 2006–7, p. 88.
5. This drawing can be seen in the photograph of Room IX of the eighteenth exhibition of the Vienna Secession (*Klimt-Kollektive*) in 1903–4 (fig. 2).

accents—the highlighted areas were achieved by erasing the bright orange basic tones. The face is framed by a mass of red hair, following in light waves as a lustrous counterweight to the dark hair of the figure in front. This visionary figure is directly connected to the painting *Nuda Veritas* of 1899 (fig. 1).[3] The analogy between the gold paint in the figure's eyes in the painting, which reflect the "true" light, and the magically luminous gaze in the face of the drawing is remarkable.[4] Both faces—that of the painting and that of the drawing—are permeated by the demonic type of face advocated by Fernand Khnopff; the red hair is also characteristic of Khnopff.

By repeating the emphatically frontal *Nuda Veritas* and the profile portrait as a metaphor for turning inward, Klimt's composition seems to be alluding allegorically to the two main aspects of the early Secessionist program. On the one hand, he and his fellow artists concentrated on energetically conveying new ideals, often employing provocative nudity. On the other hand, the discovery of the soul led to a new internalization and cultivation of the hermetically sealed "world of the artist." As in *Thalia and Melpomene* (cat. no. 24), the overlapping spatial layers correspond to two levels of meaning, which also find expression in the nature and color of the hair of the two figures. For example, the broadly flowing red hair seems to point to artistic independence and sexual liberation, while the strict, self-contained appearance of the black-blue-violet hair coincides with the spiritual quality of the main figure.[5]

The Faculty Paintings: *Philosophy*

The project to paint the decorations of the ceiling of the university auditorium, with which he and Franz Matsch had been entrusted in 1894, was of crucial significance to Klimt. He did the majority of his highly intense work on the monumental faculty paintings *Philosophy* (1900–1907), *Medicine* (1901–7), and *Jurisprudence* (1903–7) during the founding period and early years of the Secession, where the works were exhibited successively. Each of these presentations caused vehement controversies. In the end, those who had commissioned Klimt's monumental allegories rejected them. In 1905, the year he resigned from the Secession, Klimt purchased the paintings back with the help of friends. He continued to make essential changes to these three major works until 1907.[1]

The problem with this large commission was that, following his fundamental turn to Symbolism, it had become impossible for Klimt to approach the great questions of life in a traditional, positivist spirit. In *Philosophy* and *Medicine*, following his inner conviction, he painted the mysterious vision of humanity floating in space, exposed to the powers of fate. He drew inspiration from the works of contemporaries such as Auguste Rodin, Albert Besnard, Fernand Khnopff, Jan Toorop, and James Abbott McNeill Whistler, whose works he studied at Secession exhibitions but also in reproductions.[2]

In the course of his innovative grappling with the basic questions of human existence, Klimt found a radical and modern approach to the naked body. Nonclassical, at times even antiaesthetic nakedness came to represent the elemental state of inner isolation and sense of helplessness. In his studies for the nudes in the faculty paintings, Klimt nearly always concentrated, as he had earlier in the decorations for the Burgtheater, on individual figures, but this time the sensitive outlines marked the psychological boundary between the inner life of human beings and their empty surroundings. The key position of these works in Klimt's own artistic evolution

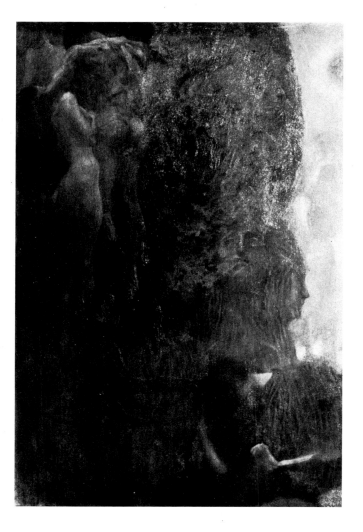

Fig. 1. Oil sketch for *Philosophy*, 1897–98, oil on canvas, 430 x 300 cm, burned in 1945

26
Seated Woman with Head Propped, 1897–98
Study for oil sketch for *Philosophy*
Black chalk, 45.3 × 33.5 cm
Albertina, Vienna, inv. 34556 | Strobl I, 455

27
Male Nude with Outstretched Left Arm, Seen from Behind, 1898–99
Study for *Philosophy*
Black chalk, 42.3 × 26.6 cm
Albertina, Vienna, inv. 23654 | Strobl I, 459

28
Kneeling Nude of an Old Woman, 1898–99
Study for *Philosophy*
Black chalk, 37 × 26.5 cm
Albertina, Vienna, inv. 23655 | Strobl I, 469

29
Fragment of a Couple Embracing: Seated Male Nude, Seen from Behind, 1898–99
Study for *Philosophy*
Black chalk, 40.7 × 29 cm
Albertina, Vienna, inv. 23644 | Strobl I, 479

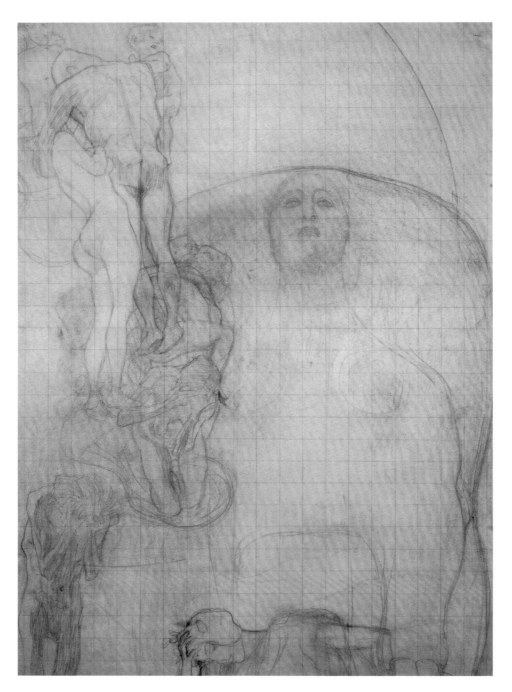

Fig. 2. Transfer sketch for *Philosophy*, 1898–99, black chalk and graphite, 89.6 x 23.2 cm, Wien Museum

ements of the allegory emerge only schematically.[3] A brooding sibyl, a group of philosophers, the naked bodies of a family, and a sphinx—the symbol of the "riddle of the universe"—convey a gloomy, pessimistic mood (fig. 1). The turn toward the great cosmic vision is revealed in the composition design he sketched in 1898–99 (fig. 2). Here the cycle of "becoming, fruitful existence, passing away" seems like a random detail from a stream of people projected into space. The main allegorical figure, the sibyl, is almost oppressed by the oversized, four-headed sphinx, the "riddle of the universe." In the first version of the painting from 1900, the sibyl is replaced by a brightly lit, frontally presented woman's head—Knowledge—while the sphinx glimmers in the background; the stream of people was increased (fig. 3). Yet the impression of something moving past derives not from the human figures, who appear to be in a trance, but rather from the rhythmically pulsing outlines of their bodies and the veil of lines that envelops them.

The study of a brooding figure dressed in the antique style was preparation for the sibyl in the oil sketch (cat. no. 26). The slight view from below, the flowing lines, and the pronounced contrasts between light and shadow still carry a distant echo of the neo-Baroque tradition of the Ringstrasse. The studies for the preparatory drawing and for the painting correspond rather to the modern conception and refer to the various primal situations in human life or to certain moods. In several sketches, including the sheet exhibited here, Klimt studied the figure of the young head of the family seen from behind, who in the large preparatory drawing has placed his left arm protectively around his companion's shoulder.

and for Austrian Expressionism in the broader sense cannot be emphasized enough. The studies for *Philosophy* shown here date from three phases in the process, which will be sketched briefly here.

In the oil sketch for *Philosophy* that was painted in 1897–98 and is known only from a black-and-white reproduction, the various el-

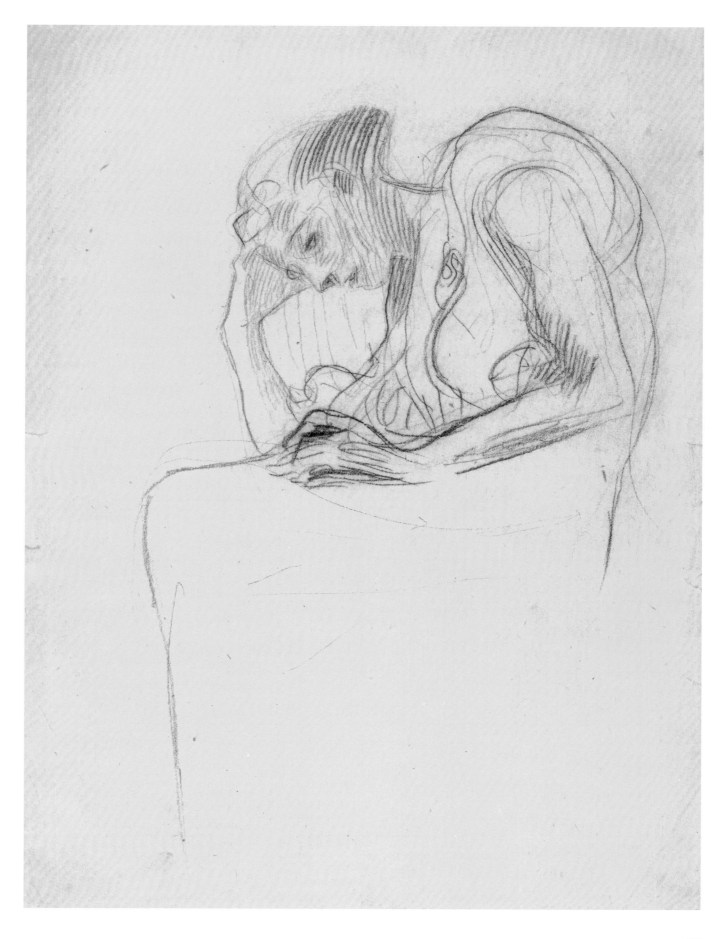

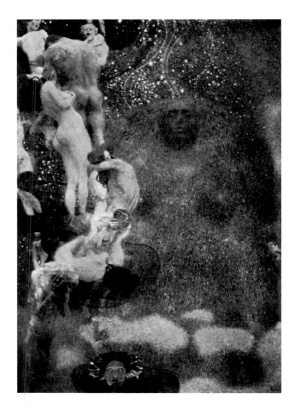

Fig. 3. *Philosophy* (first version), 1900, oil on canvas, burned in 1945

In the present study, the protective role is expressed by the continuous contour line of the head bent forward pensively, the shoulder, and the bent arm (cat. no. 27). Klimt emphasized the man's powerful musculature by accentuating the flowing outlines of the body and modeling it with parallel hatching. At the same time, the figure is in a metaphysical state of suspension—as in nearly all the studies for the faculty paintings, Klimt did not render the feet. He contrasts for the first time the muscular figure seen from behind as the epitome of male vitality with the soft female body. This contrast later played a big role in his depictions of lovers.

The kneeling old woman looking desperately into the abyss of death was also the subject of several studies. In the context of *Philosophy*, Klimt first associated unsparingly depicted old age with the expression of worry about transitoriness. In the study shown here, he succinctly emphasized the old woman's drooping breasts and hanging belly (cat. no. 28). Using strongly characterizing contour lines, he isolated the kneeling old woman covering her face, thus avoiding any impression of being bound to the earth. The influence of Rodin's sculptures on Klimt is often mentioned in relation to his depictions of old age in particular. Yet Klimt caused the realistic details to fit in with the overall melody of lines in a way that was very much his own.

Sometimes Klimt combined several motifs, as the study shown here does (cat. no. 29). The drawing of a powerfully outlined, huddled male figure seen from behind corresponds to the miniature form who in the first version of *Philosophy* from 1900 emerges from the head of Knowledge as a symbol of thinking.[4] Above it is the motif of the interwoven pelvis areas of a pair of lovers, by means of which Klimt refers—as he does in several other studies—quite openly to the physiological origin of human life. In the painting, he replaced this motif with the naked upper bodies of a couple intimately entwined in embrace. Both aspects of life between man and woman—the physical and the spiritual—mark the start of the towering role Eros began to play in Gustav Klimt's oeuvre.

[1] For essential information on the faculty paintings, see Strobl 1964; Strobl I, 1980, pp. 147–58, 265–300, 253–72; Strobl 2007.
[2] On the influence of Fernand Khnopff and Jan Toorop on *Philosophy* and *Medicine*, see Marian Bisanz-Prakken, in Exh. cat. The Hague 2006–7, pp. 107–17.
[3] Novotny and Dobai 1975, no. 87; Weidinger 2007, no. 117.
[4] Bisanz-Prakken 1976, p. 201.

28

30
Transfer Sketch for *Medicine*, **ca. 1900**

Black chalk, graphite, enlarging grid
86 × 62 cm
Albertina, Vienna, inv. 29545 | Strobl I, 605

31
Two Studies of a Standing Nude, 1897–98

Study for the oil sketch for *Medicine*

Black chalk, 47.8 × 31.4 cm
Albertina, Vienna, inv. 23672 | Strobl I, 527

32
Floating Female Figure with One Arm Hanging and One Outstretched, 1897–98

Study for the oil sketch for *Medicine*

Black chalk, 38.2 × 28 cm
Albertina, Vienna, inv. 23674 | Strobl I, 534

33
Floating Female Figure in Profile, 1897–98

Study for the oil sketch for *Medicine*

Black chalk, 38 × 27.3 cm
Albertina, Vienna, inv. 23650r
(verso: cat. no. 34) | Strobl I, 537

34
Floating Female Figure in Profile, 1897–98

Study for the oil sketch for *Medicine*

Black chalk, 38 × 27.3 cm
Albertina, Vienna, inv. 23650v
(verso of cat. no. 33) | Strobl I, 536

35
Floating Female Figure in Profile with Flowing Hair, 1897–98

Study for the oil sketch for *Medicine*

Black chalk, 41.8 × 28.7 cm
Albertina, Vienna, inv. 23647 | Strobl I, 538

36
Floating Female Figure with Outstretched Left Arm, ca. 1900–1901

Study for the first version of *Medicine* **(1901)**

Black chalk, 41.5 × 27.3 cm
Albertina, Vienna, inv. 23664 | Strobl I, 621

The Faculty Paintings: *Medicine*

A completely new approach to the naked human body had already manifested itself in the artist's studies for *Philosophy*. In the drawings for the painting *Medicine*, which was executed as a companion piece to *Philosophy* in 1901, Klimt continued to develop these newly discovered possibilities.[1] The group of study drawings for *Medicine* occupy a central position in the Albertina's Klimt holdings. The complex process of the painting's evolution, briefly outlined here, is reflected in the great variety of motifs in these sheets, some of which exist in series.

The painted composition study from 1897–98 already contains the main components of the allegory (fig. 1).[2] "Suffering Humanity" can be seen emerging from the space behind Hygieia, the goddess of medicine. Reaching out toward this group is a floating young woman who is in turn supported by the out-

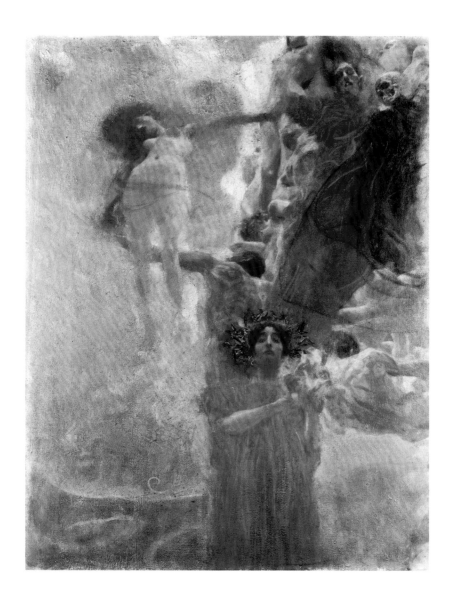

Fig. 1. Oil sketch for *Medicine*, 1897–98, oil on canvas, 72 × 55 cm, private collection

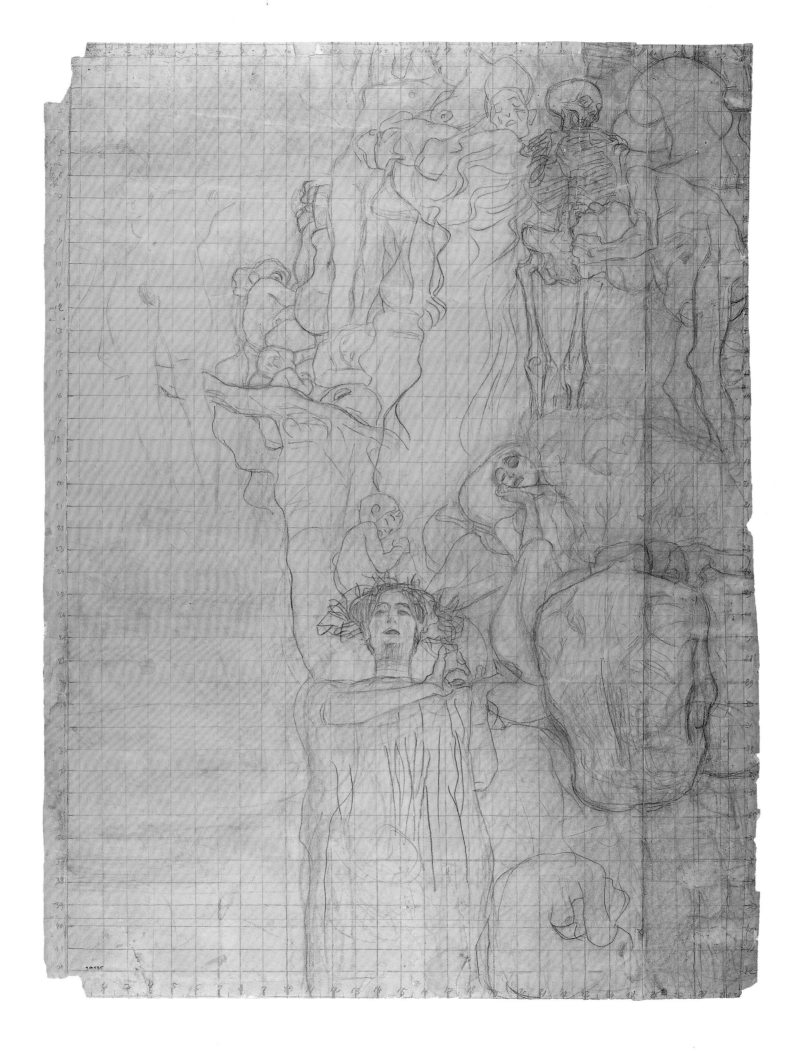

31

37

**Floating Male Nude,
Seen from Below, ca. 1896**

Earliest study for *Medicine*

Black chalk, 43 × 28.4 cm
Albertina, Vienna, inv. 23679 | Strobl I, 540

38

**Male Nude with Arms Spread,
Seen from Behind, Repetition of
Head and Shoulder Area, ca. 1898**

**Study for the oil sketch or
the transfer sketch for** *Medicine*

Black chalk, 44.3 × 31.9 cm
Albertina, Vienna, inv. 23661| Strobl I, 547

39

**Hygieia with Broad Headdress,
1897–98**

Study for the oil sketch for *Medicine*

Black chalk, 44.6 × 31.2 cm
Albertina, Vienna, inv. 31459 | Strobl I, 517

40

**Naked Pregnant Woman; Upper
Body of an Old Man, 1900–1901**

Studies for the first version of
Medicine **(1901)**

Red chalk, black chalk, 39.4 × 29.2 cm
Albertina, Vienna, inv. 23668 | Strobl I, 637

41

**Head of an Old Man;
Seated Female Nude, Seen from
Behind; Detail of a Female Torso,
1900–1901**

Studies for the first version of
Medicine **(1901)**

Black chalk, white heightening, 38.7 × 29 cm
Albertina, Vienna, inv. 23660 | Strobl I, 628

42

**Female Nude, Seen from Behind;
Distraught Old Man, 1900–1901**

Studies for the first version of
Medicine **(1901)**

Graphite, black chalk, 38.2 × 28.2 cm
Albertina, Vienna, inv. 23643 | Strobl I, 638

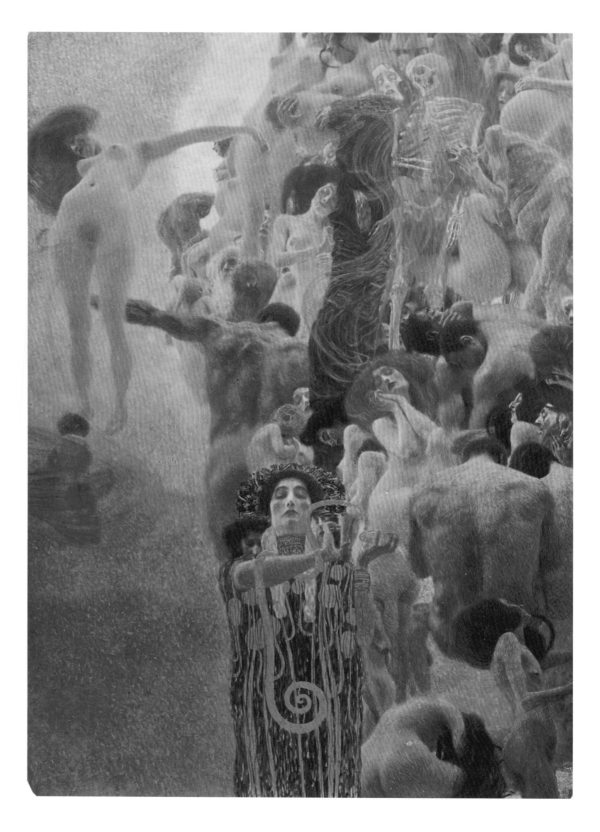

Fig. 2. *Medicine*, 1901 version, oil on canvas,
430 x 300 cm, burned in 1945

stretched arm of a man seen from behind. The sweeping curve of the painterly, dramatically lit stream of people in this transitional work from the early days of the Secession is still characterized by the neo-Baroque tradition of the Ringstrasse.[3] At the same time Symbolism is also on display, especially in Hygieia's rigidly frontal, gold-wreathed face; in the floating woman's somnambulistic expression; and in the glaringly illuminated heads of the figures symbolizing death and transitoriness.

Fundamental changes are seen in the transfer sketch drawn around 1900 (cat. no. 30). In an analogy to the "Becoming, Fruitful Existence, Passing Away" group in *Philosophy* the considerably enlarged "Suffering Humanity" group seems like a detail lifted from an endless, vertically drifting stream of naked creatures of various ages. In the predominantly reddish painting an even larger crowd of densely overlapping yet completely inward-turned figures—men, women, children, elderly—embodies all the nuances of physical and emotional suffering (fig. 2). These trancelike figures do not express their own personal pain, however. Rather, they symbolize supraindividual states of mind, emotional values, or basic conditions of human existence; as a result their gestures and movements seem as if guided from above. According to the critic Ludwig Hevesi, the depiction of these people was shaped by the "etherealization of the corporeal." "One clearly feels its breath and pulse, but it is nevertheless something else, a mere 'eidolon,' a likeness of life."[4]

Far removed from historicism, these modern qualities were, according to Hevesi, internalized again and again by Klimt in "stacks of nude drawings."[5] The numerous surviving studies testify to the artist's never-ending search for the formulas suitable for particular emotional values; he always focused on the individual figure or on a specific detail. Sometimes he spent several years searching for the ideal solution to a particular figure, as revealingly indicated by the group of drawings for the woman floating in space seen here. The earliest studies for the painted sketch (1897–98) feature a voluptuous model captured in sweeping outlines. Initially she is shown standing, while later she floats freely; hatching provides powerful modeling (cat. nos. 31, 32). Klimt briefly experimented with a profile position (cat. nos. 33–35). The endpoint of this intense search proves to be a perfect balance between style and expression (cat. no. 36). By leaving out the feet and depicting only the raised arm's upper part—the head bowed in sleep is cursorily sketched—Klimt concentrated entirely on the streamlined movement of the contours and the long, curved parallel hachures. This female body both curves seductively outward and vanishes mysteriously, thereby displaying the combination of sensuality and metaphysics characteristic of Klimt. This high degree of linear stylization is reserved solely for the ideal form of the floating woman within the group of *Medicine* drawings. Klimt's differentiating approach to degrees of stylization would manifest itself a short time later—influenced by the Symbolist linear style of Jan Toorop—in his *Beethoven Frieze*.[6] Around 1896 Klimt drew the male pendant to the floating woman using elastic contours, while in a later study he concentrated on the shoulder area (cat. nos. 37, 38). In the study for the columnar, frontal form of Hygieia, which is clearly influenced by Fernand Khnopff, Klimt emphasized the

finely pleated garment and the magic of the simple, angled arm gesture (cat. no. 39). In numerous studies Klimt used sensitively rendered bodily contours to bring out the weak, imperfect, sorrowful, or meditative aspects of his models, whose bodies he modeled with a gentleness, but often also with an unsparing realism, via delicate hatching and occasional white heightening (cat. nos. 40–43). He took the painting's particular lighting conditions into account through this shading, while the relatively frequent use of red chalk—for example, in the study of a heavily pregnant woman (cat. no. 40)—is probably connected with the dominant red of the painting. The group of studies featuring wrestling men, on the other hand, documents the various stages of Klimt's thorough examination of geometrically interlocking body shapes (cat. nos. 44–46). A sheet with several small sketches shows the sensitive and accurate approach Klimt took to the portrayal of a sleeping baby (cat. no.

47). An equally sensitive interpretation is seen in the rhythmic line study of the skeleton for the figure of death (cat. no. 48). The human touch, conveyed through the sideward turn of the skull, is typical of Klimt. The evocative red chalk study of a seated male figure seen from behind—done in the context of the partially reworked version of *Medicine* shown in 1903—boasts a meditative, self-contained character (cat. no. 49).

In the nude studies for *Medicine* Klimt captured the essence of his subjects with more intensity than ever before. Both as a draftsman and as a painter Klimt would repeatedly fall back on the repertoire of motifs used in the *Philosophy* and *Medicine* faculty paintings— paintings that address the fundamental situations of human existence, from procreation to death. An important, forward-looking factor was also the "etherealization of the corporeal," a product of the floating limbo state combined with the somnambulistic nature of the figures.

[1] For the seminal discussion of the different versions of the painting and their associated studies see: Strobl I, 1980, pp. 165–99.

[2] Oil on canvas, 72 × 55 cm, private collection. Novotny and Dobai 1975, no. 88; Weidinger 2007, no. 118; Exh. cat. The Hague 2006–7, no. 39.

[3] Possibly inspired by the painting *Cycle of Life* (1884–85) by Hans Canon, in Exh. cat. The Hague 2006–7, p. 114.

[4] Hevesi 1906, p. 318, in his review of the first presentation of the painting (March 1901).

[5] Ibid.

[6] For Jan Toorop's influence on *Philosophy* and *Medicine*, see Marian Bisanz-Prakken in Exh. cat. The Hague 2006–7, pp. 107–19.

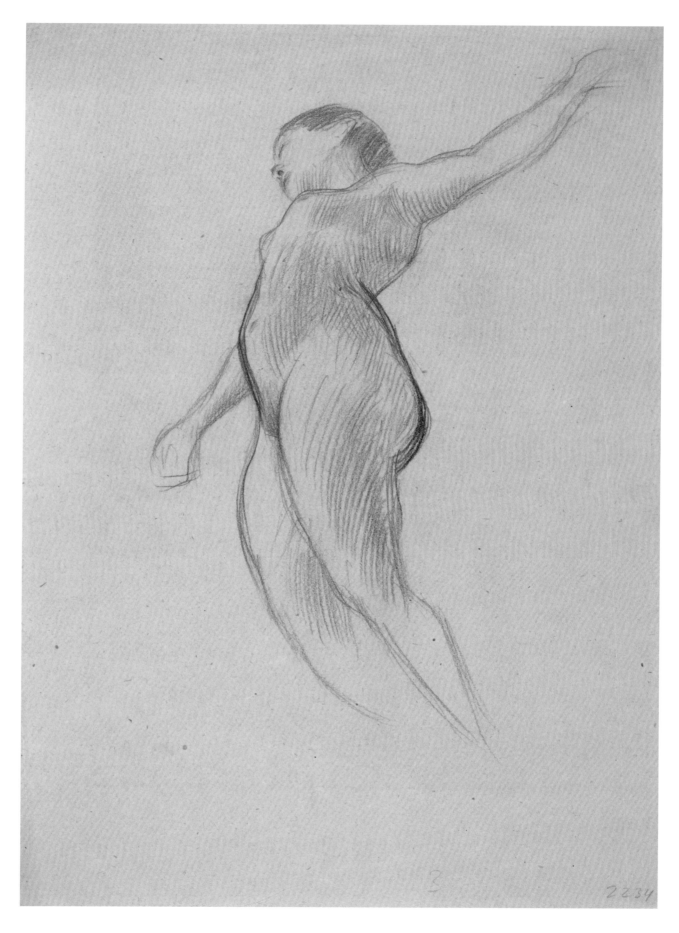

33

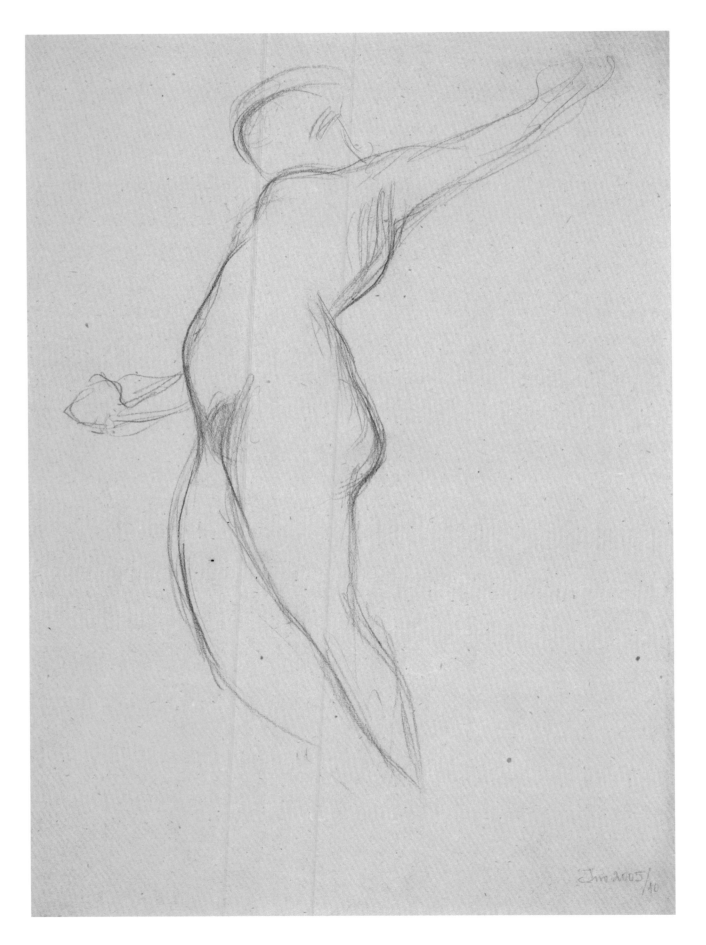

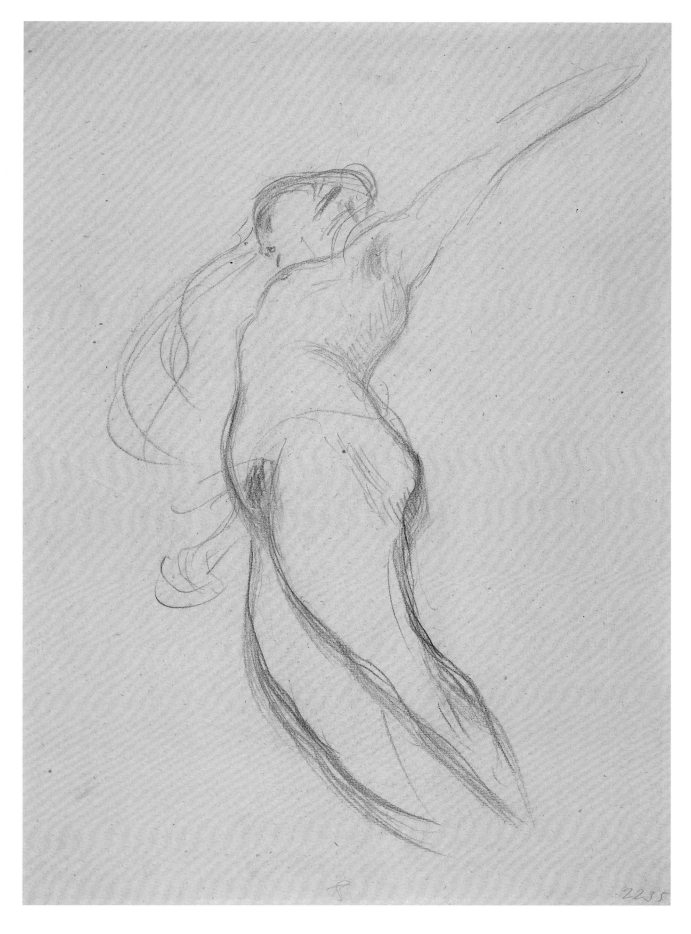

35

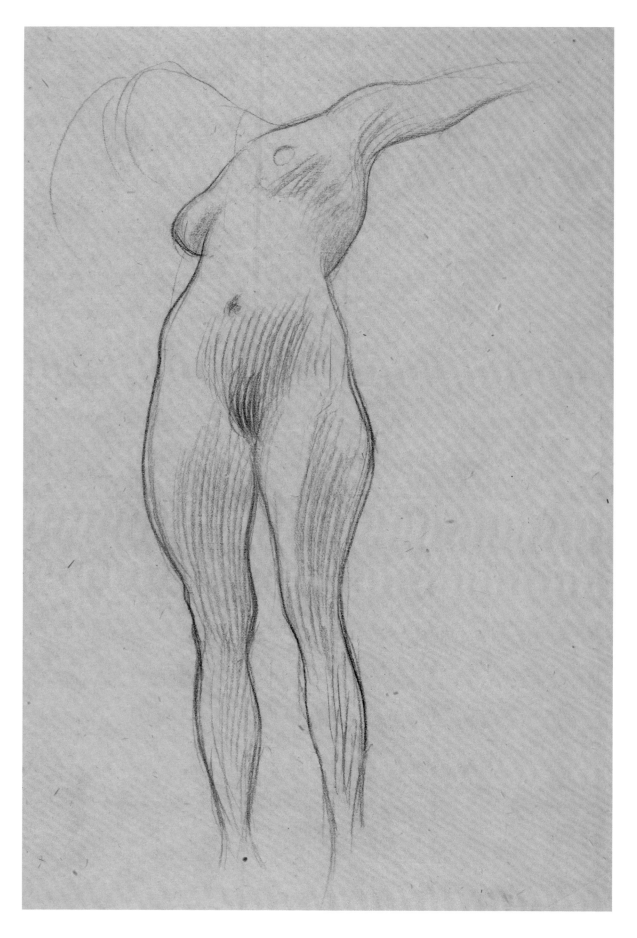

36

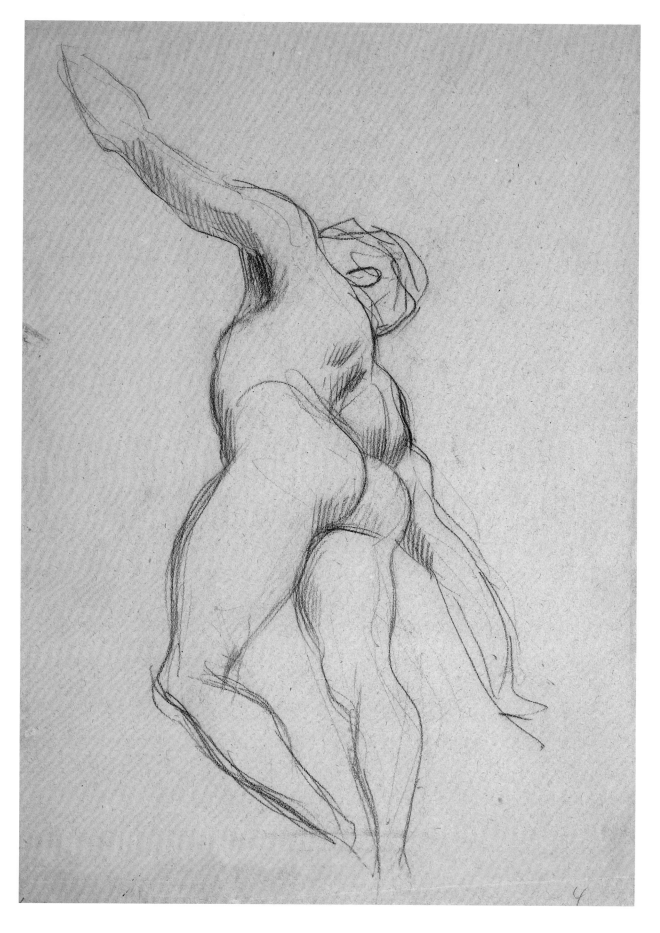

4

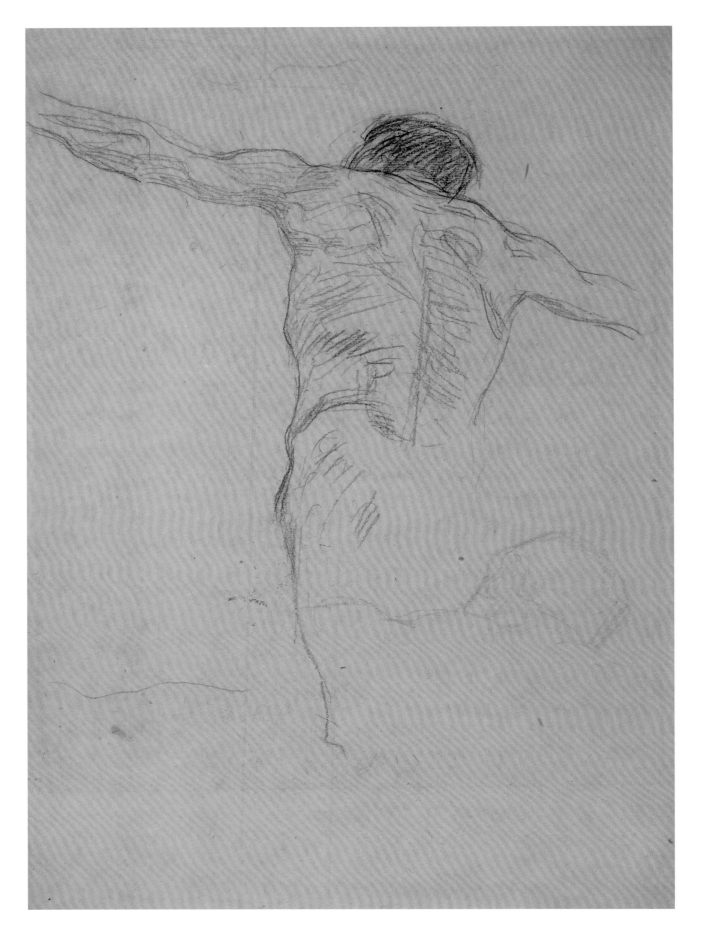

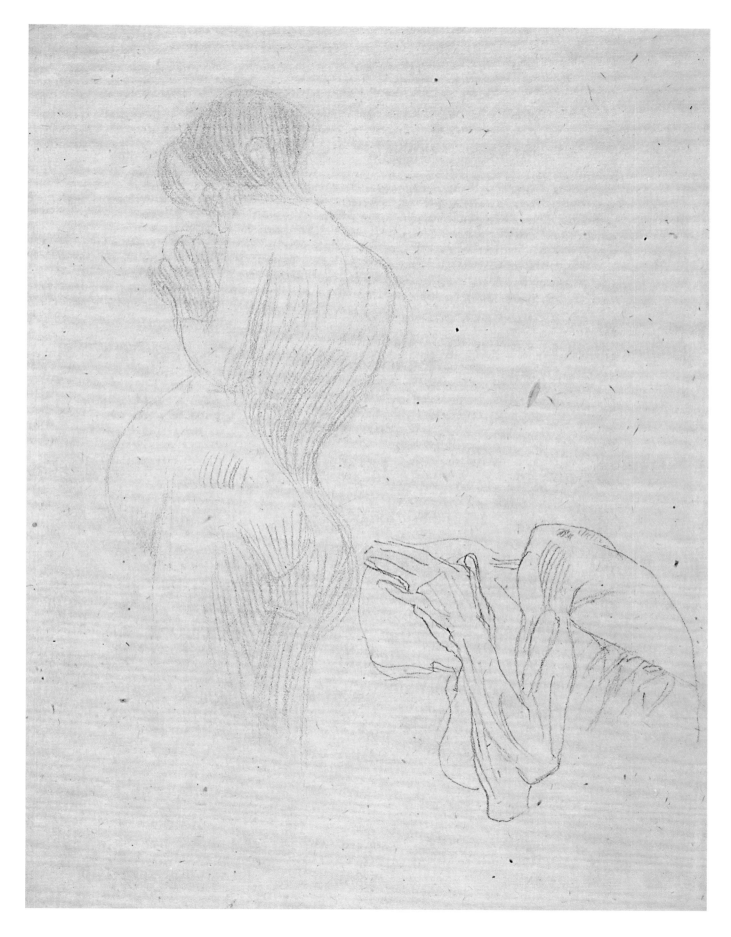

41

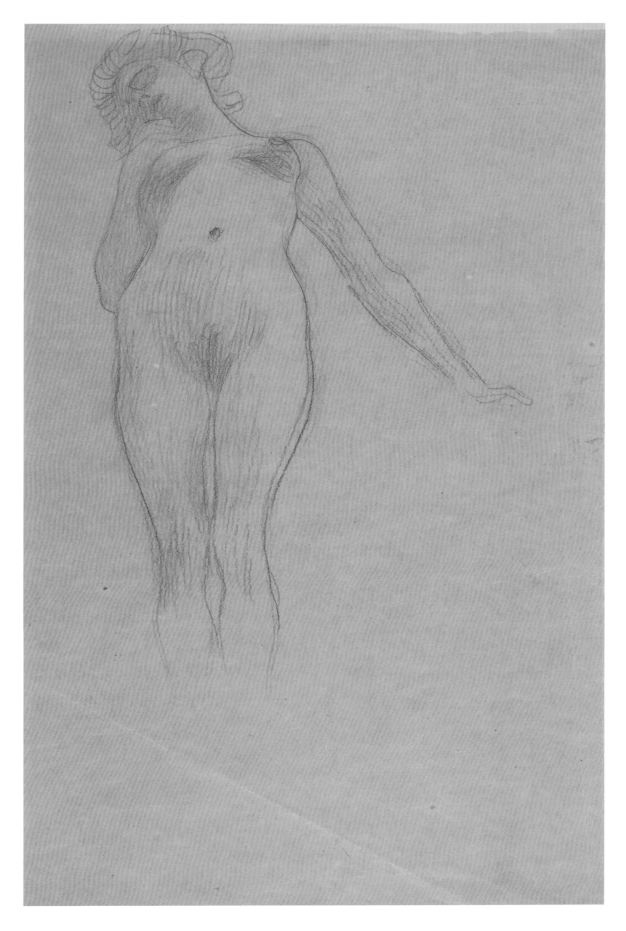

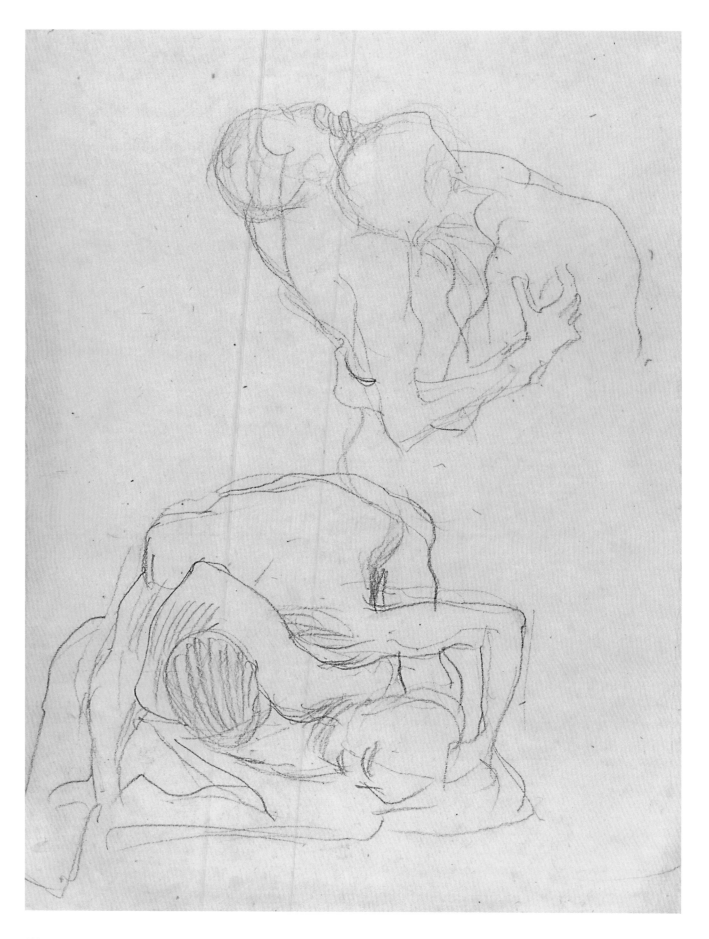

44

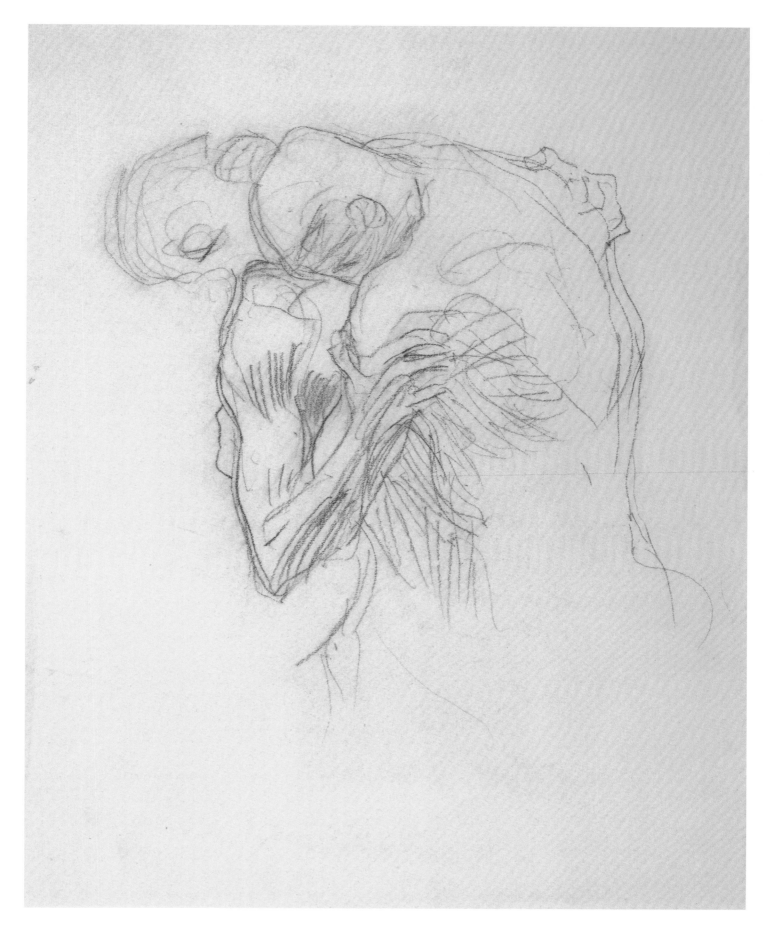

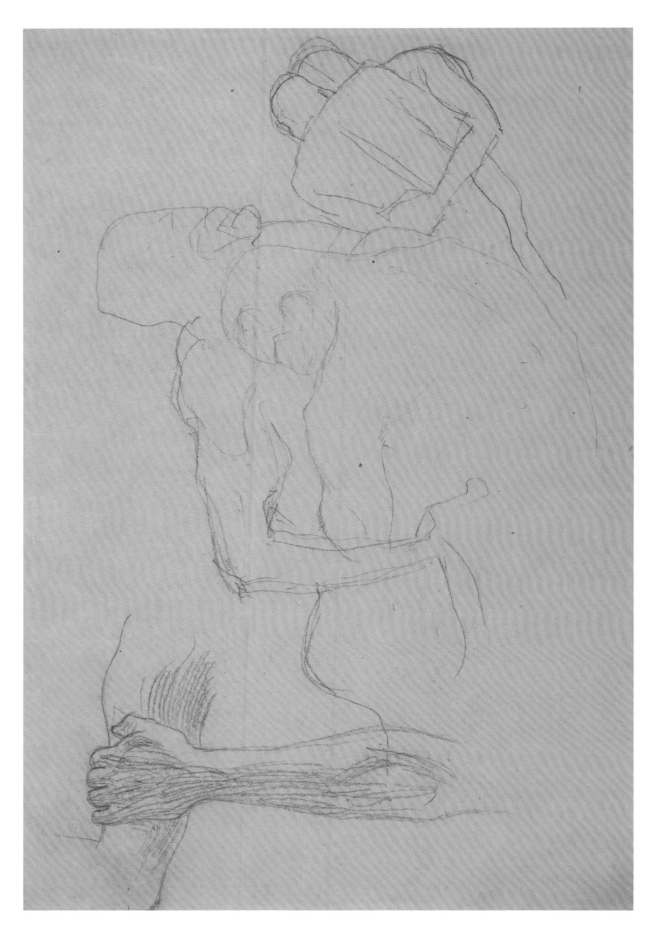

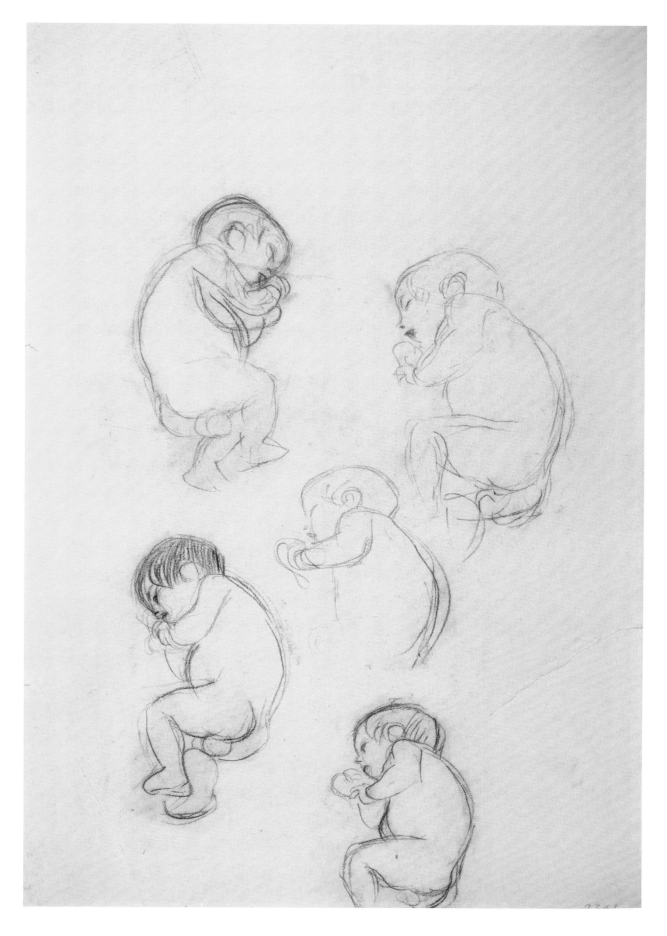

49

**Two Studies of a Seated Nude
with Long Hair, Seen from
Behind, 1901**
Studies for *Goldfish*

Black chalk and red pencil, 31.7 × 45.2 cm
The J. Paul Getty Museum, Los Angeles,
inv. 2009.57.2 | Strobl I, 862

Fig. 1 *Goldfish*, 1901–2, oil on canvas,
181 × 67 cm, Kunstmuseum Solothurn,
Dübi-Müller-Stiftung

Goldfish

In rhythmically curved outlines, Klimt cap-
tured the voluptuous, round forms of a seated
nude viewed from behind in two versions on
one sheet. These studies were produced in
the context of the life-sized painting *Goldfish*,
which was presented for the first time at the
thirteenth exhibition of the Vienna Secession
(February–March 1902; fig. 1).[1] In this mys-
terious underwater scene, the gleaming head
of a monstrous goldfish forms a striking con-
trast to the sensuous nakedness of the four
water nymphs, whose round bodies are sur-
rounded by flowing hair and aquatic plants
of stylized lines. The Viennese public took of-
fense at the provocative pose of the figure be-
low, seen from behind as she looks mockingly
over her shoulder; her ample behind seems
to burst open the canvas. Apparently Klimt
originally wanted to title the painting *To My
Critics*, as a response to the scathing commen-
taries on the bluntly realistic nudity of the fig-
ures in his faculty painting *Medicine*, which
had been presented at the Secession in spring
1901.[2]

The present sheet is a notable link between
the atmospheric spatiality of the figure studies
sketched for *Medicine* (cat. nos. 30–49) and
the emphasis on contour found in the draw-
ings for *The Beethoven Frieze*, which, according
to the latest research, were produced in sum-
mer 1901 (cat. nos. 51–63). In these two
versions of a figure seen from behind, Klimt
concentrated on the contour lines, but the
soft, powerfully accentuated curves still make
the physical features stand out sculpturally.
At the same time, Klimt underscored the
weightlessness of the models posing as aquatic
creatures by isolating them emphatically from
the completely empty surroundings. He him-
self regarded the right figure with flowing dark
hair as particularly significant: in 1902 he had
it reproduced in the Secession journal *Ver
Sacrum*. For the pose Klimt went back to a fe-
male figure on the lower edge of the faculty
painting *Medicine*, which he would later paint
over in the final version of 1907. In two stud-
ies for "Lust" in *The Beethoven Frieze*, the same
model, or a similar one, is presented from the
front (see cat. no. 59).[3] The outstretched arm
of the figure on the left is a preliminary form
of the allegory of the arts' horizontal gesture
leading into paradise, depicted frontally in
The Beethoven Frieze.[4]

[1] Dübi-Müller-Stiftung, Solothurn. Novotny and
 Dobai 1975, no. 124; Weidinger 2007, no. 152.
[2] Novotny and Dobai 1975, p. 324.
[3] Strobl I, 1980, nos. 812, 813.
[4] Ibid., p. 250.

51
Two Studies of a Reclining Draped Figure, 1901
Studies for "Longing for Happiness"
Black chalk, 31.8 × 45.6 cm
Albertina, Vienna, inv. 39320 | Strobl I, 750

52
Kneeling Male Nude with Outstretched Arms, 1901
Study for "The Sufferings of Weak Humanity"
Black chalk, 44.8 × 31.7 cm
Albertina, Vienna, inv. 39321 | Strobl I, 762

53
Woman with Hands Folded, 1901
Study for "Compassion"
Black chalk, 52.2 × 27.2 cm
Albertina, Vienna, inv. 39322 | Strobl I, 769

54
Standing Female Nude, 1901
Study for "The Three Gorgons"
Black chalk, 44.9 × 32 cm
Albertina, Vienna, inv. 39316 | Strobl I, 776

55
Standing Female Nude, 1901
Study for "The Three Gorgons"
Black chalk, 44.5 × 31.9 cm
Albertina, Vienna, inv. 39324 | Strobl I, 785

56
Standing Female Nude with Raised Right Leg, 1901
Study for "The Three Gorgons"
Black chalk, 44.5 × 31.9 cm
Albertina, Vienna, inv. 39317 | Strobl I, 806

57
The Three Gorgons (Two Composition Sketches), 1901
Graphite, 29.2 × 39.7 cm
Albertina, Vienna, inv. 39315 | Strobl I, 802

58
Portrait of a Woman in Three-Quarter Profile, 1901
Study for "Lasciviousness"
Black chalk, 45.1 × 31.1 cm
Albertina, Vienna, inv. 39323 | Strobl I, 810

Fig. 1. The left-hand room of the Beethoven exhibition, with Gustav Klimt's *Beethoven Frieze*, Viennese Secession, 1902

The Beethoven Frieze

None of the other groups of studies Klimt produced in connection with his paintings seems as homogeneous and harmoniously cohesive as the outstanding complex of drawings for *The Beethoven Frieze*.[1] These sheets are especially close to this major work, which was in turn inseparable from the epochal Beethoven exhibition (April–July 1902). With this temporary exhibition, a group of twenty-one Secession artists sought to demonstrate their ideal notions of a modern *Gesamtkunstwerk*, or "total work of art." In the center of this templelike interior designed by Josef Hoffmann, Max Klinger's sculpture of Beethoven stood like a religious object, an allegorical glorification of the composer as redeemer and liberator of humanity (fig. 1). The decorations of the exhibition were thus under the signs of struggle and overcoming, longing and redemption.[2] The colorful, diverse materiality of the figure of Beethoven inspired the Viennese artists to numerous experiments with "honest" materials; smooth, rectangular surfaces dominated Josef Hoffmann's purist exhibition architecture. The cosmic, timeless character of the main room intended for the Beethoven figure was set against the narrative element of the side rooms.

Gustav Klimt painted his *Beethoven Frieze* on three walls of the side room on the left, where the path through the exhibition began. He found his inspiration in ancient Greece, Mycenae, Byzantium, the early Middle Ages, and Japan as well as in contemporary artists,

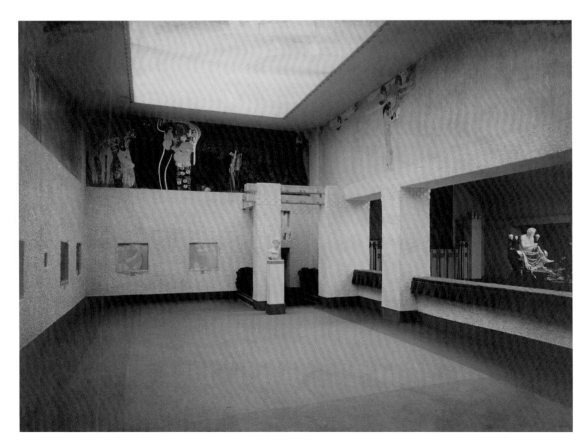

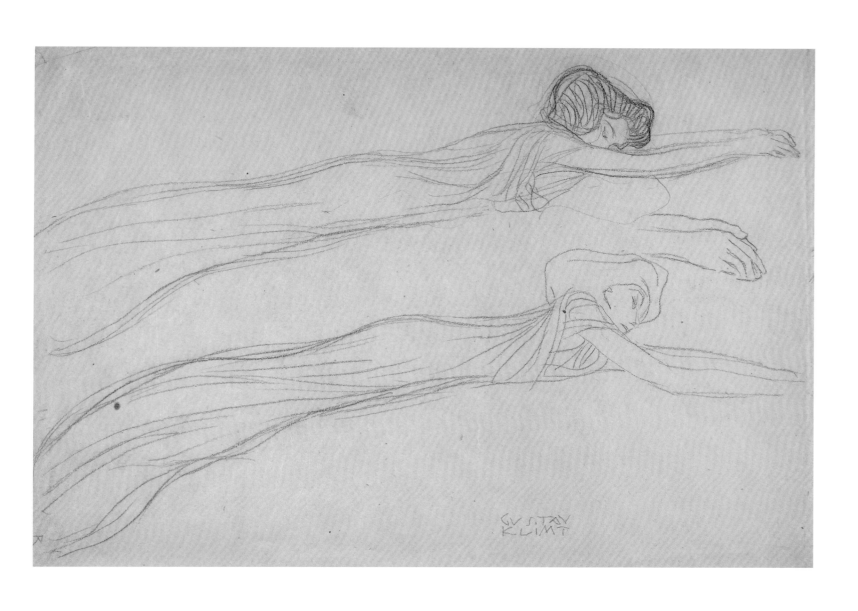

51

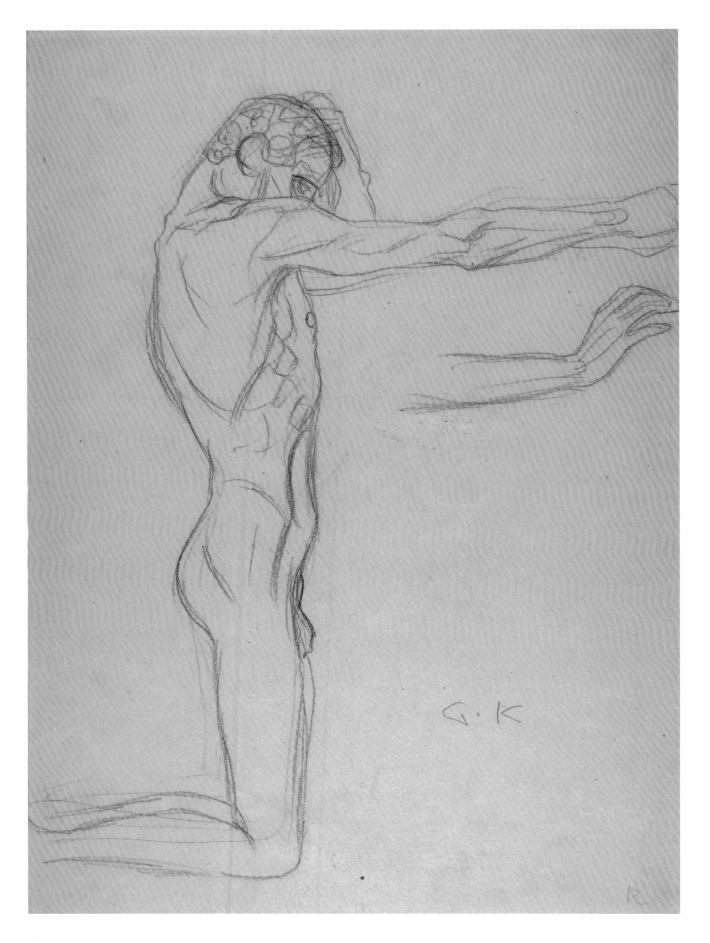

Fig. 2. Jan Toorop, illustration for W. G. van Nouhuys, *Egidius en de Vreemdeling* (Haarlem, 1899), lithograph, 14 x 21.8 cm, private collection

including Jan Toorop, Fernand Khnopff, George Minne, Ferdinand Hodler, Edvard Munch, and Axel Gallén-Kallela.[3] Klimt's self-confident approach to these diverse sources of inspiration led to the development of a completely new stylistic vocabulary. He emphasized the profile and frontal orientations of the figures, arranged parallel to the picture plane; he subordinated their poses and gestures to the main horizontal and vertical lines. He defined the contours using brushes, and at times charcoal, graphite, and pastel crayons; the main parts are only slightly colored, so that the light gray of the plaster serves as the primary color. The combination of flatly applied casein paints with gold leaf and appliqués result in an overall look of intense contrasts.[4]

The pictorial program is explained in brief sentences in the exhibition catalogue. The chain of floating genii—"Longing for Happiness"—links the individual scenes from the first wall to the first third of the last wall. At its beginning the "Knight in Full Armor," implored by suffering "Weak Humanity" and spurred on by "Compassion and Ambition," takes on the struggle for happiness. "Hostile Forces"—mentioned as "The Three Gorgons, Illness, Madness, Death, Lust, Lasciviousness,

Excess," and "Gnawing Grief"—darken the central short wall. On the final, bright wall, "Longing for Happiness" ultimately finds "Satiation in Poetry." Finally, the "Arts" lead us to the "ideal realm, the only place we can find pure joy, pure happiness, pure love. Chorus of the angels of paradise. This kiss to the entire world."[5] In essence, this monumental allegory of longing, courage, struggle, turning inward, and redemption is based on an explanation of the program of Beethoven's Ninth Symphony that Richard Wagner wrote for a lay audience in 1846.[6]

According to most recent research, these figure studies for *The Beethoven Frieze*, which until now have been dated 1901–2, were produced in summer 1901, immediately after the first plans for the exhibition had been developed.[7] Klimt must have produced this complicated overall concept in an astonishingly short period, since the system evident in *The Beethoven Frieze*—using contour lines in different degrees of stylization as a way of strikingly distinguishing the character of the figures

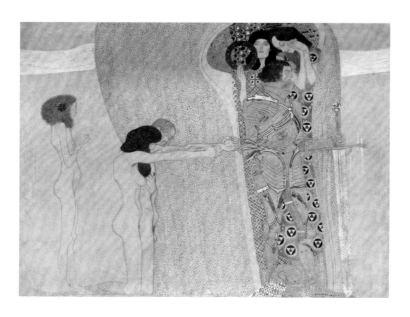

Fig. 3. "The Sufferings of Weak Humanity," "The Knight in Full Armor," behind which "Compassion and Ambition," *Beethoven Frieze*, 1901–2, mixed media (charcoal, chalks, casein paints, appliqué, etc.) on mortar, H 215 cm, Belvedere (Secession), Vienna

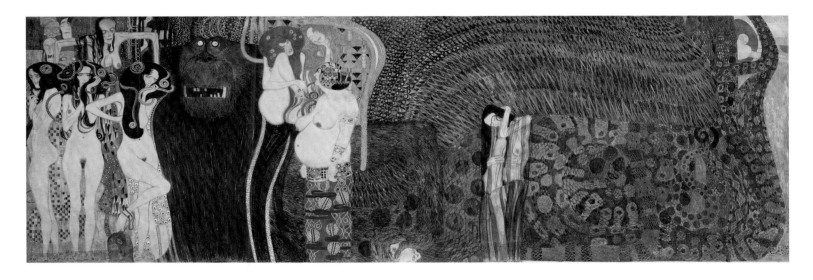

Fig. 4. "Hostile Forces": "The Three Gorgons,"
above which "Illness, Madness, and Death,"
"Typhoeus," "Lasciviousness, Lust, and Excess,"
"Gnawing Grief," *Beethoven Frieze*, 1901–2,
mixed media (charcoal, chalks, casein paints,
appliqué, etc.) on mortar, Belvedere (Seces-
sion), Vienna

from one another by their course, dynamic,
and direction—is already completely worked
out in the figure studies. With highly confident
contour lines in black chalk, Klimt subtly dif-
ferentiated the entire spectrum of personifica-
tions. The compelling linearity and balanced
planarity of these drawings leaves the impres-
sion that Klimt was already exploring on paper
the connection to the exhibition architecture,
which makes these studies an integral com-
ponent of the *Gesamtkunstwerk*. The group of
studies shown here conveys a representative
impression of the various sections of the alle-
gory.

The delicately flowing lines of the studies
for the rhythmically repeating, floating pair
of figures for "Longing for Happiness" corre-
sponds to the metaphysics of this part of the
program. An illustration by Jan Toorop was
apparently very helpful to Klimt in relation to
the strictly horizontal movement (fig. 2). The
independent way Klimt utilized the stylized
linearity of the motif of the dreamy woman in
a long garment floating is characteristic of his
way of thinking and working.[8] First he had

several models lying outstretched, posing in
equally long, delicately draped garments, just
as he did in the sheet exhibited here (cat. no.
51). In a linear language entirely his own, he
captured the wavy, flowing movement that is
made even more intense here by the duplica-
tion of the figure that fills the entire width.
Despite the stylization of the garments' lines,
the forms of the model's bodies remain palpa-
ble. In the painted version, Klimt moved much
closer to the linear abstraction of his inspira-
tion in Toorop: but there was no getting
around the internalization of the motif based
on studying a live model.

The figure of the gaunt kneeling man in
profile among "Weak Humanity" conveys an
impression of humility and asceticism with
his head bent forward and his arms out-
stretched horizontally (fig. 3). The powerful
outlines and the modeling in the preparatory
study point to a relatively high degree of real-
ism (cat. no. 52). The right angle of its posture
clearly reveals that this figure was inspired by
the kneeling boys in *The Fountain of the Kneel-
ing Boys* by the Belgian sculpture George

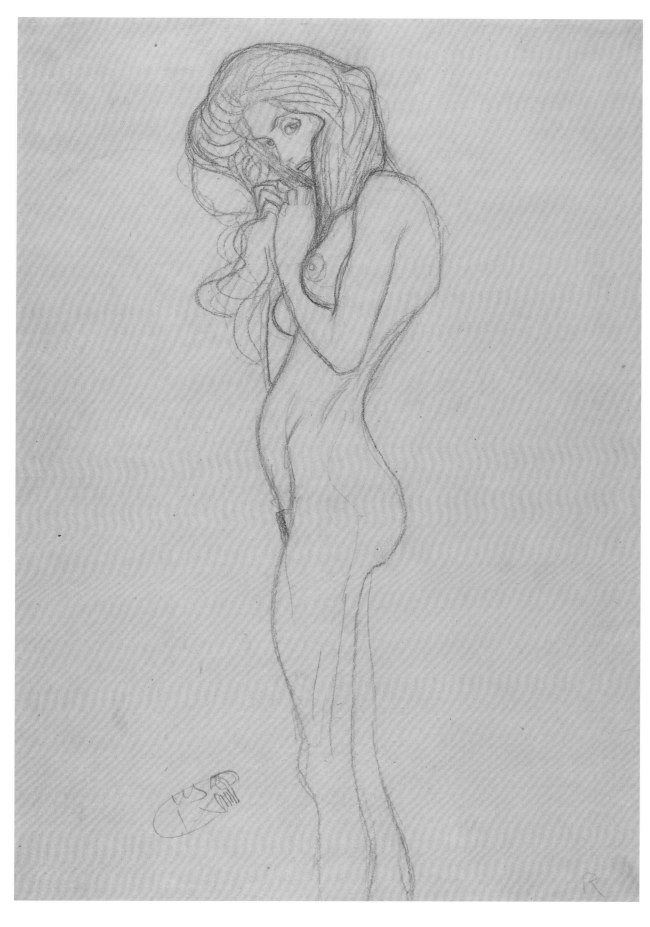

55

Fig. 5. "Longing for Happiness Finds Satiation in Poetry," *Beethoven Frieze*, 1901–2, mixed media (charcoal, chalks, casein paints, appliqué, etc.) on mortar, Belvedere (Secession), Vienna

Minne, which had recently been exhibited at the Secession.[9] The fact that the introverted figure of "Compassion" belongs to a very different, extrasensory level of meaning is immediately evident from the fragile contours of the preparatory study (cat. no. 53). The bowed head, the folded hands, and the crossed arms make it clear that Klimt was inspired by the religious side of Minne's modern "Gothic."[10]

Klimt dedicated numerous studies to the erotic, provocative group "The Three Gorgons," whose naked forms stand out on the frieze owing to the contours of their shoulders, elbows, hips, stomachs, and loins, which alternate between the sensuously flowing and the strikingly angular (fig. 4).[11] In an outstanding study, a slender, stylized standing female figure with dark, wild locks embodies the seductive type of the femme fatale; here the sensuously flowing lines dominate (cat. no. 54). The outlines of the gaunt nude with a hysterical expression are more angular; it is characterized by a tangled mass of bright hair and cramped gestures (cat. no. 55). Klimt employed simple, organically animated contour lines to prepare the female figure on the frieze who nestles up to the monster and breaches the orthogonal discipline with a zigzag movement of her sharp elbow and raised knee (cat.

no. 56). In two small, compositional sketches for this provocative group of three figures within rectangular frames, Klimt experimented vividly with the linear rhythm of the bodies' contours and the masses of hair, which alternate between light and dark. The staccato rhythm of the pubic areas, which is also emphasized in the frieze, strikes a playful note (cat. no. 57). The studies for the voluptuous, self-absorbed seated figure of "Lust" and the seductively gazing face of "Lasciviousness," whose undulating, flowing mass of hair points to the Symbolist linear art of Jan Toorop, which was of towering significance for *The Beethoven Frieze* (cat. nos. 58, 59).[12] The theme of grief is characterized by a sheet of sketches for a frontal kneeling figure bent over in pain, which in the transfer sketch is positioned between "Weak Humanity" and the "Knight in Full Armor"—and by the gaunt, crouched figure of "Gnawing Grief " (cat. no. 60, fig. 4).[13] The latter figure was clearly inspired by George Minne, and its radically angular gestures point ahead to Expressionism; on the sheet exhibited here, Klimt captured this figure in two black-and-white notes reduced to a plane.[14]

Two studies of figures, one dressed and one undressed, for the profile of "Poetry" demonstrate how intensely Klimt immersed himself

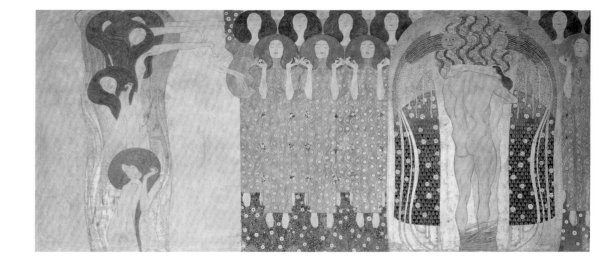

Fig. 6. "The Arts," "This Kiss to the Entire World," *Beethoven Frieze*, 1901–2, mixed media (charcoal, chalks, casein paints, appliqué, etc.) on mortar, Belvedere (Secession), Vienna

in the essence of his figures as expressed by their poses and gestures (fig. 5). The firm contours of this nude monumentally fixed to the surface of the paper are of archaic austerity; its angular, stylized gesture of playing music is particularly emphasized (cat. no. 61). For the figure dressed in a long gown, Klimt concentrated on the subtle interplay of fixed, angular lines and freely flowing ones, with the blank bright spaces of the bent arm subtly standing out (cat. no. 62). In both drawings, features such as the line of the neck bent forward, the withdrawn facial expression, and the falling hair point to a concentrated listening turned inward. Whereas the studies for "Poetry" suggest a spiritually heightened, modernized variation on a motif from a Greek vase, the drawing of the embracing couple of "Ideal Realm" is defined by a timeless nudity (cat. no. 63, fig. 6). Within this monumentally cohesive pair, Klimt differentiates between the

plasticity of the athletic, muscular tension of the man viewed from behind and the flat silhouette of the woman, who is largely concealed by her partner. The male-female dialogue between powerfully pulsating and softly flowing outlines is programmatic. Within the allegorical program, the erotically vital man, who finds supreme fulfillment in the ideal fusion of art and love, represents the highest level of reality. Nevertheless, like the other figures in the studies for *The Beethoven Frieze*, he lacks contact with the earth. The figures, most of which are depicted standing, are cut off above the feet by the edge of the sheet. This formula makes them appear monumentally anchored in the plane, while at the same time separating them from earthly reality. This tension-filled ambivalence between sensuous presence and metaphysics, between substance and shadow, would characterize Klimt's later figure studies as well.

1 Strobl I, 1980, nos. 741–859; Strobl IV, 1989, nos. 3444–67a.
2 Bisanz-Prakken 1977, 9–30; Bisanz-Prakken 1985.
3 On these influences, see Bisanz-Prakken 2007.
4 For essential discussions of the technique, see Koller 1978–79; Koller 2006.
5 *Klinger, Beethoven: XIV. Kunstausstellung der Vereinigung Bildender Künstler Österreichs Secession* (Vienna, 1902), pp. 3–4.
6 First noted in Bisanz-Prakken 1977, pp. 32–34.
7 For this information I am grateful to Hansjörg Krug, who will be publishing his findings in the near future.
8 Jan Toorop, illustration in W. G. van Nouhuys, *Egidius en de Vreemdeling* (Haarlem, 1899), opposite p. 9. See Marian Bisanz-Prakken, in Exh. cat. The Hague 2006–7, pp. 165–66, 172.
9 Marian Bisanz-Prakken, in Exh. cat. The Hague 2006–7, pp. 172–73.
10 Ibid., p. 173.
11 These figures are an erotically transformed version of the three small nudes in the drawing *Sphinx* (1893) by Jan Toorop. See Marian Bisanz-Prakken, in Exh. cat. The Hague 2006–7, pp. 168–69.
12 On this influence in general, see Exh. cat. The Hague 2006–7. This chronology of the events will, however, need to be reconsidered in light of the findings to be published by Hansjörg Krug (see note 7).
13 The transfer sketch is illustrated in Weidinger 2007, p. 121. According to the most recent research (see note 7), Klimt produced the transfer sketch in Litzlberg am Attersee in August 1901.
14 On the inspiration of George Minne in general, see Marian Bisanz-Prakken, in Exh. cat. The Hague 2006–7, pp. 189–210; with specific reference to "Gnawing Grief," among other works, see Bisanz-Prakken 1995, p. 177.

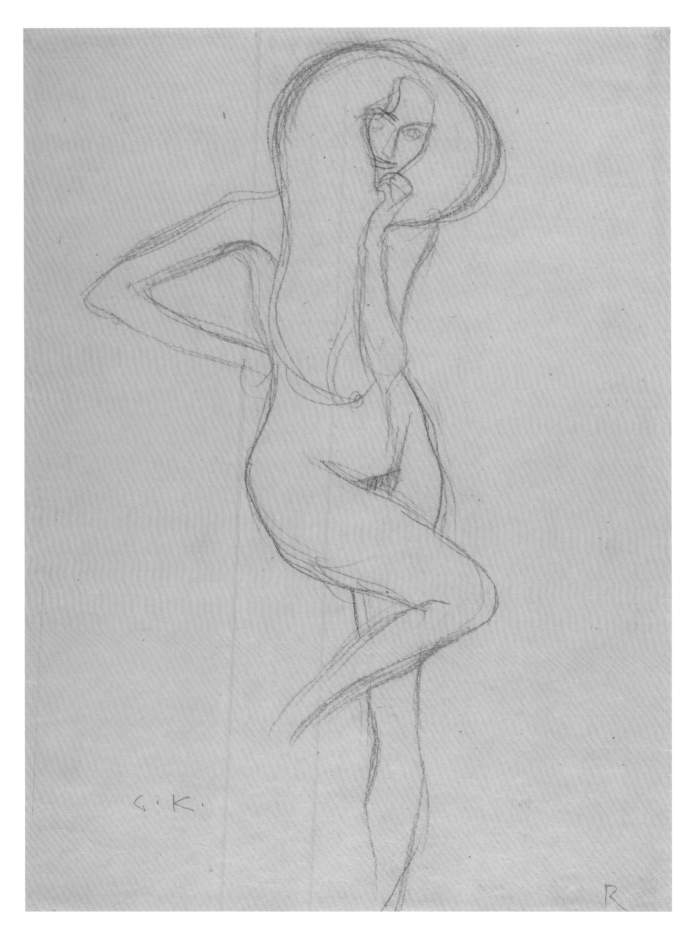

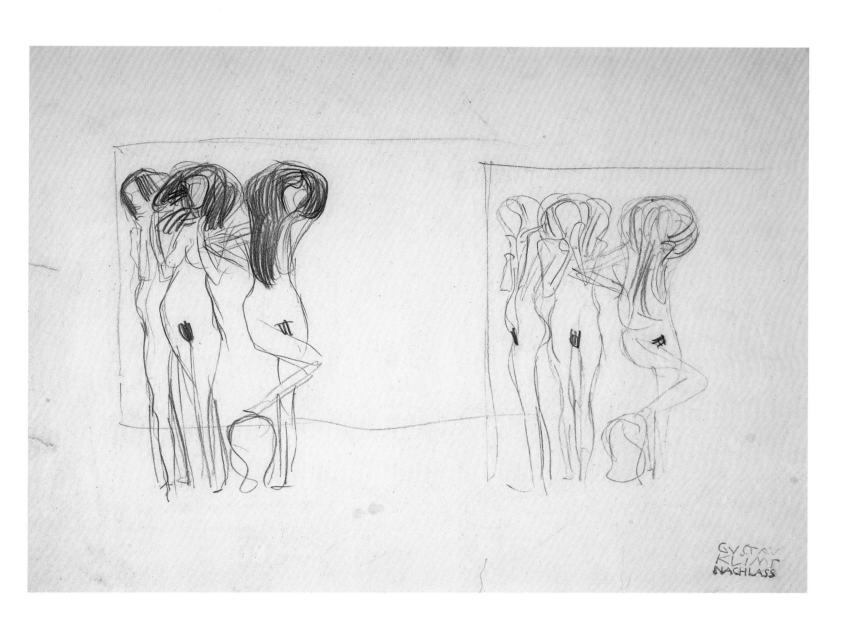

57

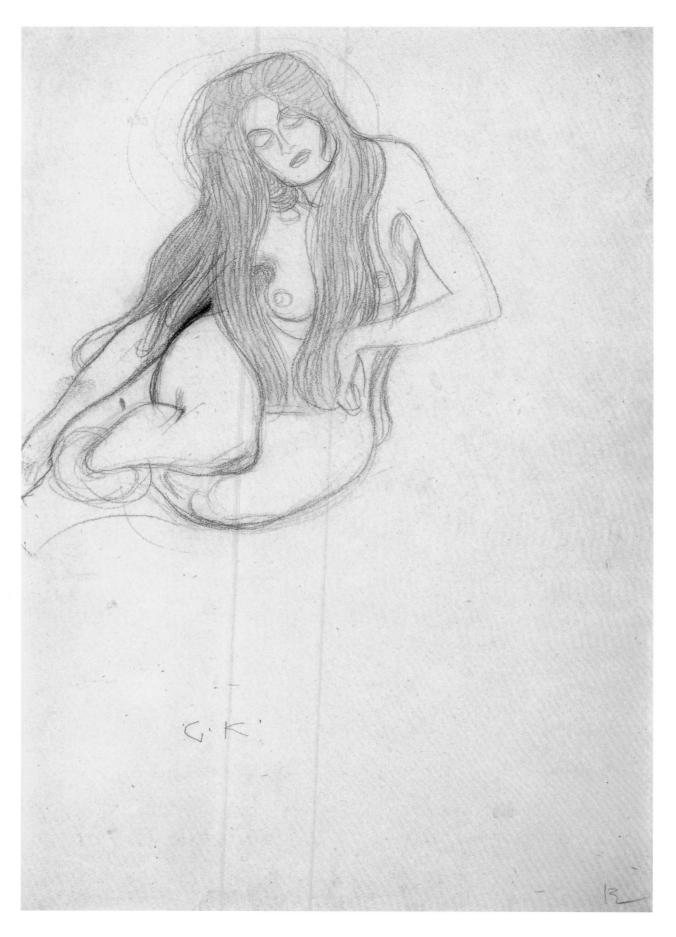

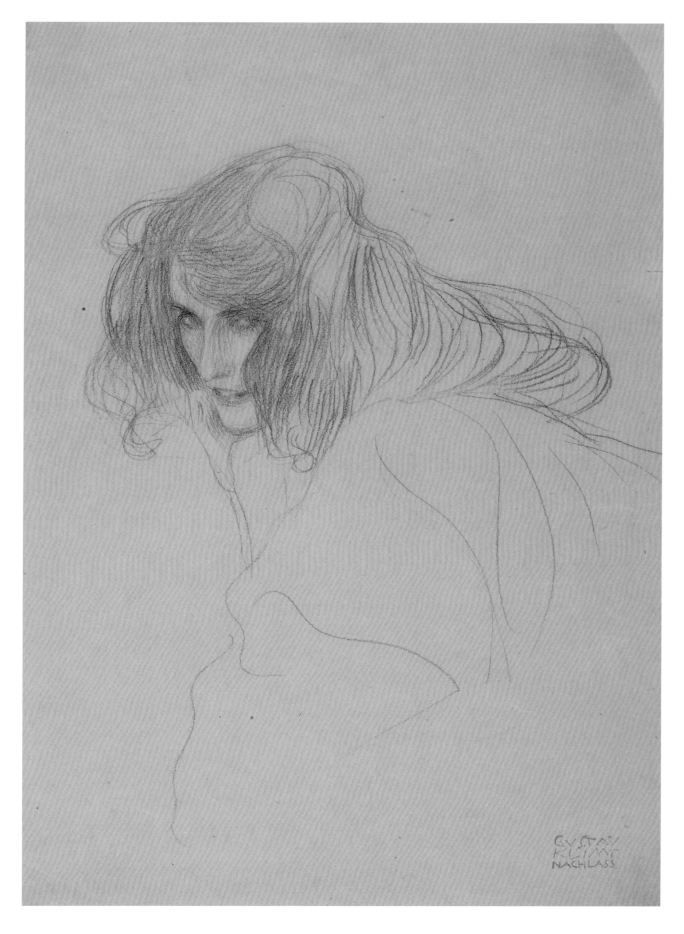

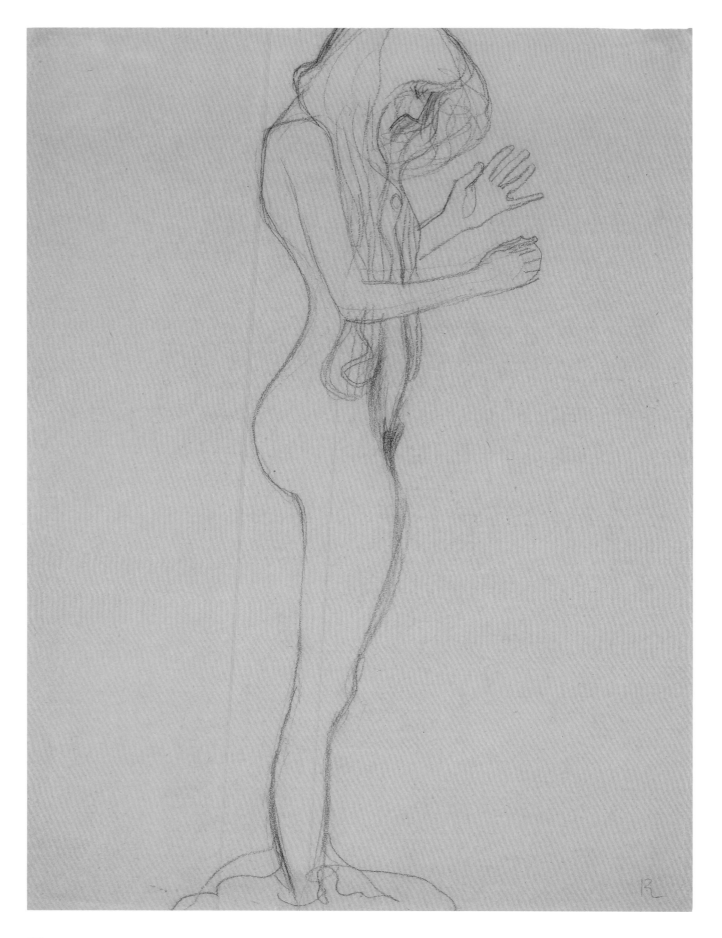

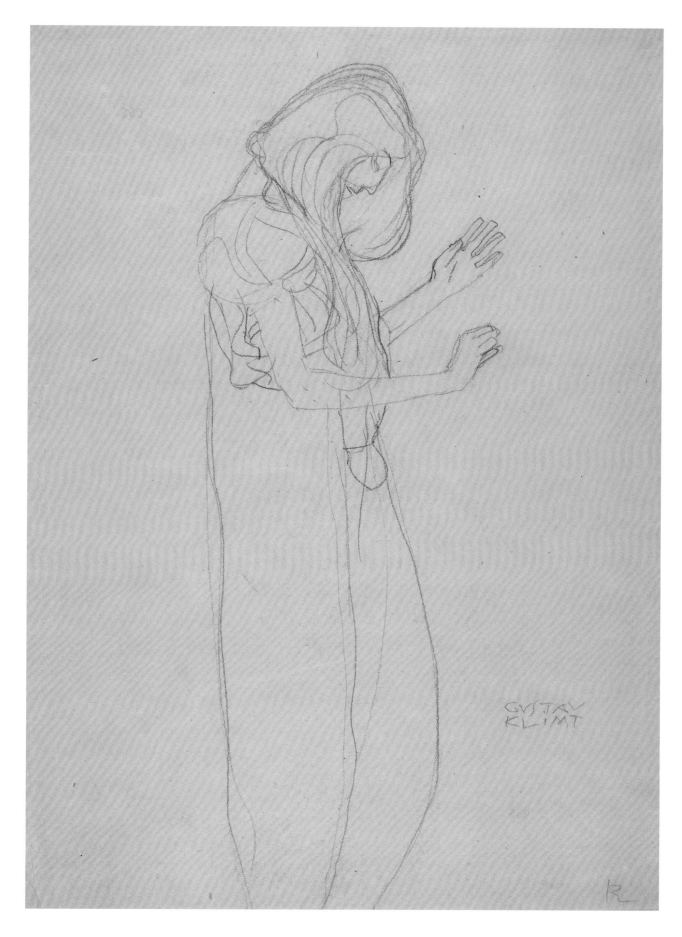

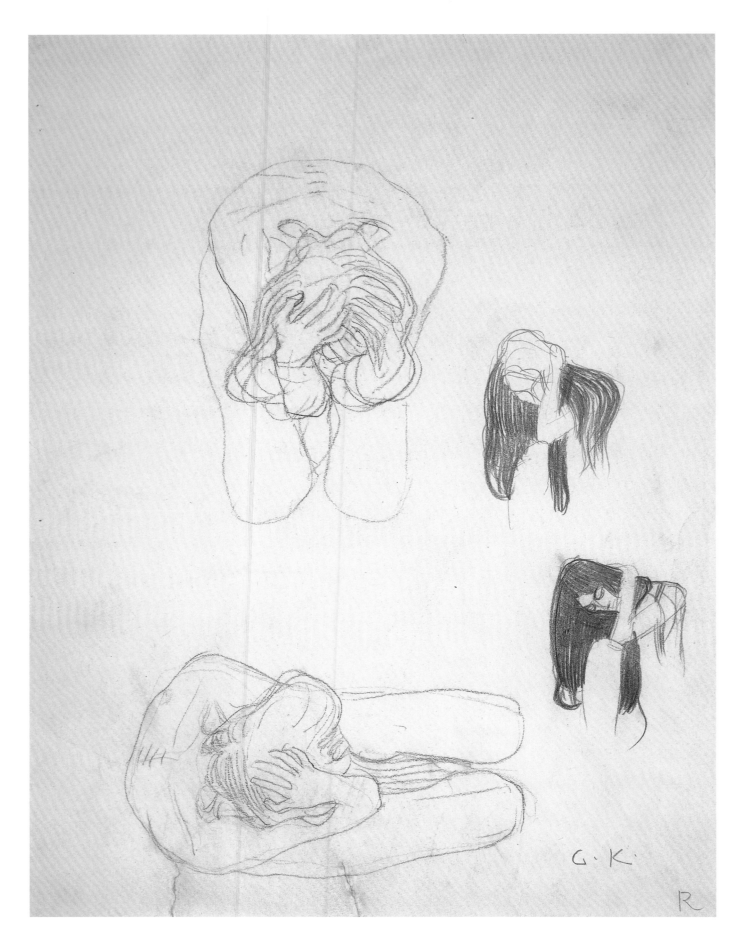

G. K.

R

60

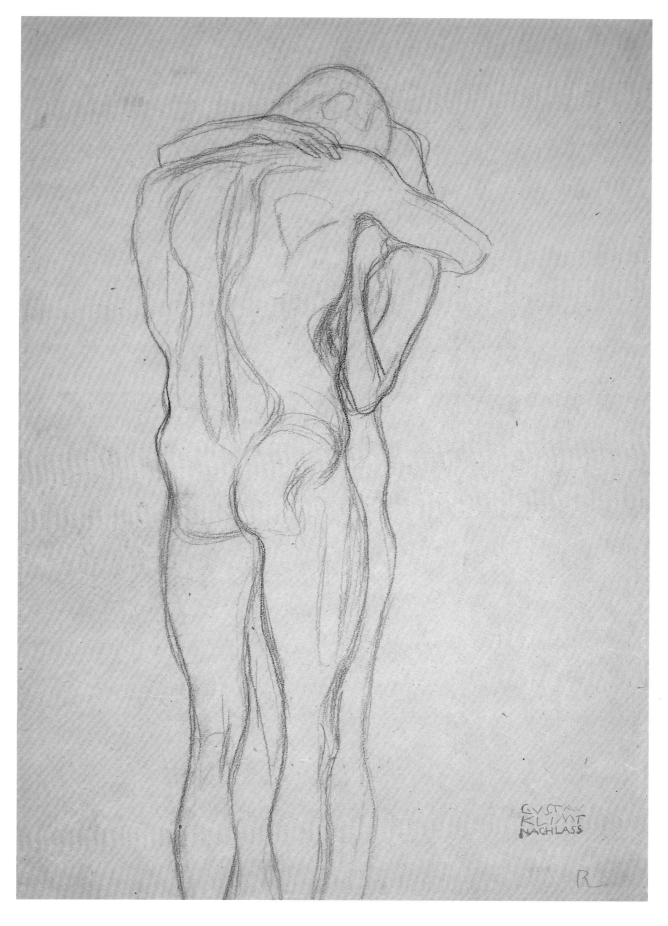

The Faculty Paintings: *Jurisprudence*

In the large Klimt retrospective that opened at the Secession in November 1903, the three faculty paintings created for the university auditorium could be seen together for the first time: *Philosophy* and *Medicine*, which had been exhibited previously in 1900 and 1901, respectively (fig. 3 on p. 78; fig. 2 on p. 86), and the still unfinished *Jurisprudence* (fig. 1).[1] Whereas Ludwig Hevesi characterized *Philosophy* as a "mystical symphony in green" and *Medicine* as a "roaring overture in red," he wrote of the third painting: "*Jurisprudence* is dominated by black and gold, which are not

Fig. 1. *Jurisprudence*, 1903, oil on canvas, 430 × 300 cm, burned in 1945

proper colors, but the line is elevated to a significance that must be called monumental."[2] A return to illusionism and to the atmospheric effects of the first two faculty paintings had become inconceivable after the crucial experience of his work on *The Beethoven Frieze* (see cat. nos. 51–63). In *Jurisprudence*, the oversized main figures loom with a succinct acuity out of their gloomy, infernal surroundings. Three extremely gaunt, linearly stylized goddesses of revenge, or Erinyes—monumental caricatures of the "Three Gorgons" in *The Beethoven Frieze*—rise over the doubled-over naked figure of the "Sinner," who is viewed from behind and helplessly exposed to the powers of fate. Klimt prepared countless studies for his figures: "Study drawings were scattered on the floor, several for each figure, with variations on the positions, poses, movements," as Ludwig Hevesi reported of a visit to the artist when working on this painting.[3] The present portrait drawing was produced for the Erinye on the left, who is nestling her outstretched, folded hands against her inclined, sleeping face (cat. no. 64). The regular, thin, almost brittle lines of black chalk with which Klimt sketched the contours of the sunken cheeks and the geometrically stylized hands are far removed from the curving contours of the studies for *The Beethoven Frieze*. The hair in its linear articulation seems almost like a woodcut. The brooding, melancholy facial expression is essentially characterized by the slanted slits of the eyes beneath drooping lids. The sculptures and graphic works of George Minne were of profound significance for the emphatically angular gestures and the expression of mourning. Since *The Beethoven Frieze* (esp. cat. nos. 52, 53), Klimt had been

grappling with the modern "Gothic" of the Belgian artist—who several years later would have a crucial influence on the early Expressionism of Oskar Kokoschka and Egon Schiele—with increasing intensity.[4]

Stylistically and thematically close to the studies for *Jurisprudence* is this completely autonomous drawing of a frontally viewed woman perched cross-legged, who fixes a provocative gaze on the viewer: a variation on the central goddess of revenge who belongs to the real world but is no less memorable for that (cat. no. 65). The magnetic effect of this study derives not only from the hypnotizing pair of eyes but also from the strictly symmetrical structure. The dark silhouette of undergarments and stockings, curving outward on both sides, is delimited by the side edges; the lower point where the hands and feet meet is also the nodal point for the radially converging contour lines of the arms and legs. The angularly marked straps for the white outer garment provide a particular accent. The exacting restriction to the plane reveals how Klimt worked intensely to come to terms with the new ideals of the "art of space" (*Raumkunst*) in his drawings—especially since *The Beethoven Frieze*. The artist's characteristic tension between sensuous immediacy and higher order, between organic life and abstraction, is manifested with particular clarity in this drawing. The subtly handled contours cause the shoulders and the V-shape arrangement of the arms to stand out brightly and almost three-dimensionally. The impression that the face is protruding slightly results from the strong accents on the contour of the chin. The smiling mouth, defined by a few brief strokes, and the eyes oscillating beneath heavy brows are particularly lively. The motif of a frontal view of a crouching female figure with a penetrating gaze appears here for the first time; Klimt would take it up again in a series of studies around 1909–10.[5]

[1] *Jurisprudence*, 1903–7, oil on canvas, 430 × 300 cm, destroyed by fire in 1945. Novotny and Dobai 1975, no. 128; Weidinger 2007, no. 166.
[2] Hevesi 1906, p. 448.
[3] Ibid., p. 444.
[4] Exh. cat. The Hague 2006–7, pp. 183–210.
[5] Strobl II, 1982, nos. 1941–52.

**Two Standing Girls, Holding
Sheets in Their Hands, 1897–98**
Study for *Schubert at the Piano*

Black chalk, 44.9 × 31 cm
Albertina, Vienna, inv. 39058 | Strobl I, 309

Schubert at the Piano

Fig. 1. *Schubert at the Piano*, 1899, oil on canvas, 150 x 200 cm,
burned in 1945

In 1893 the patron of the arts Nikolaus Dumba commissioned Gustav Klimt and Franz Matsch to design the architectural and painted decorations for two rooms of his palace on the Parkring. Matsch was assigned the dining room and Klimt the adjacent music salon.[1]

The studies for the interior decoration and the paintings in the music salon, completed in 1900, that are known today are from different phases of the preparations.[2] The present drawing shows two young women standing, each holding a sheet. This motif is clearly connected to *Schubert at the Piano*, both the small oil sketch painted in 1896 and the two-meter-wide overdoor painting completed in 1899 (fig. 1).[3] Both versions show a candlelit interior in which the composer is depicted from the side as he plays piano, surrounded by standing female figures. Only in the final version did Klimt give the piano player Franz Schubert's facial features. The theme was probably inspired by Nikolaus Dumba, who was a great admirer of the Viennese composer.[4] As a Symbolist artist, Klimt did not fulfill his commission in the spirit of a historically accurate genre scene. His primary medium was light,

which plays about the static, self-absorbed figures and mysteriously connects them—in the oil sketch by means of Impressionistically loose brushwork; in the finished painting, with a wealth of glittering pointillist structures.

In the study exhibited here of two models not dressed in historical clothing—the women in the painting are wearing imagined garments reminiscent of the clothing styles of Schubert's day—Klimt also came to terms with the light. He emphasized the kindred means of chiaroscuro. With dense concentrations of vertical lines, whose curved parallel course is interrupted in places, he fused the silhouettes of the two figures standing one behind the other, as if emerging ex nihilo. This continuous, compelling rhythm of lines also incorporates the bent arm of the figure in front and continues up to the hairdos of the two women. The skirt of the figure in the foreground is a bright void, as is her left hand and part of the sheet she is holding, which in the finished painting shines forth from the darkness as a striking angular form. One actively involved element of the drawing is the negative space that stands out like an island between the two touching contours of their shoulders and heads. This generously summarizing, planar depiction characterizes Klimt's drawing style during the period the Secession was founded in 1897–98.[5] This sheet was thus in all probability produced following the oil sketch during the preparations for the large painting.[6] Using purely linear means, the artist internalizes the mood and essence of his figures and thus goes far beyond the purely purpose-oriented function of the studies.

[1] On Nikolaus Dumba, see Konecny 1986. On the Dumba music salon, see Nebehay 1969, pp. 170–78; Natter 2003, pp. 22–26.
[2] Strobl I, 1980, nos. 300–20; Strobl IV, 1989, nos. 3296–3304.
[3] *Schubert at the Piano* (oil sketch): 1896, oil on canvas, 30 × 39 cm, private collection. Novotny and Dobai 1975, no. 100; Weidinger 2007, no. 95; *Schubert at the Piano*, 1899, oil on canvas, 150 × 200 cm, destroyed by fire in 1945. Novotny and Dobai 1975, no. 101; Weidinger 2007, no. 130.
[4] His large Schubert collection included the watercolor *The Parlor Game of the Schubertians in Atzgenbrugg* (1821) by Leopold Kupelwieser. See Novotny and Dobai 1975, p. 11.
[5] See, for example, Strobl I, 1980, nos. 355 and 382.
[6] Alice Strobl leaves open the question whether this study and the associated one (Strobl I, 1980, nos. 309, 310) were produced for the oil sketch or the large painting.

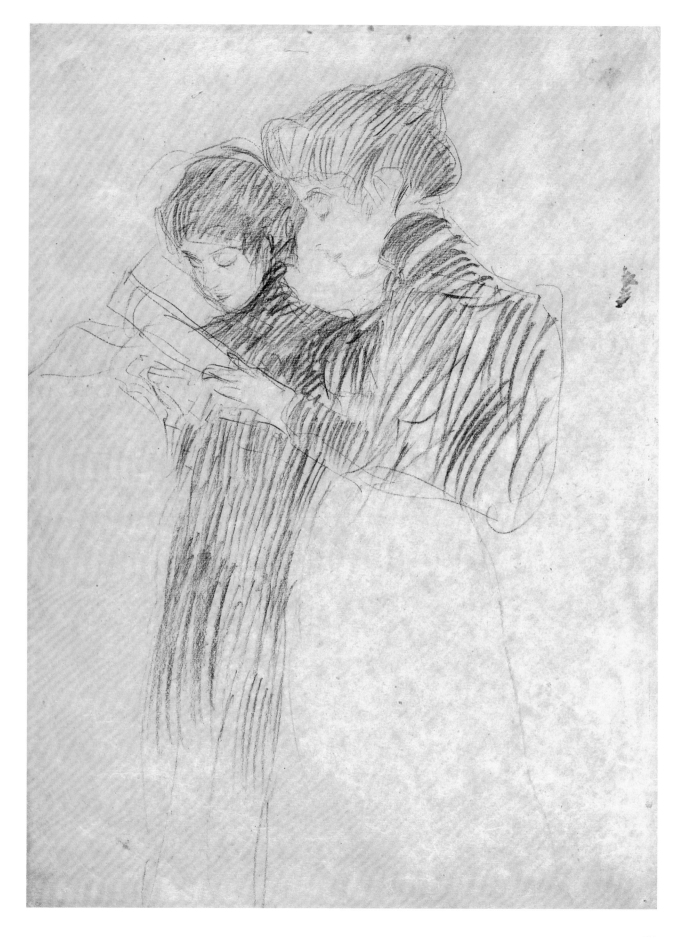

**Woman Sitting in an Armchair,
1897–98**
Study for *Sonja Knips*
Black chalk, 32 × 45.2 cm
Albertina, Vienna, inv. 34933 | Strobl I, 420

Portrait *Sonja Knips*

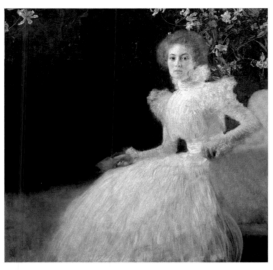

Fig. 1. *Sonja Knips*, 1898, oil on canvas, 145 × 146 cm, Belvedere, Vienna

In the first exhibition presented by the Secession in November 1898 in its new building, Klimt showed his recently completed portrait of twenty-three-year-old Sonja Knips, née Freifrau Potier des Echelles (fig. 1).[1] This wealthy young aristocratic lady had made Klimt's acquaintance early on and had been especially helpful to the modern endeavors of the Secession from the outset. Her portrait, executed in the well-balanced square format that signals Viennese modernism, was Klimt's first portrait painting in the new style. Elements of *Japonisme* and Impressionism were just as influential here as works by the English Pre-Raphaelites, the Belgian Symbolist Fernand Khnopff, and the American James Abbott McNeill Whistler. These diverse sources of inspiration led to a highly personal synthesis: this brilliantly painted work presents itself as a mysterious mix of acute and diffuse forms.[2]

The turn Klimt's approach took in the context of the preparatory studies was no less revolutionary and consequential. His innovation

was working in series on sheets of packing paper cut to the same size; he would use this paper until 1903–4.[3] With subtly handled black—and occasionally blue—chalk, Klimt got to the essence of the woman to be depicted, trying to summarize the different poses in the overall appearance on sheet after sheet. The horizontal study exhibited here is relatively close to the position chosen for the painting. Of particular significance is the new function of the "animated" contour lines with which Klimt tried to capture the essence of a pose, a gesture, or a gaze. Here he accentuated especially the fingers clutching the arm of the chair. The chiaroscuro values are also brought out: the line of the chin, supported by the ruff, stands out most powerfully. With energetically flowing lines, he fixes the figure in the plane and cuts off the chair and skirt with the edges of the image, thus creating the dialectic of proximity and distance characteristic of his work: the figure presented is tangibly close and yet is separated from the viewer. The depiction of fashionable clothing plays a big role in the study drawings; in the portrait commissions executed subsequently, the clothing would harmonize with the essence of the sitters.

The painting *Sonja Knips* marked the beginning of Klimt's evolution into a painter of women from the circles of wealthy friends and patrons of the Viennese avant-garde. In all phases of his development, Klimt would remain faithful to the drawing method he developed in the context of *Sonja Knips*. Every study was produced in a cohesive working process and combines the spontaneously seen with the eternally valid.[4]

[1] *Sonja Knips*, 1898, oil on canvas, 145 × 146 cm, Belvedere, Vienna. Novotny and Dobai 1975, no. 91; Weidinger 2007, no. 126.
[2] On Gustav Klimt's relationship to Sonja Knips, see Von Miller 2004.
[3] The format was about 45 × 31.5 cm, resulting from tearing a sheet of packing paper into four pieces. He used these sheets of packing paper between 1897 and around 1903–4; see Strobl IV, 1989, p. 211.
[4] Bisanz-Prakken 2000–2001.

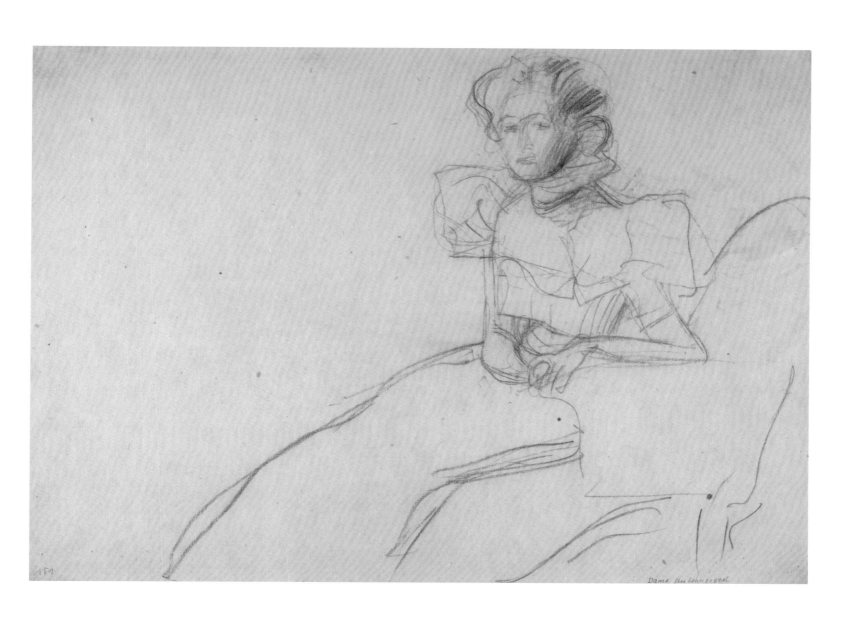

Dame im Lehnsessel

Portrait *Serena Lederer*

A year after completing his first modern portrait painting, *Sonja Knips* (1898, fig. 1 on p. 132), Klimt produced his portrait of Serena Lederer, née Pulitzer (1867–1943, fig. 1).[1] The sitter and her spouse, the major industrialist August Lederer (1867–1936), were two of the artist's most important friends and patrons.[2] In this painting composed of the most delicate nuances of white, which is often compared to the portraits of women by James Abbott McNeill Whistler referred to as his *Symphonies in White*, the main accent falls on the expressive face of the dark-haired beauty.

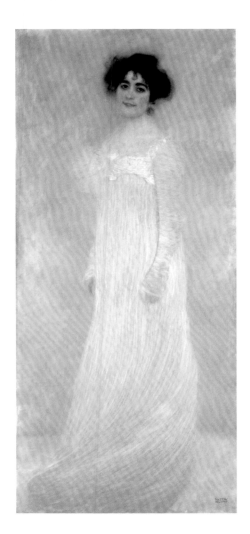

Fig. 1. *Serena Lederer*, 1899, oil on canvas, 190.8 × 85.4 cm, Metropolitan Museum of Art, New York

The delicate folds of her loosely draped reform dress swing forward like a nuanced, bluish-white wave and are cut off by the lower edge of the canvas, making the figure, which is already almost absorbed by the broken white of its surroundings, seem even more enthralled.

During the phase of work on the preparatory drawings, Klimt grappled intensively with the metaphysics of endless flow, as is clear from the fourteen known studies for the painting found, nine of which are held in the Albertina (cat. nos. 68–76).[3] In all these sheets, the young woman standing upright is wearing the flowing, delicately pleated dress that she also wears in the painting. Klimt was following a formula he would often employ subsequently: he allowed the standing figure to take up the full length of the paper in such a way that, at least in most cases, it is cut off at the top and bottom. This trick results in an ambiguous effect in which the figure in question is anchored in the plane while at the same time seeming to float in a vacuum.[4] The studies for *Serena Lederer* are dominated by a tension-filled dialogue between the vertical sweep of very thin, parallel flowing lines and the rectangular paper. The focus is on the weightlessness of the figure, whose physiognomy is only cursorily indicated. Within the constants of the liltingly outlined central figure flanked by two empty spaces, he searched for the optimal position, the most effective sweep of the drapery, and the appropriate gestures. In chronological sequence, the Albertina's nine sheets resemble the frames of a film in which a whole spectrum of body and arm positions, variously accented stances, and changing flows of lines unfold. A compelling linear rhythm runs through the whole group, only occasion-

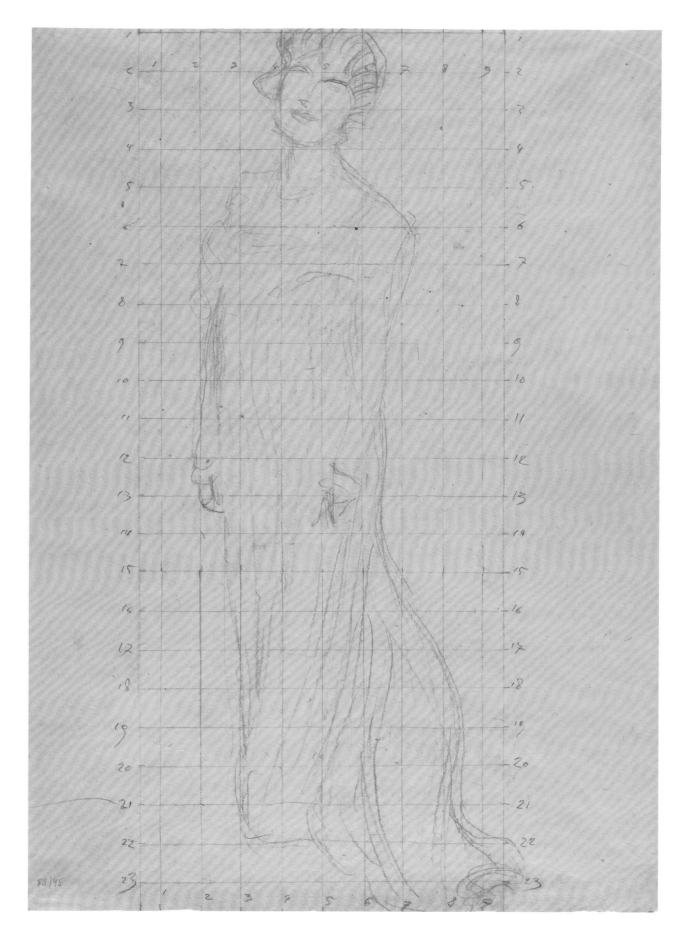

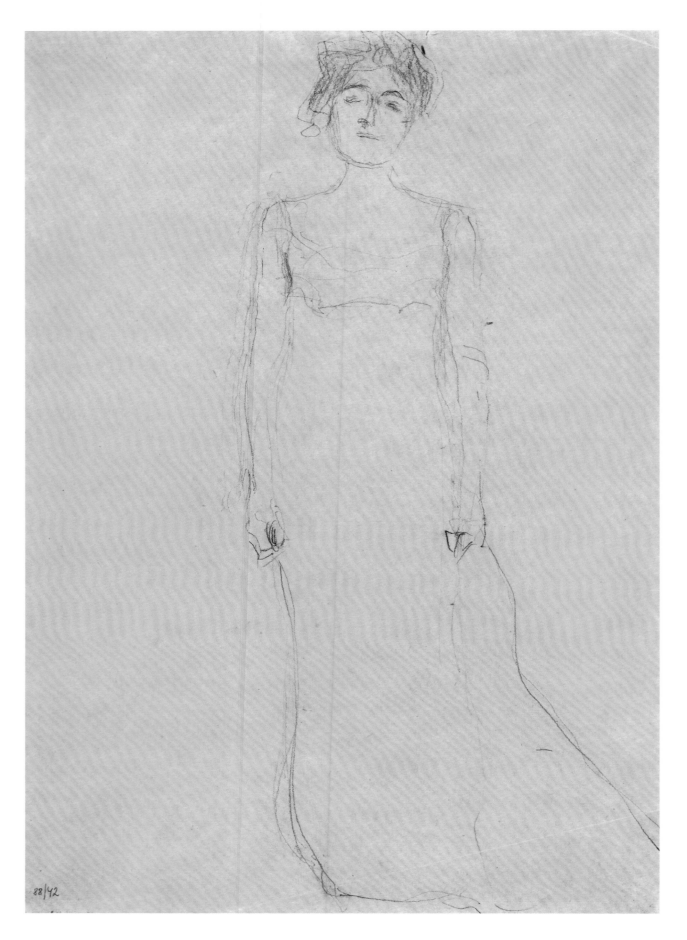

88/42

ally slightly interrupted, as on the sheet where the sitter is depicted from the side, leaning on a simple chair, which provides a stable counterweight to the slightly diagonally flowing movement (cat. no. 71). In three of the studies, the outward curvature of the delicate pleats visible at bottom right was clearly produced by positioning an object under the dress (cat. nos. 74–76). The drawing with an enlarging grid (cat. no. 68) differs slightly from the others in the series and does not yet correspond to the ultimate solution.

Klimt's use of parallel lines in paintings and drawings in order to suggest higher spheres should be seen in the context of the influence on him of the Symbolist linear art of Jan Toorop, which grew stronger toward the end of 1898. The principle of waves of lines running parallel to the picture plane employed by this artist—in *Sphinx* (1892–97), for example—plays an essential role in Klimt's paintings *Moving Water* (1898, fig. 1 on p. 62), *Nuda Veritas* (1899, fig. 1 on p. 72), and *Philosophy* (1900, fig. 3 on p. 78). The painting *Serena Lederer* and the preparatory drawings for it illustrate memorably how individualistically Klimt internalized this linear flow and integrated it into his work.[5]

74
Woman Standing Facing Front, with Both Hands on Her Waist, 1898–99
Study for *Serena Lederer*
Black chalk, 44.4 × 31.6 cm
Albertina, Vienna, inv. 35168 | Strobl I, 452

75
Woman Standing Facing Slightly Left, with Right Arm Akimbo, 1898–99
Study for *Serena Lederer*
Black chalk, 44.8 × 31.4 cm
Albertina, Vienna, inv. 35169 | Strobl I, 453

76
Woman Standing Facing Slightly Left, with Arms Dangling, 1898–99
Study for *Serena Lederer*
Black chalk, 44.1 × 30.9 cm
Albertina, Vienna, inv. 35172 | Strobl I, 454

[1] *Serena Pulitzer Lederer*, 1899, oil on canvas, 190.8 × 85.4 cm, Metropolitan Museum of Art, New York. Novotny and Dobai 1975, no. 103; Weidinger 2007, no. 134.
[2] On the subject of Gustav Klimt and the Lederer family, see Nebehay 1987, pp. 11–33.
[3] For all the studies for *Serena Lederer*, see Strobl I, 1980, nos. 442–54.
[4] Bisanz-Prakken 2000–2001, p. 199.
[5] On these themes, particularly as they relate to *Serena Lederer*, see Marian Bisanz-Prakken, in Exh. cat. The Hague 2006–7, p. 130.

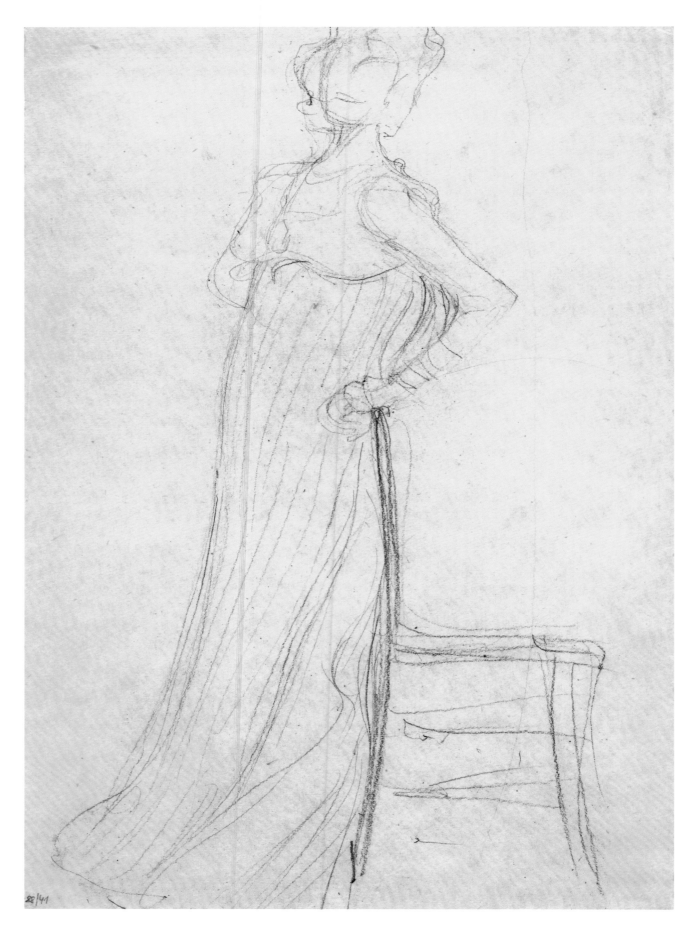

88/41

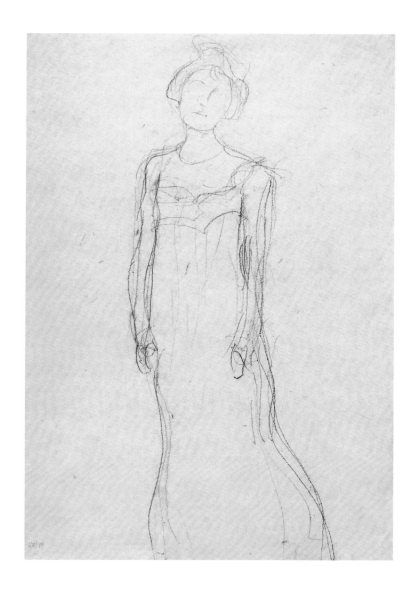
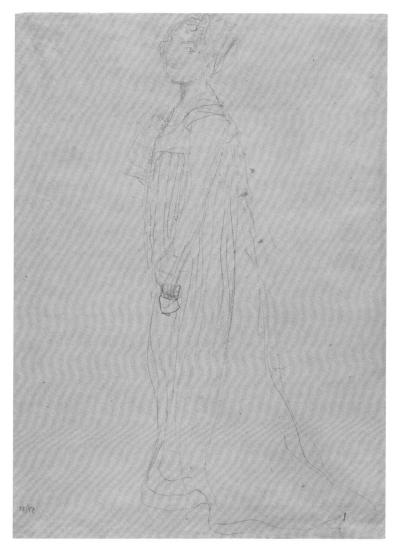

70 | 72

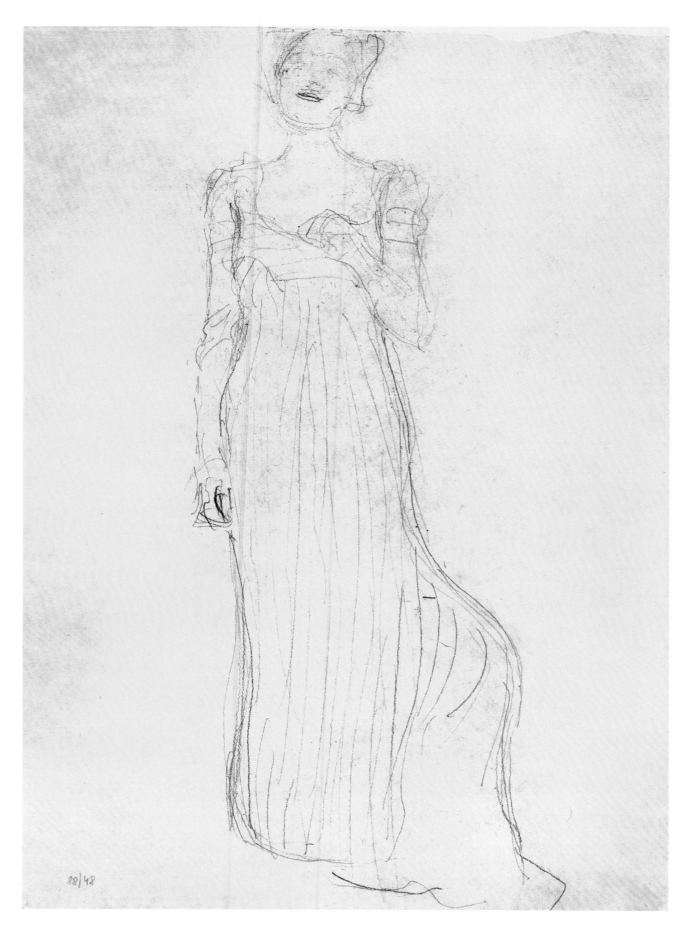

88/48

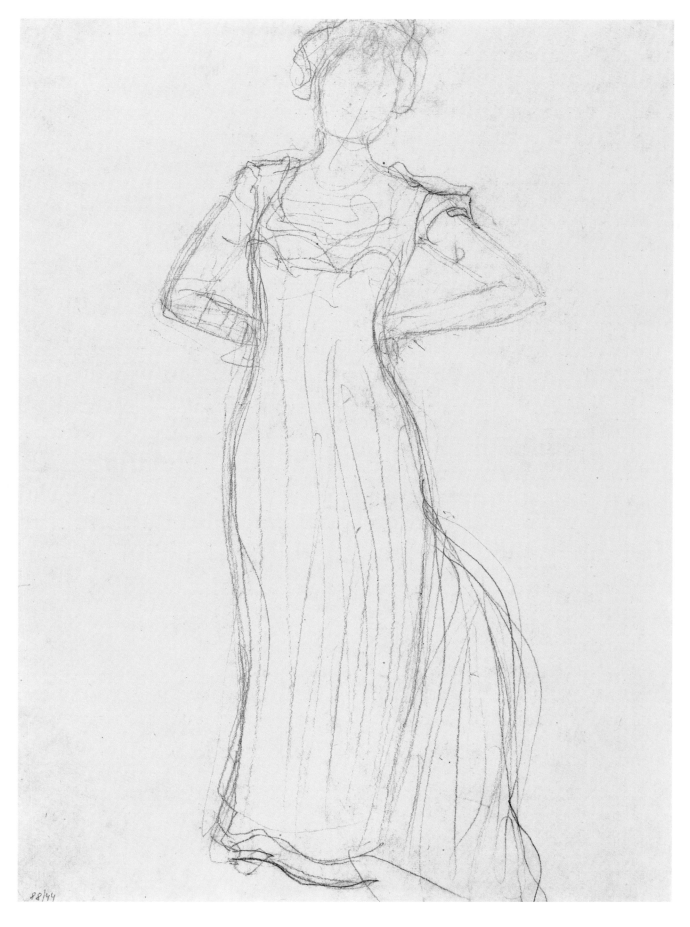

88/44

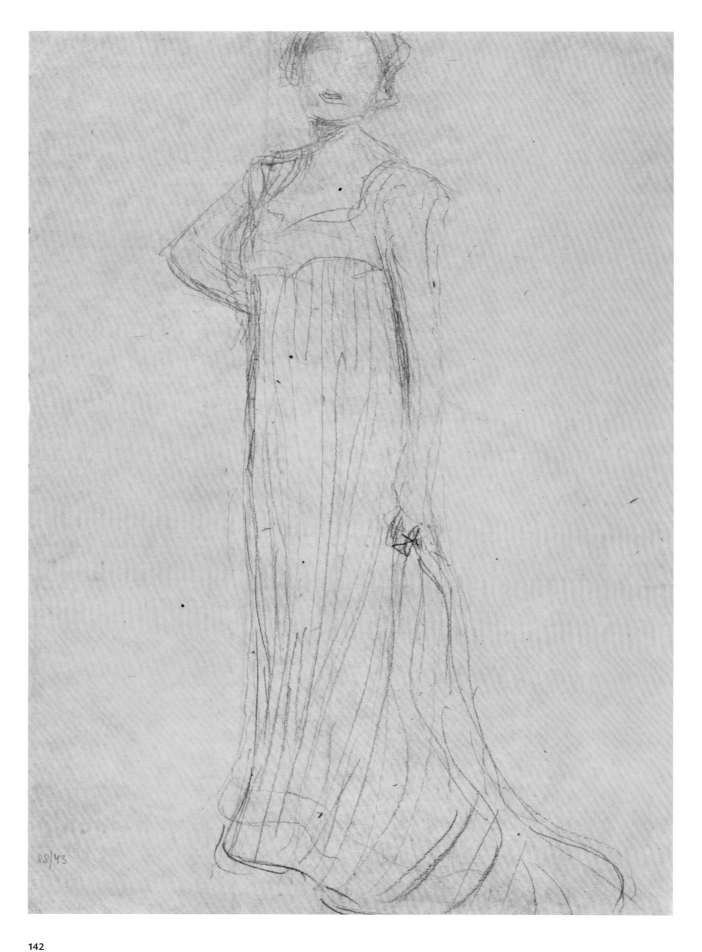

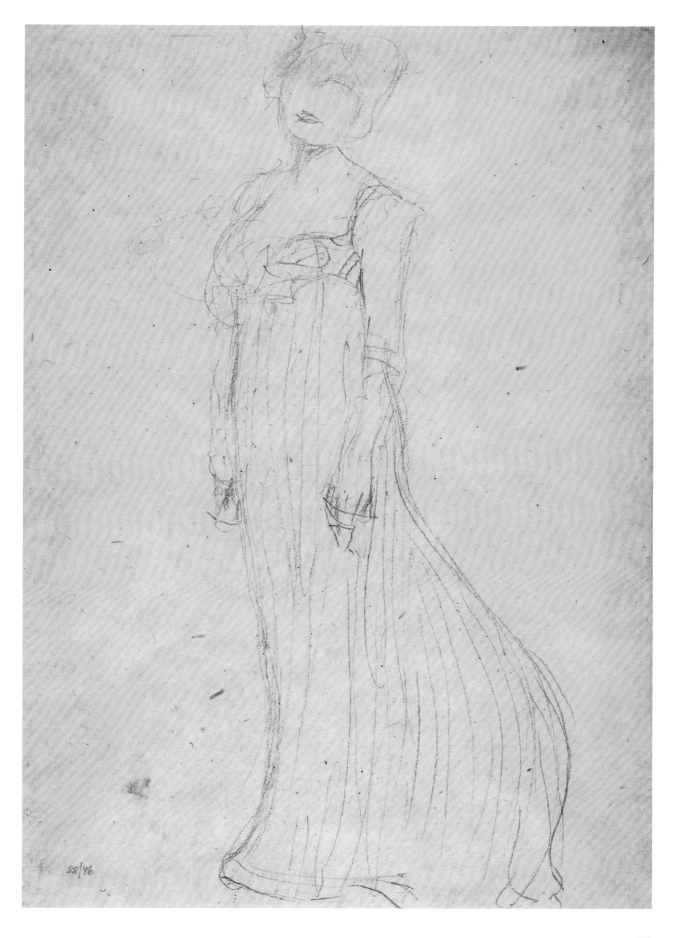

88/46

Standing Woman, Leaning on a Chair, 1900–1901
Transfer sketch for
Rose von Rosthorn-Friedmann

Black chalk, pencil, enlarging grid
45 × 31 cm
Albertina, Vienna, inv. 34554 | Strobl I, 511

Portrait *Rose von Rosthorn-Friedmann*

At the time Gustav Klimt painted her portrait, Rose von Rosthorn-Friedmann (1864–1919) was married to the industrialist Ludwig (Louis) Friedmann, her second husband, and was around thirty-six years old (fig. 1).[1] The painting was first presented at the tenth Secession exhibition (March–May 1901). It clearly fascinated the critics: Ludwig Hevesi, for example, emphasized the mysterious, sphinxlike character of the sitter, whereas Felix Salten emphasized not only the glittering materiality but also the ambiguity between the truth of life and distance from reality.[2] The internal contradictions are indeed already re-

vealed at first glance: the sensuously wavy physical forms whose contours seem to dissolve against the diffuse background or the complicated, twisted pose of the figure, which at the same time conveys the impression of a planar, almost floating silhouette. That Klimt subjected his works to what Alice Strobl called a "process of stylization" during the year 1900 is evident not only from the paintings but above all from the drawings, from which we can directly read the constantly transforming role of the line.[3] In connection with the portrait *Rose von Rosthorn-Friedmann*, Alice Strobl distinguished between a first group of studies, still somewhat haltingly sketched, and a second series, in which Klimt tried to capture the outlines of the figures in curving arabesques.[4] The final stage of this latter process is the present transfer sketch, in which the various experiments with lines come together in a highly effective synthesis. Employing powerfully stylized lines, Klimt marked the outlines of the figures, whose dark clothing he emphasized—in connection with the support of the chair—with long parallel hatching of various density and thickness. Thanks to the continuous rhythm of lines, the boa placed around her shoulders and her dress form an almost organic unity, out of which the blank area representing her décolletage gleams emphatically—as it does in the painting. The parallel hatching follows the forms of the body to a certain extent, but here too the impression of a dark silhouette dominates. As with the famous drawing of the floating woman for *Medicine* (cat. no. 36), the streamlined stylizations of the present transfer sketch slightly anticipate the great stylistic turn of *The Beethoven Frieze* (see cat. nos. 51–63).[5]

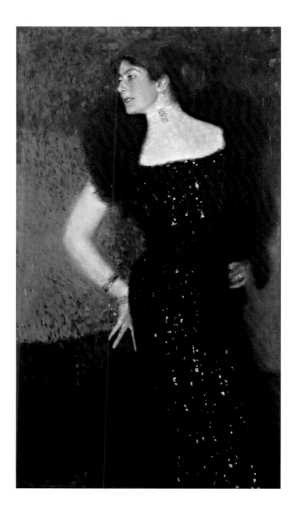

Fig. 1. *Rose von Rosthorn-Friedmann*, 1900–1901, oil on canvas, 140 x 80 cm, private collection

1 *Rose von Rosthorn-Friedmann*, 1900–1901, oil on canvas, 140 × 80 cm, private collection; Strobl I, 1980, p. 159; Exh. cat. Vienna 2000–2001, pp. 92–93; Weidinger 2007, no. 145.
2 Hevesi 1906, p. 318; Felix Salten, "Secession (Der Fall Klimt)," *Wiener Allgemeine Zeitung*, April 14, 1901, p. 2.
3 Strobl I, 1980, p. 159.
4 Ibid., nos. 489–93 (first group); nos. 494–511 (second group).
5 On the significance of Jan Toorop in this process, see Marian Bisanz-Prakken in Exh. cat. The Hague 2006–7, pp. 132, 134.

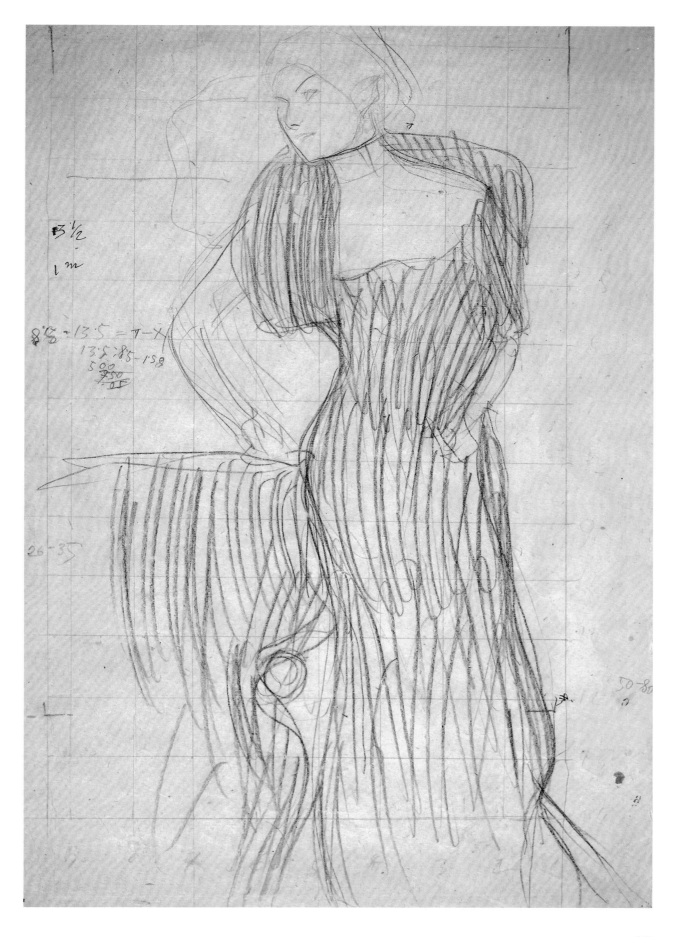

Woman Sitting in a Chair, 1901
Study for *Marie Henneberg*

Black chalk, 30 × 45.9 cm
Albertina, Vienna, inv. 22492 | Strobl I, 737

Portrait *Marie Henneberg*

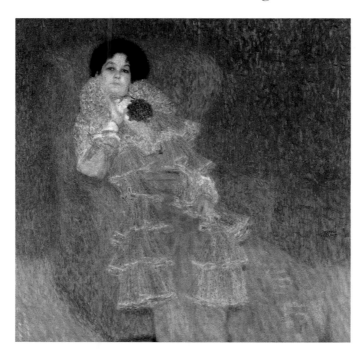

Fig. 1. *Marie Henneberg*, 1901–2,
oil on canvas, 140 x 140 cm,
Stiftung Moritzburg, Kunstmuseum
des Landes Sachsen-Anhalt,
Halle an der Saale

[1] Exh. cat. Vienna 2000–2001, pp. 95–97.
[2] The expression "astral chair" was suggested in
the context of the painting's unfinished state,
with the chair not yet executed; see Franz
Dülberg, in *Zeitschrift für bildende Kunst*, n.s. 15
(1904): 555, quoted in Exh. cat. Vienna 2000–
2001, p. 95. See also Strobl II, 1982, p. 217.
[3] Strobl I, 1980, nos. 732–40; Strobl IV, 1989,
no. 3443.
[4] On the stylistic connections to *The Beethoven
Frieze*, see Strobl I, 1980, p. 217.

Marie Henneberg, née Hinterhuber, was married to the physicist Hugo Henneberg, who was also active as an engraver, wood carver, and above all art photographer. The couple lived in one of the four villas on the Hohe Warte built by Josef Hoffmann between 1900 and 1902. The other residents of this "artists' colony" were the Secessionists Kolo Moser and Carl Moll with their families and the art photographer Friedrich Victor Spitzer.[1] Klimt painted Marie Henneberg in 1901–2; the square painting was presented—not yet completely finished—at the thirteenth Secession exhibition (February–March 1902; fig. 1). As part of the decorations for the new villa, it was integrated into the mantelpiece that Josef Hoffmann designed for the large entrance hall.

The portrait of Marie Henneberg in particular reveals the divergence between the artist's painting and drawing. In the painting, the form

of the chair is absorbed in an almost magical way by the blue-and-yellow *pointillé* of the background, so that the diagonally positioned seated figure seems to exist in an extrasensory "astral" atmosphere.[2] In *The Beethoven Frieze*, painted around the same time, Klimt would break radically with the *Stimmungskunst* (mood art) of the early Secession, which was characterized by forms and colors gently blending.

In the few surviving studies for this portrait, Klimt alternated between a standing and sitting pose, between profile and frontal views, and between a vertical and horizontal format of the paper.[3] In the oblong study exhibited here, he adopted a compositional formula, inspired by James Abbott McNeill Whistler, that he had employed earlier in 1897–98 (cf. the portrait *Sonja Knips*, cat. no. 67). In the present drawing, Klimt attempted to work out the connection between the figure and the chair through various systems of lines, which he sharply distinguished in several parallel layers of space. In the very front looms the bright barrier of the chair, whose curving edge is emphatically distinguished from the density of the adjacent rhythmic structures of lines. This spatial sequence continues in turn with the bent arm resting on the back of the chair, then the triangular form of the flounce scarf, the flowing contour of the skirt, and finally her right forearm raised to her face, with its geometrically stylized fingers. This quasi-architectural form is stabilized by being integrated into the plane. This almost abstract approach to flowing and geometrical lines appears to be close to the drawings for *The Beethoven Frieze*, which also date from 1901 (cat. nos. 51–63).[4]

78

Portrait *Adele Bloch-Bauer I*

In 1907 Klimt completed his portrait of Adele Bloch-Bauer (1881–1925), daughter of the banker Moritz Bauer and wife of the large industrialist Ferdinand Bloch.[1] Because of its wealth of gold ornament and echoes of Egyptian, early Christian, medieval, and Japanese influences, the painting is considered a major work of the artist's Golden Period (fig. 1).[2] The numerous drawings in which this extravagant young woman posed standing or sitting in a series of fashionable creations were largely produced during the phase of intense production that immediately preceded the *Klimt-Kollektive* exhibition (Vienna Secession, November 1903–January 1904). Within Klimt's development as a draftsman, this extensive group of lyrically lilting studies is a culmination.[3] These works mark a fascinating departure from the flowing linearity of the early Secessionist period as well as the prelude to the geometrically determined planarity of the Golden Period. His work on *The Beethoven Frieze* in 1901–2 was a catalyst for this process, with its clear contours of figures, contrasting decorative effects, and emphatically separated, geometrically ornamented planes. *The Beethoven Frieze* was associated with a concept very topical at the time: *Raumkunst*, or "art of space," which concerned the supremacy of wall painting related to the architecture over the autonomous framed painting. Klimt realized modern *Raumkunst* not only in his painting but also in his drawing, as is clear from the studies for *The Beethoven Frieze* (cat. nos. 51–63). In the drawings for the portrait *Adele Bloch-Bauer I*, he continued to develop these recently established principles. The present studies (cat. nos. 79–82) reveal his commanding and unencumbered approach to the dictates of the edges of the sheet.

In one of the earliest drawings of this group, Klimt placed the woman sitting in a chair within an asymmetrical triangular form and enveloped her in the outlines of the back and armrests (cat. no. 79).[4] These well-calculated superimpositions of forms lead to a tension-filled balance between the vividly structured areas and the empty ones. This work still lacks the sweeping movement of the lines that characterizes the subsequent studies, which was essentially inspired by Jan Toorop.[5] In most of the drawings that depict Adele Bloch-Bauer sitting, the motif of the freely flowing strap dress is presented in impressive diversity, as three examples of this category exemplarily demonstrate (cat. nos. 80–82). The way her forehead is cut off by the top edge of the sheet in every case is also characteristic. More than ever before, this method, which was clearly inspired by Fernand

Fig. 1. *Adele Bloch-Bauer I*, 1907, oil on canvas, 138 × 138 cm, Neue Galerie, New York

Khnopff, results in a peculiar ambivalence between majestic distance and sensuous proximity. This sensuousness is crucially reinforced by the powerfully accented, stylized triangle of her mouth—the magical center of attraction in all the studies of Bloch-Bauer. The parallel structures of flowing lines is a motif that dominates everything in the drawing, in which Klimt repeated the sitting figure on a smaller scale at top left (cat. no. 80). The wavy movements of the delicately stylized drapery contrast subtly with the angular contours and geometrical patterns of her bolero.

The two studies of a seated figure enthroned on cushions against a backdrop demonstrate the principle of parallel, overlapping strata of space of differing structure that are strictly integrated into the plane (cat. nos. 81, 82). A lively alternation between gently flowing formations of lines and stable, rectangular elements unfolds. The small square patterns of the cushions are reminiscent of the founding of the Wiener Werkstätte, where the square played a dominant role as a basic ornamental form. Each of these two sheets establishes a complex of mutual dependencies and relationships of dynamic tension, in which the areas left blank also play an active role.

For all the abstraction, the focus of Klimt's attention is again and again the central detail of interlocked hands, which also played an important role in the painting—albeit angular and stylized. One of Adele Bloch-Bauer's fingers is said to have been slightly lame.[6]

The innovative *Raumkunst* of the Bloch-Bauer studies was accompanied by a new quality of the line. With his chalk Klimt walked a tightrope between individual characterization and subjective state of mind, on the one hand, and the higher laws of the overall context, on the other. A distinctive combination of sensibility and sublimating power, of sensuousness and transcendence characterizes the linearity of the Bloch-Bauer drawings. Yet the tightrope walk described here does not appear to have been an arduous one, but rather a process guided by unhampered, confident intuition and no doubt with great concentration. Klimt seems to have already internalized completely the polarity of linear freedom and formal discipline that would subsequently characterize his drawings. The creative, highly inspired approach to the motif of freely flowing, repeatedly overlapping formations of lines became an artistic end in itself and goes far beyond the immediate purpose.

1 Exh. cat. Vienna 2000–2001, pp. 115–18.
2 Novotny and Dobai 1975, no. 150; Weidinger 2007, no. 184.
3 On the studies for *Adele Bloch-Bauer*, see Strobl I, 1980, 301–2, nos. 1054–61; Strobl IV, 1989, nos. 5320–31c; Bisanz-Prakken 2000–2001, pp. 200–201.
4 Not in Strobl. It is most closely related to Strobl IV, 1989, nos. 3521 and 3526c.
5 On the combined significance of Fernand Khnopff, Jan Toorop, and George Minne for the Bloch-Bauer studies, see Bisanz-Prakken 2000–2001, pp. 201–2; Marian Bisanz-Prakken, in Exh. cat. The Hague 2006–7, pp. 197–98.
6 Exh. cat. Vienna 2000–2001, p. 118.

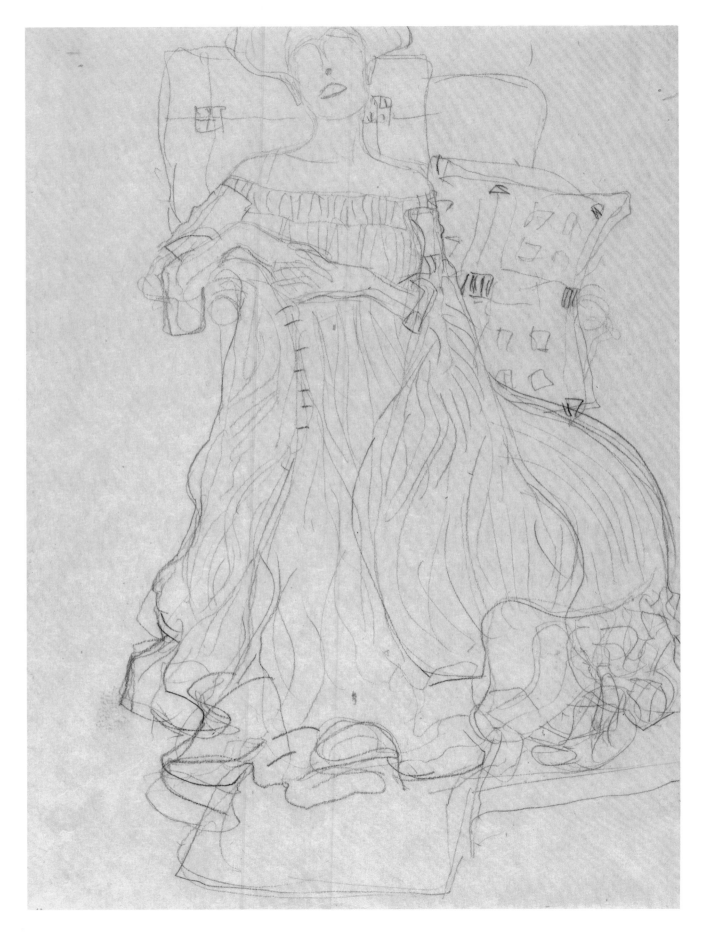

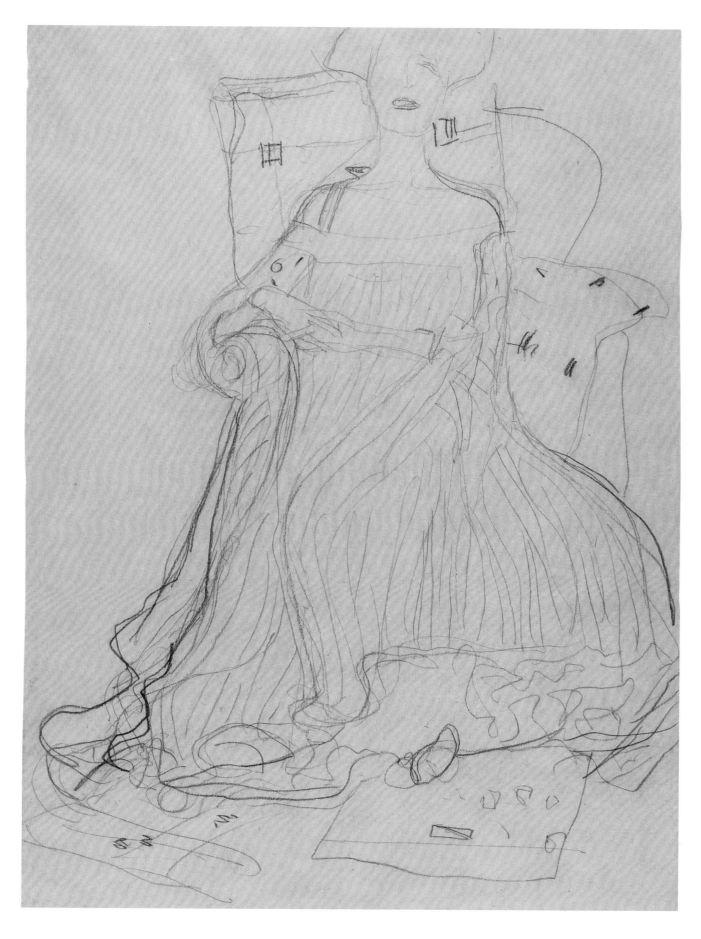

The Golden Style

1903–1908

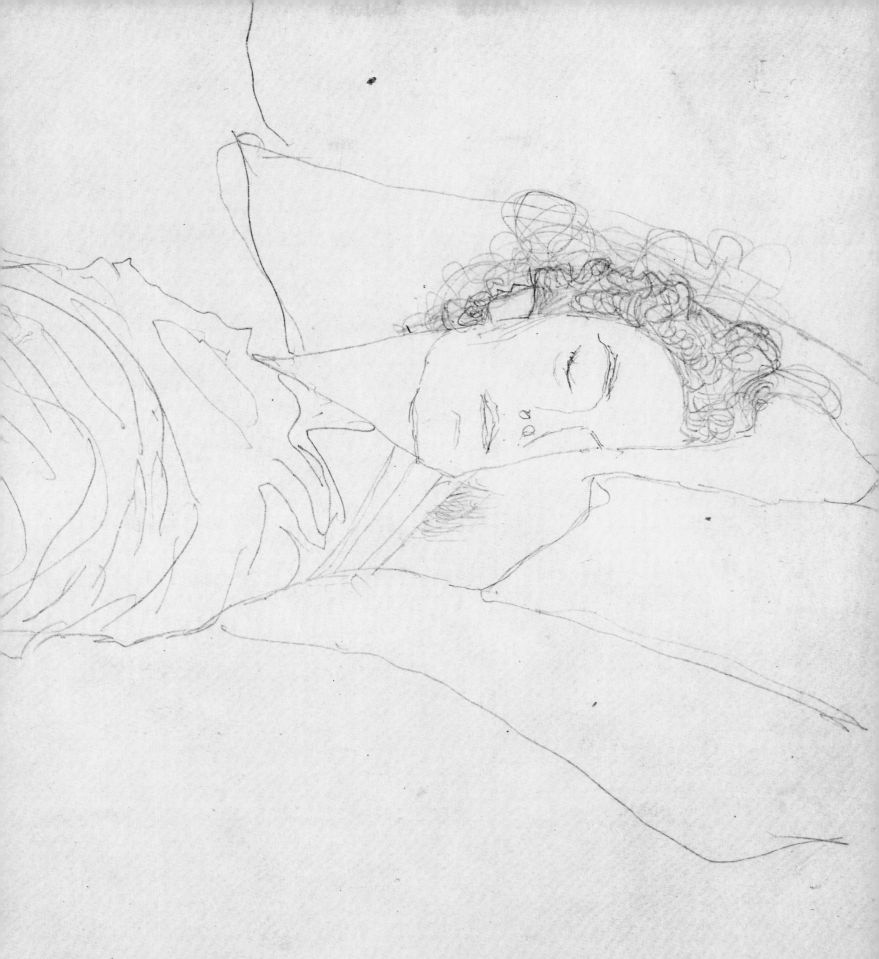

GVSTAV
KLIMT.

83

Standing Pregnant Woman with Man, ca. 1902

Study for Hope I

Red pencil, 44.7 × 30.5 cm
Leopold Museum, Vienna | Strobl I, 950

84

Standing Pregnant Woman with Man, ca. 1902

Study for Hope I

Blue pencil, 44.7 × 30.4 cm
Gallery Kovacek & Zetter, Vienna
Strobl I, 953

85

Standing Pregnant Woman in Profile, with Repetition of Figure, ca. 1902

Study for Hope I

Black chalk, 44.8 × 30.7 cm
Albertina, Vienna, inv. 39038
Strobl IV, 3511a

86

Skeleton Dressed in Long Gown, ca. 1902

Study for Hope I

Black chalk, 45 × 30.8 cm
Albertina, Vienna, inv. 23682 | Strobl I, 997

87

Three-Quarter-Length Portrait of a Skeleton Dressed in Long Gown, ca. 1902

Study for Hope I

Black chalk, 44.7 × 31.2 cm
Albertina, Vienna, inv. 23680 | Strobl I, 998

88

Profile of Clothed Pregnant Woman with Her Face Turned to the Viewer, 1907–8

Study for Hope II

Graphite, red and blue pencil
55.7 × 36.9 cm
Albertina, Vienna, inv. 23537 | Strobl II, 1776

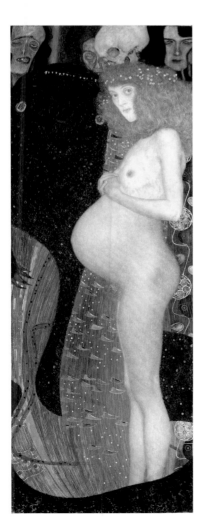

Fig. 1. *Hope I*, 1903–4, oil on canvas, 189.2 × 67 cm, National Gallery of Canada, Ottawa

Hope I and *Hope II*

In the tall, narrow painting *Hope I* (1903–4), the life-sized figure in profile of a naked pregnant woman with red hair is besieged by repellent, grotesque faces, a figure of Death in a long gown, and a dark monster (fig. 1).[1] The gloomy backdrop is known to have been produced only in November 1903; by the artist's own account, the background was initially a landscape.[2] It is not known when and for what reason Klimt abandoned this original idea. Alice Strobl suspected that the pessimistic turn in the concept may have been triggered by the death of his illegitimate son Otto Zimmermann, at the age of just three months, on September 11, 1902, which affected him very profoundly.[3] Because it was expected to cause a scandal, the painting was not ultimately shown in the *Klimt-Kollektive* exhibition, which opened on November 14, 1903.[4] *Hope I* and the studies passed into the hands of arts patron Fritz Waerndorfer in 1905. This enthusiastic collector of Klimt's work and cofounder of the Wiener Werkstätte kept the painting hidden in a display cabinet designed especially for it by Kolo Moser, and its double doors were opened only for special guests.[5]

After his trailblazing experiences gained during his work on *The Beethoven Frieze*, Klimt painted *Hope I* as the prelude to the monumental allegories of his Golden Style. In the latter paintings, isolated single figures or formations of figures emphatically symbolize various basic situations of human life. In terms of subject matter, Klimt repeatedly alluded to specific motifs from his *Philosophy* and *Medicine* faculty paintings. For example, the figure of the very pregnant woman depicted at top right in *Medicine* (cat. no. 40) is a precursor of the main figure in *Hope I*. Moreover, Klimt also addressed the symbolism of fertility and eternal rebirth in the context of the woman floating next to "Suffering Humanity," who gives birth to new life (cat. nos. 31–36).

Klimt's crucial turn to the monumental depiction of individual themes from life also had essential consequences for his practice of drawing. Unlike the broad spectrum of existential situations and human types to which the artist had devoted himself in his drawings for *Philosophy*, *Medicine*, and *The Beethoven Frieze*, in *Hope I* he concentrated for the first time on a single existential motif, which he studied in a

great variety of drawings. So he had several models in various stages of pregnancy pose for him: sitting or standing, in profile or frontal, with and without a male partner.[6] Initially, Klimt experimented extensively with the motif of a standing, naked pair of parents, whom he depicted by turns in black, red, or blue chalk (cat. nos. 83, 84). The clear stylistic proximity of these works to the drawings for *The Beethoven Frieze* is evident from the way the figures are integrated vertically into the plane of the paper, from the concentration on the continuously flowing outlines, and from the profile view of the pregnant woman. In all these sheets, Klimt reproduced the constellation of the pair more or less from knee height to the top edge of the paper. In their monumental unity, the nestling figures recall the study of the pair of lovers in *The Beethoven Frieze* (cat. no. 63), although they differ essentially in the expression of intimacy. In both sheets exhibited here, the joyful anticipation of the parents is expressed in their faces as they bend together to look down on the unborn child. The tenderly protective role of the man is underscored by the emphatic angularity of his bent arms and by his hand grasping the woman's elbow. These studies are characterized by the play of alternation between the strongly emphasized and gently flowing contours of the man and the woman. The rhythmically emphasized juxtaposition of sex characteristics—a tone typical of Klimt—joins in this sensitive dialogue. As the crowning of the physical and mental connection between the couple, the curved outlines of the volume of her body swells in the center of the studies. It seems to glow especially magically in the present version in red pencil, as a result of the stronger accent on the contour lines. The motif of the flowing contours of the curvature of her stomach—the core of all the known drawings for *Hope I*—testifies to Klimt's undiminished fascination with the mystery of unborn life. The early idea of a pair of parents affectionately connected in anticipation seems to correspond to the original phase of his concept that was characterized by the idea of a landscape. Alice Strobl thus proposes that work on the studies for *Hope I* began around 1902.[7]

Among the numerous separate studies of pregnant models, the sheet with a figure sketched twice in profile comes especially close to the main figure of the painting (cat. no. 85). One crucial difference from the main work, however, is the position of the head, which is bent forward contemplatively here. In this rhythmically arranged pair of figures, the sharply stylized profile face with downcast eyelid has clearly been inspired by Jan Toorop, whose Symbolist linear art influenced Klimt's design for *Hope I* on several levels.[8] In terms of the strict axiality of positions and gestures and in the taut yet sensitive contours, both profile figures largely correspond to the studies for *The Beethoven Frieze*. The slender, stylized limbs of the standing woman recall the corporeal ideal of the "Three Gorgons," while her face seen in profile as it bends forward points to the soul-searching of "Poetry" (cat. nos. 61, 62). In nearly all the studies, the pregnant woman is looking down at her hands protectively folded over her stomach, which stand out spatially thanks to more strongly outlined contours. As in the drawings for *The Beethoven Frieze*, both figures in the study exhibited here are not shown in contact with the ground; in

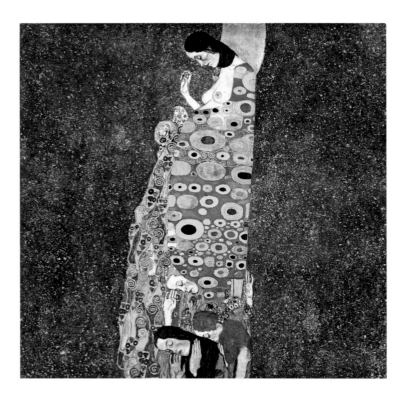

Fig. 2. *Hope II*, 1907–8, oil on canvas, 110 x 110 cm, Museum of Modern Art, New York

1 *Hope I*, 1903–4, oil on canvas, 189.2 × 67 cm, National Gallery of Canada, Ottawa; Novotny and Dobai 1975, no. 129; Weidinger 2007, no. 171. The fact that Klimt may have begun the painting already in 1902 is perhaps indicated by a letter from Fritz Waerndorfer to Josef Hoffmann, dated April 29, 1902: "Regarding my *Love* and my Child of Sorrows, *Hope*, a decision has been made as well. Kolo is very interested in painting the doors for the painting, and naturally I was delighted to offer him the 'commission.'" See archives of the Universität für angewandte Kunst, Vienna, inv. no. 3977/2, pp. 2–3. This remark may imply that Waerndorfer had already offered Klimt the commission for *Hope* during the Beethoven exhibition. The reference to *Love* needs to be studied. I am grateful to John Collins for this reference.
2 Hans Koppel, "Wiener Neuigkeiten bei Gustav Klimt," *Die Zeit*, 406, November 15, 1903, p. 4. See Strobl 1978–79, pp. 138–39; Strobl I, 1980, p. 274.
3 Strobl I, 1980, p. 274, no. 999.
4 For the latest findings on this, see Collins 2001, pp. 37–41.
5 Shapira 2006, pp. 76–78.
6 Strobl I, 1980, pp. 273–74, nos. 943–98; Strobl IV, 1989, nos. 3508–11a.
7 Strobl I, 1980, p. 274.
8 Bisanz-Prakken 2001b; Marian Bisanz-Prakken, in Exh. cat. The Hague 2006–7, pp. 212–18.
9 *Hope II*, 1907–8, oil on canvas, 110 × 110 cm; Novotny and Dobai 1975, no. 155; Weidinger 2007, no. 188.

the painting, too, because the feet of the figure in profile are surrounded by a black monster, she seems distinct from reality, despite all her physical presence.

In the study of a skeleton dressed in a gown, which is connected to the figure of Death in the painting, Klimt's efforts to fix the figures in the plane while at the same time causing them to persist in a timeless void lead to a strict tripartite structure of the picture plane (cat. no. 86). Between the intersection in the area of the skull and the point at which the tips of the toes of the dangling foot touch the edge of the sheet, the vertical flow of delicate drapery dominates—very much in the style of the studies for *The Beethoven Frieze*. Despite the succinctly outlined bones, the skull leaning forward almost seems alive, an impression further reinforced by the close-up of the motif (cat. no. 87).

Hope II, painted in 1907–8 and a major work of Klimt's Golden Style (fig. 2), differs dramatically from the sensuousness and the play of harmoniously flowing lines in *Hope I* (fig. 1).[9] The figure of the pregnant woman in profile, whose pale face leaning forward seems to be marked by mourning, is wrapped in a richly ornamented gown that exposes only her breasts and the top of the curve of her stomach. The symbolism of death is limited here to a skull clinging to the stomach of the expectant mother. The praying figures on the lower part of the gown seem to protect the growing life.

The studies produced for that painting are—unlike the drawings for *Hope I*, which were still executed on packing paper—drawn on the kind of Japanese paper that Klimt used from around 1904 onward. At the same time, he replaced black chalk with graphite. The drawing exhibited here of a pregnant woman standing in profile, her clear gaze pointed directly at the viewer, conveys a remarkably positive, rooted impression (cat. no. 88). The dark hatching with which Klimt reinforced the contours of the chin and back areas fixes the figure in the plane, which makes the broadly draped frilled dress seem to unfold all the more freely. The blue and red accents give the drawing a particular coloristic dimension. This sheet is one of those autonomous studies in which Klimt explores various aspects of pregnancy beyond the primary, pessimistic idea and sublimates them in his brilliant linear idiom.

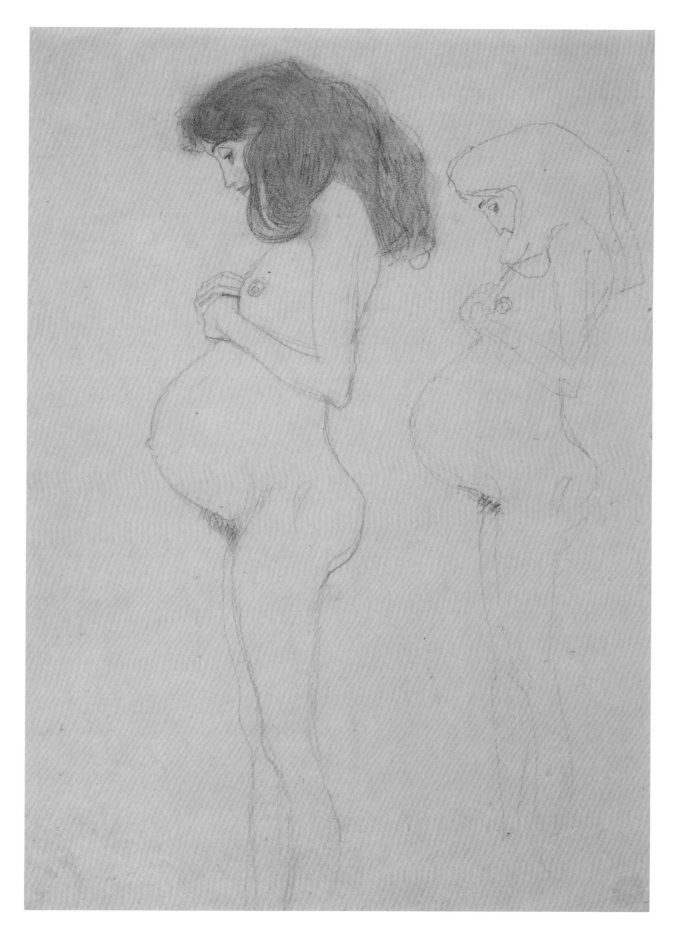

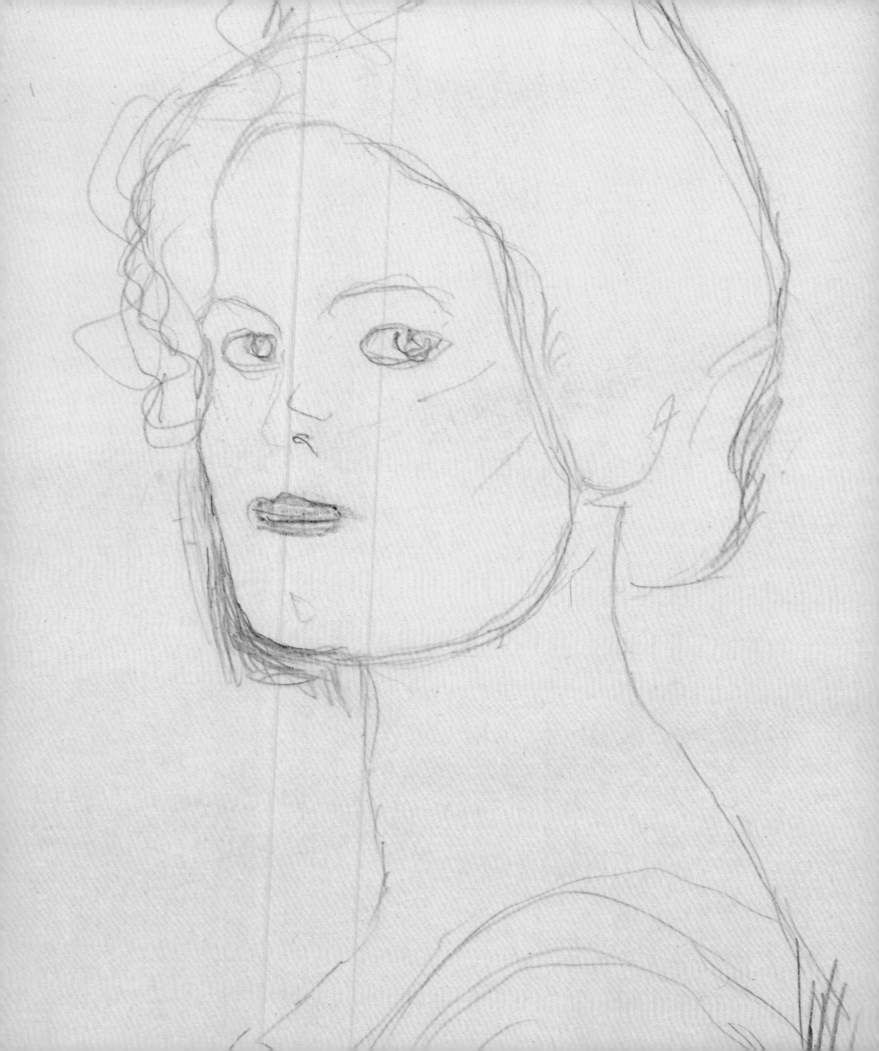

The Three Ages of Woman

In 1905, the year he left the Secession, Klimt completed the monumental painting *The Three Ages of Woman* (fig. 1).[1] In this early example of his Golden Style, he took up again the themes of "becoming," "fruitful existence," and "passing away" and concentrated on the three main female figures. Against an abstract, cosmic-looking background, an old woman—picking up a motif from a figure the artist depicted in *Medicine*—and a youthful mother gently holding her baby move across the picture plane.[2] The two grown women, depicted in contrasting profile and frontal views, are surrounded by colorfully ornamented cocoons that dovetail in a spatially alienating way. The old woman's ornamental field overlaps the young mother's right leg. The latter's shoulder in turn looms up into the space of her aged neighbor. The elder woman's brown strands of hair fall in curls at a right angle to the horizontally spread, golden blonde splendor of

Fig. 1. *The Three Ages of Woman*, 1905, oil on canvas, 180 × 180 cm, Galleria nazionale d'arte moderna, Rome

the young figure's hair. The complexly interlocked pictorial elements symbolically allude to the fact that the main figures are inseparably connected, despite their self-absorption.

In Klimt's characteristic method, first developed in *The Beethoven Frieze*, the figures of his allegories are distinguished thematically from one another by means of different levels of linear stylization. In *The Three Ages of Woman*, this method becomes the main element. There is a striking contrast between the extreme verism of the desperate old woman and the gaunt, linearly stylized forms of the young mother's body, with her head inclined fully to one side and her dreamy, Madonna-like facial features.[3] The ideal character of the young woman is also conveyed by the bright translucence of her skin color, the fact that her feet are not depicted, and the blue-and-red formations of lines that surround her lower body. Since 1898 Klimt had been employing this veiling motif, inspired by the Symbolist linear art of Jan Toorop, as a way of symbolizing the otherworldly quality of his allegorical figures.[4] The peacefully sleeping baby is presented quite realistically. The innocent world of the child was apparently not subjected to any tendency toward stylization in Klimt's work—neither in the direction of a heightened realism nor in the manner of a metaphysical ideal sphere.

In the studies for the mother and child shown here (cat. nos. 89–91), Klimt proves to be a psychological acute, empathetic observer of small children—a talent he repeatedly brought to bear convincingly from the outset. With confident, flowing lines he captured the quickly changing positions of the infant held up in its mother's hands, placing striking accents: the outlines of its small leg

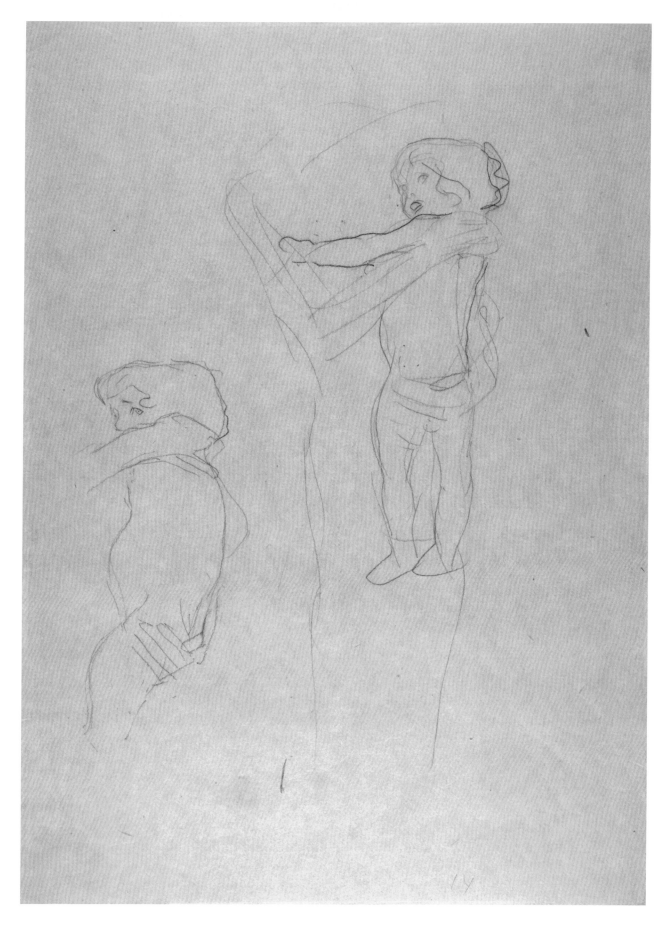

repeated several times, a turn of its little head, a frightened glance cast over its shoulder, a curve of its tummy. With a single stroke that dominates everything, he brilliantly recorded its eye closed in sleep (cat. no. 89). Already in the phase of the preparatory drawings, Klimt distinguished between the naturalness of the child's movements and the geometrically positioned hands and the arm and shoulders of the mother stylized as a right angle (cat. no. 91). This series, which was doubtless originally extensive, is still executed in black chalk on packing paper, but soon thereafter he switched to the Japanese paper he began to prefer, which was associated with a slightly larger standard format.[5]

The 1904 study of a seated figure of a clothed old woman, which has been connected to the painting *The Three Ages of Woman*, was already executed on the new paper. Klimt still used black chalk for it, but soon thereafter he replaced it completely with graphite (cat. no. 92). This sheet is part of a series of autonomous studies by Klimt with variations on the motif of an old woman seated. His own mother served as model. The present drawing is marked not by mourning or despair but by the calm dignity of advanced age. With the sharpness of a woodcut, Klimt captured the facial features of his frontally arranged model, which stand out distinctly from the simple contours of her voluminous clothing. In the blank areas, the woman's hands resting in her lap stand out all the more characteristically.

The life-sized drawing in charcoal is a great rarity within the artist's oeuvre; it seems to have served to transfer the image to the canvas (cat. no. 93). Klimt very likely used tracing paper. This quite common method leaves no traces on the drawing and also permits the figures to be transferred in mirror reverse.[6] This would also explain the big difference between the drawing and the painting, in which the position of the young woman has been reversed. This results in crucial thematic differences. In the drawing, the heads of the mourning old woman, the dreamy young mother, and the sleeping child face one another and produce an intimate compactness. Their bodies are pressed closely together within a single ornamental shell. The question when and why this crucial change in the concept was made must remain unanswered for the moment. The studies of mother and child shown here (cat. nos. 89–91), which were produced in 1904 at the latest, already relate to the ultimate solution that results in the isolation of the figures described above. In the painting, the inner connection of the two women is manifested not primarily on the emotional level but rather on the suprapersonal, decorative level. The geometricizing of the poses and gestures plays a big role here—for example, in the axial harmony of the lines of their necks curving to the right. The painting is further along in terms of the evolution of Klimt's monumental style. In sum, it appears quite justified to date this impressive transfer drawing to 1904.

[1] *The Three Ages of Woman*, 1905, oil on canvas, 180 × 180 cm, Galleria nazionale d'arte moderna e contemporanea, Rome; Novotny and Dobai 1975, no. 142; Weidinger 2007, no. 178.

[2] This precursor of the figure of the old woman was produced by 1903 at the latest; see Strobl I, 1980, no. 672.

[3] The source of inspiration for the physical decay of the old woman has often been emphasized: Auguste Rodin's sculpture *She Who Was the Helmet Maker's Once-Beautiful Wife*, bronze, 50 cm, Musée Rodin, Paris. On the profound influence of George Minne and Jan Toorop on the slender, stylized ideal figure of the young mother, see Marian Bisanz-Prakken, in Exh. cat. The Hague 2006–7, p. 203.

[4] Ibid.

[5] Strobl IV, 1989, pp. 211–12.

[6] Other examples of works on paper that are identical in size to the final version and were used for the transfer include the cartoons for the paintings in the Burgtheater (not in Strobl) and the nine working drawings for the mosaic frieze in the Palais Stoclet in Brussels (Strobl II, 1982, nos. 1810–18). Cat. no. 93 discussed in Toni Stoß and Christoph Doswald, eds., *Gustav Klimt 1862–1918*, exh. cat. (Zurich, Kunsthaus, 1992), no. Z 76; Exh. cat. Frankfurt 1995, no. 28; Exh. cat. Ottawa 2001, no. 86; Christian Witt-Dörring und Paul Asenbaum, eds., *Vienna Art & Design: Klimt, Schiele, Hoffmann, Loos*, exh. cat. (Melbourne, National Gallery of Victoria, 2011), pp. 160-61.

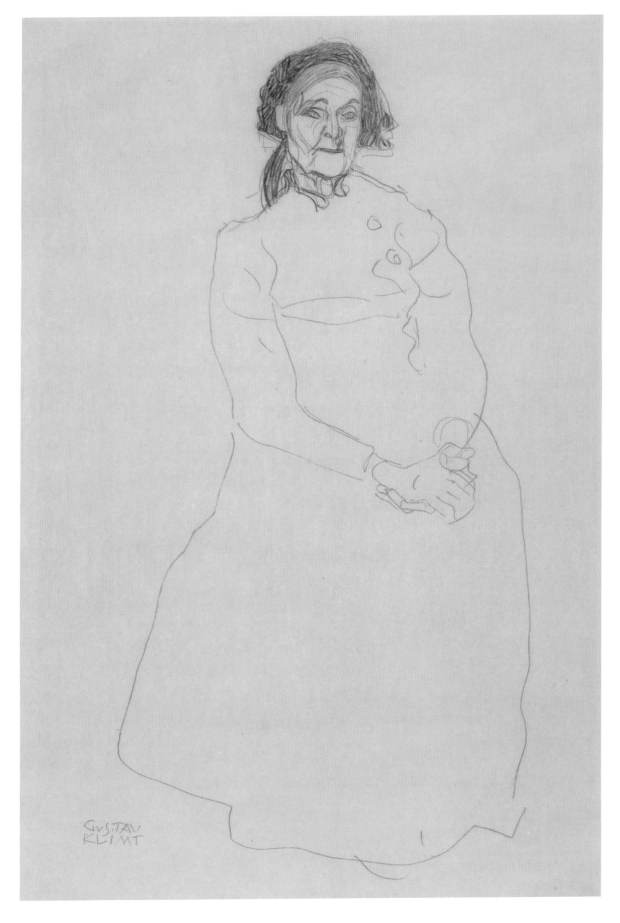

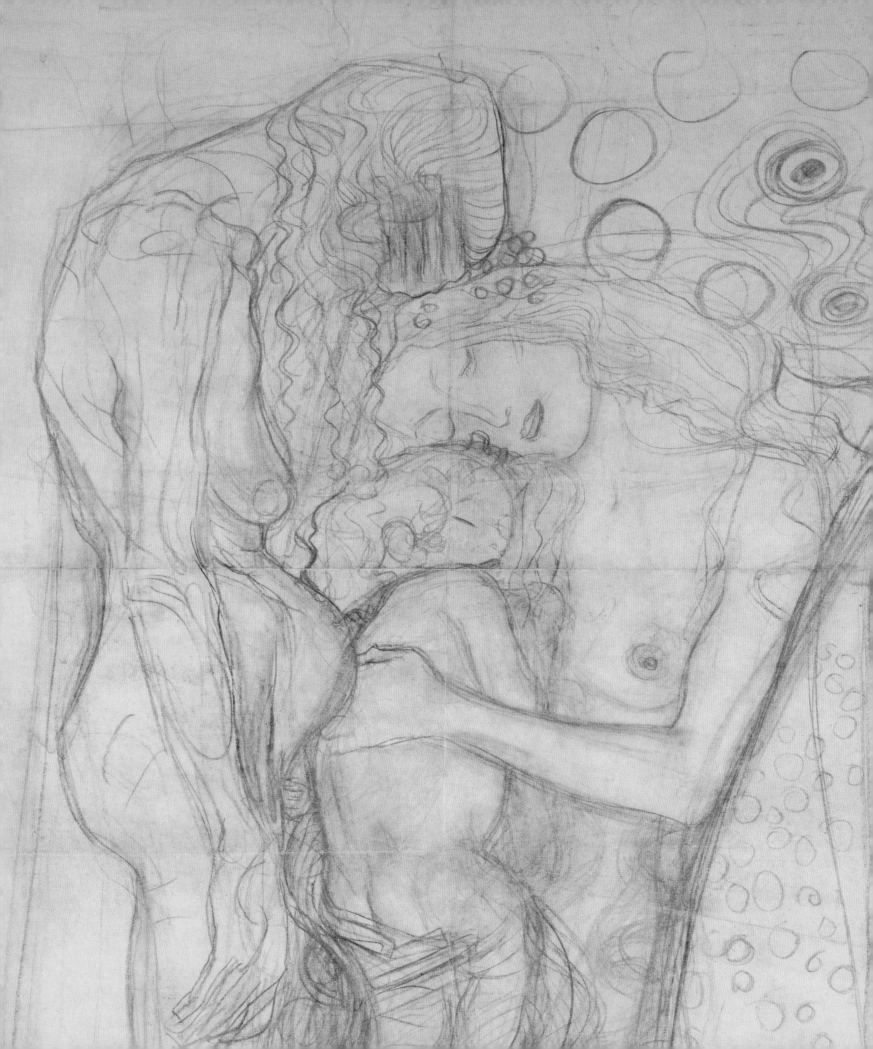

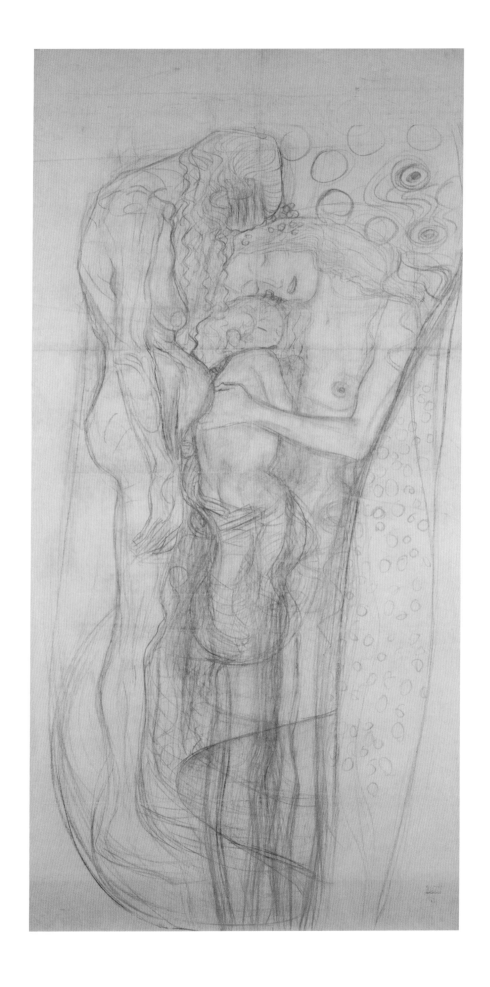

94
Reclining Woman, 1904
Study for *Water Snakes II*,
first version

Graphite, 35 × 55 cm
Albertina, Vienna, inv. 39012 | Strobl II, 1401

95
Seated Woman with Legs Spread, 1904

Graphite, 35 × 55 cm
Leopold Museum, Vienna | Strobl II, 1393

96
Woman Reclining with Right Leg Raised, 1904

Graphite, 35 × 55 cm
Albertina, Vienna, inv. 36633 | Strobl II, 1395

97
Reclining Woman, 1905–6
Study for *Water Snakes II*,
second version

Blue and red pencil, 37.1 × 55.9 cm
E. W. K., Bern | Strobl II, 1465

98
Two Reclining Women, 1905–6
Study for *Water Snakes II*,
second version

Red pencil, 37 × 54.3 cm
Albertina, Vienna, inv. 30213 | Strobl II, 1514

Water Snakes II and *Dialogues of the Courtesans*

Klimt's new monumental art developed immediately after *The Beethoven Frieze* and culminated in the major works of the Golden Style from 1904 to 1908. In November 1903 the artist expressed his views in an interview: "The painter is not called upon to visualize an idea in a sensual way but rather to decorate a space."[1] Not coincidentally, Klimt's emphatically geometric paintings of the Golden Period seem like parts of an imaginary architectural context, with echoes of the space-related art of the fresco, the altarpiece, and above all the mosaic.

In parallel with the paintings, Klimt's increased interest in the principles of *Raumkunst*, or "art of space," were clearly manifested in his drawings as well. Some of the earliest examples of this include the 1904 studies for models lying outstretched and arranged vertically, in which the artist first addressed the taboo themes of lesbian love and autoeroticism with a view toward the paintings *Water Snakes I* and *II* (figs. 1, 2).[2] The study for the first version of *Water Snakes II*, which was revised in 1907, is one of the outstanding examples of this group (cat. no. 94). Klimt had earlier devoted himself to the motif of flowing or floating nudes, oriented either horizontally or vertically, in the faculty painting *Medicine* and in erotically playful works such as *Moving Water*, *Goldfish*, and *Will-o'-the-Wisps*. The floating figures of "Longing for Happiness" in *The Beethoven Frieze* were based on preparatory studies with curving lines (cat. no. 51). In the present work, Klimt bid farewell to that curvilinearity as well as to the medium of packing paper and black chalk. The overall impression of the drawing is characterized by the metallic sharpness of the pencil lines, which in combination with the shimmer of the Japanese paper seems to correspond congenially with the materiality and aesthetic of the paintings. Klimt meticulously distinguished between the linear structures of the ruffed fabrics and hair. The play of sharply defined forms overlapping with one another in subtle ways is particularly explicit in the area of the exposed midsection of the body and the partially covered, erotically active hand. With sensitive lines, Klimt characterized

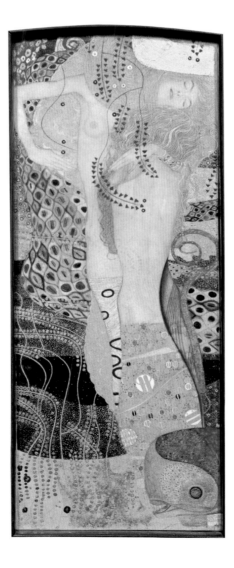

Fig. 1. *Water Snakes I*, 1904–7, mixed media, gold leaf on parchment, 50 × 20 cm, Belvedere, Vienna

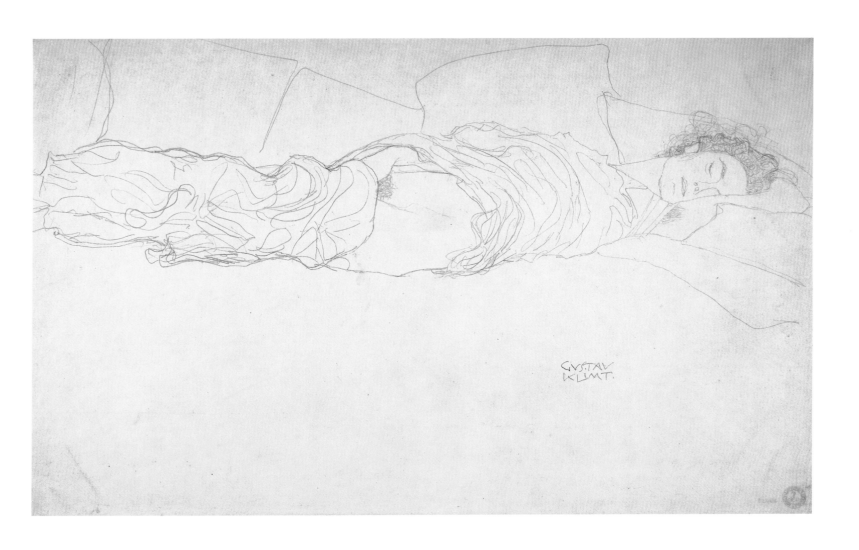

94

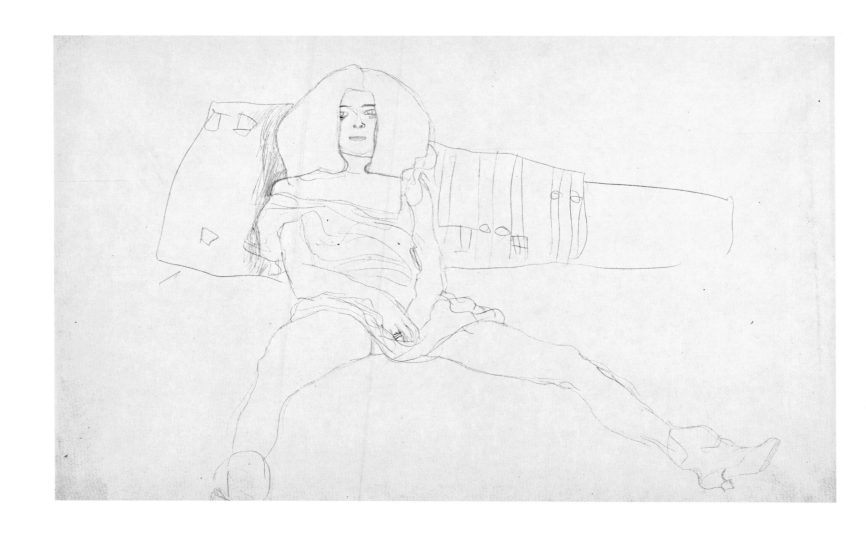

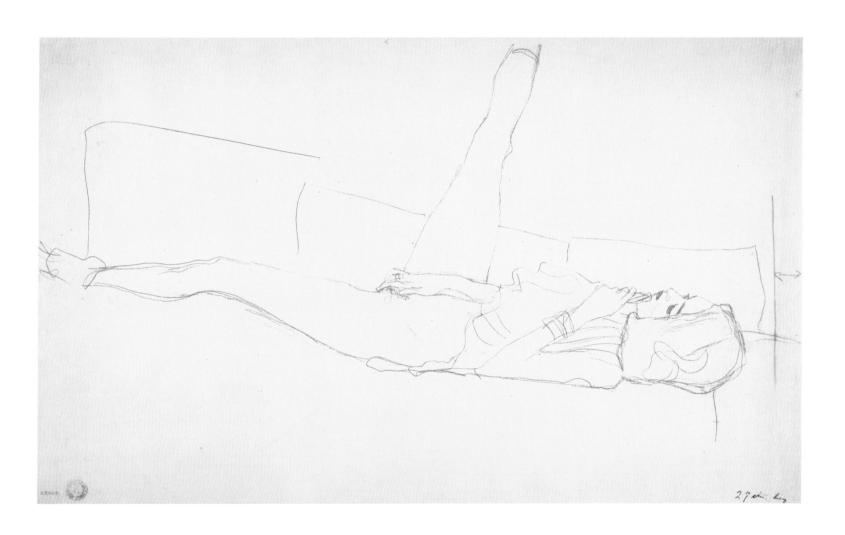

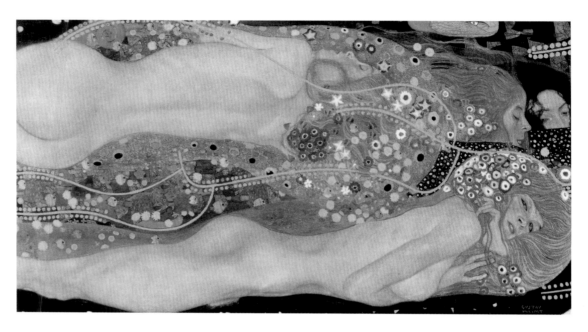

the mysterious expression of the face turned toward the viewer. Despite her outward passivity, the figure stretched in parallel with the picture plane seems to be part of a horizontal continuum. This effect is enhanced by fragmentations on both sides; moreover, the outline of the fabric embedding the body looks like a wave. The geometry of the rectangular form of the cushions located on the upper edge of the sheet contributes essentially to the highly balanced planar organization. The structural density of the upper section of the image is effectively balanced by the lower blank area; the well-calculated position of the signature is characteristic of Klimt.

This sheet points to several essential changes in the artist's drawing practice. Eros as the mysterious core of the themes of life becomes the focus of tireless study of the female model. Later Klimt attempted again and again to capture the essence of a dreamy mood or an erotic ecstasy and subject it to formal rules. The horizontal position as a metaphor

for dreamy flowing along as seen here would remain a favorite formula in all phases of his development. Increasingly, the figure drawings go beyond their function as preparation for the paintings and become ends in themselves.

In the creative tension between erotic nuances and formal discipline, he often depicted extreme physical positions like those of a lying and frontal seated model, respectively, in two studies from 1904 (cat. nos. 95, 96). In both cases, the angular forms of cushions and strikingly outlined parts of the body organize the surface of the paper. This results in a geometrically oriented dialogue between radically overlapping forms and blank areas. The focus is on erotic accents—the hands of the seated model facing forward, folded in front of her covered pubic area, or the masturbating hand of the woman lying on her back with her right leg extended upward. Both drawings were included among fifteen illustrations by Klimt in a 1907 bibliophile publication of Lucian's *Hetärengespräche* (Dialogues of the Courtesans).[3]

In 1905–6, Klimt produced several studies in blue and red pencil for the second version of *Water Snakes II* (1907, fig. 2), including the sheets exhibited here (cat. nos. 97, 98). In terms of its position and hair color, the model lying on her stomach, sketched in blue and red, corresponds to the lower figure in the painting. The contrast between the brightness of her naked, exposed behind and the linear movement of the "inner life" of the clothing seems almost painterly. The superimposed nudes of the study drawn in red anticipate the multiple figures of the painting. In this sensitive study on the theme of lesbian love, Klimt concentrated on the dreamy facial expressions of the two women, whose heads seem to grow together as a result of the overlapping contours of their hair. Despite the closeness to the painting, both drawings—like all the sheets in this group—are presented as cohesive, autonomous works.

[1] Hans Koppel, "Wiener Neuigkeiten: Bei Gustav Klimt," *Die Zeit*, 406, November 15, 1903, p. 4.

[2] *Water Snakes I*, 1904–7, mixed media, gold leaf on parchment, 50 × 20 cm, Belvedere, Vienna; *Water Snakes II*, 1904–7, oil on canvas, 80 × 145 cm, private collection. Novotny and Dobai 1975, no. 140; Weidinger 2007, no. 173. The studies from 1904 (Strobl II, 1982, nos. 1358–1409) were produced for the first version of the painting, which was later painted over. The theme of lesbian love is also treated in the studies for *Water Snakes I* (1904–7).

[3] Lucian, *Hetärengespräche* (Dialogues of the Courtesans), trans. Franz Blei (Leipzig, 1907), figs. opposite p. 8 (cat. no. 95), and opposite p. 26 (cat. no. 96).

The Stoclet Frieze: "Expectation"

One of the outstanding major works of Gustav Klimt's Golden Style is the mosaic frieze he designed for the dining room of the Palais Stoclet built by Josef Hoffmann in Brussels. In 1910–11 the frieze was executed by a team of highly qualified artisans working for the Wiener Werkstätte.[1] They worked from plans nearly two meters high drawn by the artist, which are now located in the Österreichisches Museum für angewandte Kunst in Vienna.[2] When they were living in Vienna (1903–4), Adolphe and Suzanne Stoclet had their first discussions about a potential building in the Hohe Warte with the elite of the Secession and the Wiener Werkstätte.[3] This highly cultivated and wealthy couple visited the *Klimt-Kollektive* exhibition at the Secession, where *The Beethoven Frieze*—which would soon enter a private collection—was still in place. This monumental work was certainly at the root of the idea to commission Gustav Klimt to design a frieze for the dining room of their palais.[4] Most of the work on the designs and mosaic tiles, which were sent to Brussels at the end of 1911, was done between 1908 and 1911. Klimt's grappling with the central themes of "Expectation" (fig. 1) and "Fulfillment" (fig, 1, p. 190) had already begun in 1904–5 in several series of figure studies.[5] The present selection of drawings is based on these two themes in order to spotlight aspects of the complex process of work on the project.

The 1904–5 drawing of a standing man carrying a weight on his bent neck is one of a group of studies of athletes that cover this male theme, which was rare for Klimt (cat. no. 99).[6] In the present drawing, perhaps an early attempt to note ideas for the frieze, the muscular body is combined in unusual ways with the introverted facial expression of the highly stylized profile.[7] This combination of heroism and melancholy points to two aspects of *The Beethoven Frieze*: the heroism of "The Knight in Full Armor" and the internalization of "Poetry," whose head bent forward emphasizes the aspect of spiritualization. In both cases, the profile pose is connected with the striving for an ideal state: in the case of the knight, on an active level, and in the case of "Poetry," on a contemplative one.

This active and spiritual striving for the distance also characterizes the subsequent series of studies in which Klimt treated the theme of expectation several times. Active striving is the theme of a large group of studies from 1906–7 of muscular female models in energetic striding postures.[8] The 1907–8 study of a woman reading is an impressive example of the outstanding series of reading and singing women that alludes to the inner exaltation of human beings through art (cat. no. 100). This is another example of grappling again with the ideas of *The Beethoven Frieze*.[9] In parallel with the painted masterpieces of his Golden Style in 1907–8, Klimt also produced highlights as a draftsman. The artist's characteristic balance of strict discipline and linear freedom produces particular tension here. The sharply outlined, strictly stylized face of the reader in profile is of great linear concentration, with her lowered eye directed at the sheet being held up. The course of the lines of her patterned cape, which unfurl downward with increasing vehemence, is tamed by the powerfully repeated contours that emphatically set off the ramrod-straight figure from the empty background. The lack of a connection to the ground underscores the elevated, serious mood of the study.

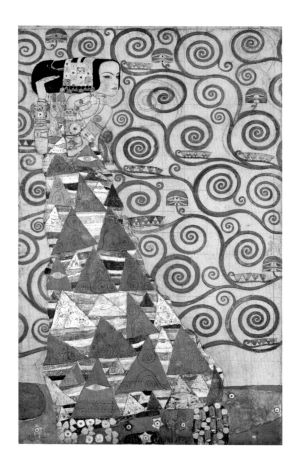

Fig. 1. "Expectation," cartoon for *The Stoclet Frieze*, 1910, tempera, watercolor, chalk, gold leaf, etc., 195 x 120 cm, MAK—Austrian Museum of Applied Arts / Contemporary Art, Vienna

1 Novotny and Dobai 1975, no. 153; Weidinger 2007, no. 192.
2 Strobl II, 1982, nos. 1810–18. For a detailed discussion of the *Stoclet Frieze*, see Friedrich Kurrent and Alice Strobl, *Das Palais Stoclet in Brüssel* (Salzburg, 1991).
3 Weidinger 2007, pp. 119–20.
4 Presumably the Stoclets acquired on this occasion the transfer sketches with an enlarging grid for *The Beethoven Frieze*, which are still in the possession of their family (Weidinger 2007, p. 121). Adolphe Stoclet had to take over the family businesses when his father suddenly died, so the couple was forced to return to Brussels and built the palais there.
5 Strobl II, 1982, pp. 161–64.
6 Strobl II, 1982, nos. 1520–32.
7 On the possible connection between these studies and the *Stoclet Frieze*, see Strobl IV, 1989, p. 149. See also the great similarity of the male profile to Strobl II, 1982, no. 1790, which makes it possible to date this drawing to 1904–5.
8 Strobl II, 1982, nos. 1533–70; Strobl IV, 1989, nos. 3580–87.
9 Strobl II, 1982, nos. 1637–49; Strobl IV, 1989, nos. 3592–96a.
10 Strobl II, 1982, nos. 1660–91.
11 Strobl II, 1982, p. 143.
12 Marian Bisanz-Prakken, in Exh. cat. The Hague 2006–7, pp. 205–8.

The last stage before the final sketch for the richly ornamented, Egyptian-inspired "Expectation" is represented by a number of studies of female dancers (cat. nos. 101, 102).[10] On the one hand, the choice of this motif was connected with the great interest the Stoclets had for this art form. On the other hand, Klimt himself was enthusiastic about both exotic dance and modern expressive dance.[11] Nevertheless, the female dancers he sketched expressed their spiritual striving for the distance not through movement but rather through their postures, gestures, and dreamy facial expressions. His figures remain in an "Egyptian" position, with body facing front and face turned to the side. The striding postures of the dancers are defined by the simple contours of their skirts, which drape broadly and are cut off by the lower edge of the sheet; the lack of contact with the ground lends these figures

the appearance of floating. With the ritual gestures of their overly slender arms and hands angled in many directions, Klimt created a highly personal synthesis of his impressions of ancient and contemporary role models. The fragile geometry of these timelessly, elegantly "styled" figures should be traced back not only to Egyptian inspiration but also to his intense reception at the time of the ideal figure represented by George Minne and Jan Toorop.[12] In the context of the figure of the female dancer, Klimt also sketched several autonomous female heads inspired by Egyptian models. The example shown here is characterized by a classical, monumental serenity (cat. no. 103).

This previously unpublished study of a columnlike figure fragmented above and below stands completely alone (cat. no. 104); based on the closeness of its motifs and style to studies produced for the *Stoclet Frieze*, it can plausibly be placed in this context—presumably toward the end of the phase of the preparatory drawings. The monumental cohesiveness of the figures recalls an Egyptian mummy but also the abstracted figure of the knight on the short wall of the mosaic frieze. The free ornamental structures—in which the perspective of the bent right arm is completely flattened out—recall some of the patterns produced around the same time, including the clothing of some of the female readers. Last but not least, the "Egyptian" profile of the summarily sketched head determines the fascinating character of this singular autonomous work.

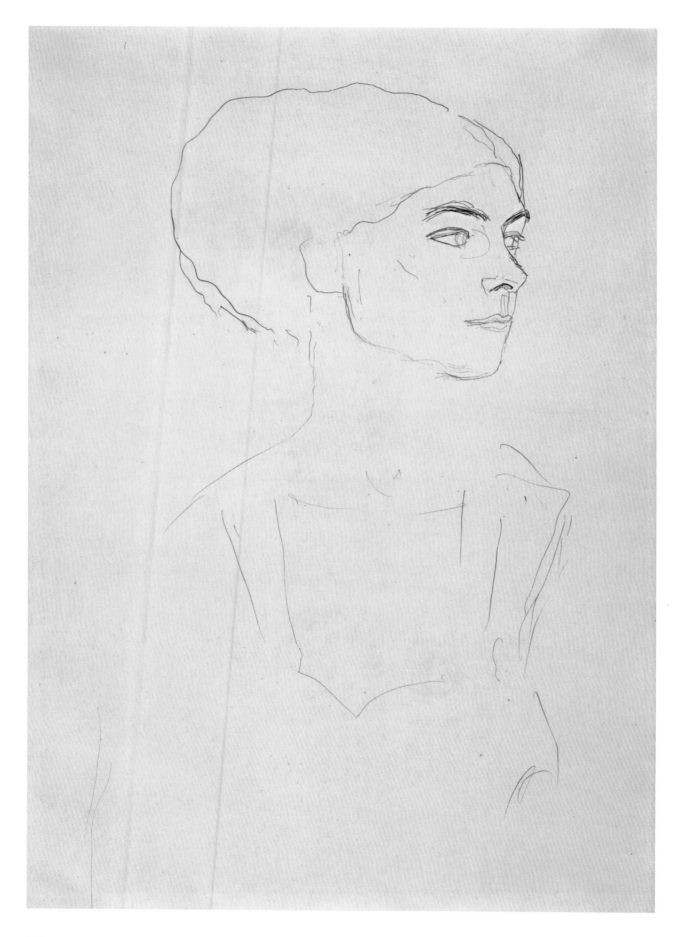

103

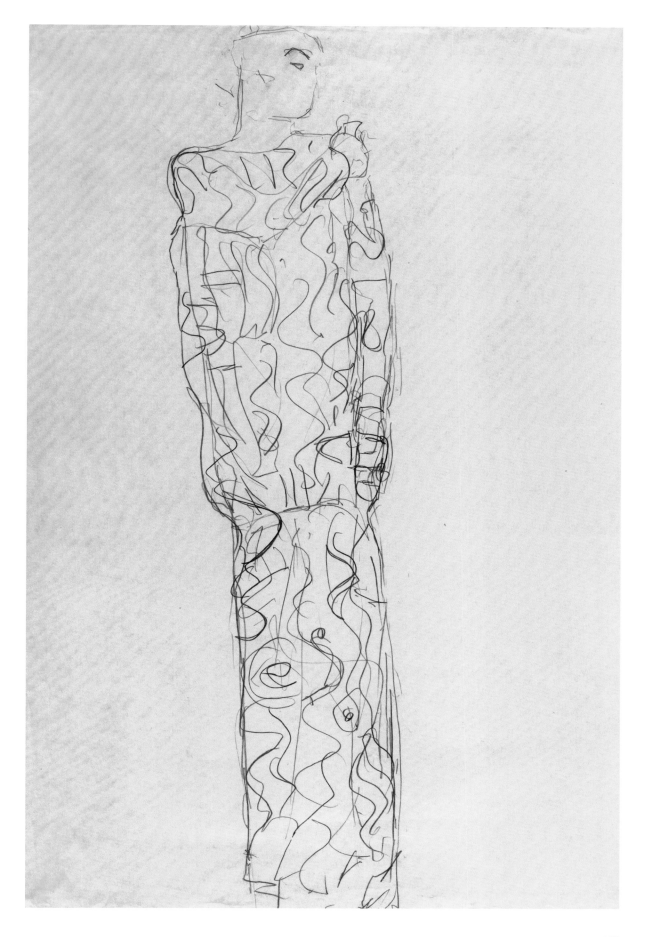

105
Standing Pair of Lovers, Seen from the Side, 1907–8

Blue pencil, 56 × 37.1 cm
Albertina, Vienna, inv. 29843 | Strobl II, 1787

106
Standing Pair of Lovers, Seen from the Side, 1907–8

Graphite, 56.5 × 37.3 cm
Leopold Museum, Vienna | Strobl II, 1788

107
Standing Pair of Lovers, Seen from the Side, 1907–8

Graphite, red pencil, gold paint
29.6 × 28.2 cm (sheet); 24.4 × 14 cm (image)
Albertina, Vienna, Batliner Collection,
inv. DL391 | Strobl II, 1793

108
Kneeling Man and Seated Woman Embracing, 1907–8

Graphite, 56.5 × 37 cm
Private collection
Bisanz-Prakken, forthcoming

109
Pair of Lovers, 1907–8

Graphite, 37.2 × 56.5 cm
Private collection, courtesy of Richard Nagy
Ltd., London | Strobl II, 1794

110
Two Male Heads in *Profil Perdu*, 1907–8
Studies for *The Kiss*

Graphite, 56 × 37 cm
Albertina, Vienna, inv. 34557 | Strobl II, 1800

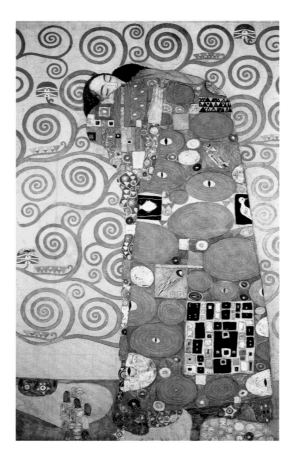

Fig. 1. "Fulfillment," cartoon for *The Stoclet Frieze*, 1910, black chalk, watercolor, etc., 195 × 120 cm, MAK—Austrian Museum of Applied Arts / Contemporary Art, Vienna

The Stoclet Frieze:
"Fulfillment" and *The Kiss*

In the mosaic frieze for the Palais Stoclet (1905–11), the figure of "Expectation" (fig. 1, p. 184) gazing into the distance stands diametrically opposed to the embracing lovers of "Fulfillment" (fig. 1). For this polarity, Klimt went back to *The Beethoven Frieze* (1901–2), in which several figures in profile seem to strive for the ideal of happiness.[1] Human desires and wishes find their symbolic fulfillment in the physical and spiritual unity of man and woman: the standing, embracing pair of lovers in the "Ideal Realm" forms the stable opposite pole to this horizontal movement. In his studies for the group of two nudes, Klimt emphasized the sweep of the subtly differentiated contour lines (cat. no. 63).

His grappling with the theme of man/woman was considerably more complex in the context of the preparatory drawings for the mosaic frieze.[2] As in *The Beethoven Frieze*, in the final version the female figure is largely covered by the man seen from behind, with the difference that the lovers here are wrapped in long, ornamented gowns. Only some of the studies relate directly to this final constellation of figures. Most of the drawings of the lovers were clearly produced for their own sake and served primarily to immerse himself in the themes, which—created at the same time as the preparatory drawings for the pair of lovers in the mosaic frieze—were employed in the world-famous painting *The Kiss*, which was completed in 1908 (fig. 2).[3] That major work, in which the man sinks down and bends over the kneeling woman, is also only loosely connected to the preparatory drawings, with only a few being more closely related. In the 1907–8 drawings produced in connection with "Fulfillment" and *The Kiss*, the artist developed a large spectrum of stylistic solutions and psychological nuances. Klimt was always concerned with taking an empathetic approach to the subtle give and take between the partners—contrasting with the executed versions, which are characterized rather by male dominance and female passivity.[4]

Unlike the completely dressed lovers of the frieze and painting, in many of the drawings the man is wearing a kimono and the woman is naked. Klimt repeatedly played the empty, expansive form of the man's clothing out against the sensuous forms of the woman's body in subtle ways. With spontaneous, confident lines of blue pencil, he recorded on the sheet presented here the moment when a man

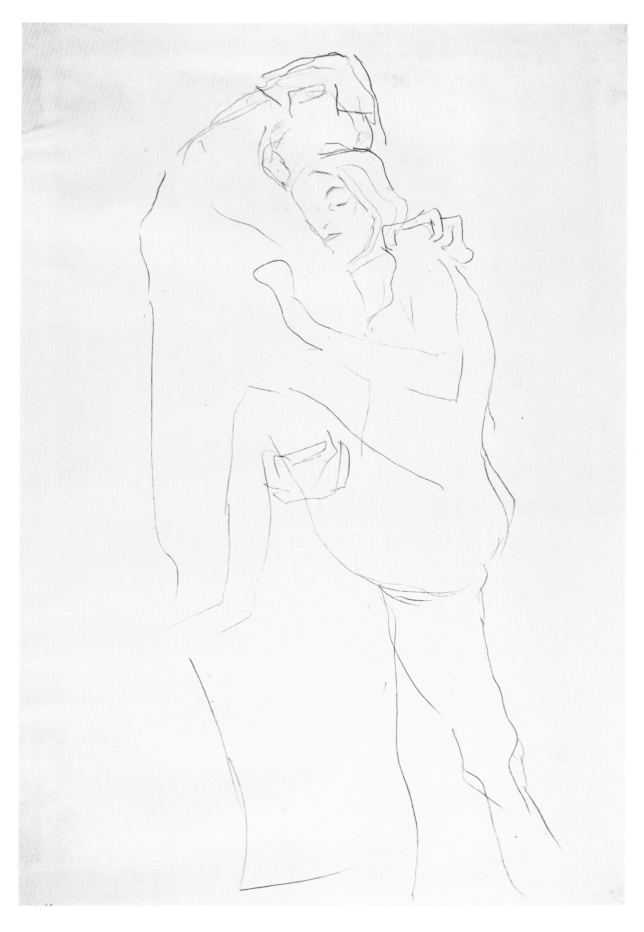

105

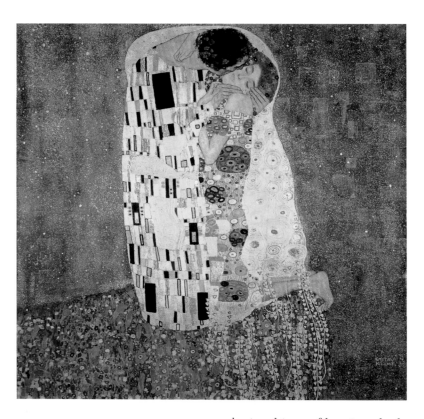

Fig. 2. *The Kiss*, 1908, oil on canvas, 180 x 180 cm, Belvedere, Vienna

contour of her bare buttocks. The dancing movement of the feet evokes an immaterial state of floating.

The motifs of this study are for the most part similar to those of a drawing of a couple standing, whose small format and painterly, ornamental character, combined with the subtle use of gold and watercolors, occupies a unique position (cat. no. 107).[5] In this work produced for a dedication, both the suggestion of an abyss and the columnlike background filled out with spiral forms point to the painting *The Kiss*. With their statuelike quality, however, the lovers are related to the standing couple of "Fulfillment."

Sometimes the masterly legerity with which Klimt manages the tightrope walk between sensuousness and emotional content, on the one hand, and formal discipline, on the other, produces outstanding results. The way he tamed the visible geometrically and at the same time enlivened it erotically and spiritually at the height of his Golden Style is exemplified by the completely autonomous study of a pair of lovers, one kneeling and one sitting (cat. no. 108). The kneeling man anticipates the pose of the woman in the painting *The Kiss*, while the partner squeezing him with her legs seems to linger in a vacuum, with no suggestion of anything to sit on. This merely emphasizes the couple as a hermetically isolated, graduated overall form. Klimt the draftsman's search for the quintessence of the male-female relationship finds its erotic culmination in a drawing in which he explores with linear precision the cosmic force of the love act, as it were (cat. no. 109). The complex of highly calculated overlapping corporeal forms and clothing is presented like a work

depicted in profile raises the knee of his partner, who is leaning against his chest (cat. no. 105). In this nuanced constellation of planes, accents stand out for their psychological acuity, such as the man's supporting hands or the tender coming together of the two heads. By contrast, the study of a pair of lovers standing in profile is dominated by the interlocked forms of the striking, angular arms of the woman embracing the man and the rectangular sleeves of the kimono (cat. no. 106). The geometric contour of the heads nestling together anticipates to a certain extent the formal solution of *The Kiss*. Here too Klimt established psychological and erotic accents. He emphasized the tensed hands of the woman and their rhythmical harmony with the gesture of the man embracing her; the enraptured expression of her face in profile; and the outward curving

of architecture centered on the male genital region. The tension between abstraction and naturalness, between formal discipline and linear movement, is particularly effective here.

One of the few studies directly connected with the painting *The Kiss* is a sheet with two details for the bending man in *profil perdu*, or "lost profile" (cat. no. 110). In the painting, Klimt did away with the small beard seen here. The sharpness of the sketched outlines corresponds to the striking contours of the sun-tanned face in the oil painting, which stands out strikingly against the masklike pallor of the woman's face.

1 Bisanz-Prakken 1977, pp. 47–48.
2 Strobl II, 1982, nos. 1718–44, nos. 1786–1809; Strobl IV, 1989, nos. 3607–16.
3 *The Kiss*, 1908, oil on canvas, 180 × 180 cm, Belvedere, Vienna. Novotny and Dobai 1975, no. 154; Weidinger 2007, no. 189.
4 On the connotation of the depictions of lovers with the personality of the artist and his companion, Emilie Flöge, see Strobl II, 1982, p. 162, and Strobl IV, 1989, p. 241.
5 From the Egge Sturm-Skrla dedication portfolio, *Kunstschau 1908* (auction catalogue of the Galerie Hassfurther in the Secession, May 8–31, 1979, no. 155, with no further information).

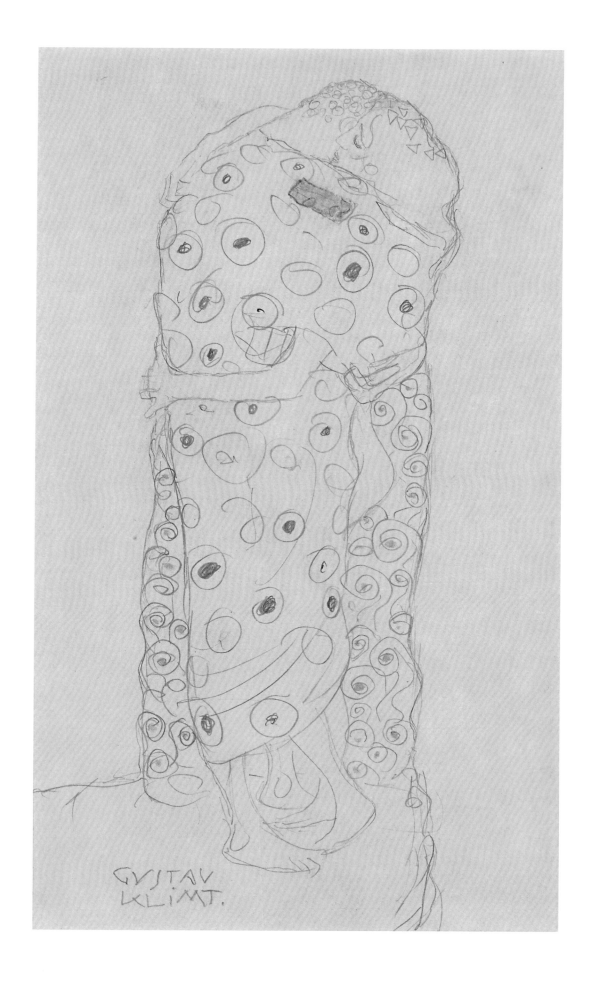

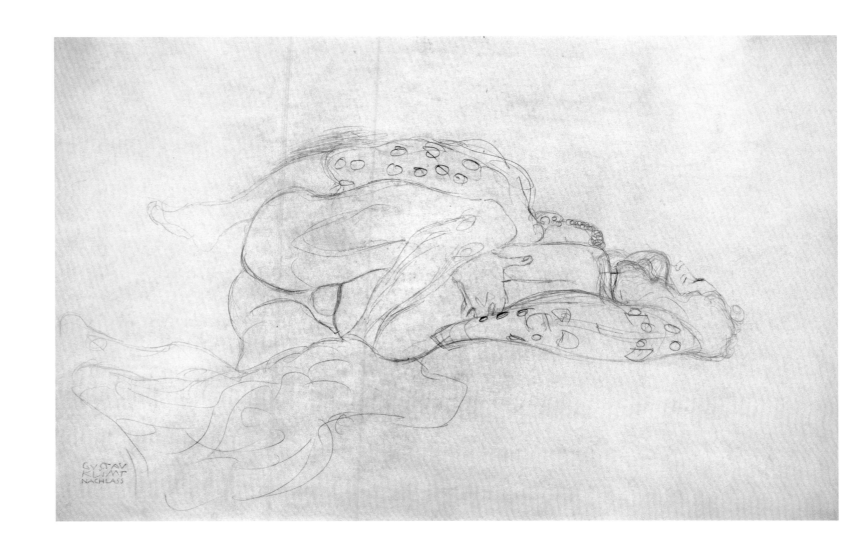

109

Judith II (Salome)

First presented in 1909 under the title *Judith*, this painting was subsequently exhibited as *Salome*. Today the painting is known both as *Judith II*—to distinguish it from *Judith I*, painted in 1901—and as *Salome* (fig. 1).[1] The latter is connected to the figure Klimt painted above all by the sweeping veils that spread down from her bare breasts across the picture plane. In exchange for her dance of the veils, Salome obtained from her stepfather Herod the severed head of John the Baptist, whom she had coveted in vain. This biblical topic was widespread in the literature, music, and visual arts of the turn of the century. Klimt assimilated a number of inspirations on the subject, including the Salome illustrations of Aubrey Beardsley (1894), in order to produce a highly original creation.[2] Crammed into an extremely narrow vertical format, the gaunt, dark-haired woman has pale skin and fire-red, slightly open lips; her protruded, colorfully adorned hairstyle explodes this slender format. Her madness is suggested by her lascivious, veiled gaze and her cramped fingers, from which the severed head dangles by its hair. The Golden Style's decorative idiom of forms and lines still dominates here, though the artist would soon distance himself from it.

Klimt's attempt to come to terms in a drawing with this New Testament femme fatale dispensed with extreme depictions of madness and glaring eroticism. The two studies of a gaunt model with raised leg depicted frontally are connected both with the dance theme of Salome and with the drawings of dancers produced in 1907–8 in preparation for *The Stoclet Frieze* (cat. nos. 101–104).[3] The figure in the drawing in blue is distinguished, despite its central anchoring in the plane, by a lively play of geometrically angled arms, hands, and shoulders, continued by the diagonal orientation of the head and its sweeping hair and seductively furtive eyes (cat. no. 111). With a coquettish gesture, she gathers up the broad pleats of her dress and thereby exposes her obliquely angled lower leg, which forms a diagonal with her right upper arm. The same leg position is found in the dancer in the graphite drawing whose form is repeated on a smaller

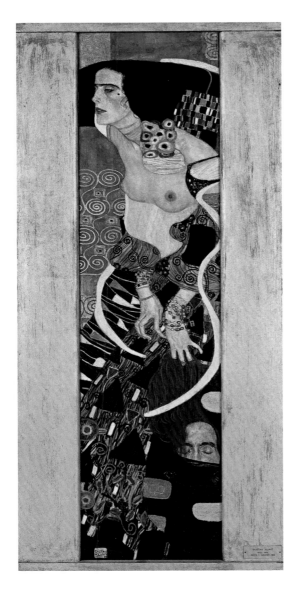

Fig. 1. *Judith II (Salome)*, 1909, oil on canvas,
178 × 46 cm, Galleria internazionale d'Arte
Moderna di Ca' Pesaro, Venice

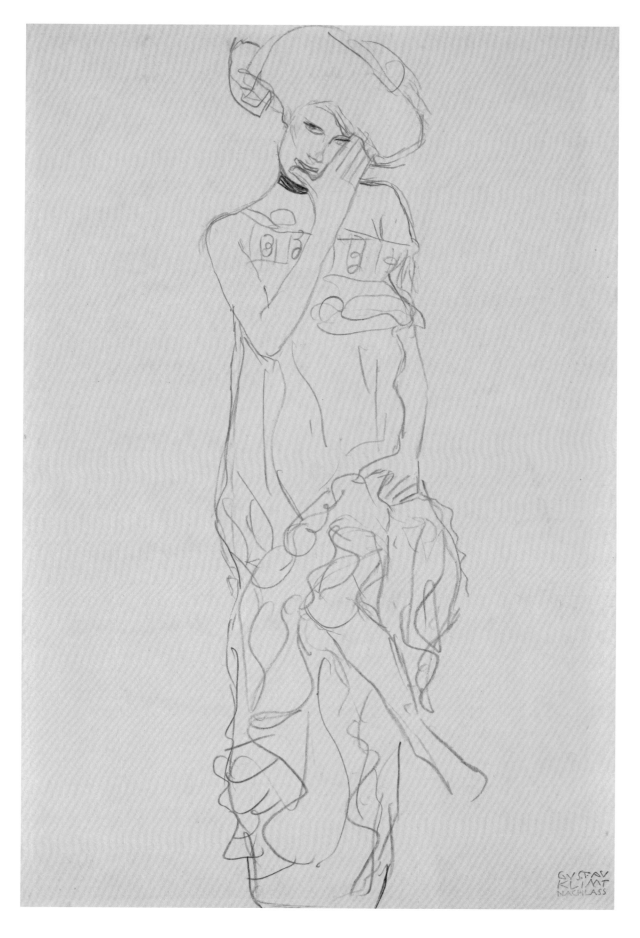

111

scale (cat. no. 112). In this study there is a strange split between the buoyant lines of the skirt and leg and the solemn, frozen-looking gesture of the upper body. By concentrating powerful strokes, Klimt distinguished the broad hairdo from the blank section like a relief. This emphasizes all the more the serious, meditative expression of the woman's face bent forward, supported by her slender, vertically extended hand. The rhythm of the bent limbs reveals a recollection of the Gorgon on the right in *The Beethoven Frieze* who breaks through the canon of horizontal and vertical lines with a zigzag movement of her arms and legs (cat. nos. 56, 57, and fig. 4 on p. 112). But in the works in pencil of the Golden Style, this monumental tendency is associated with highly differentiated lines. The introverted atmosphere of the present work is at odds with the subject matter of the painting.

This optimal balance between a strict commitment to the plane and an unforced, sensitive use of line is also found in a drawing of a seated model who has removed her clothing down to her waist (cat. no. 113). In the painting, Klimt took his lead from this study especially in relation to the slight forward bend of the naked, gaunt upper body and the diagonal course of the shoulder's contour; the flowing lines of her patterned undergarments anticipate the veils of the painting. The relaxed figure gazing openly at the viewer is, however, far from the femme fatale type. Klimt was primarily concerned with achieving a balanced relationship between volume and plane, of striking, contrasted forms and empty fields. The body becomes a monument; the poses and gestures follow the higher laws of geometry.[4] Nevertheless, Klimt knew how to bring a figure organically and spiritually to life by means of subtle handling of the lines. He effectively plays the succinct contours of the upper body against the agitated lines of the clothing, in the middle of which the angular knees emerge like islands. The subtle blue and red accents and the decoratively integrated signature contribute to the impression of a finished, autonomous work.

[1] *Judith II (Salome)*, 1909, oil on canvas, 178 × 46 cm, Galleria Internazionale d'Arte Moderna di Ca' Pesaro, Venice; Novotny and Dobai 1975, no. 160; Weidinger 2007, no. 193.
[2] Strobl II, 1982, pp. 151–53.
[3] Ibid.
[4] On the influence of George Minne and Jan Toorop on the ideal of the gaunt body and the gestures of the figures of the Golden Style, see Marian Bisanz-Prakken, in Exh. cat. The Hague 2006–7, pp. 200–210.

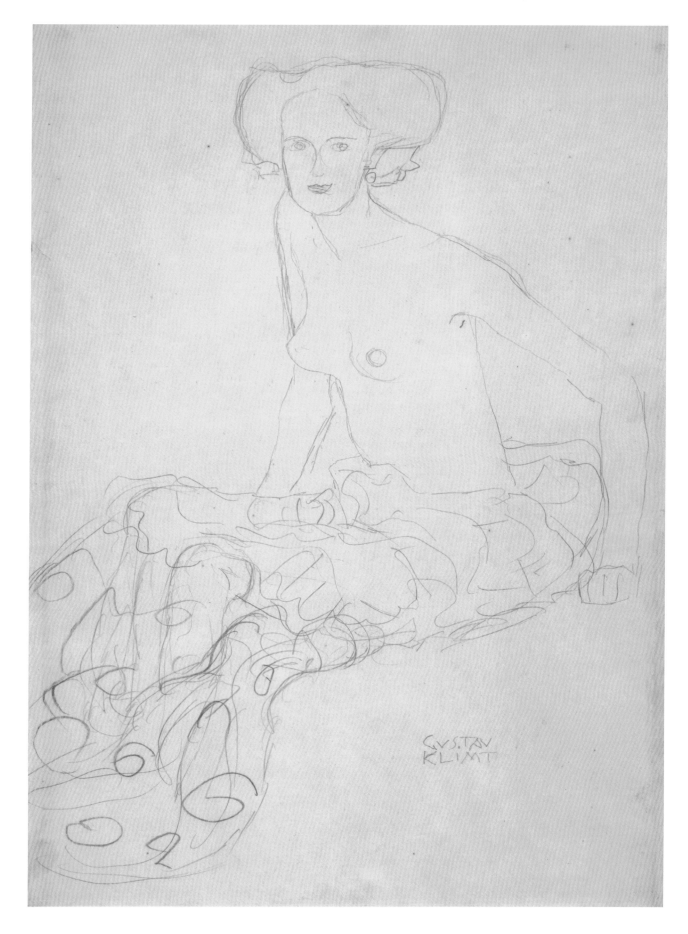

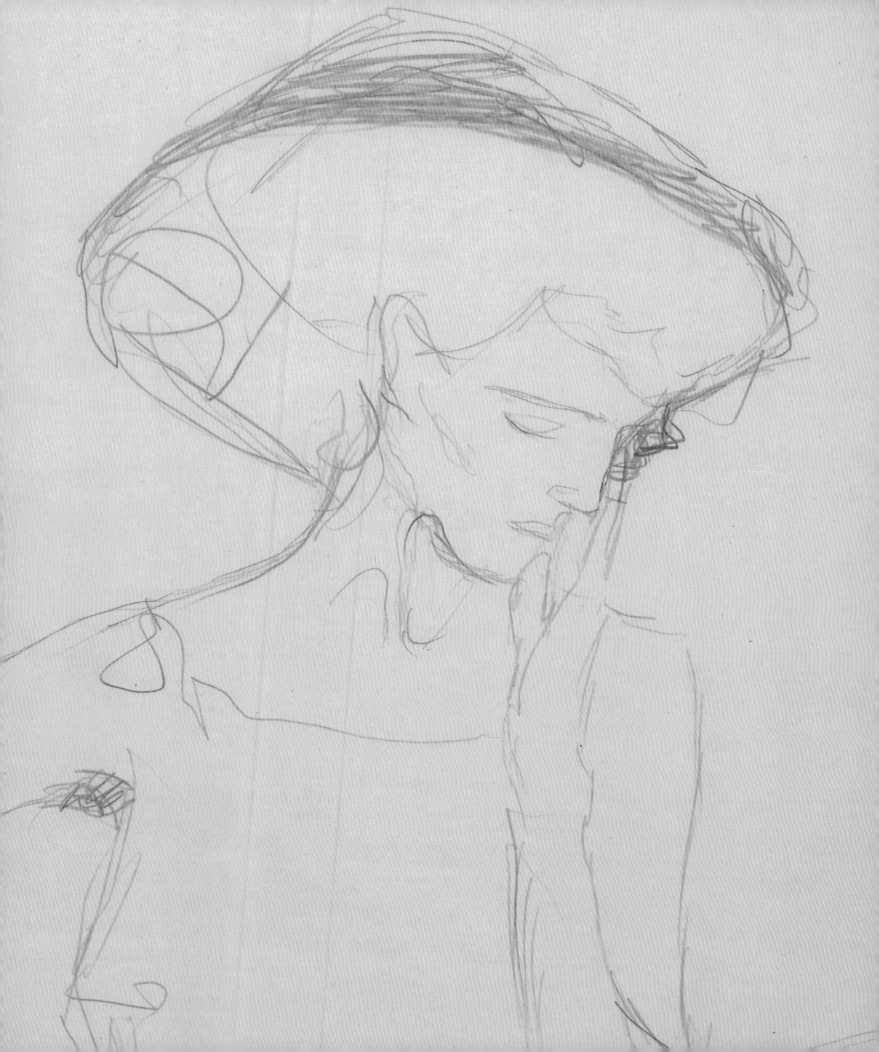

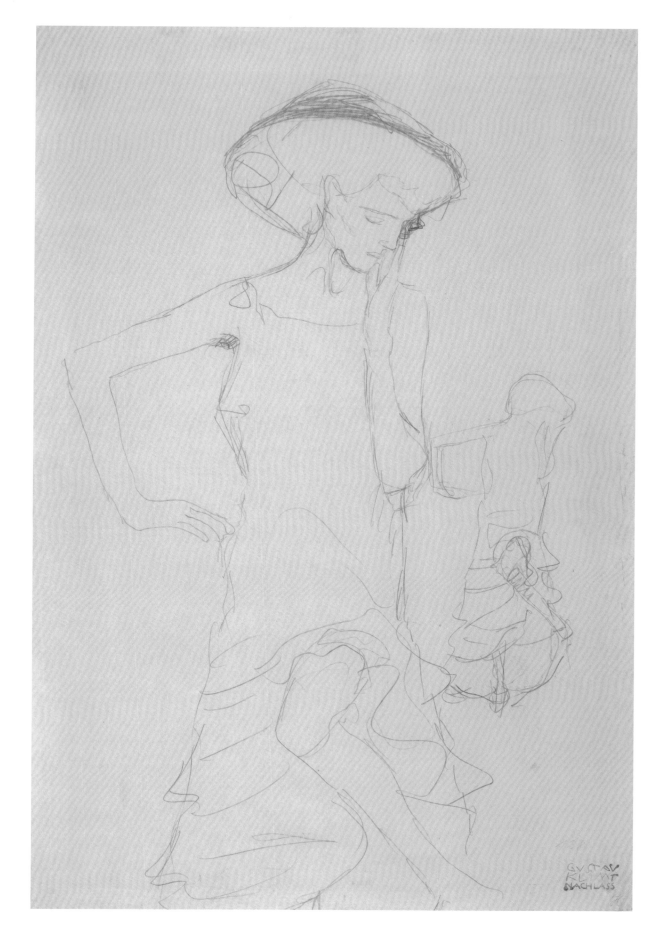

112

Death and Life

Death has many faces in Gustav Klimt's oeuvre.[1] The genre of drawings and paintings of Death and of posthumous portraits is represented many times from the 1880s onward.[2] In his Symbolist works of the 1890s, the metaphysics of transience plays an increasingly important role. After the turn of the century, the connection between death and life became a dominant theme: in the trailblazing allegories of life *Philosophy* and *Medicine*, death is found both in an actively threatening role and as seen from the perspective of suffering. The sufferers are the naked people floating in space, impotently exposed to fate. In *Philosophy*, death is latently perceptible in the abyss into which the desperate old people visible in the lower part of the image are floating downward (fig. 3 on p. 78); in *Medicine*, Death appears as a skeleton in a long, blue gown (fig. 1 on p. 82). In *Hope I* (1903–4; fig. 1 on p. 156), Death in

a blue garment of veils threatens life growing in the mother's womb.

In the painting *Death and Life* (fig. 1), for which the first studies were produced in 1908–9—including the sheet exhibited here of a bowed male head (cat. no. 114)—the connectedness of the extremes that determine human existence become the program for the first time. In the process, Klimt referred both to *Philosophy* and *Medicine* and to *The Three Ages of Woman* (1905; fig. 1 on p. 166). The first version of the painting (1910–11), of which an illustration survives (fig. 5 on p. 256), was reworked in 1916 (fig. 1).[3] In both versions, Death is dressed in a long gown and standing emphatically opposite a tower of figures. Originally, this monumental form symbolizing the stages of life consisted of a young mother and her child, a frontal head of an old woman, and a middle-aged man bending protectively over his female companion. In the final version, Klimt added several figures to this core group and changed the positions of the body and head of Death. Whereas the hair of the woman depicted at the bottom is replaced by a pinned-up hairstyle, he left the man's upper body, for which the study exhibited here was produced, essentially unchanged.

This centrally positioned figure has two allegorical functions. The man protects the woman's life with the physical power of his extremely muscular body. At the same time, the spatial, plastic protrusion of his face leaning forward—the introverted expression which is the focus of the work—represents the melancholy reflection on the transience of life. Both functions are reflected in the 1908–9 studies. The protective role of the man is a theme in several autonomous draw-

Fig. 1. *Death and Life*, 1910–11, revised in 1916, oil on canvas, 178 x 198 cm, Leopold Museum, Vienna

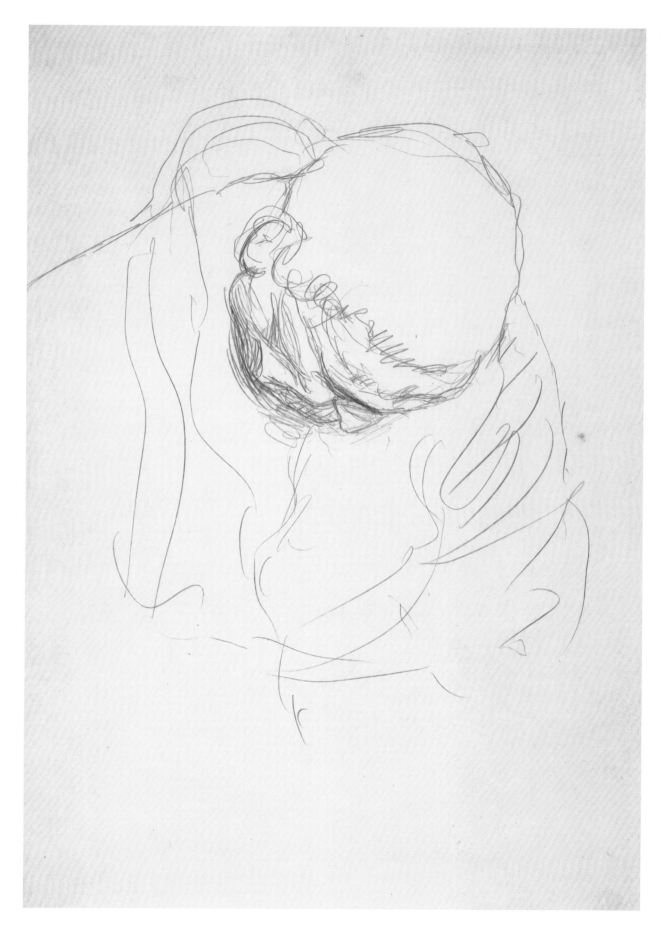

ings of lovers—such as the depiction of a man in a kimono and an undressed woman in the slightly earlier studies for *The Kiss* and *The Stoclet Frieze* (cat. nos. 106, 107).[4] The man in the study exhibited here, whose face bent forward is Klimt's primary reference for the version in oil, is also wearing a kimono, albeit only sketchily indicated. As in the painting, his bowed face, drawn with vigorous lines, seems to break out of the picture plane, emphasizing even more effectively the aspect of spiritualization. In this meditative, monumental work in pencil, the connection between death and life symbolized in the painting found its specific expression. The expansive, expressive depiction of the man's face seems to announce the end of the Golden Style.

For the woman in the couple in *Death and Life*, Klimt produced a series of nude studies in which he explored in many variations the motif of the mourning, self-engrossed figure with head bent forward.[5] About a year later he went back to these drawings for a series of autonomous studies of seated nude and seminude figures. One of these is a drawing of a balanced seated frontal figure whose expression of immediate naturalness already points to future developments (cat. no. 115).

[1] On this theme, see Strobl II, 1982, pp. 197–200.
[2] On the theme of portraits of Death, see Bisanz-Prakken 1996.
[3] *Death and Life* (other titles used during Klimt's lifetime: *Death, Death and Love, Fear of Death*), oil on canvas, 178 × 198 cm, Leopold Museum, Vienna; Novotny and Dobai 1975, no. 183; Weidinger 2007, no. 206. For the first discussion of both versions, see Strobl II, 1982, pp. 198–99.
[4] Pair of lovers for *Death and Life*: Strobl II, 1982, nos. 1869–76.
[5] Strobl II, 1982, nos. 1819–50; Strobl IV, 1989, nos. 3621–24.

115

Portrait *Fritza Riedler*

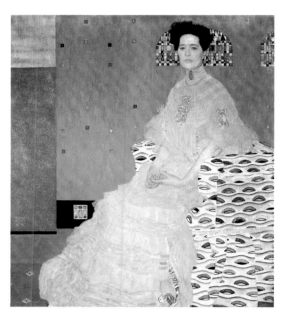

Fig. 1. *Fritza Riedler*, 1906, oil on canvas, 153 x 133 cm, Belvedere, Vienna

The drawings for his portraits clearly reveal Klimt's turn to a new monumentality around 1904—as a parallel phenomenon to the nude studies. The euphoria of the "Sacred Spring" of the Secession corresponds to the verve of linear flows that characterizes the studies for the portraits *Serena Lederer* (1898–99), *Rose von Rosthorn-Friedmann* (1900–1901), and *Adele Bloch-Bauer I* (ca. 1903)—in the last case in combination with geometric motifs (cat. nos. 68–77, 79–82). In the 1904 studies for the portrait of Fritza Riedler, completed in 1906, the artist's breakthrough to geometric design principles is clearly manifest.[1] During this period the avant-garde—the so-called Klimt group—left the Secession in 1905, which marked the beginning of a new era.

Fritza Riedler, née Langer, was married to Aloys Riedler, a professor at the Technische Hochschule Berlin-Charlottenburg, and frequently stayed in Vienna.[2] No information is available regarding the commission for her portrait. In this major work of Klimt's Golden Style, the forty-six-year-old woman sits enthroned against a backdrop consisting of large- and small-scale rectangular forms (fig. 1). The woman's majestic pose and the ornamentation around her face reveals that Klimt was inspired by the portrait of the Infanta Maria Theresa by the painter Diego Velázquez, whom he admired.[3]

The studies for the painting are also marked by this courtly feel, in which the model is sitting in a chair in a ramrod-straight pose.[4] The drawing presented here—which corresponds largely to the painting in terms of pose, clothing, and decoration, apart from the boa—is dominated by a serene balance of effectively contrasted planes. The triangular void of the armrest that has been left out on the front acts as a barrier between the viewer and the aristocratically contrasted figure. Within the contours, Klimt used subtle, carefully distributed lines to define the vertically draped boa, the geometrically stylized hands resting in her lap, and the folds of her clothing. The delicate rhythm of the structure of her necklace causes her face to stand out brightly. Her visual contact with the viewer is limited to one eye; her mouth is slightly open, as if to speak. Although he was focusing on the study of the positions and gestures of the sitter posing for him, Klimt causes the essential aspects of her facial expressions to flash through now and again. This tension between the spontaneity of the moment and the claim to the eternally valid accounts for the autonomous character of his studies for painted portraits.

1 *Fritza Riedler*, 1906, oil on canvas, 153 × 133 cm, Belvedere, Vienna; Novotny and Dobai 1975, no. 143; Weidinger 2007, no. 180.
2 Exh. cat. Vienna 2000–2001, pp. 111–14.
3 Diego Velázquez, *Infanta Maria Theresa*, ca. 1652–53, oil on canvas, 127 × 98.5 cm, Kunsthistorisches Museum, Vienna; see Strobl II, 1982, p. 27.
4 Strobl II, 1982, nos. 1226–46; Strobl IV, 1989, nos. 3542–42b.

117
Standing Woman with Wrap, 1904
Study for
Margarethe Stonborough-Wittgenstein
Green pencil, 54.9 × 34.5 cm
Albertina, Vienna, inv. 29734 | Strobl II, 1256

118
Woman Standing with Head Turned Slightly Left, 1904
Study for
Margarethe Stonborough-Wittgenstein
Black chalk, 55 × 35 cm
Albertina, Vienna, inv. 29842 | Strobl II, 1265

119
Woman Standing with Hands Clasped, 1904
Study for
Margarethe Stonborough-Wittgenstein
Black chalk, 55 × 34.6 cm
Albertina, Vienna, inv. 27935 | Strobl II, 1266

120
Woman Standing with Head Inclined, 1904
Study for
Margarethe Stonborough-Wittgenstein
Red pencil, 55 × 35.2 cm
E. W. K., Bern | Strobl II, 1268

121
Woman Standing with Arms Dangling, 1904
Study for
Margarethe Stonborough-Wittgenstein
Black chalk, 55 × 34.8 cm
Albertina, Vienna, inv. 29736 | Strobl II, 1270

Portrait
Margarethe Stonborough-Wittgenstein

That the drawings Klimt created for his portrait paintings are more than just technical preparatory works is particularly evident from the studies for the portrait *Margarethe Stonborough-Wittgenstein* (1905, fig. 1).[1] The twenty-three-year-old was a member of a famous family: She was the daughter of Karl Wittgenstein, one of the most important patrons of the Viennese Secession; her siblings included the philosopher Ludwig and the pianist Paul Wittgenstein. Margarethe called herself Margaret after marrying Jerome Stonborough, the New York–born son of a factory owner, in 1905. She had a forceful personality, and her intellectual abilities and artistic interests liberated her completely from the cliché of the bourgeois "young lady." Correspondence demonstrates that the drawings were produced in 1904.[2] The painting—one of the pinnacles of the Golden Style—was completed in 1905, after several modifications, but it pleased neither the sitter nor her family, a fact that even today is often considered incomprehensible.[3]

Apparently, the studies that preceded the painting were not judged negatively in this way. Four sheets from this extensive series are held in the Albertina and, supplemented by a loan, offer here informative insight into his working process (cat. nos. 117–21). Klimt had his model pose in many positions, though apart from a few studies with a seated figure all are based on standing upright.[4] He employed a formula he had used repeatedly since his studies for the portrait *Serena Lederer* (1898–99, cat. nos. 68–76), fixing the centrally placed figure in the plane by having it extend beyond the upper and lower edges of the page. This self-imposed dictate of the boundaries of the sheet became the prerequisite for a free unfolding of the lines with which he tried to capture the overall appearance of each of his models and hence in as many aspects of their essence as possible.

In Klimt's evolution as a draftsman, the studies for the portrait *Margarethe Stonborough-Wittgenstein* mark a transitional stage.[5] Around 1904, the artist gradually shifted from black chalk to graphite. At the same time, the packing paper he had been using since 1897–98 gave way to a more brightly shimmering vari-

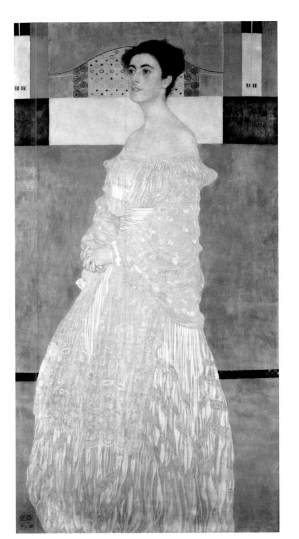

Fig. 1. *Margarethe Stonborough-Wittgenstein*, 1905, oil on canvas, 180 × 90 cm, Bayerische Staatsgemäldesammlungen, Neue Pinakothek, Munich

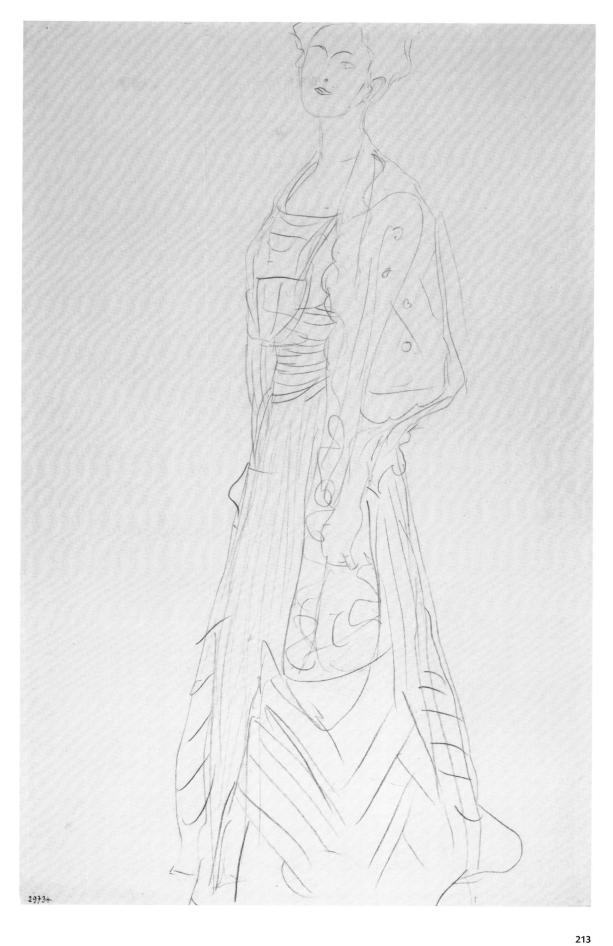

117

29734.

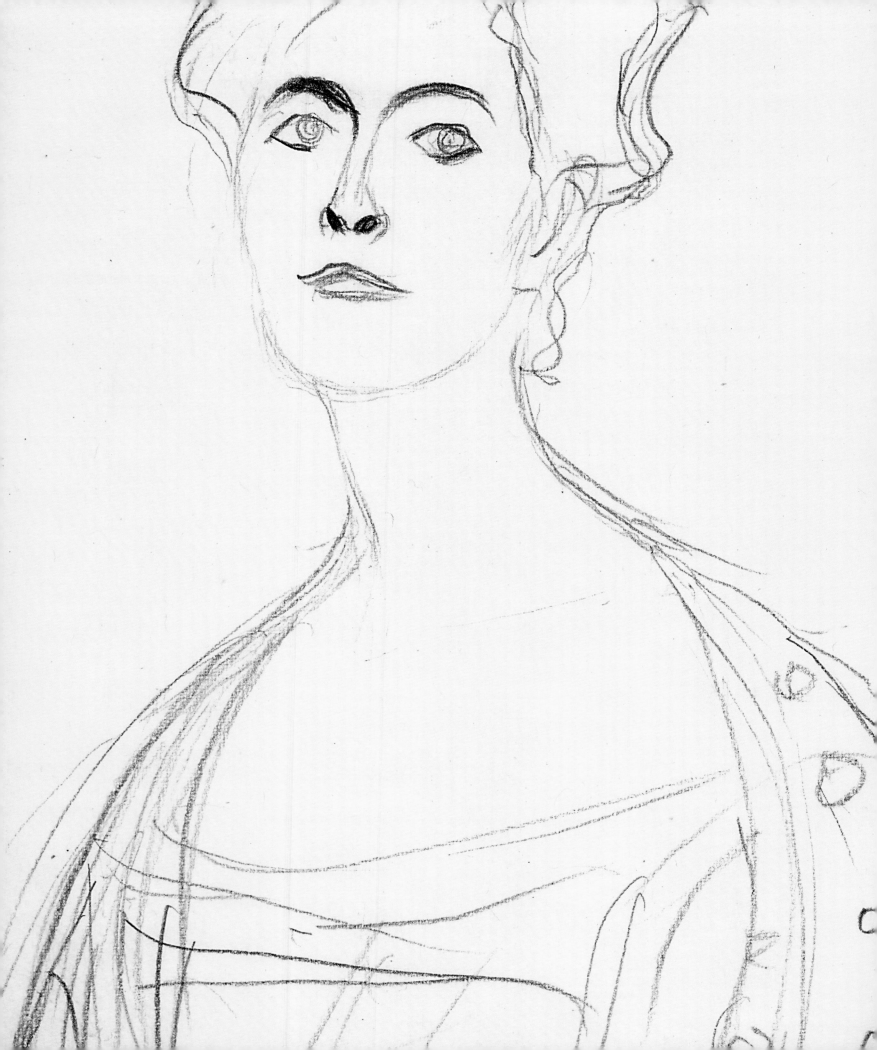

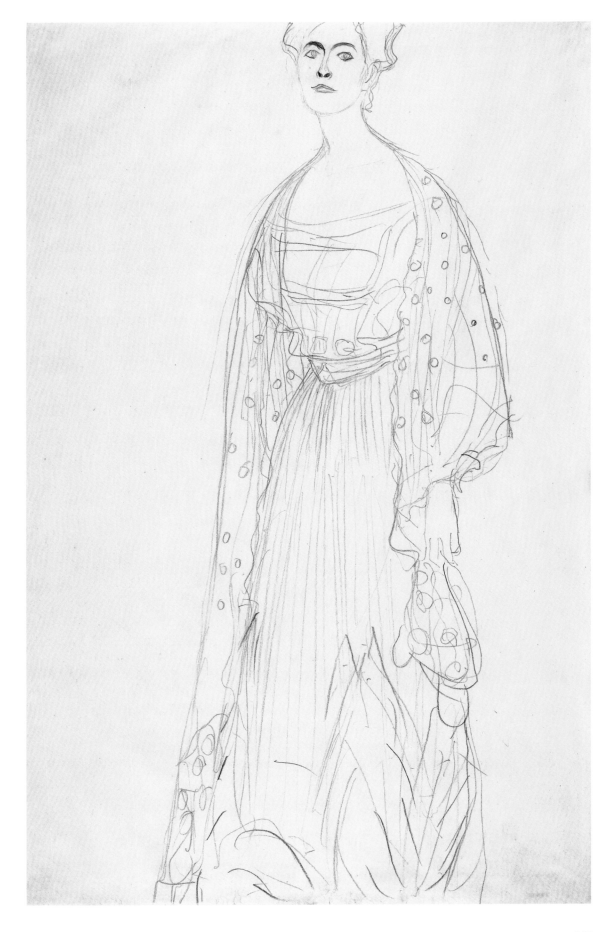

ety of paper in a slightly larger format that was imported from Japan. In the group of studies discussed here, Klimt was still working for the most part with black chalk but already on the new paper, which results in specific effects. He also showed a new interest in the structure and surface effects of delicately patterned, transparent materials; the stark contrast between the intense black of the thin lines of chalk and the bright color of the paper evidently suited him. Again and again, Klimt varied the motif of the overlapping layers of a pleated, low-cut dress and a light, freely draped cape. As in the painting, the figure is always summed up as a bell-shaped form. The dynamic of his line aimed at contrasting structures that he played out against each other in subtle ways—in delicate parallel strokes, intense zigzags, or fine ringlets. In nearly all these studies, Klimt emphasized the contrast between the light transparency of the fabrics and the vigorously marked facial features, which seem to summarize the young woman's intellectually open, self-confident being. The eyes of the sitter are sometimes focused directly on the artist sketching here and sometimes idealistically on a distant point. In the painting, the sitter's gaze in the distance to one side creates an essentially greater distance between her and the viewer. Her anchoring within the geometrically constructed backdrop contributes substantially to the impression of a majestic and enraptured figure.

The effect of the new paper was explored not only with black chalk but occasionally also with graphite and above all with red and green pencil, as two of the works shown here demonstrate (cat. nos. 117, 120). In the study executed in red, the brilliance of the color combines in a unique way with the psychologically subtle depiction of the frontal standing figure. In works like this one, the autonomous quality of the studies for portrait paintings is brought to bear particularly clearly.

[1] *Margarethe Stonborough-Wittgenstein*, 1905, oil on canvas, 180 × 90 cm, Bayerische Staatsgemälde-sammlungen, Neue Pinakothek, Munich; Novotny and Dobai 1975, no. 142; Weidinger 2007, no. 179.
[2] Strobl II, 1982, p. 35.
[3] On the sitter and the probable reasons for rejecting the painting, see Zaunschirm 1987; Exh. cat. Vienna 2000–2001, pp. 108–10.
[4] Strobl II, 1982, nos. 1247–74; Strobl IV, 1989, nos. 3545–46.
[5] Strobl II, 1982, p. 35.

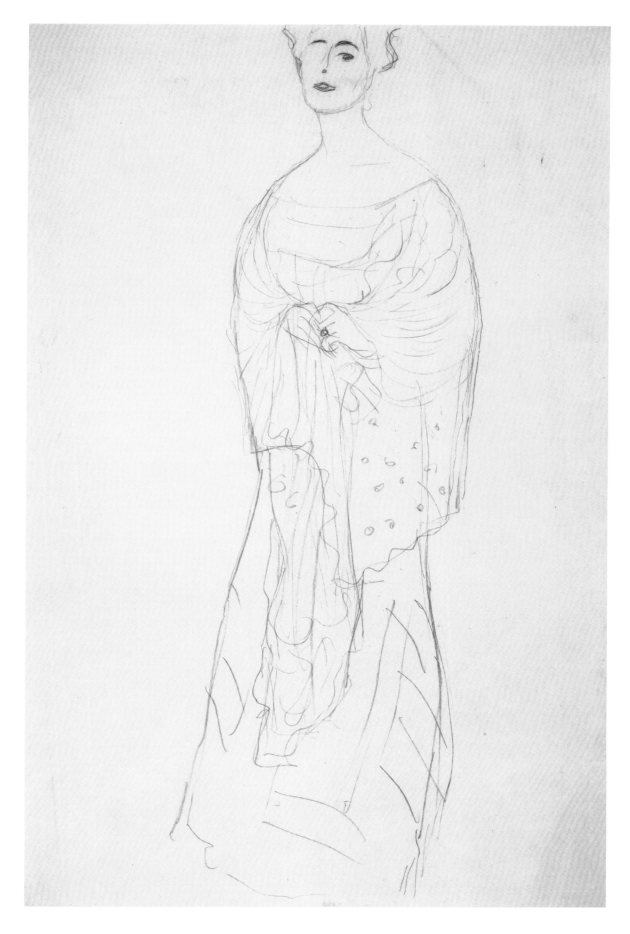

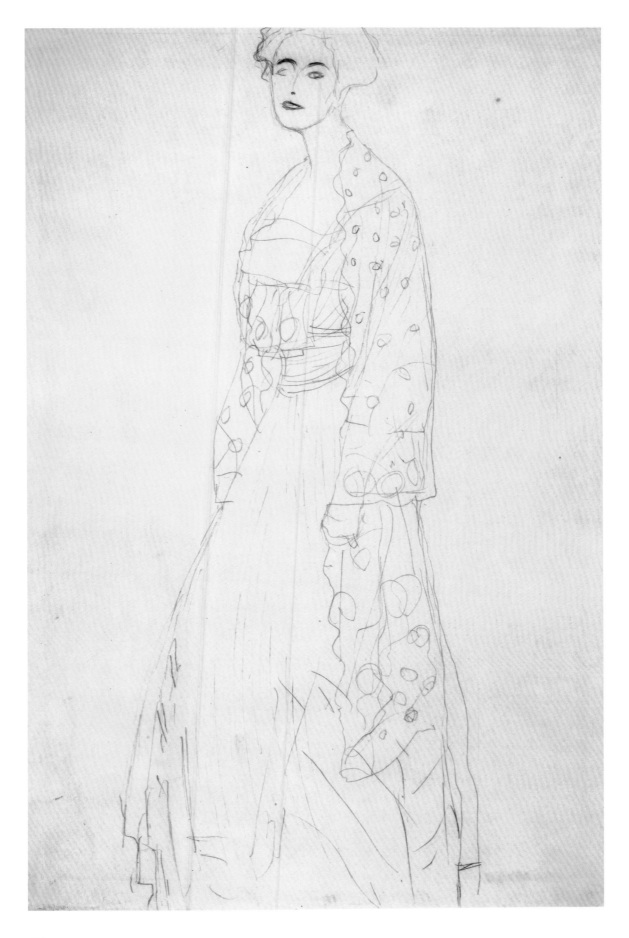

121

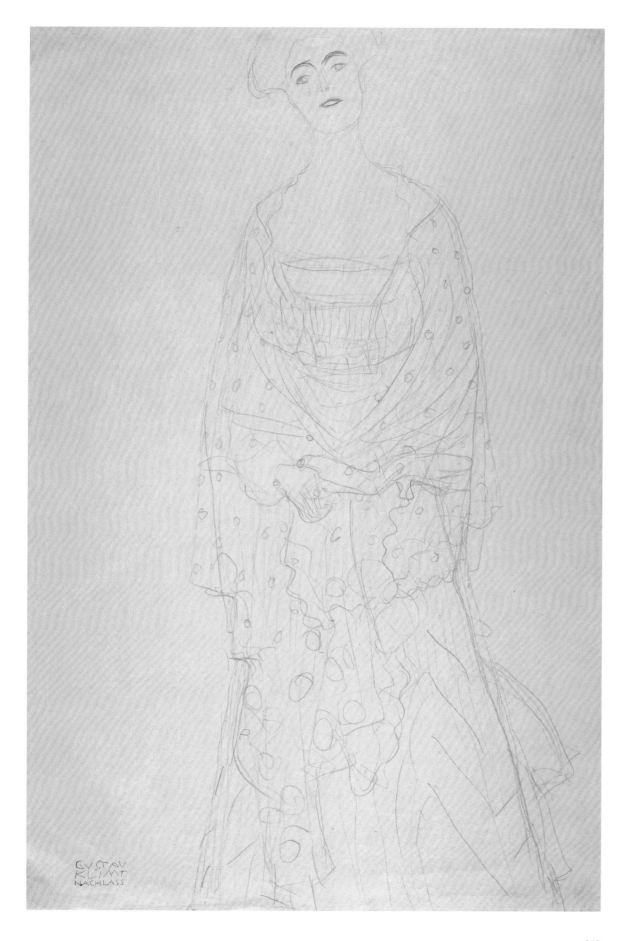

122
Woman Seated with Her Hand on Her Chin, 1904–5
Study for an Unrealized Portrait of Magda Mautner von Markhof

Black chalk, 55 × 34.6 cm
Albertina, Vienna, inv. 29841 | Strobl II, 1219

Magda Mautner von Markhof

In Klimt's studies for portraits, the language of the poses and gestures is controlled and restrained throughout. For the most part, the sitters are veiled by the layers of their clothes. Nevertheless, Klimt enables us to sense his own attitude toward his models to a certain extent from subtle nuances in his rendering. The woman depicted seated and facing frontally here is neither majestically elevated nor anchored unshakably in the plane. Her contemplatively gazing face, reduced to a few succinct strokes, rests on her supporting hand and is thus at eye level with the artist opposite her, with whom she is perhaps conversing. The frills of her broadly draping dress surround her in harmoniously articulated layers, and the curved back of her chair completes her cohesive appearance.

The drawing belongs to a group of studies for a portrait of Magda Mautner von Markhof that was never realized, perhaps because she traveled to Paris.[1] The young woman's father, Carl Mautner von Markhof, was the eldest son of the famous dynasty of brewers. Magda was active as an artist, taking painting lessons from Alfred Roller, and closely connected to Gustav Klimt's circle. She admired Gustav Klimt, whom she visited frequently. Her sister Editha was married to Kolo Moser. Alice Strobl noted that her internalized, philosophically inclined character was expressed in several studies when she was twenty-three or twenty-four. This is particularly true of the work under discussion, which appears to have been produced in a casual, friendly atmosphere. As Alice Strobl explained, there are several arguments for dating it to 1904–5: Klimt's penchant for the motif of frills, with which both the skirt and the sleeves are densely covered, was manifested above all in 1904. Moreover, the use of the new Japanese paper in combination with traditional black chalk is characteristic of the transitional phase of 1904 (cf. cat. nos. 117–21). Soon thereafter Klimt switched to graphite entirely.

[1] Strobl II, 1982, p. 15, nos. 1217–25; Strobl IV, 1989, nos. 3541, 3541a–b. On the sitter, see Strobl II, 1982, p. 15.

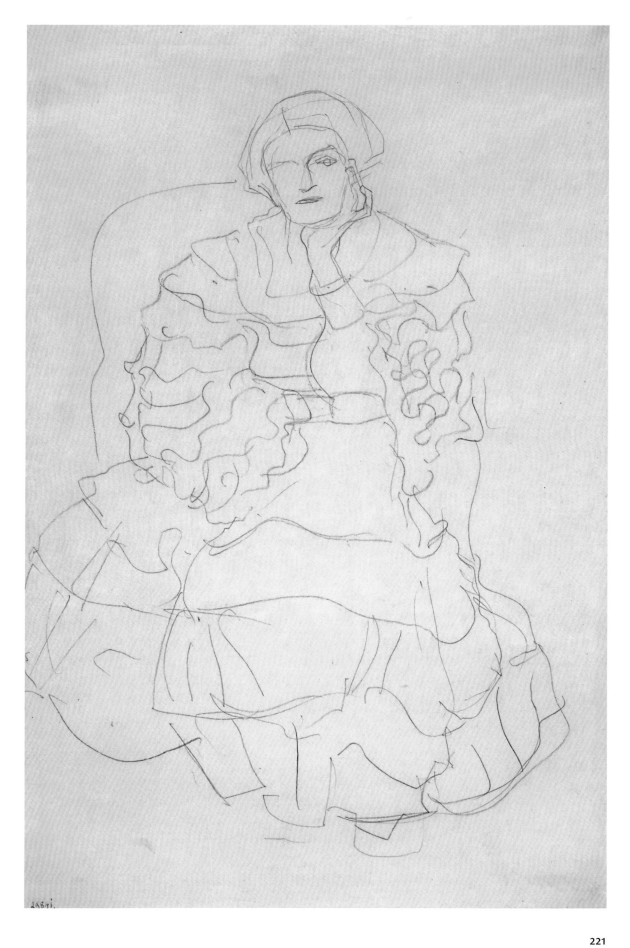

Portraits of Women, 1904–1908

The two sheets *Lady in Profile with Hat* (1904–5) and *Lady with Plumed Hat* (1908) belong to the genre of autonomous drawings of female portraits that occupied Klimt continuously from about 1895 onward. These portraits, most of which are anonymous, are sometimes largely stylized and idealized in character. The focus is on depicting different types of women, combined with a touch of mystery and a seemingly frozen character. They are dominated by profile and frontal views, as the works exhibited here—which constitute to a certain degree a pair of opposites—symptomatically demonstrate.[1] The profile was produced at the beginning of his Golden Period; the frontal view is a major work among the drawings of the mature phase of this famous era. Both poses have their programmatic origin in the early years of the Secession, which was founded in 1897.

Hence Klimt's dreamy female profile heads from the early period of that association are linked metaphorically to the newly discovered "realm of the soul." In the monumental *Beethoven Frieze* (1901–2), the profile pose became a symbolic formula for courage, longing, or meditation. In the present profile, finally, the artist concentrated with uncompromising acuity on the horizontal, looking into the distance. The metallically delicate graphite lines that characterize the early phase of the Golden Style convey a new spirituality; the timeless ideal character is now replaced by a manner of depiction that emphasizes the fashionable. With easy intuition, Klimt establishes the decorative balance between the sparsely described lines of the hat, veil, and shoulders and the detailed depiction of the striking profile line, the facial features, and the hair. Dark accents

are provided by the angularly marked eye, the pronounced eyebrow, and the fragment of hair with its miniature structures. In terms of both its linearity and emphatic profile, it reveals analogies to profile portraits drawn by Jan Toorop.[2]

In the strictly frontal *Lady with Plumed Hat*, in turn, Klimt seems to have taken his lead from the fixed, hypnotizing facial expressions of the women in *Pallas Athena* (1898, fig. 8, p. 51) or *Nuda Veritas* (1899, fig. 1, p. 72), works from the early period of the Secession in which he programmatically advocated the freedom of art. At the same time, the masklike face with its pronounced chin and small mouth points to the ideal feminine type of the Belgian artist Fernand Khnopff, who was a crucial influence on Klimt's early Symbolism.[3] In the present work, however, the hypnotizing facial expressions are no longer linked to allegorical values but rather to the fashionable aspect, whose mannerist acuity recalls the creations of Henri de Toulouse-Lautrec.[4]

This frontal portrait of a woman is extremely rare within Klimt's oeuvre in its use of a brush, which combines subtly with the other techniques. Compared to paintings with a related theme, such as *Red and Black* (1907–8),[5] this portrait on paper has a broader spectrum of nuances. As is clear from his early, highly finished drawings of allegories, Klimt employed the medium of drawing with complete control to play out contrasts on the creative and the symbolic level in highly subtle ways. The present work is characterized by decorative extremes and is based on the tension between the transparency of drawing and the density of painting. The succinctly stylized face and hair contrast effectively with the dark,

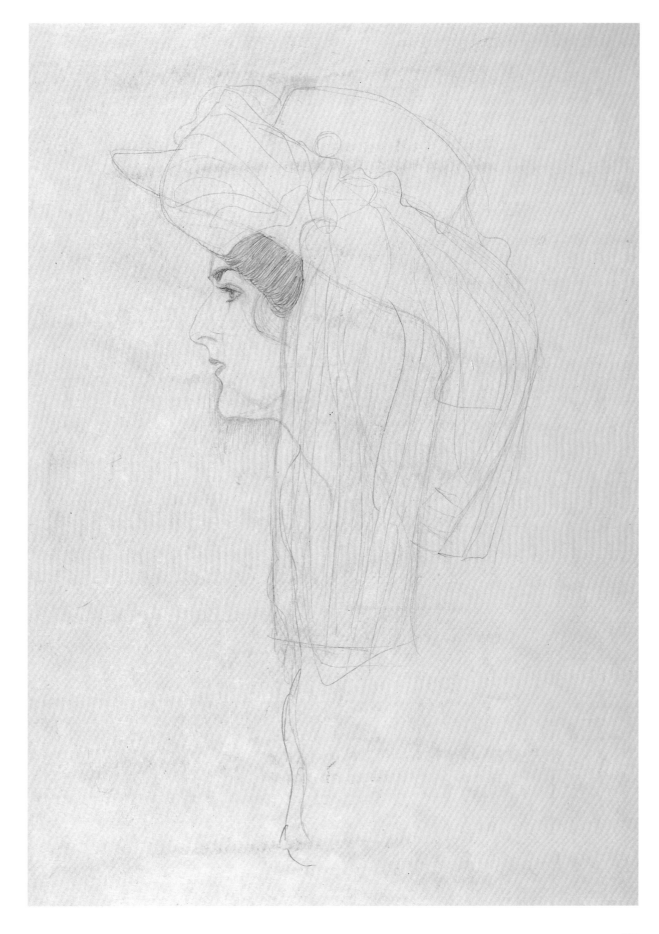

123

cloudy structures of the plumed hat and clothing; the form of the hand stands out brightly as a blank spot amid cursory sketching. On the level of the line, there is a tense dynamic between the very precise facial features and the loosely sketched, squiggly pattern of the background. The balance within the asymmetrical positioning of the hat, the pair of eyes, and the collar is particularly refined. Color is used only sparsely: Klimt marked the mouth and the edge of the patterned backdrop with a red pencil; with a thin brush he applied white gouache for the delicately spun gauze on the hat. The various pictorial elements overlap like stage sets. With its imagelike presence, this singular work can be regarded as the equivalent in drawing to the paintings of the Golden Style. The ambiguity between decorative rigidity and sensuous expression is elevated to the level of a program, as it were.

[1] On the programmatic combination of frontal and profile views, see cat. no. 24.
[2] On the profound influence of Jan Toorop's Symbolist art of the line on this facial type, see Marian Bisanz-Prakken, in Exh. cat. The Hague 2006–7, pp. 226–28.
[3] See Marian Bisanz-Prakken, in Exh. cat. The Hague 2006–7, pp. 84–103.
[4] Strobl II, 1982, p. 217. The author refers in this context to the color black in Toulouse-Lautrec's lithographs.
[5] Red and Black, 1907–8, oil on canvas, 96 × 47 cm, private collection. Novotny and Dobai 1975, no. 158; Weidinger 2007, no. 186.

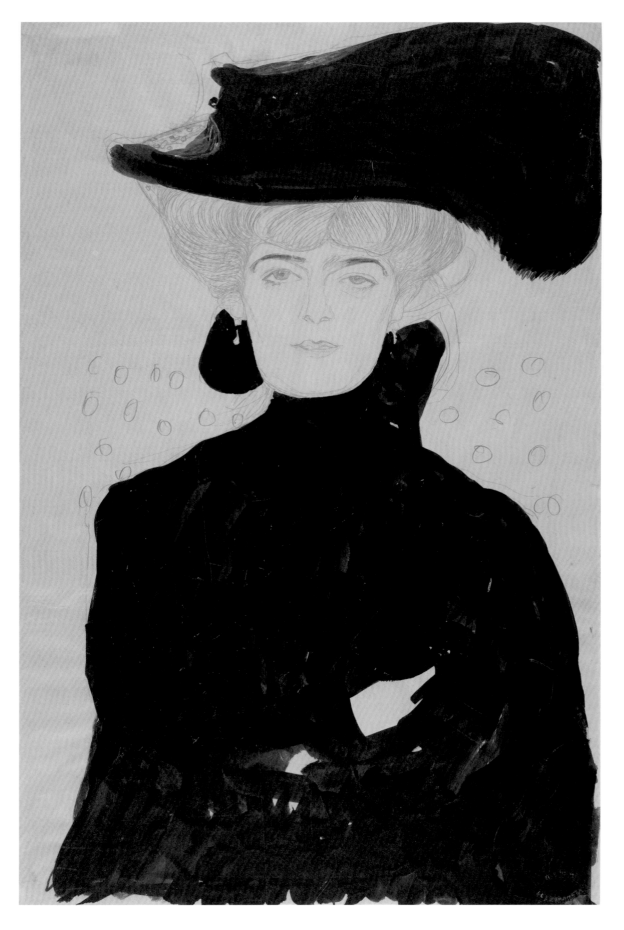

The Late Years

1910–1918

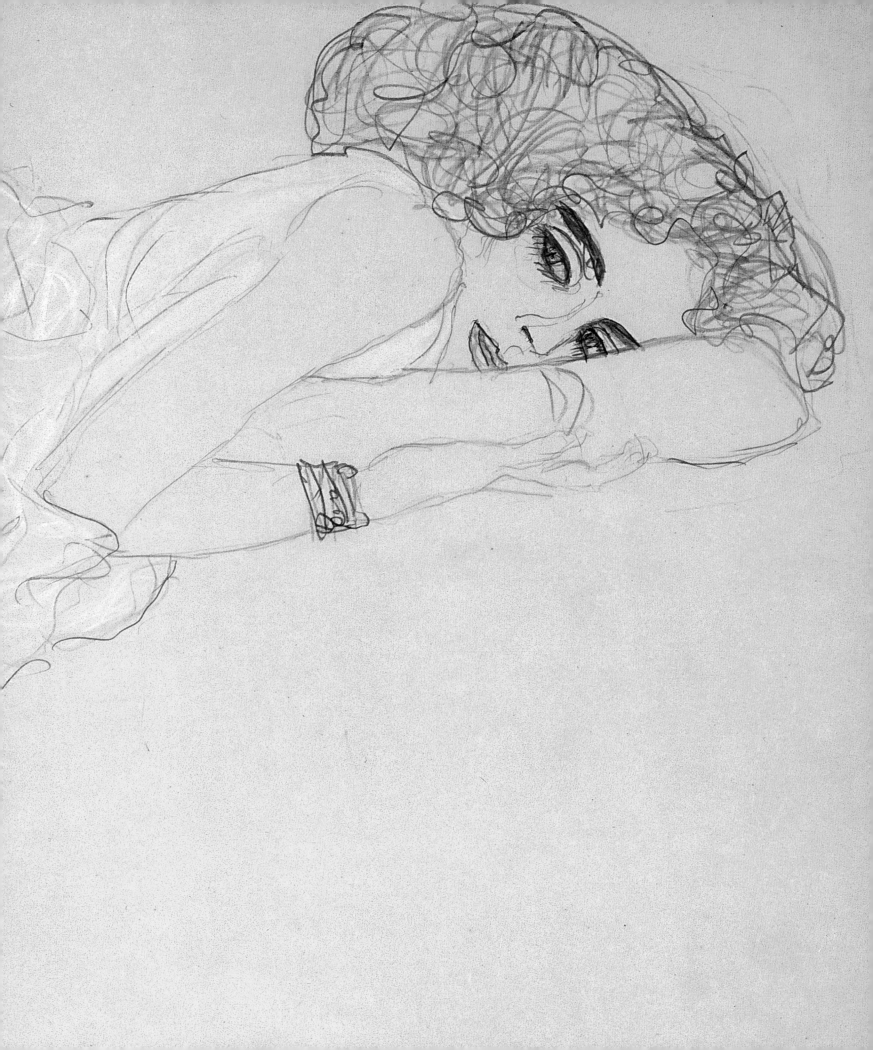

125
Seminude Lying on Her Stomach, 1910

Graphite, blue and red pencils,
white heightening, 37 × 56 cm
E. W. K., Bern | Strobl II, 1968

Erotic Nudes, 1910

As president of the epochal *Kunstschau* exhibition of 1908, in his opening speech Klimt evoked once again the unity of art and life that was cultivated around the turn of the century. The exhibition focused on presenting his recent major works, including *The Kiss*; he would also be represented at the *Kunstschau* in 1909. Soon thereafter the artist broke away from his Golden Style. The works by his French contemporaries that impressed him greatly in Paris in 1909 probably played a crucial role in this artistic turn.[1] He characterized his *Stoclet Frieze*, completed in October 1911, as a work "that may well be the final consequence of my ornamental evolution."[2] Despite the loosening of his brushstroke and an increasingly free approach to the line, in his final decade Klimt continued to be an artist profoundly rooted in the decorative who, as is clear from his figure studies, still never lost sight of the overarching context.

As a draftsman Klimt increasingly shifted to Eros as a theme. The sheet presented here of a model lying on her stomach is considered the acme of a group of completely autonomous nude studies produced around 1910. As in the studies related to *Water Snakes II* (cat. nos. 94–98), the passively reclining woman is borne as if by a wave; as a result of the way the figure is introduced slightly obliquely into the picture, however, there is a new tension between space and plane. The subtly outlined form of the slightly elevated buttocks looms into focus, with the rustling drapery seeming to wash gently around it. The clothing flowing down from her shoulders is enlivened by strong accents in blue, red, and white chalk. Klimt effectively positions the erotic signals: her sharply defined, dark-haired genitalia, her powerfully accented, seductive eyes, and her smiling red mouth. The anchoring of the figure in the sheet above and below, separating the plane along the diagonal, makes the body seem palpably close.

Despite this refined calculation, a highly cultivated language of lines dominates, from the subtle contours of the body to the painterly structures. Light plays a special role here: The rich coloristic nuances that Klimt achieves with just a few colors stand out effectively against the bright blank surfaces of the skin. As a result the bare areas of the body seem to glow magically from within, which, for all the eroticism, leads to an almost otherworldly effect. The autonomous character of this aesthetically highly ambitious, completely worked-out drawing is also underscored by the effectively placed oval signature.

[1] Strobl II, 1982, p. 227.
[2] Zuckerkandl 1911, pp. 2–3.

125

The Virgin

With the painting *The Virgin*, which he completed at the end of 1912 or at the latest by early 1913, Klimt took a crucial step in the area of his figural allegories (fig. 1).[1] In this major work of his final creative phase, he grappled comprehensively for the first time with the various stages of erotic consciousness—from young girl to mature woman—which he saw as characterizing feminine existence.[2] In a bubblelike image running diagonally along the picture plane in diffuse, brownish surroundings, the title figure of the virgin dominates with a stylized planarity. The bell-like tapering form of her colorfully ornamented garment betrays that her thighs are spread. Her bare arms are raised as if in a trance, and her dreamy, masklike face is inclined to the side. A much higher degree of reality characterizes her attendants arranged in a circle, with colorful veils and garlands of flowers playing round their naked bodies. The typological features, the temperaments, and the erotic moods of these six figures reveal a well-balanced program. The gaunt figure with a cramped gesture seen from behind at bottom left has an expressivity particularly close to Egon Schiele's nudes. A joyfully self-contained woman with sensuously curved contours presents a contrasting figure at lower right. Above her to the right, the round figure of a girl with bashfully downcast head and a chaste, parted hairdo conveys an impression of innocence and shyness. Jammed in between her and the dematerialized main figure sits an animalistic-looking woman with a demonic gaze and powerful, spread thighs—the only one whose pudenda are exposed. The ecstatic young woman at top left is recognizable as a bride thanks to her veil and wreath of flowers with which Klimt anticipated a motif of his painting *The Bride* (1917–18, unfinished, fig. 1 on p. 254).

One new aspect relative to his earlier allegories of life is the spatial depiction of the group of figures arranged in an oval, combined with the twisted postures of the nude figures, the curves of whose bodies are often emphasized several times.[3] The contours play a role both as a way of succinctly characterizing the figures and as a way of defining the space. This dual function of the contour lines also characterizes the numerous figure studies produced in 1911–12, which feature a richly nuanced spectrum of emotional moods and erotic states of mind. In terms of appearance, the models vary from plain and stocky to highly sensitive, and their expressions range from introverted shyness to effusive ecstasy. With regard to their typological diversity and

Fig. 1. *The Virgin*, 1913, oil on canvas, 190 × 200 cm, Národní galerie, Prague

the open eroticism of their poses, the figure drawings go far beyond the resulting painting. Each study is an autonomous step in the process of carefully analyzing this theme, one that would intensely occupy Klimt as a draftsman subsequently as well (see cat. nos. 135–38).

In his search in his drawings for the basic attitudes and emotional moods appropriate to each case, Klimt experimented with different types of figures, as is evident from the nine studies from the Albertina's collections presented here (cat. nos. 126–34). In seven of the drawings from this group, the artist employed full-figured and even portly models in various emotional situations (cat. nos. 126–32). For the shy girl sitting at far right in the painting, he sketched upright figures, which, as so often, he anchored centrally in the plane (cat. nos. 126–29). These monumental, serene, introverted-seeming figures represent the phlegmatic temperament. In the study of a model depicted from the side, whose head position, facial expression, and hairstyle he largely followed for the painting, Klimt emphasized the continuous contour line of her neck bent forward and shoulders hanging down (cat. no. 126). He carefully recorded the contours of the imperfect body, and the continuous lines of breast, stomach, and thighs have a rhythmical and ornamental life of their own. Constantly changing the pressure on the pencil produces an effect of vibrant pulsation, particularly in those areas where the contours are reinforced by dense formations of strokes. In the other studies as well, Klimt demonstrates again and again his ability to convey volume, plasticity, and even light values by means of contour lines.

Yet each work has its own character and specific atmosphere. The study featuring a seated portly model who represents an early preliminary stage for the expressive figure seen from behind at lower left in the painting seems introverted and shy (cat. no. 130). Shame and sorrow characterize the expression of the woman depicted from the front, probably the same model, whose posture and type of figure are only loosely connected to the woman in the painting with a demonic gaze (cat. no. 131). Both drawings subtly accentuate the curves of the body. In the powerful, frequently repeated contours of the standing figure seen from behind, with her elbow propped on her raised leg, Klimt especially emphasized the jutting, round forms of the heavy body (cat. no. 132). This study was also produced with an eye to the aforementioned nude seen from behind in the painting, and her melancholy gravity is far removed from the nervous, Schiele-like expressivity.

For the figure at the bottom right of the painting, Klimt combined a reclining position with an upright, floating pose. This deliberate ambivalence was explored in several of the preparatory drawings. In the study shown here, he positioned the reclining model, who is seen from above at an angle, diagonally in the plane, so that the figure seems to float away (cat. no. 133). The complexity of the study is determined by the zigzag pose of the body, which twists several times. The light strokes, combined with the smiling expression, contribute essentially to the lighthearted atmosphere of this work. The round forms of the thighs and buttocks radiate sensuously between the draped clothing.

Most of the studies for the main figure in

The Virgin differ essentially in their erotic and ecstatic character from the mysterious reserve of the figure in the painting. One unique case is the drawing of a model dressed in a sleeveless top and billowing skirt; the dancer's posture, with a slightly raised leg, anticipates the posture depicted in the painting (cat. no. 134). The lively rhythm of the contours, which are reinforced here and there, and the dreamy facial expressions of the face inclined to the side contribute to the effect of the figure's being distanced from reality. As Alice Strobl demonstrated, Klimt was very probably influenced here by Auguste Rodin's drawings inspired by Cambodian dancers, yet as always he brilliantly integrated these impulses into his own pictorial and stylistic vocabulary.[4] This autonomous work joins the large spectrum of depictions of emotional moods in a self-evident way.

[1] *The Virgin*, 1913, oil on canvas, 190 × 200 cm, Národní galerie, Prague. Novotny and Dobai 1975, no. 184; Weidinger 2007, no. 214.
[2] On the typology of the figures and their relationship to contemporary nude photography, see Bisanz-Prakken 2007–8, pp. 105–21.
[3] Strobl III, 1984, pp. 7–24.
[4] Ibid., pp. 22, 24.

GUSTAV
KLIMT

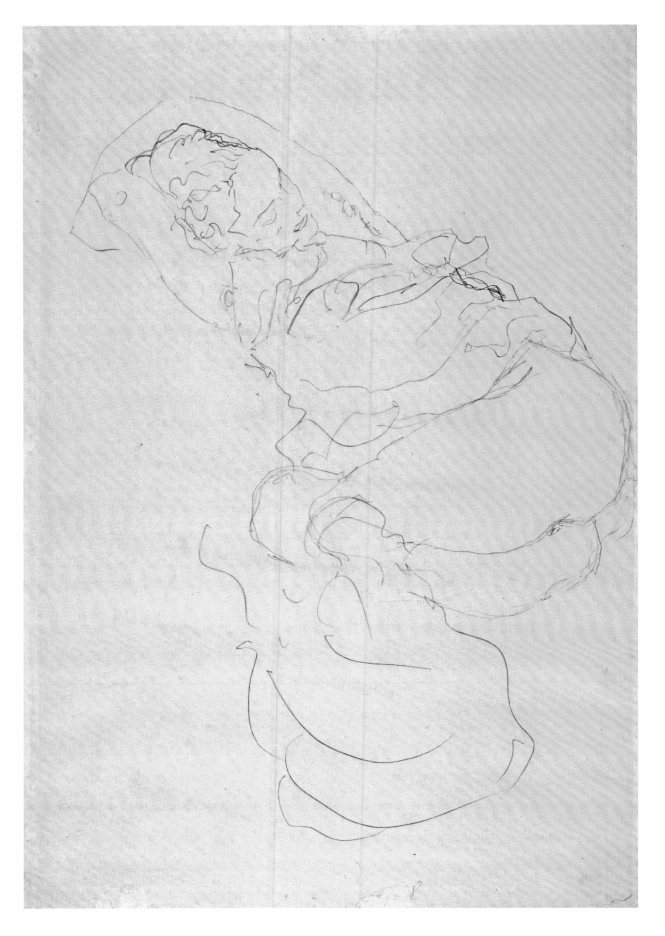

133

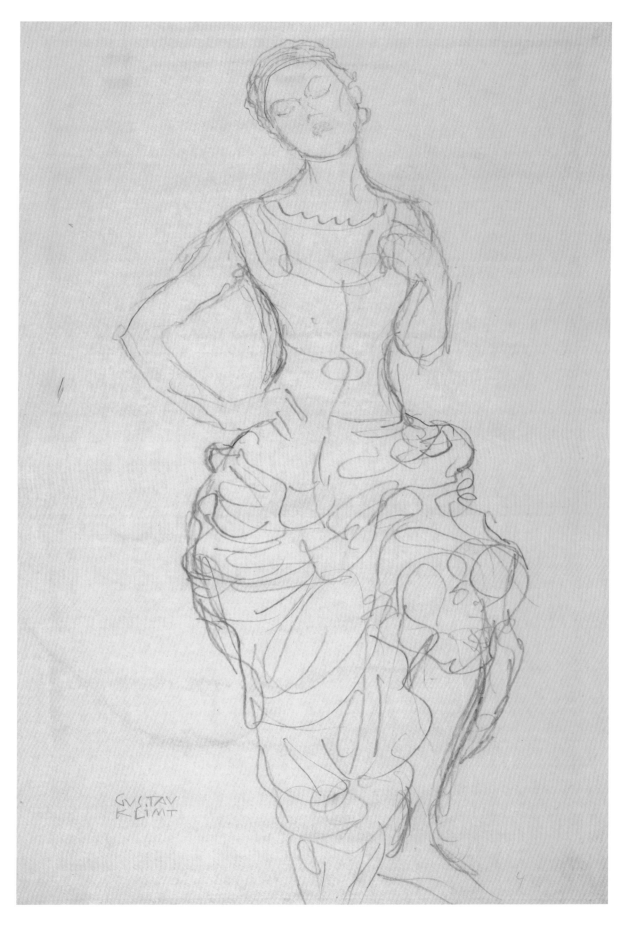

135
Reclining Nude with Leg Raised, 1912–13

Graphite, 37.1 × 56 cm
Albertina, Vienna, inv. 23543 | Strobl III, 2311

136
Reclining Nude with Knee Pulled up to Her Face, 1912–13

Graphite, 37.2 × 56 cm
E. W. K., Bern | Strobl III, 2322

137
Reclining Nude, 1912–13

Red pencil, 36 × 56 cm
Leopold Museum, Vienna | Strobl III, 2324

138
Pair of Lovers, 1913

Graphite, 36 × 55 cm
Private collection, courtesy Richard Nagy
Strobl III, 2442

Erotic Nudes, 1912–1913

As a draftsman, Klimt was famous above all for his refined erotic nudes. He himself regarded Eros as the mysterious core of a comprehensive set of life themes, as is clear from the sacred earnestness that characterizes even the most extreme works in this area. This inner attitude is rooted in the faculty paintings *Philosophy* and *Medicine*, in which the artist first grappled with the basic questions of human existence. The important role of eroticism is revealed in the sensuousness of the many nudes and in the embracing couple in *Philosophy*, whose openly depicted act of love addresses the origin of human life (cat. no. 29). Klimt's drawings dealing with the theme of Eros grew increasingly subtle in its wake. Lesbian love and autoeroticism are the subject of numerous autonomous drawings from the Golden Period. His effort to capture erotic ecstasy in monumental linear compositions reached a culmination in the studies of couples produced in the context of the painting *The Kiss* and *The Stoclet Frieze* (cat. nos. 105–10).

The erotic themes reached their sublime form in the drawings from Klimt's final decade exhibited here. Both the three sheets with female models (cat. nos. 135–37) and the drawing of the pair of lovers (cat. no. 138) were produced in parallel with his major work *The Virgin* (1913; fig. 1 on p. 230) yet, like most of the erotic drawings from this phase, reveal no direct connection to it.[1] The focus of the three aforementioned nude drawings is the openly displayed female pudenda—an enduring fascination for the artist, who may have regarded this part of the body, which he elevated almost to a religious object, as the source of arousal and in general the origin of human

life. His depictions of the states of ecstasy caused by masturbation are among the most intoxicating results of his drawing activity and could only be achieved in that medium. With his marked instinct for the nuances of female eroticism, Klimt recorded the actions and reactions of women succumbing to their intimate activity before his eyes. Again and again, he walked a tightrope between immediate, sensory observation and an effort to subject the positions and movements of his models to a higher spatial order. The erotic charge of these sheets goes hand in hand with a particular tension between space and plane, which can in turn be traced back to the artist's penchant at the time for spatially complex situations and extreme effects of perspective. The play of strikingly overlapping parts of the body led to refined effects such as the "dual gaze" of the model's furtive eye and pudenda turned toward the viewer, and the position of her body, which forms a parallelogram (cat. no. 136). One of the outstanding qualities of these works is the contrast between the richly structured draperies and the brightly shining, bare parts of the body. This effect is particularly pronounced in the drawing executed entirely in red of a masturbating model, whose state of enrapture is evoked not only by her dreamy facial expression but also by the wavy verve of the draping clothes and the lines of her support (cat. no. 137).

Another autonomous study of a couple reveals a design characteristic of Klimt: the sexually active man viewed from behind, with his upper body covered by a patterned garment, and the passively receiving woman, whose ecstatic facial expression is the emotional focus (cat. no. 138). The physical center

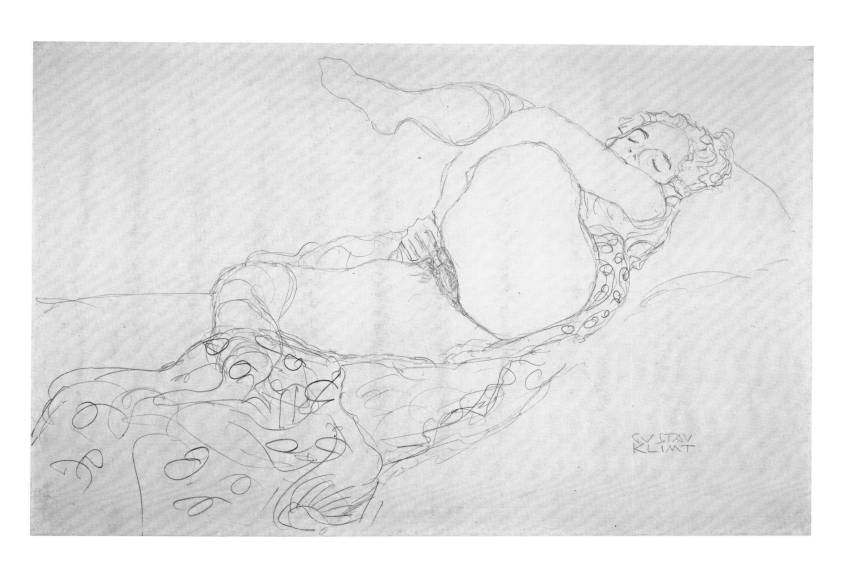

135

is the man's sex, like a nervous system where all of the axes of the body and the lines of movement converge. This strictly diagonal composition with planes that overlap in a carefully considered way is at the same time marked by a sweeping linear impetus. In this extraordinary work, Klimt strove to discipline erotic stimulus formally and force it into the plane, to a point, an effort essentially inspired by the art of the Japanese woodcut.[2] The sublimating force of the lines is devoted to Eros as the major impulse in the cycle of life.

[1] On this group, see Strobl III, 1984, pp. 45–50, nos. 2324–33.
[2] On the influence of Japanese erotic woodcuts on this theme, see Strobl III, 1984, pp. 50, 78.

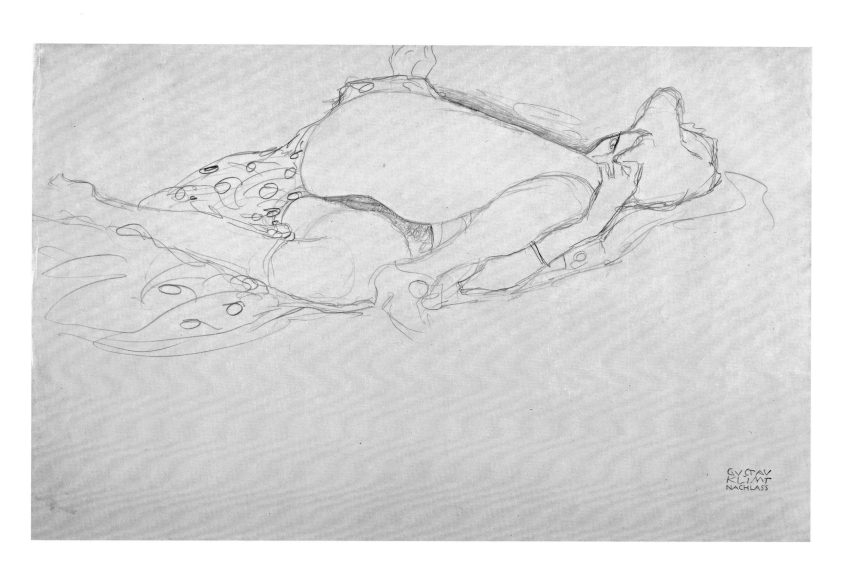

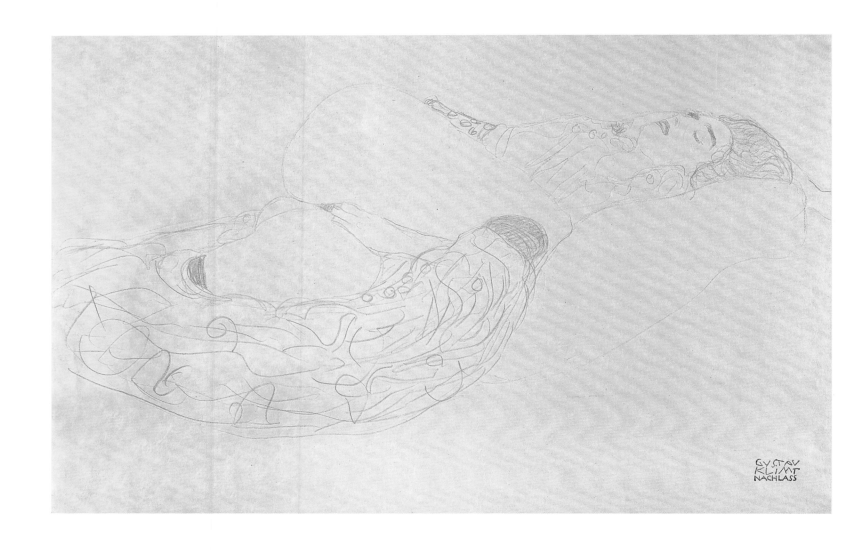

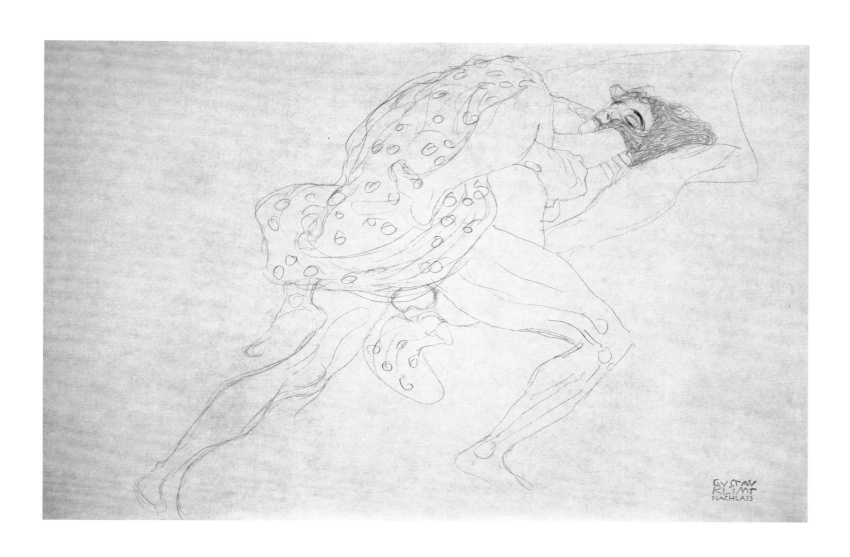

139
Reclining Nude, ca. 1913

Red pencil, 37 × 56 cm
Albertina, Vienna, inv. 32946
Strobl III, 2446

140
Reclining Nude, 1914–15

Graphite, 37.5 × 57 cm
Albertina, Vienna, inv. 36866
Strobl III, 2439

141
Reclining Woman, Seen from Behind, 1916–17

Graphite, 34.8 × 56.7 cm
Albertina, Vienna, inv. 23540
Strobl III, 2928

142
Reclining Nude, 1916–17

Graphite, 36.7 × 56.1 cm
Albertina, Vienna, inv. 30460
Strobl III, 2948

Erotic Nudes, 1913–1917

In his erotic studies of the late years, Klimt did not limit himself to spatially complex poses of the body (cat. nos. 135–38). He also continued to pay homage with great intensity to the simple compositional principle of figures arranged in parallel with the picture plane (cat. nos. 139–42). In his vertical-format drawings, he used the composition principle of figures standing upright and anchored within the plane both for majestic female characters and nude figures. In horizontal formats, the placement of the body parallel to the picture plane is exclusively associated with intimate situations. From close-up and at eye level, he studied models outstretched horizontally or at a slight diagonal as they gave in to their erotic moods. He never grew tired of capturing the quintessence of such immediately observed situations and fixing them within the plane. As in the earlier drawings for *Water Snakes II*, he was fascinated by the ambiguity between passive lying and suggested movement (cat. nos. 94, 97, 98). Often he had the contours of the textiles on which the bodies were lying, which intertwined with the bodies themselves, extend down to the edges of the paper so that the female figures seemed to be incorporated into a horizontal continuum. The diversity with which Klimt could vary the basic situation of reclining in his later years is exemplarily demonstrated by the sheets exhibited here. As with all the drawings of nudes produced during the period between *The Virgin* (1913) and *The Bride* (1917–18, unfinished), they were completely autonomous, cohesive works (see also cat. nos. 135–38). It should be remembered that the demand for drawings by Gustav Klimt increased considerably during the final years of his life.[1]

Around 1913, Klimt used red pencil to record a nude, reclining model, aiming for a rhythmic effect based on her folded arms and crossed legs (cat. no. 139). Alternating lightly and vigorously drawn contours, he emphasized both the sensuous features of the body and the spatial nuances. The latter seem to concentrate where the arms half cover the face and distinctly outlined breasts press against the body slightly. Klimt accentuates most strongly the closed eye, thereby emphasizing the dreamy state of the reclining woman. In combination with the slightly diagonal position he aimed at the effect of a dreamy flowing away—as he had in the drawing of Juliet in suspended animation in *Shakespeare's Theater* a quarter of a century earlier (cat. no. 7). Within the balanced articulation of planes, the "participation" of the empty fields is still an essential factor, including the striking triangular view through beneath the bent knee.

In the study of 1914–15, which is distinguished by a free, richly differentiated linear idiom, a reclining woman is seen stretched out in a broad arc across the width of the paper (cat. no. 140). The trancelike serenity of the stout figure is contrasted by the linear movement within the hermetically sealed contours. The abstract, densely compressed lines of her gathered-up clothing run extremely freely and vibrantly, standing out prominently from the resting hand. Out of this turmoil of lines loom the bare stomach and thigh areas like a bright island. The contours of her crossed legs follow dynamic curves; the foreshortening heightens the tension between space and plane. As if borne by a wave, the figure rendered close-up flows out beyond time and space.

139

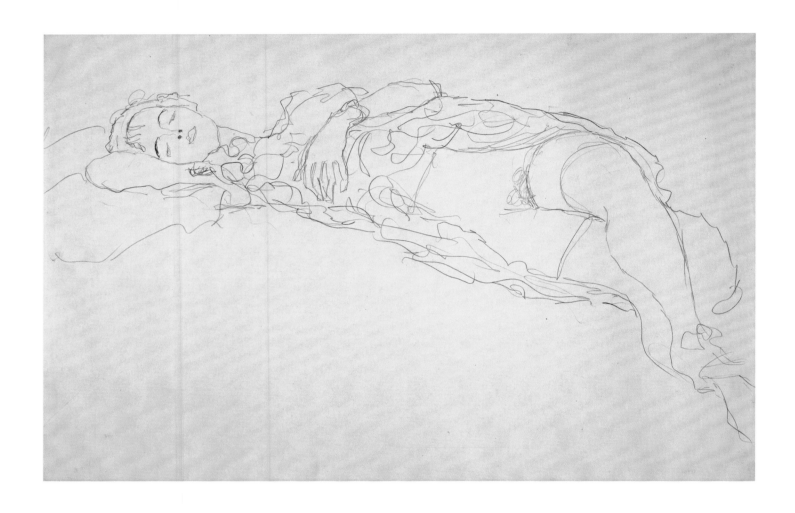

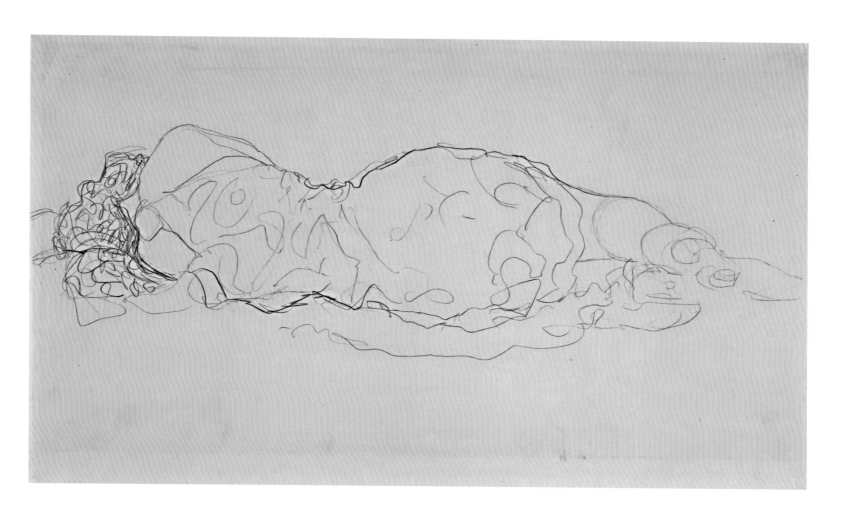

141

One outstanding example of the relationship of tension between outward calm and inner movement is this 1916–17 study of a clothed reclining figure seen from behind (cat. no. 141). In its horizontal anchoring, this figure fills the entire width, from the tip of her shoes to the top of her hair, balancing orthogonal rigor with suggestive spatiality. With rhythmic protruding and receding of the curves of the body, the taut contours of the skin and the serrated outlines of the clothing alternate vividly. The visual focus is on the intensely moving, abstract lines of the patterns and folds of the fabric. The optical center of gravity is formed by the powerful, repeated contour line of the lower shoulder by which the bright skin is emphatically delimited from the dark, tousled hair. The lightly bowed head emphasizes the expression of self-contemplation of the monumentally recorded, isolated figure seen from behind. Klimt fixed the horizontal axis in favor of a balance between the empty spaces just above the center, making it clear that his extremely free, seemingly detached line is based on a precise calculation.

Within the scale of atmospheric values that characterize the studies of reclining figures, the erotic ecstasy stands out. The 1916–17 drawing of a model pleasuring herself, her head facing down, resting on a diagonal support, seems to consist almost entirely of linear excitement (cat. no. 142). With vehemently intermittent lines, Klimt recorded the basic features of the gaunt, barely clothed figure. This work is far removed from the sensuous aesthetic and metaphysical dreaminess of the drawings discussed earlier, and its seemingly electrified figure points to unmistakable points of connection with Expressionism. Nevertheless, the strict commitment to the plane dominates here, too. At the culmination of his late, linearly abstract experiments, Klimt clung to the principles of *Raumkunst*, or "art of space," rooted in the turn of the century. At the same time, he remained to the end a stage director of poses, gestures, and atmospheres for his models and—invisible yet clearly palpable—formed their stable, male opposite pole.[2]

1 Strobl III, 1984, p. 195.
2 On this theme, see Bisanz-Prakken 2007–8, pp. 119–21.

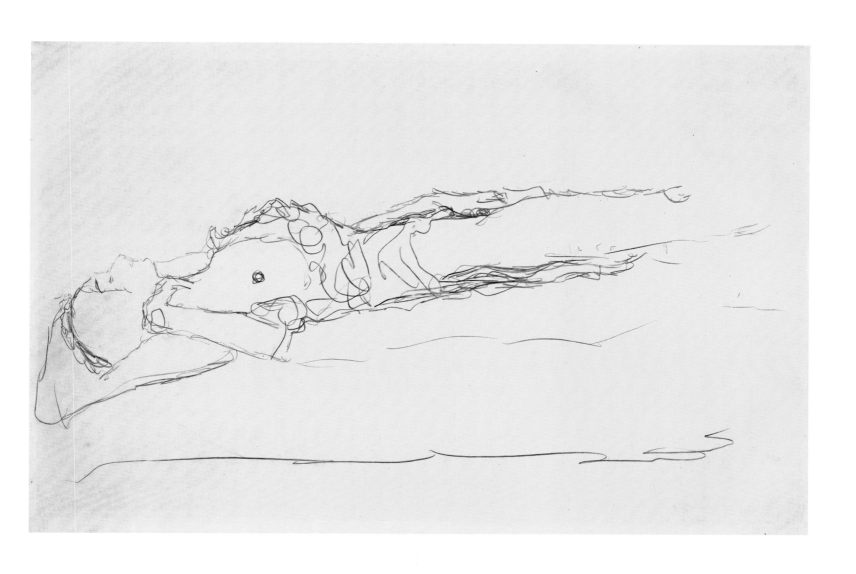

143
Seated Woman with Covered Face, ca. 1917
Study for *The Bride*

Graphite, 56.6 × 37 cm
Albertina, Vienna, inv. 23546 | Strobl III, 2986

144
Female Nude with Bent Arm, ca. 1917
Study for *The Bride*

Graphite, 50 × 32 cm
Leopold Museum, Vienna | Strobl III, 3080

Fig. 1. *The Bride*, 1917–18 (unfinished), oil on canvas, 165 × 191 cm, Belvedere, Vienna

The Bride

The monumental allegory *The Bride* remained unfinished because of the artist's premature death on February 6, 1918 (fig. 1).[1] Much as in his major work *The Virgin* (1913, fig. 1, p. 230), though with greater complexity, it reveals a cosmically projected vision of states of female erotic consciousness. Three main elements are clearly distinguished from one another. In the colorful tangle of voluptuously dreamy, ample women visible on the left, a man in a long gown is apparently trying to liberate himself from erotic entanglements. His worried face turns away from the group and toward the sleeping bride, whose masklike, smiling face is resting on his shoulder. The long, blue gown of the girlish ideal figure marks the intermediate zone between two contrary worlds: on the left, earthly seductions in the form of plastically protruding, sensuous female figures; on the right, the erotic fantasy image of a half-naked,

floating figure of a girl with legs spread and raised as if dancing. The young woman's private parts are visible through her colorfully ornamented, transparent skirt. The extremely gaunt torso, the geometrically angled arm, and the frontal profile position of body and face are a revival of the symbolically influenced figural idiom cultivated around 1900. This late work also points to a stylization of limbs and gestures in terms of the metaphysics of the mysterious that was obviously inspired by Jan Toorop and George Minne (figs. 2, 3).[2] Whereas the girl's frontally oriented body is offered openly, her dreamy face, turned to the side, exists in a sphere turned away from the world. This separation of body and soul, underscored by the scarf wound around her neck, takes on a particular dimension as a result of the presence of death in this work. The smooth, round form just to the right of the girl in profile has been identified as a fragment of a skull bent forward horizontally (fig. 4).[3] Behind the figure of the girl, Death's garment, which consists of an empty form left blank whose outlines and folds are suggested by several delicate lines of chalk, droops down to the lower edge of the image, in rhythmic harmony with the wavy contours of the already filled-out garments of the bride and the man. Death gently abducts the still untouched bride, who is rising in a dancing movement into the realm of eternal sleep. However the role of this dreamlike scene is to be interpreted, in this final large project Klimt was seeking to lend form to the symbolism of love, life, and death, which he regarded as central, in a diverse and for him unusually dramatic way (fig. 5).

Just like *The Virgin*, the thematically related allegory *The Bride* was preceded by a number

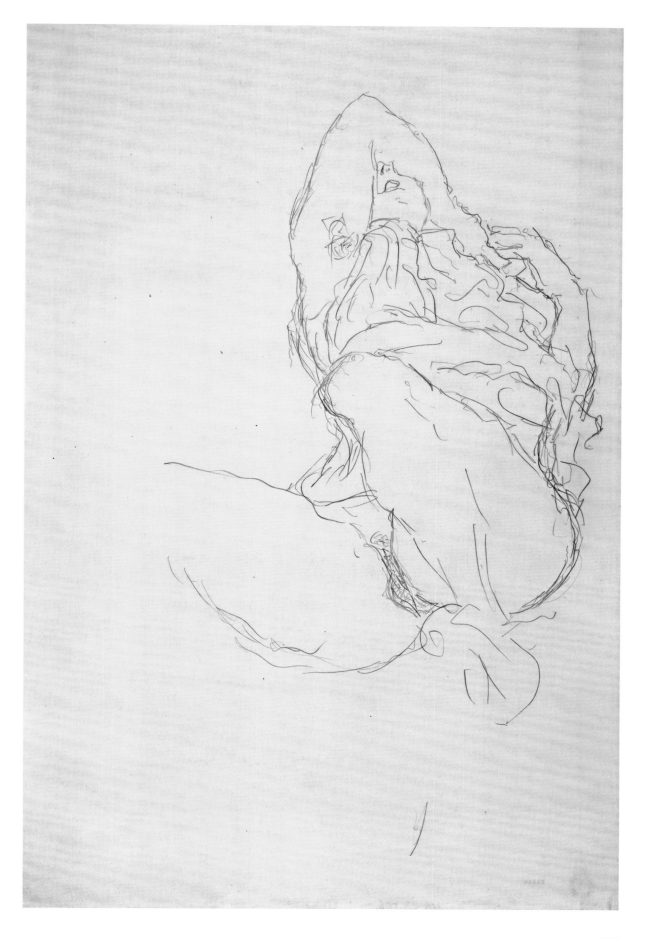

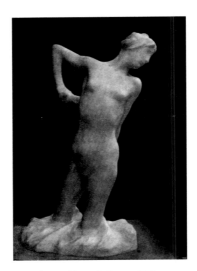

Fig. 2. George Minne, *Bather*, ca. 1899, marble, H ca. 40 cm

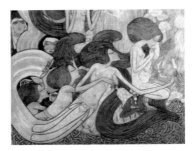

Fig. 3. Jan Toorop, *The Three Brides*, detail, 1892–93, chalk and graphite on cardboard, Kröller-Müller Museum, Otterlo

Fig. 5. *Death and Life* (first version), 1910–11, oil on canvas, 178 x 198 cm

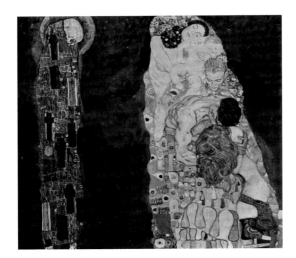

of preparatory studies, which featured an even larger range of types, body postures, and erotic moods.[4] Moreover, Klimt's approach was characterized by extremes as never before. He often almost allowed the forms to dissolve in formations of vibrating strokes, while capturing some figures in sharp contours. The first category includes the drawing of a seated model with raised, slightly opened thighs, which he sketched in the context of the voluptuous female figures in the group on the left (cat. no. 143). Despite his nervous and at times intensely intermittent lines, Klimt effectively accentuated the contours of parts of the body, such as the raised knee and buttock, which stand out brightly and almost sculpturally. The ecstatic mood of the seated figure is combined with the complex axiality of her posture; despite the weightlessness that is evoked, the figure is carefully positioned within the plane. This area of tension between dissolving the lines and formal discipline characterizes Klimt's later drawings and is effective above all in those works in which the metaphysical aspect plays a role.

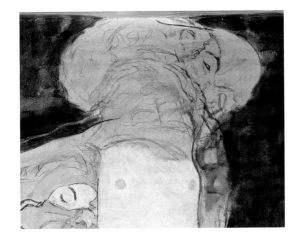

Fig. 4. *The Bride*, detail: skull, Belvedere, Vienna

This is particularly evident in the large group of studies for the figure who can be described as the bride of Death, one outstanding example of which is exhibited here (cat. no. 144). It already features the gaunt model, whom Klimt subjects to idealization in the drawings. In this close-up, expansive reproduction of the upper body and the partially visible, spread thighs, the profile still faces left and part of her upper body is clothed. Her neck is uncovered, and the outline of the neck curving to the side is emphasized with particular empathy. The gaunt, geometrically bent arm with a passively dangling hand is already important to Klimt in this version. The decisive quality, however, is the extremely free and loose use of line, with which he sought to obtain a glowing transparency. The frontal-profile contrast that had once been motivated by the program becomes a dialectic of sensuousness and asceticism, of this world and the beyond, elevated to a spiritual level he had never reached before.

1 *The Bride*, 1917–18 (unfinished), oil on canvas, 165 × 191 cm, Belvedere, Vienna, private collection (permanent loan). Novotny and Dobai 1975, no. 222; Weidinger 2007, no. 252.
2 Marian Bisanz-Prakken, in Exh. cat. The Hague 2006–7, pp. 239–41.
3 On this theme, see Bisanz-Prakken 2007–8, pp. 122–29.
4 Strobl III, 1984, pp. 207–21, nos. 2980–3111; Strobl IV, 1989, nos. 3731–41.

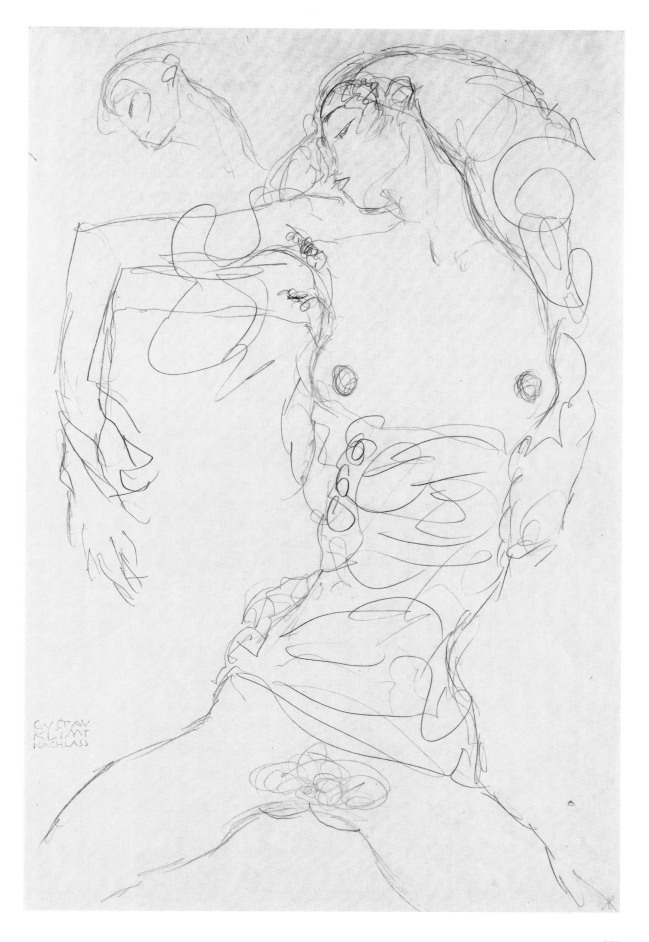

144

145
Standing Woman, Facing Slightly Left, 1911
Study for *Paula Zuckerkandl*

Graphite, 55 × 37.2 cm
Albertina, Vienna, inv. 29731 | Strobl II, 2062

146
Standing Woman in Coat, 1911
Study for *Paula Zuckerkandl*

Graphite, 55.8 × 37.4 cm
Albertina, Vienna, inv. 29733 | Strobl II, 2067

147
Standing Woman in Coat, 1911
Study for *Paula Zuckerkandl*

Graphite, 56.9 × 37.5 cm
Albertina, Vienna, inv. 30246 | Strobl II, 2069

148
Standing Woman with Cape, 1911–12
Study for *Paula Zuckerkandl*

Graphite, 56.6 × 37.4 cm
Collection of Hans-Robert Pippal and
Eugenie Pippal-Kottnig
Bisanz-Prakken, forthcoming

Portrait *Paula Zuckerkandl*

Paula Zuckerkandl, née Freund, of Breslau (now Wrocław) was the wife of the industrialist Victor Zuckerkandl. His brothers were the anatomist Emil Zuckerkandl, husband of famous journalist Berta Zuckerkandl, and the urologist Otto Zuckerkandl. The Zuckerkandl brothers and their wives were closely connected to the circle around Gustav Klimt. Klimt painted the portrait *Paula Zuckerkandl* in the winter of 1912; it was very probably destroyed in Berlin during the Second World War and is known only from a black-and-white photograph (fig. 1).[1]

The studies for the portrait *Paula Zuckerkandl* fall into two categories. For the first large group of more than twenty drawings, which can be dated to 1911 on the basis of style, the sitter posed very self-confidently in various poses and in a series of fashionable dresses.[2] In all of the drawings with a standing figure, the top part of the head is cut off by the edge of the sheet—a formula Klimt would continue to use in his late years to reinforce the majestic effect of the women posing for him. On the sheets exhibited here, the sitter is wearing a long coat of a light, gently draping fabric and an evening coat with fur trim (cat. nos. 145–47). In the drawing that features a figure turned slightly and propped against an invisible table with her ringed hand placed on her hip, Klimt distinguished the contours of the layers of her clothing with succinct, confident lines (cat. no. 145). The slightly twisted pose produces a certain spatial effect, in which the bright void that forms her ample décolletage is brought into play. The two other studies contain a note that would have been modern at the time: a dress that tapers toward the bottom (cat. nos. 146, 147).[3] In one drawing Klimt emphasized the curving overall outline of the coat and inside area; in the other he devoted himself to the delicate folds and patterns of her top, which is surrounded by her dangling arms as if by an oval. In general, these works are captivating for their powerfully pulsating lines, which evoke light and space and mark the beginning of a new era after the fading of the Golden Style.

The study being published here for the first time is completely different in the style of depiction and atmosphere and comes very close to the final composition; hence it may have been produced in 1912 (cat. no. 148). With cautious strokes, Klimt characterized the contours and the various structures of the diagonally converging ornamental layers of

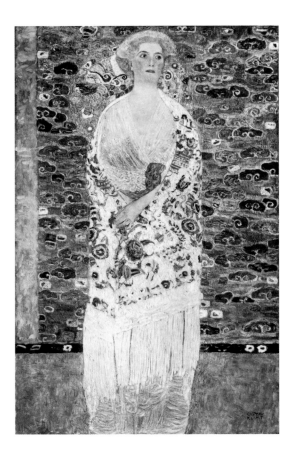

Fig. 1. *Paula Zuckerkandl*, 1912, oil on canvas, 190 × 120 cm, lost

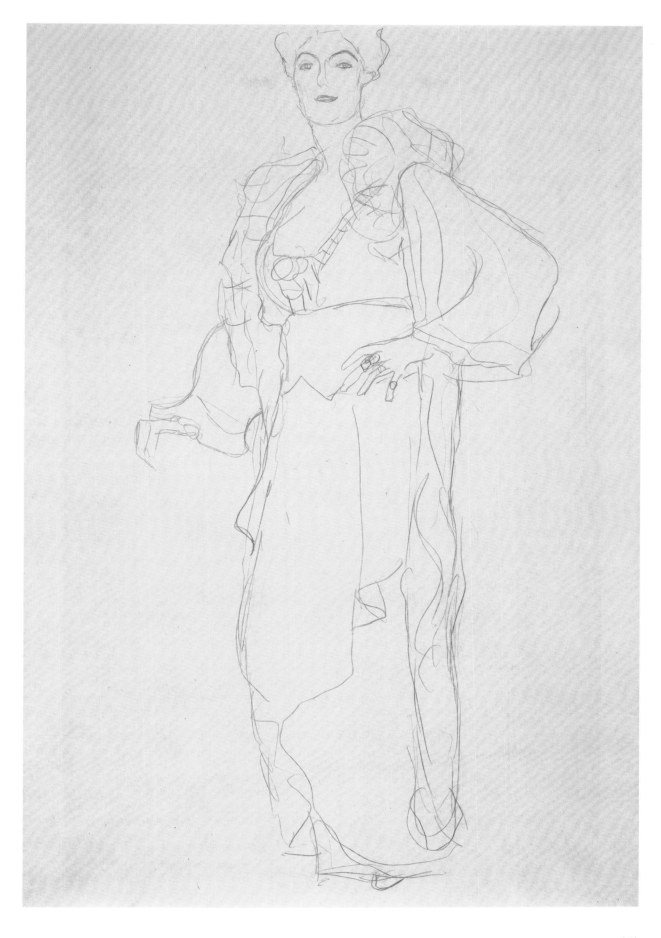

145

29733

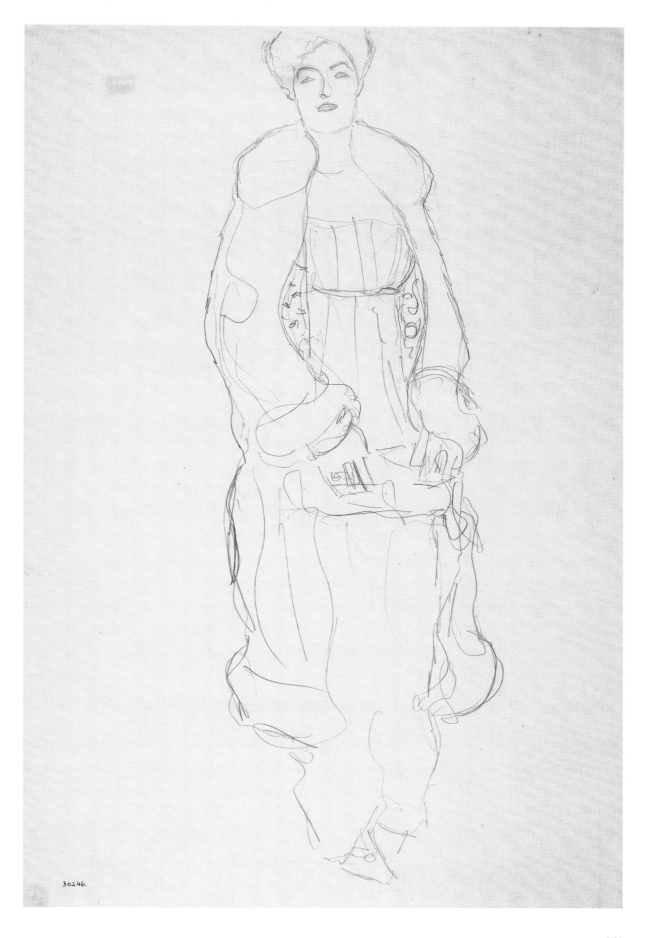

30246.

the Manila shawl with long fringe that covers her figure almost entirely. The hands remain—in contrast to the painting—completely hidden, and the object that partially covers the figure in the right foreground, which is visible only as an empty form, is not found in the final version. Klimt very delicately defined the woman's facial features; her figure, with its round, somewhat drooping shoulders, is characterized by a hermetic cohesiveness. In contrast to the clear play of contour lines in earlier studies, Klimt emphasizes here soft, round forms and the subtle gradation of light values. The effect of spiritualization achieved also characterizes the painting, in which the sitter's gaze wanders in the distance—unlike the immediacy of expression of the earlier studies.

[1] *Paula Zuckerkandl*, 1912, oil on canvas, 190 × 120 cm. Novotny and Dobai 1975, no. 178; see Natter 2003, pp. 108, 138 n. 97.
[2] Strobl II, 1982, nos. 2053–72; Strobl IV, no. 3636.
[3] Alice Strobl pointed to costume designs by Otto Lendecke and Eduard Josef Wimmer (Strobl II, 1982, p. 259).

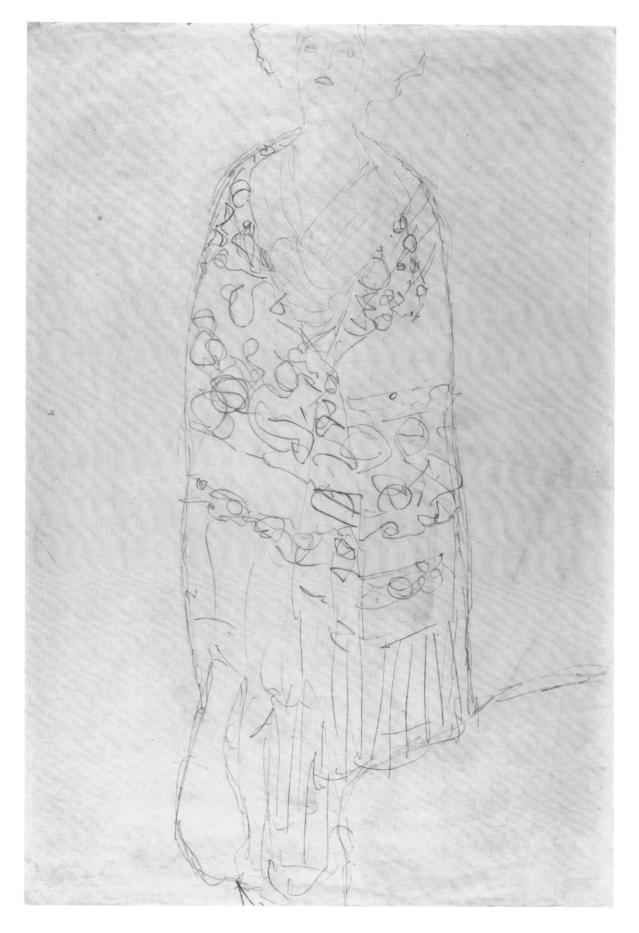

Portrait *Adele Bloch-Bauer II*

Five years after Klimt had completed his first, now world-famous portrait painting of Adele Bloch-Bauer (1907), he painted her second portrait (fig. 1).[1] There seem to be worlds between the overflowing golden ornament, on the one hand, and the painterly, loose colorism, on the other. The differences between the two paintings have usually been emphasized. The new palette, which appears in Klimt's portraiture for the first time here, can be traced back both to his encounter with the Fauves at the *Kunstschau* in Vienna (1909) and to his stays in Paris (1909) and Brussels (1911).

There are also startling differences between the groups of studies produced even further apart in time, in terms not only of style but also of psychology. In contrast to the lyrical

sensuality of the lilting lines of the works produced around 1903 (cat. nos. 79–82), the 1911 studies of Adele Bloch-Bauer are characterized by stern unapproachability.[2] Without exception, Klimt presented the thirty-year-old standing and facing front—with and without a hat and in various kinds of clothing. With this pose, he was going back to a group of preparatory drawings for *Adele Bloch-Bauer I* in which he had experimented for a time with her in a standing posture clearly inspired by the mosaic figure of Empress Theodora in the Basilica di San Vitale in Ravenna.[3] The harmoniously flowing play of lines of those early studies, in which the woman is presented standing with majestic self-confidence, contrasts starkly with the nervously repetitive way of drawing of the later sheets. In the latter, the strict tectonics of the figure, who is caught up in herself, so to speak, ossifies into the expression of a certain resignation, which results not least from the passively dangling arm. As is evident from the two studies exhibited here, the depiction of the facial features is reduced to a minimum. The distinctive form of the mouth, which had been the sensuous point of attraction in the studies for the first painting, is merely a neutral identifying feature in the drawings for the second portrait. Klimt dedicates himself all the more intensely to the overlapping layers of clothes. Using highly differentiated, often extremely intermittent strokes, he attempted again and again to characterize the fabrics, strikingly distinguishing them from one another and causing them to glow in different ways. These painterly effects achieved through purely linear means characterize the artist's late drawing style, with his preference in the last decade of his life for

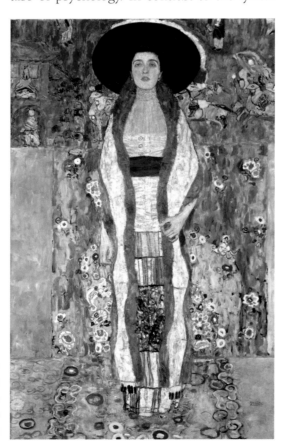

Fig. 1. *Adele Bloch-Bauer II*, 1912, oil on canvas, 190 × 120 cm, private collection

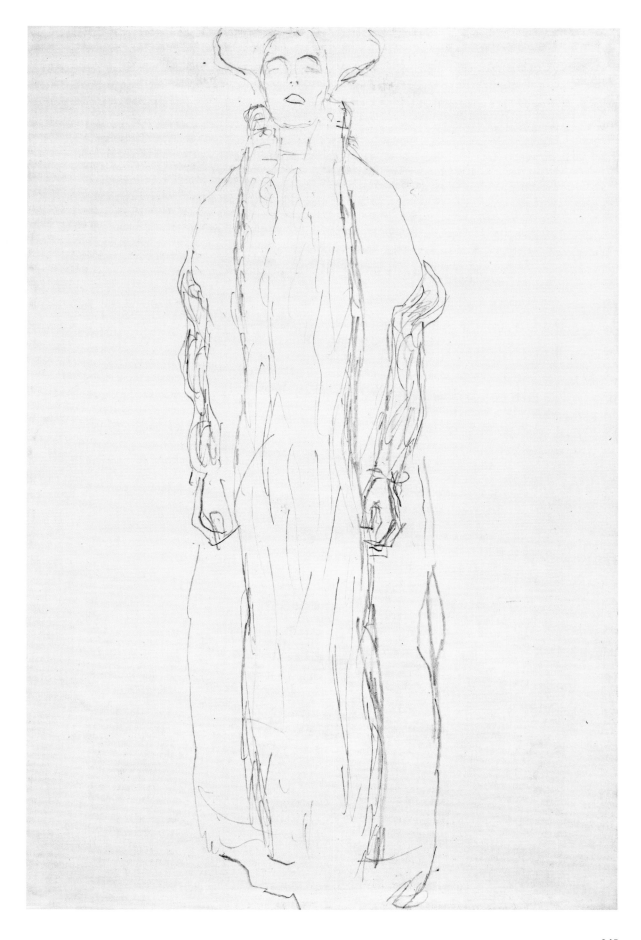

149

pencils that produced soft and saturated lines. The directions of movement continue to play a large role, as the two works shown here demonstrate exemplarily. The one study is entirely dominated by a verticality that seems to flow endlessly: both the generously hatched inner garments and the heavy contours of her long cape and the dense structure of lines of the protruding dark sleeves (cat. no. 149). In the other work shown here, Klimt played effectively with the geometrically patterned dress—which largely corresponds to the painted version—against the powerful curve of the fur-trimmed coat (cat. no. 150). The painting, too, is marked by a dialectic of orthogonal and wavelike elements.

1 *Adele Bloch-Bauer II*, 1912, oil on canvas, 190 × 120 cm, private collection. Novotny and Dobai 1975, no. 177; Weidinger 2007, no. 208.
2 Strobl II, 1982, p. 265, nos. 2008–12; Strobl IV, 1989, nos. 3635–38a.
3 Strobl I, 1980, nos. 1110–14.

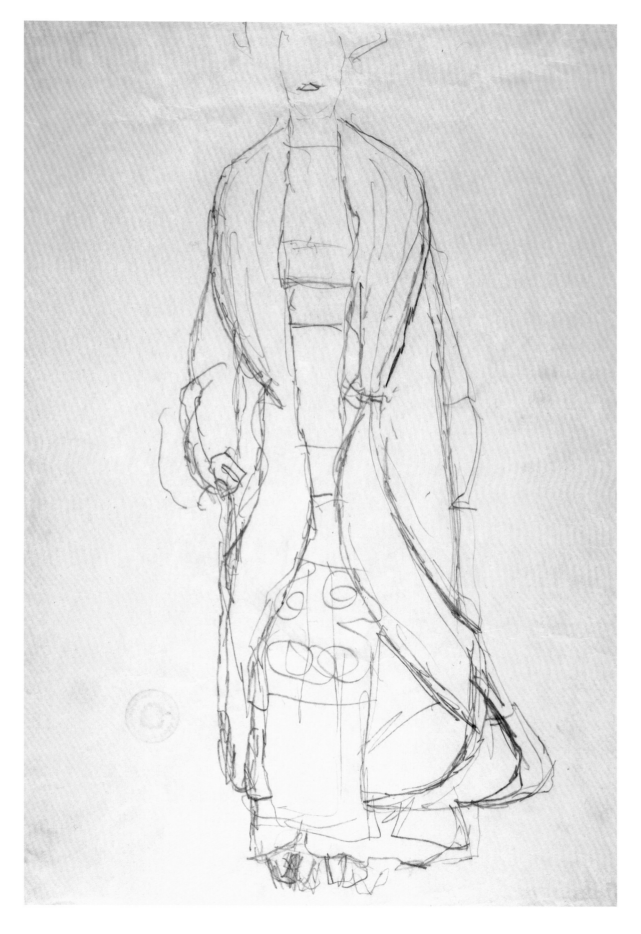

151
Seated Girl Seen from the Side, 1912–13
Study for Mäda Primavesi
Graphite, 55.9 × 36.7 cm
Albertina, Vienna, inv. 33355 | Strobl II, 2114

152
Girl Standing with Hands Clasped, 1912–13
Study for Mäda Primavesi
Graphite, 56 × 37.6 cm
Albertina, Vienna, inv. 30446 | Strobl II, 2118

153
Seated Girl Seen from the Front, 1912–13
Study for Mäda Primavesi
Graphite, 56.5 × 36.8 cm
Albertina, Vienna, inv. 30445 | Strobl II, 2121

154
Standing Girl in Coat, 1912–13
Study for Mäda Primavesi
Graphite, 55.9 × 36.7 cm
Albertina, Vienna, inv. 30443 | Strobl II, 2122

155
Standing Girl in Coat, with Hand on Hip, 1912–13
Study for Mäda Primavesi
Graphite, 55.9 × 36.7 cm
Albertina, Vienna, inv. 30447 | Strobl II, 2123

156
Standing Girl in Coat, 1912–13
Study for Mäda Primavesi
Graphite, 56.4 × 37 cm
Albertina, Vienna, inv. 30448 | Strobl II, 2124

157
Girl Standing with Her Hands Resting on Her Hip, 1912–13
Study for Mäda Primavesi
Graphite, 56.8 × 37.1 cm
Albertina, Vienna, inv. 30444 | Strobl II, 2125

Portrait *Mäda Primavesi*

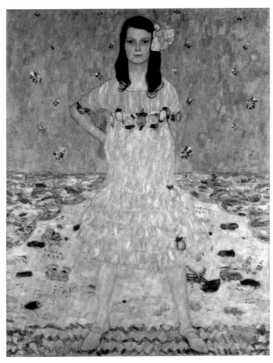

Fig. 1. *Mäda Primavesi*, 1913, oil on canvas, 150 x 110 cm, Metropolitan Museum of Art, New York

The portrait of the nine- or ten-year-old Mäda Primavesi, which was completed shortly before Christmas 1913, is the only portrait of a child Klimt was officially commissioned to paint (fig. 1).[1] Mäda was the daughter of the banker Otto Primavesi, one of the most important supporters of the Wiener Werkstätte, and his wife, Eugenia (cat. nos. 158, 159). Mäda was considered a very bright and enterprising girl who had many interests.[2] The meetings in the artist's studio must have seemed protracted to the child, yet the 1912 studies convey a lively, uninhibited impression. Klimt famously had an uncomplicated and immediate approach to children.[3]

All the drawings for the portrait *Mäda Primavesi* preserved in the Albertina are exhibited here. These seven sheets convey a diverse impression of the range of positions in which the girl posed in comfortable clothing with complete naturalness: seated, facing forward or to the side, with legs dangling freely, her hands clasped or resting on her thighs; or standing, seen from various sides, with her hand on her hip or dangling. Her shoulder-length, freely falling hair is sometimes gathered together with a ribbon. With spontaneous, succinct strokes, Klimt recorded the child's changing facial ex-

Fig. 2. Sketches for *Mäda Primavesi*, 1912–13, graphite

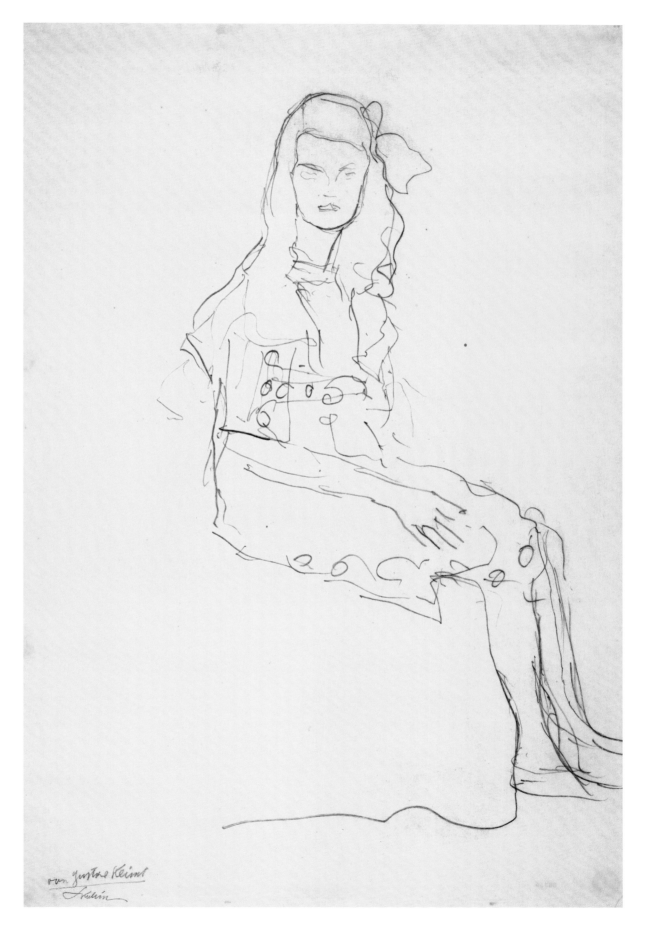

151

pressions. As with his adult women, the artist used drawing to get at the essence of his young model—with the difference that he clearly took into account the natural mobility of a child. The studies thus have the quality of snapshots, but characterized with great conciseness of line.

In these works Klimt was often feeling his way to his ideal solution, though no figure studies for the painted version are known. Klimt produced a series of small sketches concerned with the symmetrically structured composition, in which the girl, posing in a short, white frilled dress, stands with complete self-confidence, her legs splayed, in front of a colorful fantasy landscape. These sketches are known to us only from a montage used for a black-and-white illustration (fig. 2).[4] Within the borders of the images that he set himself, Klimt explored different possibilities for the final composition. For example, one drawing is about the tension between the chiaroscuro sections; another deals with the triangular overall outline of the girl in relation to the meadow in the background, while some of them are about the rhythm of the ornaments strewn across the picture plane. Each of these self-contained sketches shows a unique approach and impresses us with the impetus of the artist's lines and his inexhaustible decorative imagination. They demonstrate very clearly that Klimt considered the end result primarily in terms of lines and planes.

[1] *Mäda Primavesi*, 1913, oil on canvas, 150 × 110 cm, Metropolitan Museum of Art, New York. Novotny and Dobai 1975, no. 179; Weidinger 2007, no. 213.

[2] Klein-Primavesi 2004, p. 206. See also Exh. cat. Vienna 2000–2001, pp. 126, 128, n. 3.

[3] Strobl II, 1982, p. 273, nos. 2113–31; Strobl IV, 1989, nos. 3639–46.

[4] Strobl II, 1982, nos. 2132–40, illustrated in Emil Pirchan, *Gustav Klimt. Ein Künstler aus Wien* (Vienna, 1965), figs. 144–153.

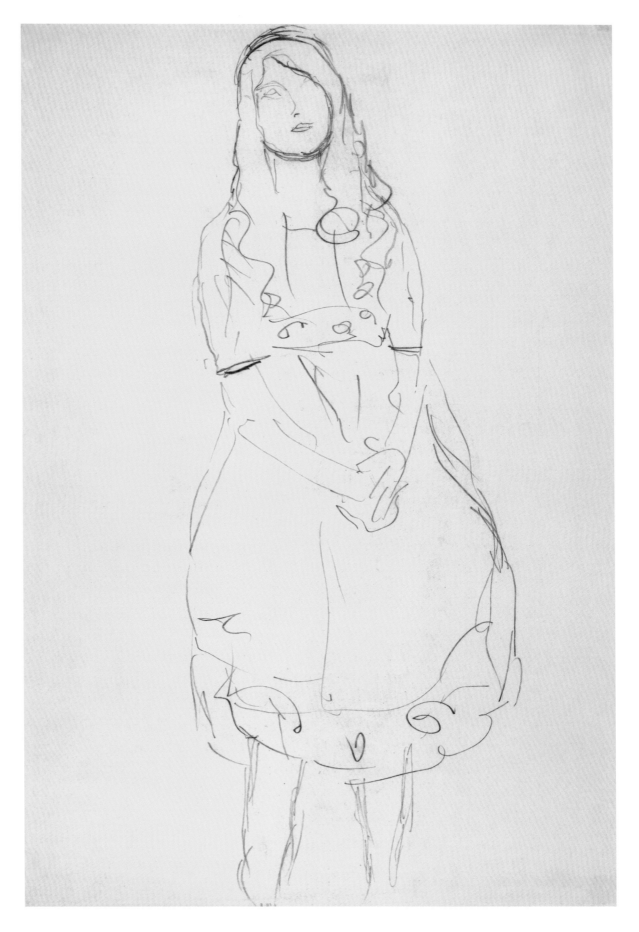

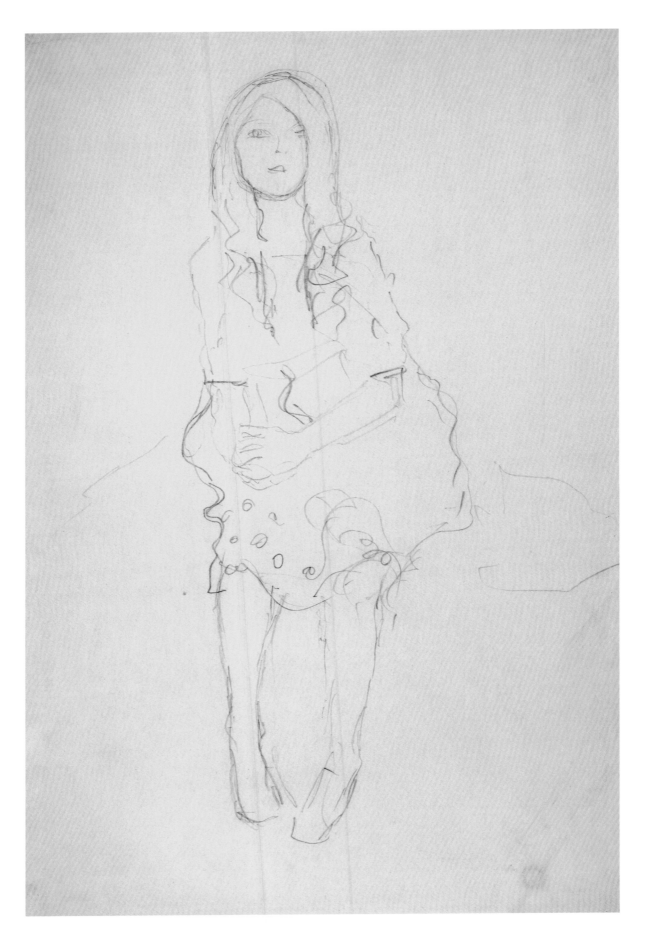

153

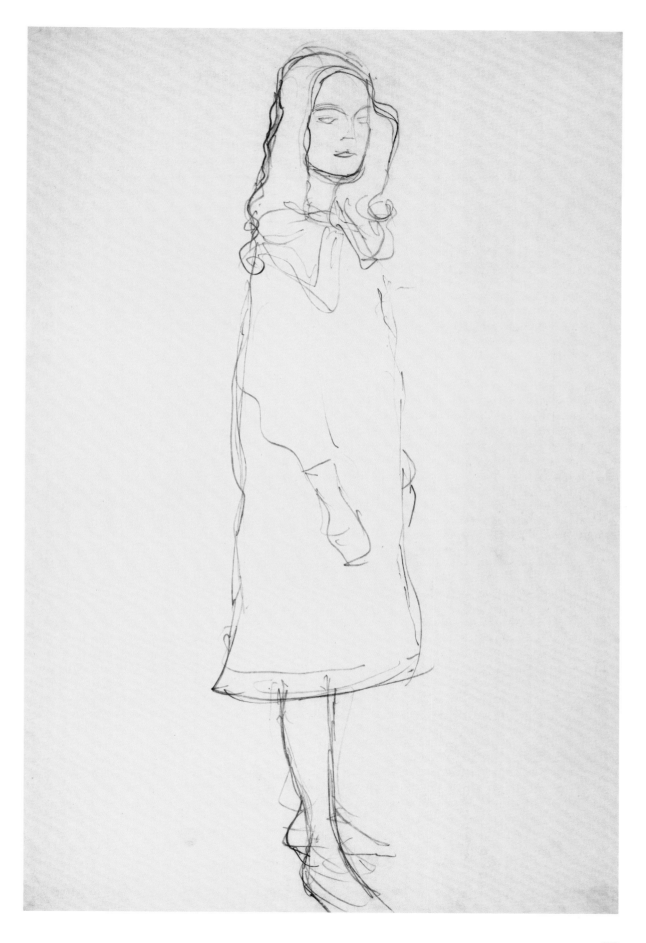

154

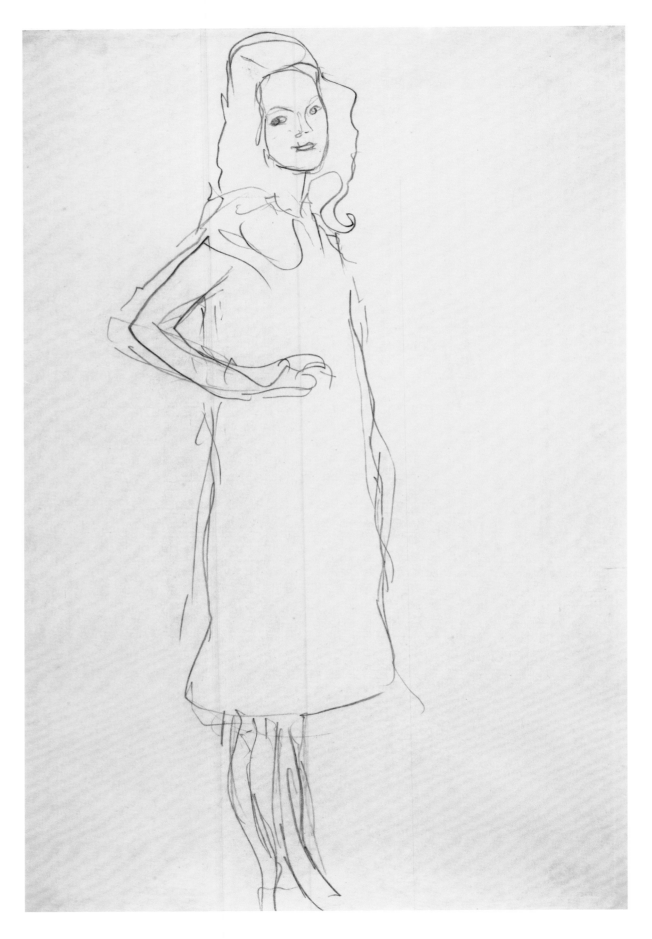

Portrait *Eugenia Primavesi*

Klimt worked on the preparations for the portraits of Mäda Primavesi (cat. nos. 151–57; fig. 1 on p. 268) and her mother, Eugenia (cat. nos. 158, 159; fig. 1), at around the same time.[1] Mother and daughter traveled regularly from Olmütz to Vienna in 1912 and 1913 so they could be sketched. The portrait *Mäda Primavesi* was completed shortly before Christmas 1913; the portrait of her mother, in 1913–14—that is to say, at the time the Primavesis were having Josef Hoffmann build them a villa in Winkelsdorf, near Mährisch Schönberg (now Šumperk). This architectural *Gesamtkunstwerk*, located in splendid surroundings, would become a social meeting place for artists and friends of the arts. Klimt was a guest several times, and the Primavesis had one of the largest private collections of his work.[2]

Eugenia Primavesi, née Butschek, who had been an actress prior to her marriage, was around forty at the time her portrait was painted. From the surviving studies for her portrait it is apparent that because of her corpulence Klimt went to some trouble to find an advantageous pose for her (cat. nos. 158, 159).[3] The study exhibited here represented an essential moment in that difficult process (cat. no. 158). Eugenia is depicted in a slight striding pose in three-quarter view. Her lower arm is bent at a right angle and stands out brightly as a blank form, assuming an energetic-looking horizontal position. Both hands are clenched into fists—apparently an important detail, as it appears again at top right. This horizontal element is balanced by the powerfully accented curve of her shoulders and by the curved ornament of the long shawl draped over her shoulders. Her slightly raised face is directed diagonally out of the picture,

and her mouth is opened slightly as if to speak. The powerful and yet subtly differentiated lines with which Klimt expansively depicts her form convey light and plasticity. The dominant impression is of an emphatically present, matronly personality.

It is, however, also clear from this masterly work that the model's corpulence made it considerably more difficult to achieve the balance between accurate characterization and idealization that he always sought. In the final study, Klimt made a virtue of necessity, as it were (cat. no. 159). In a kaftanlike garment by the Wiener Werkstätte that surrounds her body spaciously, the model poses standing upright

Fig. 1. *Eugenia Primavesi*, 1913–14, oil on canvas, 140 × 84 cm, Toyota Municipal Museum of Art

158

Standing Woman in Three-Quarter Profile, 1912–13
Study for *Eugenia Primavesi*
Graphite, 56.6 × 37 cm
Albertina, Vienna, inv. 30646 | Strobl II, 2150

159

Standing Woman, 1912–13
Study for *Eugenia Primavesi*
Graphite, 56.6 × 37 cm
Albertina, Vienna, inv. 30645 | Strobl II, 2155

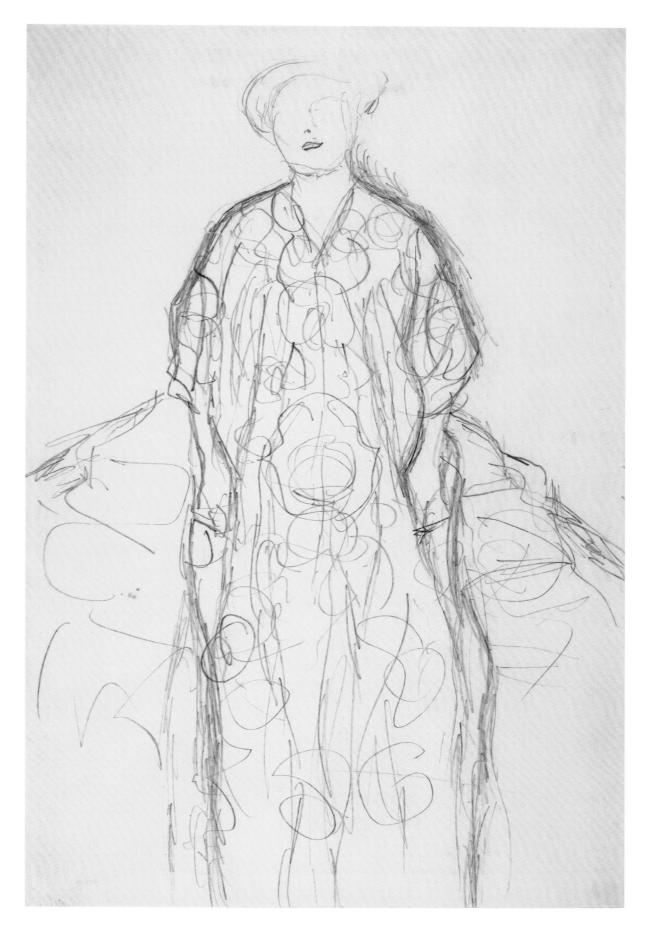

and strictly frontally before a symmetrical, mountainlike form. Her gestures and facial expressions are of less importance, since all the energy is now collected in the contours. Klimt focused on the heavy, multiple contours of her clothing, whose pulsating wave movements take up her dangling arms. The curves of her shoulders emerge emotively, and the impetus of the contours seems to be transferred to the lines of the "mountain" that flow down on both sides. This is the first of Klimt's drawings to feature an interaction between the figure and the abstract backdrop. Despite its massiveness, the figure seems to be set apart from the earth, since its base is cut off by the edge of the paper. In the painting too, gravity seems to be overcome, since the sitter presented frontally before a field of flowers glowing yellow lacks any contact with the ground. The figure is found in an indeterminate state of floating; it is not clear whether she is sitting or standing. For all the differences between the drawing and the painting, there is a certain analogy in the depiction of the garment's ornamentation. In the study, the saturated, wildly superimposed pencil lines form a structure that shimmers vividly, thinning out in the lower part. In the oil painting, too, the generously applied floral patterns open up increasingly toward the bottom. The powerful, self-contained pencil work remains unsurpassed by the magical concentration on the outlines.

[1] *Eugenia Primavesi*, 1913–14, oil on canvas, 140 × 84 cm, Toyota Municipal Museum of Art. Novotny and Dobai 1975, no. 187; Weidinger 2007, no. 218.
[2] On Otto and Eugenia Primavesi, see Exh. cat. Vienna 2000–2001, pp. 128–31; Natter 2003, pp. 72–86.
[3] Studies for the portrait *Eugenia Primavesi*: Strobl II, 1982, pp. 273–74, nos. 2141–57; Strobl IV, 1989, nos. 3647–49.

Portrait *Amalie Zuckerkandl*

Amalie Zuckerkandl, née Schlesinger, was the wife of the urologist Otto Zuckerkandl. The journalist Berta Zuckerkandl, wife of Emil, played a key role in the contacts this famous physician—as well as his brothers, Emil and Victor—had with the circle around Gustav Klimt. It was she who supported Klimt and the Viennese avant-garde with her passionate commitment (see p. 258).[1] After Klimt, probably in 1913, received a commission to paint a portrait of Amalie Zuckerkandl, who was then forty-four, he produced the first large group of studies in 1913–14, including the three works shown here.[2] In 1915–16, Amalie was staying in Lemberg (now L'viv), where her husband was active as a physician and she as a nurse. Klimt began the portrait only after their return, and it remained unfinished at his death on February 6, 1918 (fig. 1).[3]

For this study of Amalie Zuckerkandl seated facing front (cat. no. 160), Klimt took up a pictorial formula he had first developed a year earlier in the drawings for the portrait of *Eugenia Primavesi*. An item of seating furniture that fills the full width of the image was abstracted there into a landscapelike backdrop, into which the figure grows as if organically (see cat. no. 159). Following this innovative principle, he caused the bed (or sofa) on which Amalie Zuckerkandl was enthroned frontally and the tower of pillows behind her to fuse into a symmetrical triangle. The energy of the drawing concentrates on the luxuriantly flowing layers of clothing, whose borders and inner structures are defined by alternating long, flowing, vibrating complexes of lines and short, fierce strokes. The pole of serenity in these broadly sweeping currents of motion is formed by the face, frontal and inclined slightly to the

left, with its vivid gaze and slightly open mouth. The movements of the lines are tamed by the hermetic overall form anchored in the plane. A frequently recurring motif in these studies is a loosely draped, fur-trimmed coat that exposes the deep décolletage. On the sheet exhibited here, Klimt suggested the volume of the breasts in the blank space left for this part of the body with a single, short vertical stroke.

The layers of clothing, which fall differently each time as the poses change, are the subjects of numerous studies, in which Klimt repeatedly attempted to harmonize the flowing contours and the "inner life," whose lines are sometimes intense animated. As both the drawings exhibited here show, he was not interested in details but rather the overall dynamic appearance, into which he integrated effects of light caused by leaving the paper ex-

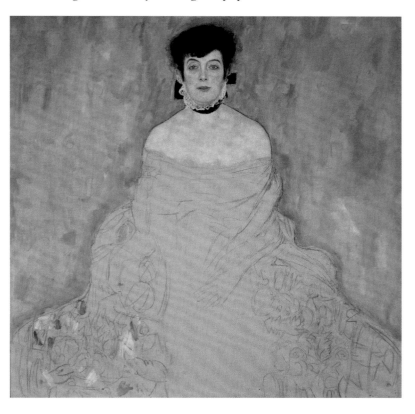

Fig. 1. *Amalie Zuckerkandl*, 1917–18 (unfinished), oil on canvas, 128 x 128 cm, Belvedere, Vienna

posed in places. In one case the seated woman is propped up in a curved pose, with her right knee crossed and one arm on an invisible piece of furniture (cat. no. 161); in another case she is seen in three-quarter view and her hands are folded in front of her chest (cat. no. 162). Both cases reveal Klimt's effort to capture the appearance of space in the plane.

Nothing of the lively, lilting character of these studies remains in either the 1916–17 drawings or the partially realized painting. Klimt retained the strictly symmetrical position of the sitter and the idea of mountainlike backdrop with which she has grown together.

1 See Natter 2003, pp. 100–110.
2 Strobl III, 1984, p. 58, nos. 2468–89; Strobl IV, nos. 3686, 3687.
3 *Amalie Zuckerkandl*, 1917–18, oil on canvas, 128 × 128 cm, Belvedere, Vienna. Novotny and Dobai 1975, no. 213; Weidinger 2007, no. 250.

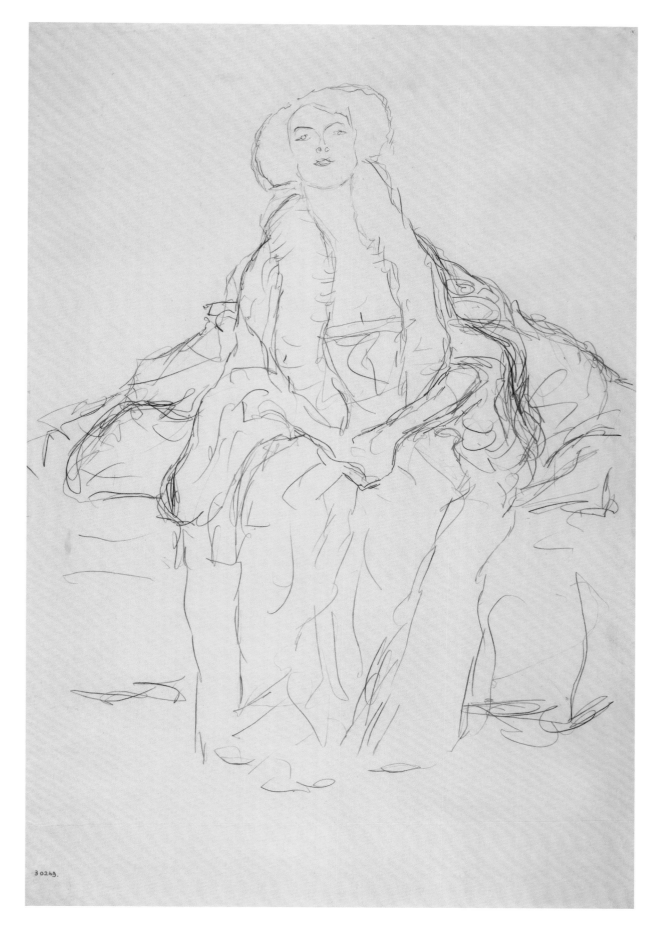

160

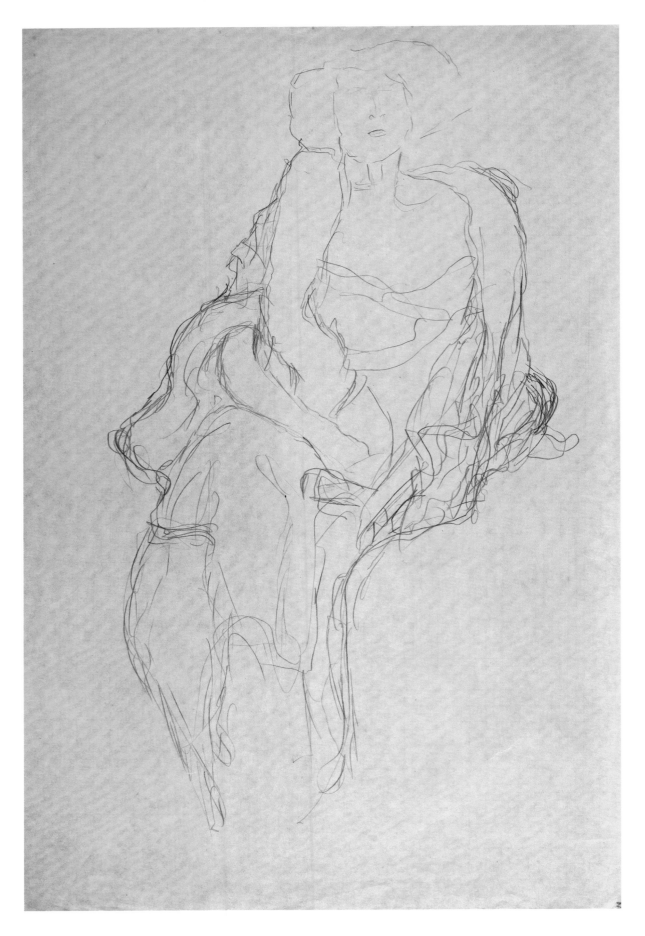

Portrait *Friederike Maria Beer*

Born in Vienna in 1891, Friederike Maria Beer was an enthusiastic supporter of the Wiener Werkstätte. The young, rich woman was a friend of the extremely wealthy Hans Böhler, who was active in the arts and had contacts with the Viennese avant-garde.[1] Through Böhler she met Egon Schiele in 1914 and Gustav Klimt in November 1915, both of whom painted her portrait.

She had requested the portrait Klimt painted of her in 1915–16 as a gift from Hans Böhler (fig. 1).[2] Decades later she reported on the creation of the work. On their first meeting, Klimt is said to have observed her hands for a long time. She tried on many Chinese and other Oriental costumes from his large collection, but the pattern of the silk fabric by Dagobert Peche that lined her expensive polecat jacket pleased him so much that he had her pose wearing it inside out—just as he would paint it.[3]

To judge from the surviving studies, in which Klimt captured the young lady in a various of poses and fashion creations, the phase of the preparatory drawings must have been very intense.[4] The round, regular face of the dark-haired sitter, which inspired the artist to produce several separate studies, also occupies an unusually prominent place in the drawings of the full figure. The works exhibited here were produced in an early phase of the preparations in which Klimt sought to study the essence and overall look of his model from various sides. In the depiction of the figure half-sitting and slightly propped up, the face is slightly fragmented by the upper edge of the paper, and the eyes directed at the viewer and the strongly pronounced eyebrows form the focus (cat. no. 163). The layers of the dress, the coat, and the fur-trimmed pelerine are articulated into regularly contoured, broadly expansive fields. With intuitive legerity, Klimt establishes a balance between the slightly curved transverse lines and the vertical, rectangular elements of the clothing—as well as between the blank sections and the geometrically patterned ones. Friederike Beer was one of the few women whose feet Klimt included in both drawn and painted portraits, lending an independent note to her personal and fashionable presence.

The study in which she sits facing front with her faced propped and bent toward the artist seems to be completely detached from the preparations for the painting (cat. no. 164).

Fig. 1. *Friederike Maria Beer*, 1915–16, oil on canvas, 168 x 130 cm, Tel Aviv Museum of Art

Aus dem Nachlass meines
Onkels Gustav Klimt
Rudolf Singer

The concentration on her hypnotizing gaze is even more intense because her body has been reduced to a distinctive arabesque. To this is added Klimt's characteristic technique in which the light-colored basic structure of lines—including the turned-up collar that surrounds the woman's head like an aureole—is overlapped with vigorous dark lines. The result of this method is a lively oscillation between a light gray and a dark gray substance. The condensation of the dark lines of graphite around the chin causes the bright oval of her face to glow almost magically. With a tension between concentrated lines and at times extremely free ones, the artist achieved particularly intense psychological expression.

[1] On Hans Böhler, see Natter 2003, pp. 186–94.
[2] *Friederike Maria Beer*, 1916, oil on canvas, 168 × 130 cm, Tel Aviv Museum of Art, Mizne-Blumental Collection. Novotny and Dobai 1975, no. 196; Weidinger 2007, no. 228.
[3] On the history leading to the painting, see Nebehay 1969, pp. 433–37; Strobl III, 1984, pp. 99–100.
[4] Strobl III, 1984, nos. 2524–64.

The Dancer (Portrait *Ria Munk II*) and Portrait *Ria Munk III*

The three posthumous portraits of Ria (Maria) Munk had a dramatic prehistory. The beautiful and wealthy young woman was engaged to the writer Hanns Heinz Ewers, who was surrounded by scandal. When he ended their relationship by letter, the twenty-four-year-old took her own life by shooting herself in the heart on December 28, 1911.[1] Commissioned by her parents, Aranka—sister to the great Klimt patron Serena Lederer—and Alexander Munk, Klimt painted her posthumous portrait in 1912.[2] Klimt was commissioned for a second posthumous painting of Ria Munk, this time standing, in 1914.[3] In parallel with that he was working on a portrait of her cousin Elisabeth Lederer, daughter of August and

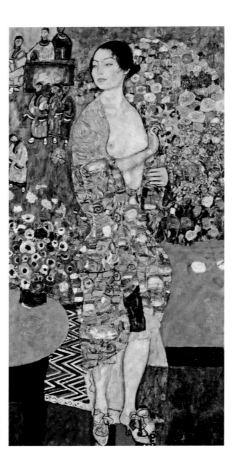

Fig. 1. *The Dancer (Ria Munk II)*, 1916–17, oil on canvas, 180 x 90 cm, private collection, courtesy Neue Galerie, New York

Serena Lederer, which he completed in 1916.[4] Work on the second posthumous painting of Ria Munk had to be stopped, however, as her parents disliked it. Klimt then painted over it with a bare-breasted dancer partly covered by a cape (*The Dancer*, 1916–17, fig. 1).[5] Alice Strobl suspected there was a connection between the unknown portrait *Ria Munk II* hidden beneath the new layer of paint and a number of studies of a standing model covered with a cape.[6] She established connections between the motifs in these works and those in the drawings for the portrait *Elisabeth Lederer* and the painting *The Dancer* as well. Many of these sheets reveal that Klimt had rediscovered his love of dance, which had occupied him intensely in the studies for "Expectation" in *The Stoclet Frieze* and for *Salome* (cat. nos. 101, 102, 111, 112). He seems to have been thinking again of the extremely ideal figure he once preferred and the fragile, angular gestures of arms and hands—for example, in the superior study of a standing dancer that largely corresponds to the version in oil with respect to the figure's pose (cat. no. 165). Here the sitter is posing in puffed, lavishly draped clothing that extends down to her knees. The nervously hatched, frequently interrupted line, which makes the figure seem airy, is characteristic of the artist's late work. The striking play of lines in the rigorously fixed face looking over her shoulder is the opposite pole to this sensitive transparency, and the smiling, dreamy facial expression is the focus. This autonomous creation balances dogmatic austerity and delicate elegance.

These qualities are elevated to the metaphysical in the studies for the third posthumous portrait of Ria Munk, which remained

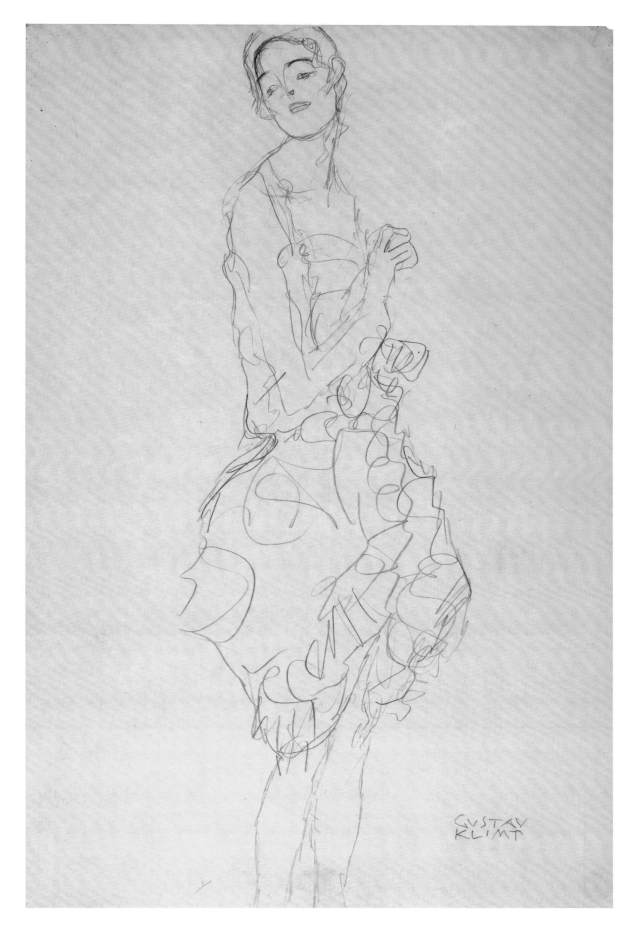

165

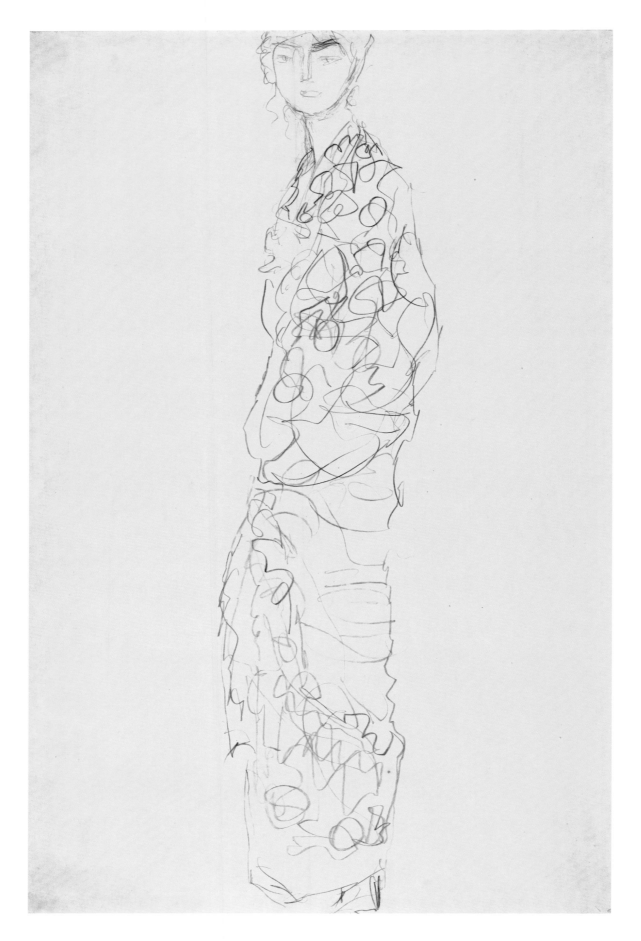

166

unfinished as a result of the artist's death (*Ria Munk III*, fig. 2).[7] In it Klimt alluded in code to the sitter's tragic fate by separating good and evil symbolically. The figure, depicted from the side and wrapped in scarves, turns her smiling face toward the viewer and tenderly holds a bouquet of hyacinths. The scenery behind her is strewn with colorful flowers of positive symbolism and Japanese stylized signs of happiness. Behind her on the right lurks evil in the form of a garish, poisonous mandrake root. Here Klimt was unmistakably alluding to Hanns Heinz Ewers's scandalous novel *Alraune* (Mandrake), which was published shortly before Ria's suicide. In Viennese society there were rumors its publication was one reason for that unfortunate act. Seemingly untouched by these negative forces, the young woman turns, blissfully smiling, toward a better world.[8]

In the drawings, Klimt grappled intensely with the portrait's posthumous quality. For lack of a sitter, he had various models pose with their bodies wrapped in patterned scarves that emphasize the transcendent character.[9] The arms of those posing are pressed against the body; only the hands sometimes loom out, as in the painting, where they hold the scarves together on the right and carry the flowers on the left. One highlight within this group is the study of a figure fixed columnlike within the picture plane, as if wrapped by a shroud and seeming to linger weightlessly in infinity (cat. no. 166). Almost without interruption, the soft, constantly turning pencil glides across the paper in changing rhythms and in the process describes a number of abstract patterns. The veiled forms of the body can be made out subtly thanks to certain systems of movement

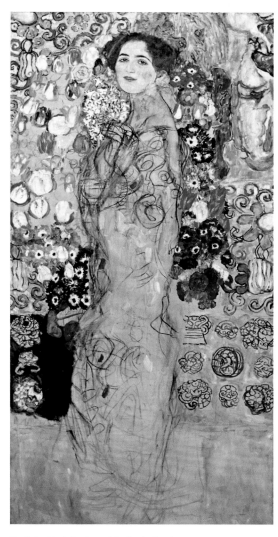

Fig. 2. *Ria Munk III*, 1917–18 (unfinished), oil on canvas, 180 x 90 cm, private collection

and variations in the concentration of strokes. Klimt employed the heavily accented eyebrows as a regulative for the central axis. As always, the dictate of the edges of the sheet determine the relationship between figure and plane and can only unfold the energy of the drawing under this self-imposed constraint. In this late linear work, Klimt achieved a maximum of expressivity within the higher order of a *Gesamtkunstwerk*, or "total work of art."

1. On Ria Munk's history, see Kugel 1992, pp. 166–68. See also Sophie Lillie, "Das kurze Leben der Maria Munk: Ein Porträt der Moderne wird restituiert," *Parnass* 29, no. 3 (2009): 60–62.
2. *Maria Munk on Her Deathbed (Ria Munk I)*, 1912, oil on canvas, 50 × 50.5 cm, private collection. Weidinger 2007, no. 207.
3. On the portraits *Ria Munk I–III*, see Strobl III, 1984, pp. 111–16.
4. *Elisabeth Lederer*, 1916, oil on canvas, 180 × 128 cm, private collection, New York. Novotny and Dobai 1975, no. 188; Weidinger 2007, no. 227.
5. *The Dancer*, 1916–17, oil on canvas, 180 × 90 cm, private collection, New York. Novotny and Dobai 1975, no. 208; Weidinger 2007, no. 238.
6. Strobl III, 1984, nos. 2512–17, p. 111.
7. *Ria Munk III*, 1917–18 (unfinished), oil on canvas, 180 × 90 cm, private collection. Novotny and Dobai 1975, no. 209; Weidinger 2007, no. 246 (as *Portrait of a Woman*).
8. On its symbolism, especially concerning the mandrake root, see Bisanz-Prakken 2009.
9. Strobl III, 1984, nos. 2606–18.

Half-Length Portraits, 1912–1917

For Klimt as a draftsman, the half-length or head-and-shoulders portrait remained one of his favorite motifs until his death. Indeed, especially in his late years these monumental, self-contained creations, which are diametrically opposed to the often vehemently animated erotic drawings, are manifested in extremely diverse ways.

This meditative pen-and-ink drawing of a girl with her hair broadly flowing (1912–13) was produced more or less at the same time as the drawings for *The Virgin*, perhaps in loose connection with the main figure of that painting (cat. no. 167; fig 1 on p. 230).[1] Klimt rarely used a pen, perhaps because it lacked the sensuous immediacy and flexibility of a pencil. Nevertheless, the hard juxtaposition of pen lines produced quite convincing results, as the present example demonstrates in the repeatedly applied contour lines, the energetic repetitions of pen strokes, the wild loops of

the hair, and the cautiously defined facial features. The model's hair spreads like a protective helmet over the introverted gaze of her face, which is bent slightly forward. The powerful curve of the upper contour of her hair is delicately echoed by the concave line of her shirt's neckline, which defines the space and fixes her upper body within the plane. Klimt continued to produce portrait drawings as autonomous works, delving into various moods.

In his head-and-shoulders portraits and half-length figures, especially in his final years, the artist repeatedly discovered new nuances. The highly cultivated aesthetic he achieved is illustrated by this frontal half-length portrait of a lady drawn in 1916–17 (cat. no. 168), which corresponds to the figure on the right in the contrasting pair of women in the painting *The Girlfriends* (1916–17, fig. 1).[2] In the painting, a naked young girl with sensuous curves cuddles up against an elegant woman dressed in a red gown and turban, whose long, mannered neck is reminiscent of a flower stalk. In the present portrait drawing, the same model is seen with her hair pinned up, wearing a patterned garment and a fur wrap. By artfully alternating precisely stylizing lines with cursorily sketched ones, Klimt achieved highly subtle effects of contrast. The delicately detailed pair of eyes with heavy lids and raised eyebrows conveys superior distance. Within the sketchy contours of the nose, the nostrils are emphasized as tiny but sharp circles. The delicately suggested, red-accented mouth stands out all the more vividly by contrast. The distinctly outlined oval of the face is flattered by the downy substance of the delicately rendered fur. In contrast to these refinements of line, the wild loops of the patterned dress, with

Fig. 1. *The Girlfriends*, 1916–17, oil on canvas, 99 × 99 (?) cm, burned in 1945

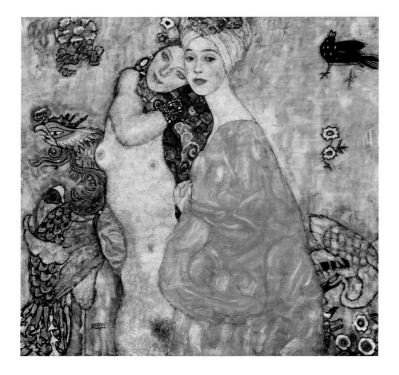

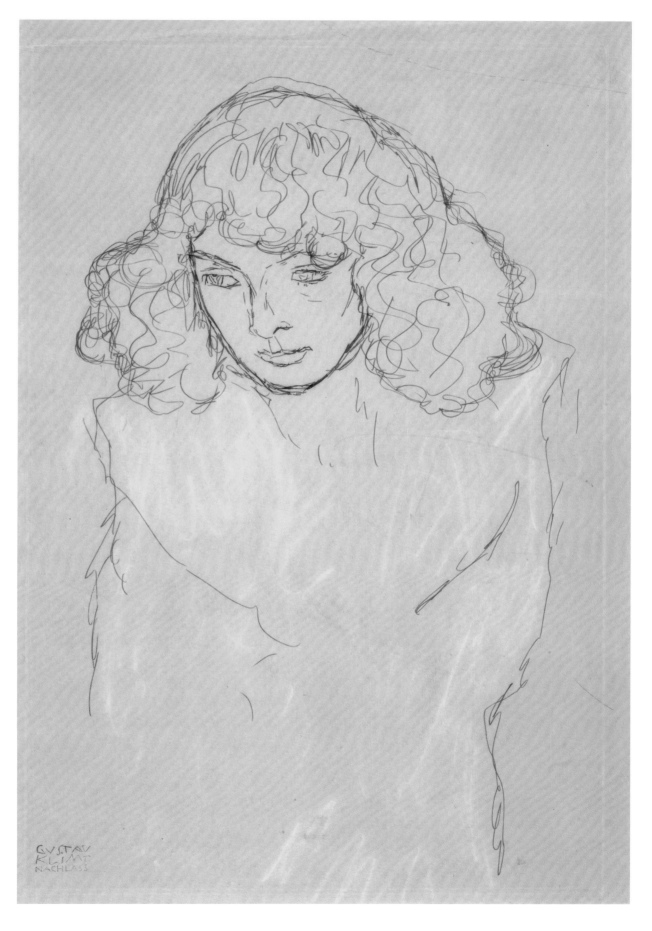

167

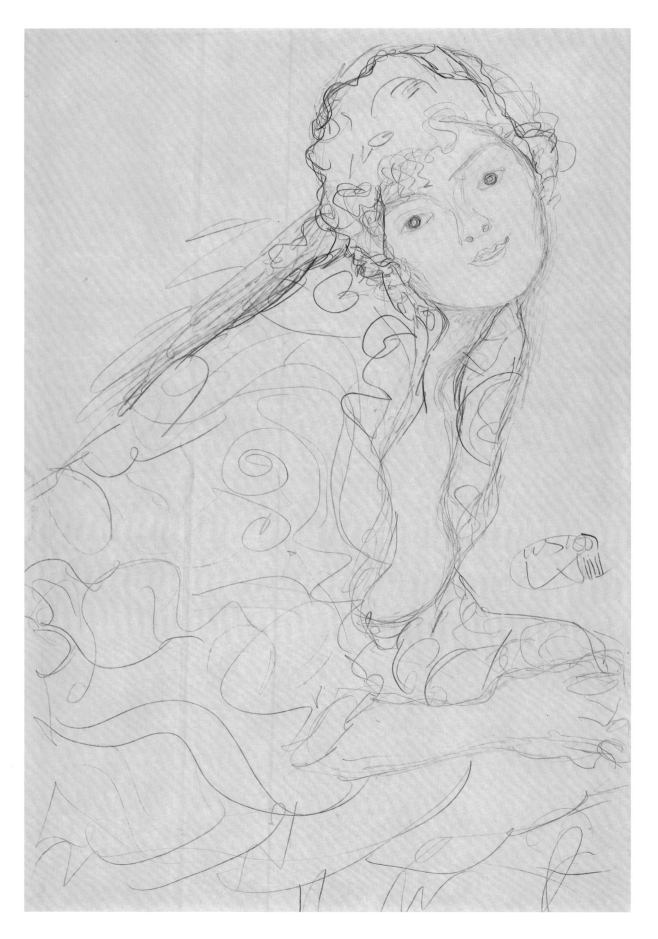

169

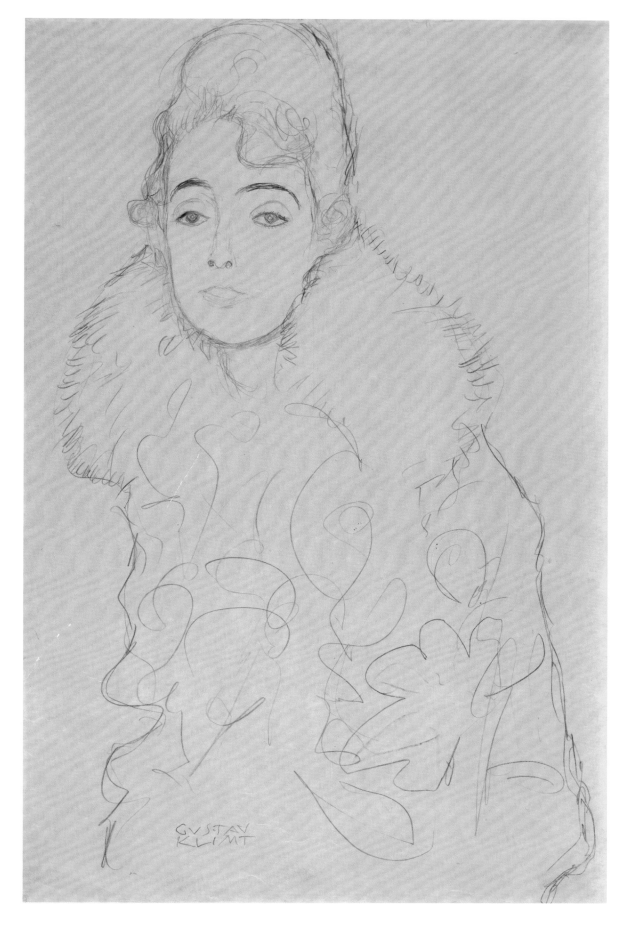

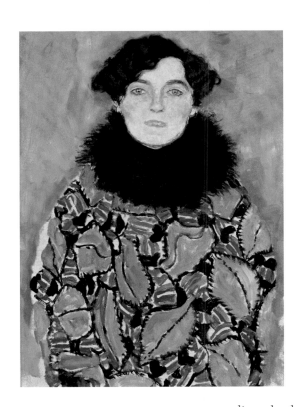

Fig. 2. *Johanna Staude*, 1917–18 (unfinished), oil on canvas, 70 x 50 cm, Belvedere, Vienna

blue and red mixed in, almost seem to dissolve. The fashionably stylized figure of the woman thus becomes a quasi-metaphysical appearance—surreal and yet emphatically present.

The half-length drawings of models with round faces from 1916–17 are the opposite pole of this hypersensitive, decadent female type, as is clear from the present work, which features an oval signature (cat. no. 169).[3] These typological extremes are particularly evident on the physical level: fragile slenderness in one case, voluptuous, round forms in the other. The present drawing features a complex axiality: the body of the seated model viewed from above looms diagonally into the picture plane, while her face is turned to the side and directed frontally at the viewer. Her head and her hands in her lap touch the edges of the sheet, which contributes considerably to the tension between space and plane. The captivating diagonal effect of the contour of her back, reinforced by several lines, is continued by the sloping axis of her eyes. The vehement, extremely free linear play of the loops, wavy lines, and spirals of the broad cape is joined by the rhythmically undulating outlines of the bare forms of the body and the fabrics. The red and blue pencils are employed for delicate accents. Characteristically for Klimt's late pe-

riod, the sharp circles of the eyes and nostrils loom strikingly out of the tangle of lines. The subtly overlapping lines of the lips, some of which are drawn in red, lend a smiling expression to the slightly accented corner of the mouth—yet this is not a momentary effect but rather expresses an elementary, positive mood.

Klimt usually based his drawings of head-and-shoulders or half-length figures on ideal types, thereby subjecting his models to a certain stylization. Occasionally he employed this method in his portraits as well, as he did in the studies for the portrait *Johanna Staude* (cat. no. 170, fig. 2).[4] In the painting, the thirty-four-year-old acquaintance of the artist is posed frontally in a jacket whose colorfully patterned fabric was produced by the Wiener Werkstätte. In the study exhibited here, which corresponds closely to the painting in terms of the pose, Klimt concentrated almost exclusively on the contour lines. The very slightly applied basic features of the face are overlapped by thicker lines, causing the forms to shift slightly. The result is a lively oscillation between light- and dark-gray pencil lines, which is particularly effective around the mouth and eyes. In this subtly characterizing study, Klimt still employed the Symbolist formula of the frontal, hypnotizing gaze, combined with a fragmentation of the hair caused by the upper edge of the sheet. Even in this late work, which is characterized by a simplicity of line, the dialectic of tangible proximity and dreamy distance dominates.

[1] Strobl III, 1984, nos. 2278–94.
[2] *The Girlfriends*, 1916–17, oil on canvas, 99 × 99 (?) cm, burned in Schloss Immendorf (Lower Austria) in 1945. Novotny and Dobai 1975, no. 201; Weidinger 2007, no. 236 (as *The Girlfriends II*).
[3] On the points of contact between this group and the portrait *Ria Munk III*, see Strobl III, 1984, pp. 114–16, nos. 2620–29.
[4] *Johanna Staude*, 1917–18 (unfinished), oil on canvas, 70 × 50 cm, Belvedere, Vienna. Novotny and Dobai 1975, no. 211; Weidinger 2007, no. 248. On the sitter, see Exh. cat. Vienna 2000–2001, p. 142.

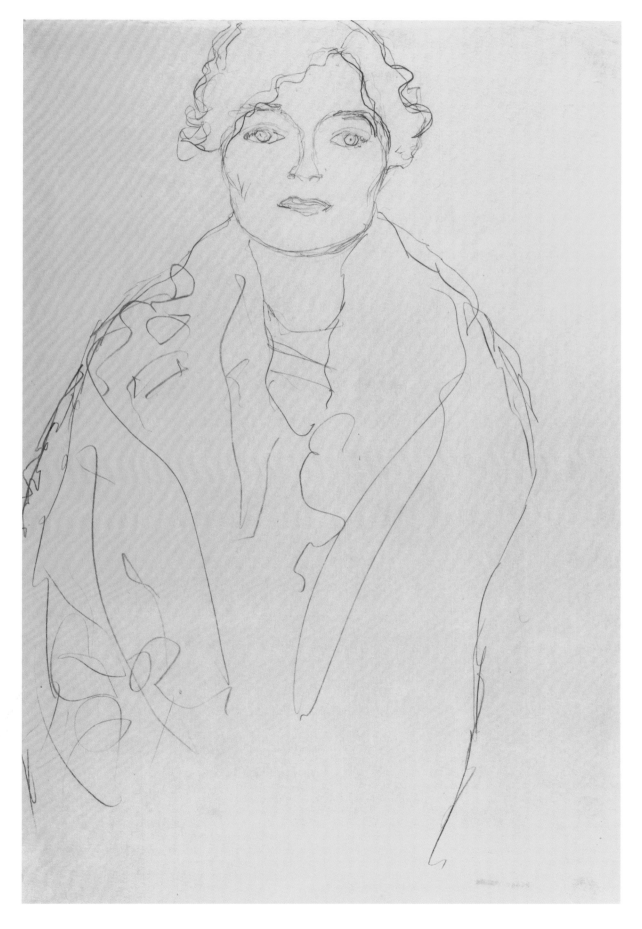

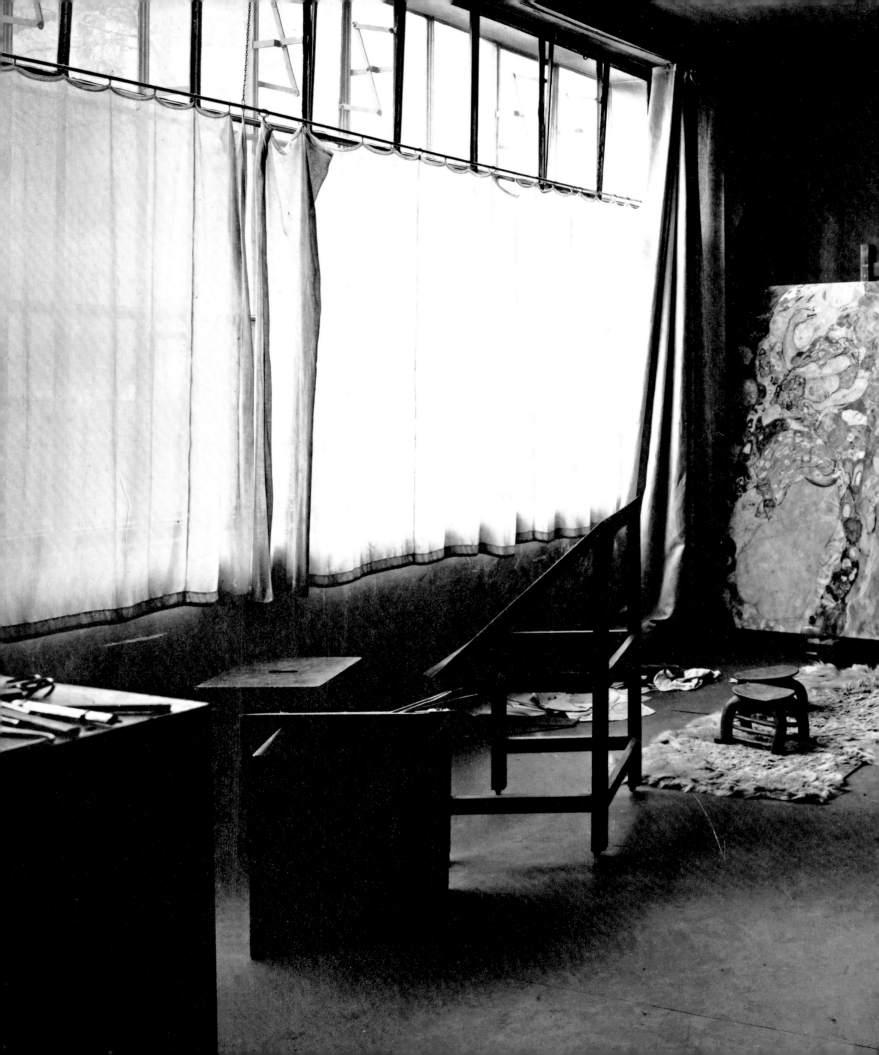

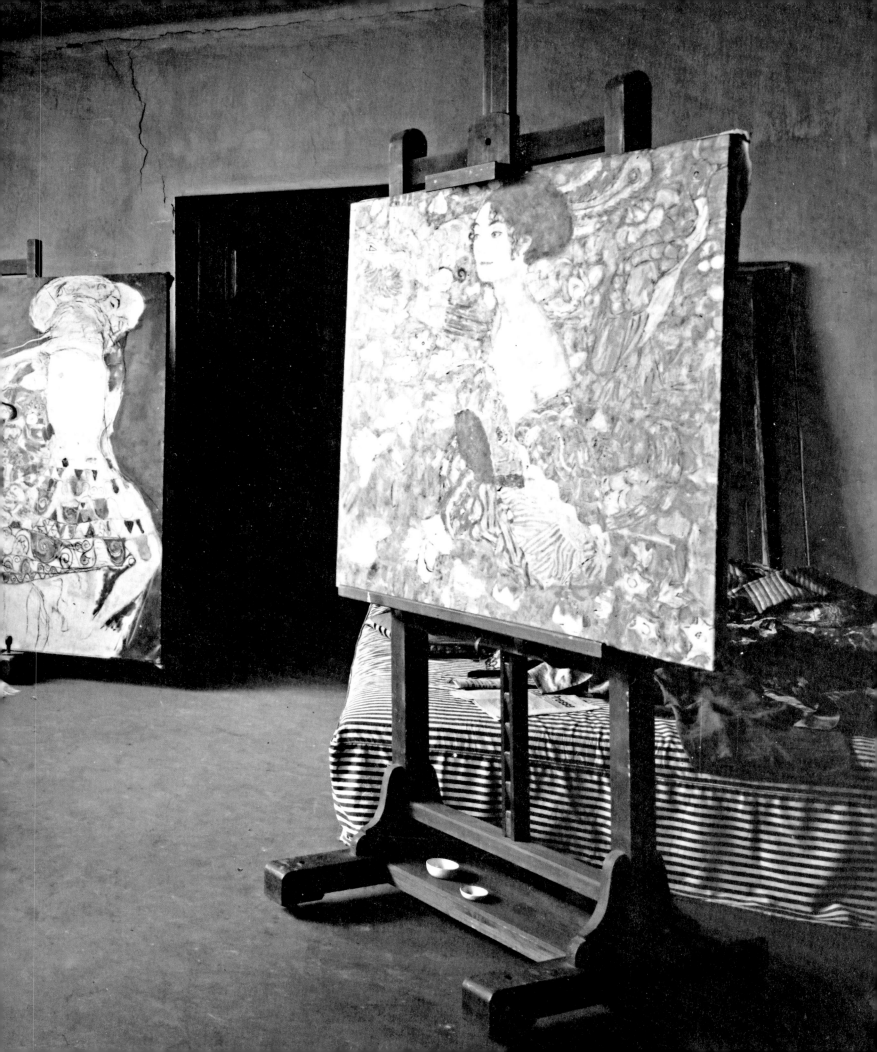

Selected Bibliography

Bisanz-Prakken, Marian. 1976. "Jan Toorop en Gustav Klimt," *Nederlands Kunsthistorisch Jaarboek* 27, pp. 175–209.

———. 1977. *Gustav Klimt—der Beethovenfries: Geschichte, Funktion und Bedeutung* (Salzburg).

———. 1978–79. "Gustav Klimt und die 'Stilkunst' Jan Toorops," *Klimt-Studien, Mitteilungen der Österreichischen Galerie* 22–23, nos. 66–67, pp. 146–214.

———. 1985. "Der Beethovenfries von Gustav Klimt in der XIV. Ausstellung der Wiener Secession (1902)," Exh. cat. Vienna 1985, pp. 528–43.

———. 1995. "Khnopff, Toorop und die 'Wiener Moderne,'" Exh. cat. Frankfurt 1995, pp. 172–78.

———. 1996. "Im Antlitz des Todes: Gustav Klimts 'Alter Mann auf dem Totenbett': Ein Porträt Hermann Flöges?," *Belvedere: Zeitschrift für bildende Kunst* 2, pp. 20–39.

———. 1999. *Heiliger Frühling: Gustav Klimt und die Anfänge der Wiener Secession 1895-1905*, exh. cat. (Vienna, Graphische Sammlung Albertina).

———. 2000–2001. "Klimt's Studies for the Portrait Paintings," Exh. cat. Vienna 2000–2001, pp. 198–219.

———. 2001a. "Gustav Klimt's Drawings," Exh. cat. Ottawa 2001, pp. 143–59.

———. 2001b. "'Die fernliegenden Sphären des Allweiblichen': Jan Toorop und Gustav Klimt," *Belvedere: Zeitschrift für bildende Kunst* 7, no. 1, pp. 34–47.

———. 2007. "*The Beethoven Frieze* and Klimt's 'Gift of Receptivity,'" Weidinger 2007, pp. 93–117.

———. 2007-8. "Gustav Klimt: The Late Work: New Light on *The Virgin* and *The Bride*," Exh. cat. New York 2007-8, pp. 105–29.

———. 2009. "Ria Munk III von Gustav Klimt: Ein posthumes Bildnis neu betrachtet," *Parnass* 29, no. 3, pp. 54–59.

———. Forthcoming. *Continuation and Supplement of Strobl I–IV* (Salzburg)

Collins, John. 2001. "Klimt's *Hope I*: New Documentation and Its Interpretation," *National Gallery of Canada Review* 2, pp. 27–58.

Comini, Alessandra. 1975. *Gustav Klimt* (London).

Eder, Franz. 2000–2001. "Gustav Klimt and Photography," Exh. cat. Vienna 2000–2001, pp. 50–56.

Eisler, Max. 1920. *Gustav Klimt* (Vienna).

Eyb-Green, Sigrid. 1999. "Zur Problematik von Restaurierung und Konservierung einer großformatigen Zeichnung: Arbeitszeichnung zum Karton für das Deckengemälde *Das Globetheater in London* im Wiener Burgtheater, Gustav Klimt," master's thesis, Akademie der bildenden Künste, Vienna.

Glück, Gustav, ed. 1922. *Gustav Klimt: Zehn Handzeichnungen mit einem Begleitwort* (Vienna).

Hevesi, Ludwig. 1906. *Acht Jahre Secession: Kritik, Polemik, Chronik 1897-1905* (Vienna).

Klein-Primavesi, Claudia. 2004. *Die Familie Primavesi und die Künstler Hanak, Hoffmann, Klimt: 100 Jahre Wiener Werkstätte* (Vienna).

Koja, Stephan, ed. 2006. *Gustav Klimt: The Beethoven Frieze and the Controversy over the Freedom of Art* (Munich).

Koller, Manfred. 1978–79 "Klimts Beethovenfries: Zur Technologie und Erhaltung," *Klimt-Studien, Mitteilungen der Österreichischen Galerie* 22–23, nos. 66–67, pp. 215–40.

———. 2006. "The Technique and Conservation of the Beethoven Frieze," Koja 2006, pp. 155–69.

Konecny, Elvira. 1986. *Die Familie Dumba und ihre Bedeutung für Wien und Österreich* (Vienna).

Kugel, Wilfried. 1992. *Der Unverantwortliche: Das Leben von Hanns-Heinz Ewers* (Düsseldorf).

Mrazek, Wilhelm. 1978–79. "Die 'Allegorie der Skulptur' vom Jahre 1889: Ein neuentdecktes Frühwerk von Gustav Klimt," *Klimt-Studien, Mitteilungen der Österreichischen Galerie* 22–23, nos. 66–67, pp. 37–47.

Natter, Tobias G. 2003. *Die Welt von Klimt, Schiele und Kokoschka: Frühe Sammler und Mäzene* (Cologne).

Nebehay, Christian M. 1969. *Gustav Klimt Dokumentation* (Vienna).

———. 1987. *Gustav Klimt, Egon Schiele und die Familie Lederer* (Bern).

Novotny, Fritz, and Johannes Dobai. 1975. *Gustav Klimt*, with a catalogue raisonné of his paintings, 2nd rev. ed., Karen Olga Philippson, trans. (Salzburg). Originally published in 1967

Rychlik, Othmar. 2007. *Gustav Klimt, Franz Matsch und Ernst Klimt im Burgtheater* (Vienna).

Shapira, Elana. 2006. "Modernism and Jewish Identity in Early Twentieth Century Vienna: Fritz Waerndorfer and his House for an Art Lover," *Studies in the Decorative Arts* 13, no. 2, pp. 52–92.

Strobl, Alice. 1964. "Zu den Fakultätsbildern von Gustav Klimt: Anlässlich der Neuerwerbung einer Einzelstudie zur 'Philosophie' durch die Graphische Sammlung Albertina," *Albertina-Studien* no. 4, pp. 138–68.

———. 1978–79. "Klimts 'Irrlichter': Phantombild eines verschollenen Gemäldes," *Klimt-Studien, Mitteilungen der Österreichischen Galerie* 22–23, nos. 66–67, pp. 119–45.

——. 1980–89. *Gustav Klimt. Die Zeichnungen 1878–1918*, 4 vols. Veröffentlichungen der Albertina 15 (Salzburg). Vol. I, 1878–1903 (1980); Vol. II, 1904–1912 (1982); Vol. III, 1912–1918 (1984); Vol. IV, Nachtrag 1878–1918 (1989).

——. 2007. "The Faculty Paintings and Sketches for *Medicine* and *Philosophy*," Weidinger 2007, pp. 41–53. First published in a special Klimt issue of *Belvedere: Zeitschrift für bildende Kunst* (2006-7), pp. 38–53.

Tietze, Hans. 1919. "Gustav Klimts Persönlichkeit: Nach Mitteilung seiner Freunde," *Die Bildenden Künste. Wiener Monatshefte* 2, nos. 1–2, pp. 1–10.

Von Miller, Manu. 2004. *Sonja Knips und die Wiener Moderne: Gustav Klimt, Josef Hoffmann und die Wiener Werkstätte gestalten eine Lebenswelt* (Vienna).

——. 2007. "The Paintings of James McNeill Whistler and Gustav Klimt," Weidinger 2007, pp. 57–70. First published in a special Klimt issue of *Belvedere: Zeitschrift für bildende Kunst* (2006–7), pp. 82–99.

Weidinger, Alfred, ed. 2007. *Gustav Klimt* (Munich).

Weixlgärtner, Arpad. 1912. "Gustav Klimt," *Die graphischen Künste* 35, pp. 49–66.

Zaunschirm, Thomas. 1987. *Gustav Klimt: Margarethe Stonborough-Wittgenstein: Ein österreichisches Schicksal* (Frankfurt am Main).

Zuckerkandl, Berta. 1911. "Kunst und Kultur. Der Klimt-Fries," *Wiener Allgemeine Zeitung*, July 13, p. 2.

EXHIBITION CATALOGUES:

Budapest 2010
Bisanz-Prakken, Marian, ed. *Nuda Veritas: Gustav Klimt and the Origins of the Vienna Secession 1895–1905*, exh. cat. (Budapest, Szépm veszeti Múzeum).

Frankfurt 1995
Schulze, Sabine, ed. *Sehnsucht nach Glück: Wiens Aufbruch in die Moderne: Klimt, Kokoschka, Schiele*, exh. cat. (Schirn Kunsthalle Frankfurt).

New York 2007–8
Price, Renée, ed. *Gustav Klimt: The Ronald S. Lauder and Serge Sabarsky Collections*, exh. cat. (New York, Neue Galerie).

Ottawa 2001
Bailey, Colin, ed. *Gustav Klimt: Modernism in the Making*, exh. cat. (Ottawa, National Gallery of Canada).

The Hague 2006–7
Bisanz-Prakken, Marian, ed. *Toorop in Wenen: Inspiratie voor Klimt*, exh. cat. (Gemeentemuseum Den Haag).

Vienna 1985
Waissenberger, Robert, ed. *Traum und Wirklichkeit*, exh. cat. (Vienna, Künstlerhaus).

Vienna 2000–2001
Natter, Tobias G., and Gerbert Frodl. *Klimt's Women*, exh. cat. (Vienna, Belvedere).

Vienna 2007
Husslein-Arco, Agnes, and Alfred Weidinger, eds. *Gustav Klimt und die Künstler-Compagnie*, exh. cat. (Vienna, Belvedere).

Vienna 2010–11
Wehdorn, Armine, ed. *"… so weinig Ansprechendes …": Gustav Klimt und die Notenbank*, exh. cat. (Vienna, Geldmuseum, Österreichische Nationalbank)

© 2012 Albertina, Vienna; Hirmer Verlag GmbH, Munich; and Marian Bisanz-Prakken

Published in the United States of America in 2012 by the J. Paul Getty Museum, Los Angeles

Getty Publications
1200 Getty Center Drive, Suite 500
Los Angeles, California 90049-1682
www.getty.edu/publications

This publication is issued in conjunction with the exhibitions *Gustav Klimt: The Drawings,* on view at the Albertina Museum, Vienna from March 14 to June 10, 2012, and *Gustav Klimt: The Magic of Line,* at the J. Paul Getty Museum, Los Angeles from July 3 to September 23, 2012.

Graphic design: Klaus E. Goeltz

Printed in Germany

Library of Congress Control Number: 20119458111

ISBN: 978-1-60606-111-4

Published simultaneously in Europe as
Gustav Klimt: Die Zeichnungen and
Gustav Klimt: The Drawings by the Albertina Museum, Vienna, in partnership with Hirmer Verlag, Munich.

Front Cover: Gustav Klimt, *Portrait of a Reclining Young Woman,* 1897–98 (detail, cat. no. 23)

Back Cover: Gustav Klimt, *Portrait of a Lady with Cape and Hat,* 1897–98 (detail, cat. no. 22)

Frontispiece: Gustav Klimt, *Standing Female Nude, Study for "The Three Gorgons,"* 1901 (detail, cat. no. 54)

pp. 20–21: Gustav Klimt, *Reclining Girl (Juliet) and Two Studies of Hands, Study for* Shakespeare's Theater, 1886–87 (detail, cat. no. 7)

pp. 56–57: Gustav Klimt, *Two Studies of a Reclining Draped Figure, Studies for "Longing for Happiness,"* 1901 (detail, cat. no. 51)

pp. 154–55: Gustav Klimt, *Reclining Woman, Study for* Water Snakes II, first version, 1904 (detail, cat. no. 94)

pp. 226–27: Gustav Klimt, *Seminude Lying on Her Stomach,* 1910 (detail, cat. no. 125)

pp. 300–301: Gustav Klimt's Studio, 1918 (see p. 18)